ART
AMERICA
A RESOURCE MANUAL

ART AMERICA
A RESOURCE MANUAL

PHILIP ALAN CECCHETTINI

Director, Media Programs
University of California, Davis

DON WHITTEMORE

Media Programs
University of California, Davis

In consultation with
THEODORE BRACHFELD
Media Programs
University of California, Davis

McGRAW-HILL BOOK COMPANY

New York St. Louis San Francisco Auckland Bogotá Düsseldorf
Johannesburg London Madrid Mexico Montreal New Delhi
Panama Paris São Paulo Singapore Sydney Tokyo Toronto

This book was set in Palatino by Progressive Typographers.
The editors were Robert G. Manley and Douglas J. Marshall;
the designer was Joan E. O'Connor;
the production supervisor was Robert C. Pedersen.
Edwards Brothers Incorporated was printer and binder.

ART AMERICA
A RESOURCE MANUAL

1234567890 EBEB 783210987

Library of Congress Cataloging in Publication Data

Cecchettini, Philip Alan.
 Art America.

 Companion volume to Art America by M. A. Tighe and
E. E. Lang, for use with the video series Art America.
 Bibliography: p.
 1. Art, American. 2. Art America. 3. Art—
Study and teaching—United States. I. Whittemore,
Don, joint author. II. Tighe, Mary Ann. Art America.
III. Title.
N6505.C39 709′.73 77-7126
ISBN 0-07-064602-3

CONTENTS

PREFACE

The Resource Manual for the *Art America* television series was produced by Media Programs, a new unit of University Extension at the University of California, Davis. Formed in 1975 by Philip Alan Cecchettini to explore possibilities of encouraging and facilitating life-long learning, Media Programs works with publishers to produce print and video materials suitable for use in continuing education programs, community colleges, and other schools. Media Programs, like University Extension, is particularly concerned with the needs of students without access or with difficult access to instructors and classrooms.

Many people worked on writing and producing this manual. Don Whittemore wrote the Introduction, Programs 1 to 11, 15, 16, and 20, and assisted in writing Program 12. Theodore Brachfeld served as technical consultant for the entire Manual, wrote Programs 13, 14, 17, 18, and 19, and assisted in writing Program 12. Cheryl A. Marks served as research assistant, assisted in writing Program 12 and prepared the manuscript. Mary Ann Tighe and Elizabeth Lang, co-authors of *Art America* (McGraw-Hill, 1977) and coproducers and cowriters for the *Art America* television series, gave valuable and timely advice on the contents of the Manual. The judgments in it, however, are entirely the responsibility of, Don Whittemore and Theodore Brachfeld.

We should also like to thank the following people and organizations: the reference staff of the Bancroft Library, University of California, Berkeley; the reference staff of the Shields Library, University of California, Davis; Patricia McKnight, Mona Smith, Margie Wilson Brachfeld, and Jan Shauer of Northern Virginia Community College; Gertrude and Philip Brachfeld, Helen Dowd, and especially Martin Greenman.

Philip Alan Cecchettini
Don Whittemore

INTRODUCTION

Developed to acquaint Americans with their artistic heritage, the *Art America* telecourse and its companion textbook* present the main developments of American art from colonial times to the present. The purpose of this Resource Manual is three-fold: to place each lesson in a general historical, aesthetic, and cultural context; to provide the title, date, and artist for each art work shown in the series; and to offer suggestions for increasing your appreciation of American art and artists. Our basic premise is that artists created their work for the pleasure and enjoyment of people in their daily lives. Museums provide an indication of the richness and the diversity of art, although, since they are designed to preserve and display only the best artistic creations, they sometimes narrow our viewpoint at the same time they increase our knowledge. It is important to visit museums, but outside them, spread all through our communities, there is much to be seen.

Each chapter of the Resource Manual is divided into five main sections: Introduction, Overview, Viewer's Guide, Questions and Projects, and Bibliography.

* *Art America*, by Mary Ann Tighe and Elizabeth Lang, McGraw-Hill, New York, 1977.

The Introduction presents a quotation setting out some of the basic ideas contained in the program followed by a brief synopsis of the chapter.

The Overview contains the approximate dates of the period under consideration (usually this corresponds to the dates of the principal works studied in the chapter), some general indications of contemporary life in America, examples of American literature which help clarify the concerns of the period, a brief sampling of foreign events, and an outline of the program.

The Viewer's Guide contains a complete list of the works of art shown in the program. (Film segments and gallery visits do not receive complete annotations because the camera moves over too much area to permit accurate descriptions.) When the whole work is shown, the title is given in full, followed by the approximate date of its completion (for example, "*John Adams* (1826)"). When only part of the work is seen, the notation is changed to "Detail of" (description of part shown) "from" (name of work) (for example, "Detail of Indian encampment from *The Rocky Mountains*"). When the camera moves slowly over the surface of the work instead of holding on one angle the notation becomes "Details from" followed by the title of the work (for example, "Details from *Home to Thanksgiving*"). A short biography introduces each artist and is usually followed by one or more examples of his or her work. However, these biographies are intended only as refreshers since the artists are all treated in greater detail in *Art America* by Mary Ann Tighe and Elizabeth Lang. The many excellent illustrations in the *Art America* text also provide an opportunity to consider the artist's work more closely. For those who would like additional prints, University Prints, Cambridge, Massachusetts, sells inexpensive reproductions, both black and white and color, of American art. Examples of the artist's work normally follow the biography, but if a work is shown out of sequence, the name of the artist is included. Annotations are to provide significant or useful information. The art works which precede the program logo or accompany the closing credits are listed, with the name of the artist in parentheses, at the beginning and end of the Viewer's Guide.

The Questions and Projects are intended to provide a simple technique for the study of American art. The first group singles out important individuals, art terms, and historical events mentioned in the program. Often the first task will be simply to define them. However, a precise definition is less important than acquiring an understanding of their importance to American art and American life. Familiarizing yourself with these words and ideas will make later programs more enjoyable. The questions in the second group are suggestions of areas for further investigation. Additional reading is a necessity. However, since there is no prescribed limit to the amount of additional work you may do on them (the questions are intentionally open-ended), you must decide yourself how much information you want to get. The third group aims at encouraging comparisons and evaluations of the works of art studied in the program. Always keep in mind, however, that these questions are not exhaustive; they are not the only ones that might be asked about the same material and they are not designed to accommodate only one answer. Last, we have included projects which will allow you to approach American art from a practical side. Some of them

are simply aimed at increasing your knowledge of the artists discussed in the program, but for the most part they are intended to broaden your appreciation not only of American art and art in general, but of American life as well.

The Bibliography emphasizes readily accessible books of general interest. Historical and cultural texts have been included along with specifically art history texts.

STUDY PROCESS FOR *ART AMERICA*

1. Read the Introduction and the Overview of the lesson.

2. Skim the Viewer's Guide to familiarize yourself with the sequence of material. Note particularly the indications of "detail." When the camera shifts from one part of a painting to another, it can easily appear that two different paintings are being shown. If you anticipate the sections of detailed analysis, it will aid and simplify your viewing.

3. Review the previous lesson and determine how the present one stands in relation to it.

4. Review the series themes stated in Program 1.

5. Watch the program. Refer to the Resource Manual to make sure you know what you are seeing. But do not feel obligated to read the annotations on the particular works as you watch the show. These "captions" are included to point out significant or unusual features of the art work. *Art America* may be approached as an introduction to American art and as an art appreciation course. Insofar as you consider it an art history course, you should try to keep track of the artists, the works, the period, and the general art trends in each lesson.

6. Return to the Resource Manual after the program and review what you have seen, making marginal notes of your impressions and reactions. Determine the relative importance of the series themes in the current lesson and note your conclusions at the end of the Program. It is essential to fix in your mind the shape and the contents of each program as soon as possible.

7. Read the corresponding chapter in *Art America*.

8. Work through the questions at the back of the lesson. They are intended to consolidate the information contained in the lesson and to encourage you to carry the study and appreciation of American art beyond the confines of the program into your everyday life.

9. Talk. Share your impressions and ideas with as many other viewers as possible. Learning what they have experienced will help broaden your awareness of the possibilities of American art.

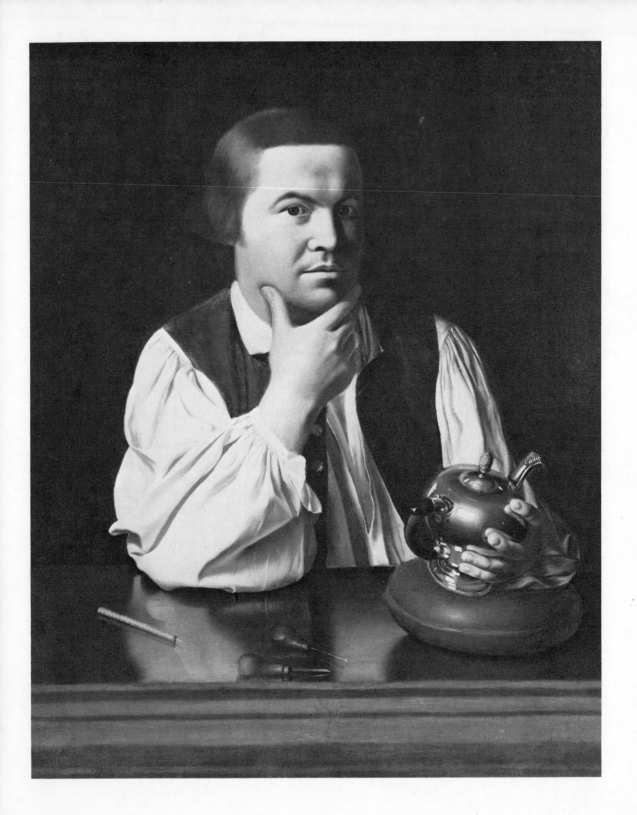

PROGRAM 1

IN SEARCH OF A VISUAL TRADITION

When in the Course of human Events, it becomes necessary for one People to dissolve the Political Bands which have connected them with another, and to assume among the Powers of the Earth, the separate and equal Station to which the Laws of Nature and of Nature's God entitle them, a decent Respect to the Opinions of Mankind requires that they should declare the causes which impel them to the Separation.

We hold these Truths to be self-evident, that all Men are created equal, that they are endowed by their Creator with certain unalienable Rights, that among these are Life, Liberty, and the Pursuit of Happiness.

<div align="right">

The Declaration of Independence, 1776

</div>

The Declaration of Independence, embodying hopes and beliefs which remain an essential expression of the American character, is undeniably an American document. Yet the political theory on which it is based was devised by an English philosopher, John Locke. This adaptation of Old World theory to New World needs typifies the development of the United States.

John Singleton Copley, Paul Revere (1765–1970). Courtesy of the Boston Museum of Fine Arts, Boston. Gift of Joseph W., William B., and Edward N. R. Revere.

1

American art, like American government, began as a continuation of European practices. In time, however, American artists, responding to their unique surroundings, established distinct traditions and new standards. Abstract expressionism, the post-World War II movement which began in New York and profoundly influenced artists all over the world, marks the emergence of American artists as an international force. But American art had become a vital expression of the national experience long before abstract expressionism. *Art America*, tracing the development of American art from colonial times, makes evident the achievements of the nation's many artists.

OVERVIEW

The first program of *Art America* proposes three questions as thematic guidelines for this survey of American art.

What Is an American Subject Matter? Like everything else in the United States, foreign influences have been reshaped and redirected to satisfy the needs of a new environment. The European-trained colonial artists continued to practice their craft as they had in their former country. Artists, however, do not create in a vacuum, but in response to their surroundings. As a result they generally mirror the society they serve, expressing common feelings and national sentiments. This question brings us closer to the nature of American life. What did American artists choose to depict in their work? Why? Are there subjects which might be called "typically American"?

What Is an American Style? Style is the manner of creating. Each artist has a recognizable, personal mark which enables the viewer to distinguish his work. But is there a national style? Are there recognizable qualities which distinguish American painting from French painting or from Italian painting or from English painting? This section suggests some formal constants in American art and relates them to specific influences. Keep in mind, however, that not *all* American art can be reduced to simple formulas or single influences. The distinctive formal features expressed here are put forward as a means of approaching American art, as guidelines from which to gauge variations and new departures. They should be appreciated as suggestions and not learned as rules. One important goal of this course is to encourage you to *look* at what American artists have produced. The information you gather in this way will allow you to draw your own conclusions about the typical marks of American art and their origins. This does not mean that all explanations are possible, merely that it would be misleading to limit the investigation at the outset.

What Is the Role of the Artist in American Life? The social function and importance of the artist varies from one country to another and naturally influences the way the artist views society.

Consider, as you watch this program and its successors, what sort of an audience would be interested in the works of art you see and what attitudes the work expresses toward American society. Does it reaffirm current social values? Does it suggest new ideas or new concepts? What does the artist tell about himself/herself by the way he/she creates?

After viewing each tape, consider what you have seen in terms of these questions. How has it increased your awareness of American subjects, American style, and the relation of American artists to American society?

VIEWER'S GUIDE

Most of the artists and the works of art mentioned in this program are taken up more fully in later programs. Of the work shown, we therefore list only the title and date, followed by the name of the artist and the number of the program in which the artist is treated more fully. In the few cases when an artist is not mentioned elsewhere, we include a short biography and indicate the program in which artists of similar style are examined.

PRE-LOGO ILLUSTRATIONS Five views of the Lincoln Gallery of the National Collection of the Fine Arts, Smithsonian Institution, Washington, D.C.

Self-Portrait (1819) by Benjamin West (Program 3).

Detail of boys, dog, and spectators on foreground rocks from *Niagara Falls.*

Niagara Falls (undated) by Alvan Fisher (1792–1863). Fisher was one of the first American artists to specialize in genre, landscape, and animal painting. A successful commercial artist, he sold over 1000 paintings during the period 1826 to 1862 alone. He painted several views of Niagara Falls (Program 5 for landscape painters and Program 6 for genre painters).

The Card Rack (1882) by John Peto (Program 4).

Two details from *The Card Rack.*

Reservoir (1961) by Robert Rauschenberg (Programs 18 and 19).

Detail of cowboy and his girl friend from *Galvin Tent Show.*

Detail of Indians watching the merry-go-round from *Galvin Tent Show.*

Detail of women riding the merry-go-round from *Galvin Tent Show.*

Galvin Tent Show (1924) by John Sloan (Program 12).

Grand Canyon of the Yellowstone River (1893–1901) by Thomas Moran (Program 6).

John Adams (1826) by Gilbert Stuart (Program 3).

The Greek Slave (1844) by Hiram Powers (Program 4).

Black Knife, an Apache Chief (1846) by John Mix Stanley (Program 7).

Three details from *Black Knife, an Apache Chief.*

The Polka Dot Dress (1927) by George Luks (Program 12).

Raigo (1955) by Stanton MacDonald Wright (Program 14).

Detail of *New* from *Int'l Surface No. 1.*

Detail of left center from *Int'l Surface No. 1.*

Int'l Surface No. 1 (1960) by Stuart Davis (Program 15).

The narrator, John Robbins, sits in front of *Small's Paradise* (1964) by Helen Frankenthaler (Program 18).

THE SEARCH FOR AN AMERICAN SUBJECT MATTER

Elizabeth Freake and Baby Mary (1674). Unknown painter called the Freake limner, from the name of the patron. (Program 2).

John Freake (1674). Unknown painter known as the Freake limner. (Program 2).

Elizabeth Paddy (Mrs. John Wensley) (1670–1680). Unidentified painter (Program 2).

Alice Mason (1670). Unidentified painter known as the Mason limner (Program 2).

The Girl with the Red Shoes (Magdalena Gansevoort) (circa 1729) by a patroon painter of the Hudson River Valley (Program 2).

Edward Jacquelin II as a Child (circa 1722) by an unidentified painter working in the Southern colonies (Program 2).

Mr. and Mrs. Thomas Mifflin (1773) by John Singleton Copley (Program 3).

The Death of Major Peirson (1783) by John Singleton Copley (Program 3).

The Artist in His Museum (1822) by Charles Willson Peale (Program 4).

Marius amidst the Ruins of Carthage (1807) by John Vanderlyn. One of the unfortunate artists of the early part of the nineteenth century, Vanderlyn (1775–1851) studied in Philadelphia with Gilbert Stuart (1795–1796) and in Paris (1796–1801). *Marius amidst the Ruins of Carthage* was awarded the gold medal by order of the Emperor Napoleon at the French Salon of 1807. Unfortunately Vanderlyn's style never pleased his American patrons, and his chances for success were further diminished by his close friendship with Aaron Burr.

Washington (1833–1841) by Horatio Greenough (Program 4).

Detail of Washington's head from *Washington* by Horatio Greenough.

Washington (1796, the Athenaeum version) by Gilbert Stuart (Program 3).

Washington (1795, the Vaughan portrait) by Gilbert Stuart (Program 3).

Washington (1779) by Charles Willson Peale (Program 4).

Washington (1796, the Landsdowne portrait) by Gilbert Stuart (Program 3).

Kindred Spirits (1849) by Asher B. Durand (Program 5).

Detail of Thomas Cole and William Cullen Bryant from *Kindred Spirits*.

Niagara Falls (1857) by Frederic Church (Program 5).

Buffalo Chase with Bows and Arrows (1832) by George Catlin (Program 7).

Indian Portrait (undated) by George Catlin (Program 7).

Woman and Child (undated) by George Catlin (Program 7).

Woman and Child (1850) by an unidentified daguerreotypist (Program 6).

Lemuel Shaw, Chief Justice (1851), a daguerreotype of Southworth and Hawes (Program 6).

W. H. Jackson on Glacier Point (1871) by an anonymous photographer (Program 7).

Best General View of Yosemite, #2 (1866) by C. E. Watkins (Program 7).

Mammoth Hot Springs, Gardiner's River (1871) by W. H. Jackson (Program 7).

Cornhusking (1860) by Eastman Johnson (Program 6).

Checkers Up at the Farm (1875) by John Rogers (Program 6).

Detail of courting couple from left foreground of *Old Kentucky Home* (1859) by Eastman Johnson (Program 6).

Detail of banjo player, child, and mother from *Old Kentucky Home*.

Snap the Whip (1872, the Youngstown version) by Winslow Homer (Program 10).

Detail of middle boys from *Snap the Whip*.

Detail of boys at handle end from *Snap the Whip*.

The Wyndham Sisters (1899) by John Singer Sargent (Program 9).

Madame X (1884) by John Singer Sargent (Program 9).

Mrs. Henry White (1888) by John Singer Sargent (Program 9).

The Breakers (1892) designed by Richard Morris Hunt (Program 9).

Central hall of *The Breakers* from balcony.

Billiard room of *The Breakers*.

Guaranty Building (now Prudential Building)(1894–1895) by Louis Sullivan (Program 11).

The Cliff Dwellers (1911) by George Bellows (Program 12).

Rooftops, Summer Night (1905, etching) by John Sloan (Program 12).

Italian Family, Ellis Island (1905) by Lewis Hine (Program 12).

Huck Finn (1936) by Thomas Hart Benton. (Huck Finn is visible at extreme right, Jim is cut out of frame) (Program 15).

July Hay (1943) by Thomas Hart Benton (Program 15).

Nighthawks (1942) by Edward Hopper (Program 15).

The Upper Deck (1929) by Charles Sheeler (Program 15).

The Bridge (1922) by Joseph Stella (Program 14).

Marilyn Monroe (1960) by Andy Warhol (Program 19).

Ironing Board with Shirt and Iron (1964) by Claes Oldenburg (Program 19).

THE SEARCH FOR AN AMERICAN STYLE

The Demuth American Dream (1964) by Robert Indiana (Program 19).

Anne Pollard (1721). Unidentified painter (Program 2).

Paul Revere (1768–1770) by John Singleton Copley (Program 3).

Detail of head from *Paul Revere*.

Detail of teapot from *Paul Revere*.

My Gems (1888) by William Michael Harnett (Program 4).

Meditations by the Sea (1850–1860) by an anonymous folk artist. Throughout the nineteenth century, untrained artists painted for their own enjoyment. These folk artists painted in a traditional fashion: forms were rendered as flat, two-dimensional entities while details of dress and costume were meticulously described. The limner paintings show some of the same characteristics (Program 2).

Coast Scene with Figures (1869) by John Frederick Kensett (Program 5).

Congress Hall: The Old House of Representatives (1821) by Samuel F. B. Morse (Program 4).

The Agnew Clinic (1889) by Thomas Eakins (Program 10).

Detail of surgical team and patient from *The Agnew Clinic*.

Nude Bathers (1883), photographic study for *The Swimming Hole*. Thomas Eakins.

The Swimming Hole (1883–1885) by Thomas Eakins (Program 10).

Galloping Horse (1878), photographic sequence by Eadweard Muybridge (Programs 6 and 10).

Artichoke, Halved (1930) by Edward Weston (1886–1948). Weston worked on the West Coast during most of his career. He specialized in sharply defined, carefully composed scenes taken with a large 8 by 10 view camera (Programs 6 and 14).

Cigarette Butt (1975) by Irving Penn (born 1917) (Program 17).

THE ROLE OF THE ARTIST IN AMERICAN SOCIETY

Self-Portrait (1819) by Benjamin West (Program 3).

John Singleton Copley (1783–1784) by Gilbert Stuart (Program 3).

Self-Portrait (1880) by Mary Cassatt (Program 9).

Self-Portrait (1871–1873) by James Whistler (Program 9).

The Painter's Triumph (1838) by William Sidney Mount (Program 6).

Detail of painter and farmer from *The Painter's Triumph*.

Detail of painter and farmer from *The Painter's Triumph*.

The Painter's Triumph (1838).

The Art Lover (1962) by Jack Levine (Program 16).

Elias Howe's patent model for his sewing machine (1846).

"1401," a Pacific-type steam locomotive.

"Big Six" hand pumper fire engine (1851).

Ford Model T. Introduced in 1908 for $850.

Suspension tower and cables from *The Brooklyn Bridge* (1867–1873) designed and built by John and Washington Roebling (Program 11).

Turning Out the Light (1905, etching) by John Sloan (Program 12).

South Beach Bathers (1903) by John Sloan (Program 12).

Detail of woman bather from *South Beach Bathers*.

Portrait of George Luks (1904) by Robert Henri (Program 12).

The Wrestlers (1905) by George Luks (Program 12).

Strikers from the Artists' Union on the picket line (circa 1938). Photograph by Irving Marantz (Program 16).

Detail of craftsmen working on a fountain group, *Light Dispelling Darkness* by Waylande Gregory (circa 1937) (Program 16).

Jackson Pollock (1951). Photograph by Hans Namuth (Program 17).

David Smith (1948). Photograph by Sam Meulendyke (Program 18).

Robert Morris. Exhibition poster, Castelli-Sonnabend, April 6–27, 1974.

Lynda Benglis. Poster, Andre Emmerich Gallery, New York 1973.

Flight and Pursuit (1872) by William Rimmer (Program 8).

Toilers of the Sea (1884) by Albert Pinkham Ryder (Program 8).

Self-Portrait (1910). Photograph by Alfred Stieglitz (Program 14).

Blue and Green Music (1919) by Georgia O'Keeffe (Program 14).

Abstraction #2 (1910) by Arthur Dove (Program 14).

Military (1913) by Marsden Hartley (Program 14).

Chinese Restaurant (1915) by Max Weber (Program 14).

Administration Building, Columbian Exposition (1893). Designed by Richard Morris Hunt (Program 11).

The Armory Show (1913). Photograph (Program 13).

Details of craftsmen working on *Light Dispelling Darkness* (circa 1937) (Program 16).

Soho district, New York City.

Soho district, New York City.

Nude Descending the Staircase #2 (1912) by Marcel Duchamp (Program 13).

The Painter's Triumph (1838) by William Sidney Mount (Program 6).

Signing of the Declaration of Independence (1817–1824). Mural in the U.S. Capitol executed by John Trumbull (Program 4).

Untitled (1965 and 1967) by Robert Morris (Program 19).

Figure Eight (1952) by Franz Kline (Program 17).

Christina's World (1948) by Andrew Wyeth.

CLOSING ILLUSTRATIONS (UNDER CREDITS) *Washington* (Greenough); *Elizabeth Paddy* (anonymous); *The Artist in His Museum* (C. W. Peale); *Washington* (Athenaeum version, Stuart); *Checkers Up at the Farm* (Rogers); *Niagara Falls* (Church); *Madame X* (Sargent).

QUESTIONS AND PROJECTS

There are no questions for this chapter.

PRELIMINARY PROJECTS

These projects are intended to suggest methods of increasing your awareness of artistic techniques and the accomplishments of American artists. They are *not* assignments.

As prelude to beginning this course in American art, we suggest the following ways of familiarizing yourself with the history and the current state of your community.

1 Visit the art museums within viewing distance. Check your area also for traveling exhibitions.

2 Find out about commercial art galleries. This is often a good place to see modern and contemporary art, both high-quality and average work, as well as older paintings by well-known artists.

3 Check the local library (or libraries) for books, prints, or films relative to art and American art. Any library of reasonable size should have monographs and studies of specific American artists. These books will provide additional illustrations and biographical material to supplement the *Art America* textbook by Mary Ann Tighe and Elizabeth Lang.

4 Refresh your knowledge of American history. Since many texts are available, you should take the time to find one that fits your needs and interests. *American Heritage* magazine offers articles and illustrations over the whole range of American history. The American Heritage Society has also published several large, well-illustrated volumes on the various periods of American history: *The Thirteen Colonies, The American Revolution, The Making of a Nation* (1789–1860), *The Civil War*, and so on.

5 Investigate the history of your community and the region of the country in which it lies. Local historical societies often provide helpful information.

BIBLIOGRAPHY

Andrews, Wayne: *Architecture, Ambition and Americans: A Social History of American Architecture,* The Free Press, New York, 1964. A survey of American architecture from colonial times to 1950 with a very good bibliography.

Halus: *The Artist in America,* compiled by the editors of *Art in America,* W. W. Norton & Company, Inc., New York, 1967. A look at American art by the artists.

Hunter, Sam: *American Art of the 20th Century,* Harry N. Abrams, Inc., New York, 1973. Modern art in all its variety.

Larkin, Oliver: *Art and Life in America,* rev. ed., Holt, Rinehart and Winston, Inc., New York, 1960. Standard survey of American art.

McCoubrey, John W.: *American Tradition in Painting,* George Braziller, Inc., New York, 1963. Clear, incisive treatment of the development of American painting.

Mayor, A. Hyatt: *Prints & People: A Social History of Printed Pictures,* The Metropolitan Museum of Art, New York, 1971. A clear comprehensive outline of the development of printing techniques.

Richardson, E. P.: *A Short History of American Painting,* Thomas Y. Crowell Company, New York, 1963. An abridged version of Richardson's *450 Years of American Painting.* Readable, clear, valuable beginning text.

Taylor, Joshua C.: *To See Is to Think: Looking at American Art,* George Braziller Inc., Smithsonian Institution Press, Washington, D.C., 1975. A useful approach to a fuller appreciation of American art.

ARTISANS TO ARTISTS: THE FIRST GENERATION

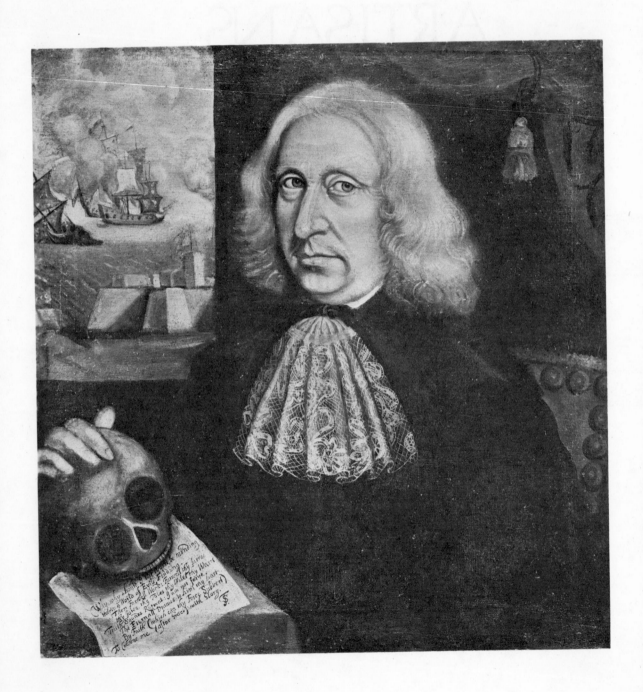

ARTISANS TO ARTISTS: THE FIRST GENERATION

It's more noble to be employed in serving and supplying the necessities of others, than merely in pleasing the fancy of any. The Plow-Man that raiseth Grain, is more serviceable to Mankind, than the Painter who draws only to please the Eye. The Carpenter who builds a good House to defend us from Wind and Weathere, is more serviceable than the curious Carver, who employs his art to please the Fancy.

Anonymous New England pamphlet, 1719

The Puritan colonists of New England certainly laughed more than we think they did, but probably less than they might have, had they not been so anxious to work and prosper in the eyes of God and man. Their frugality, expressed in the proverb "waste not precious time," has permanently marked the American character. Still they appreciated the colorful artifacts which help make life pleasant and this interest, however slight, brought American artists their first patrons.

Thomas Smith, Self-Portrait (1670). Courtesy of Worcester Art Museum.

OVERVIEW

The Period Approximately 1630 to 1755.

American Life The small English settlements of the early seventeenth century grew rapidly into substantial and prosperous communities. The total population of the Colonies increased from 85,000 in 1670 to 360,000 in 1713 and to 1,500,000 in 1754. Many of the immigrants were indentured servants who received a grant of land at the end of their term. Such incentives were needed to overcome the dangers of the long and hazardous Atlantic voyage. The religious cohesion of the first colonial communities was a strong factor in their success, but fervor eventually turned to fanaticism, culminating in the Salem trials of 1692, which cost the lives of twenty colonists. By the middle of the eighteenth century, however, the colonists had probably become the freest subjects of the English commonwealth: they paid light taxes, advancement was by talent, and the Zenger libel trial (1736) had ensured freedom of the press.

American Literature William Bradford (circa 1588–1657), one of the originators of the Mayflower Compact and first governor of the Plymouth Colony, described the founding in a *History of the Plymouth Plantation*. Anne Bradstreet (1612–1672) wrote some of the finest poetry of the period. William Byrd, the owner of Westover (1675–1744), noted countless details of life in the Southern colonies while Sarah Kemble Knight (1666–1727) drew a sharp portrait of New Englanders in her *Journal*.

International Events The English were on their way to becoming the greatest sea power in the world. There were constant antagonism and intermittent fighting between England and France: the War of the League of Augsburg (1689–1697), the War of the Spanish Succession (1702–1713), and the War of the Austrian Succession (1741–1748). In Eastern Europe Frederick the Great was building a strong Prussia while Peter the Great was dragging backward Russia into the modern world.

CONTENTS OF THE PROGRAM *Seventeenth-Century Painting* Painting in the seventeenth century concentrates on portraiture, the principal activity of the early colonial painters.

Seventeenth-Century Architecture A few of the best remaining examples of early colonial buildings are examined.

Gravestones and Handicrafts in Colonial America This, the shortest of the sections, offers a look at the first colonial sculpture and at colonial crafts.

Eighteenth-Century Architecture This documents the elegant grandeur of the Georgian style, the successor of the simple designs of early colonial style.

Eighteenth-Century Painting By establishing contact between America and contemporary European art, John Smibert and Gustavus Hesselius significantly affected the development of American art.

SEVENTEENTH-CENTURY PAINTING

In the early days of colonization, itinerant craftsmen, largely self-taught, traveled through the colonies painting signs, portraits, and decorative scenes in public houses. The first colonial portraitists, untrained but certainly not unskilled, were called "limners," from *limn* meaning "to draw." The limners treated the canvas as a solid, flat surface, making no attempt to render the illusion of weight and volume by the adroit use of light and shade. Their sitters are usually shown full-face or three-quarter profile, with a dark background, flat lighting (to eliminate shadows), and clothing adorned with intricate patterns of lace.

Elizabeth Freake and Baby Mary (1674). Although to modern eyes both figures appear uncomfortably stiff and we might legitimately wonder what is holding baby Mary up, the precisely rendered details of clothing, in particular the delicate lacework, are a typical mark of the first American portraitists.

Detail of lacework from *Elizabeth Freake and Baby Mary*.

Elizabeth Freake and Baby Mary (1674).

Detail of mother and child from *Elizabeth Freake and Baby Mary*.

Alice Mason (1670).

Elizabeth I (1600). English painting during the Tudor period (1485–1603) developed in a manner similar to that of American colonial painting. England had many artisans and craftsmen, but foreign artists, such as Hans Holbein, were brought over to execute most important commissions. In general, the portraits of the period emphasize line at the expense of color and volume. Queen Elizabeth I (1534–1603) liked the style so much that English artists continued to practice it long after continental painters had gone on to the baroque. The first colonial painters were trained by these men and they naturally went on depicting their sitters in traditional ways. Moreover their sitters, equally aware of the two-dimensional style, preferred portraits done in this manner.

John Freake (1674). Note that the distinctive flatness of the hands, the curious position of the fingers, and the stylized pose are all characteristic of the limner portrait style.

Captain Thomas Smith (active late seventeenth century) is one of the few early portraitists to sign his work.

Self-Portrait (1670). The sea battle in the background may represent one of the great naval engagements between Dutch and English vessels during the 1660s.

Detail of Smith and naval scene from *Self-Portrait.*

Detail of inscription under skull from *Self-Portrait.*

Major Thomas Savage (1679) (attributed to Smith) shows traces of the baroque style popularized by Van Dyck half a century before.

Elizabeth Paddy (Mrs. John Wensley) (1670–1680) (unknown painter).

Anne Pollard (1721) was over 100 years old when a New England painter fixed this likeness. Although Mrs. Pollard is posed, as in limner portraits, against a dark background, the artist's effective use of shading to suggest volume and solidity makes it difficult to speak of this work as a limner portrait. Compare this painting, for example, with *Elizabeth Freake and Baby Mary.*

Detail of face from *Anne Pollard.*

The patroon painters of the Dutch colonies, trained in the very different tradition of Dutch realist painting, were much more concerned with proper rendering of volume and three-dimensional space than their New England counterparts.

Girl with the Red Shoes (Magdalena Gansevoort) (circa 1729) was painted by a patroon artist of the Hudson River Valley.

Detail of shoes from *Girl with the Red Shoes.*

Deborah Glen (circa 1740).

This portrait of *Edward Jacquelin II as a Child* (circa 1722) originated in the Tidewater region of Virginia. The pose is copied from an English engraving, a common practice in eighteenth-century colonial art. Whether the system was originated by a painter in need of inspiration or by a patron anxious to imitate European fashion is impossible to say.

Detail of hand and parakeet from *Edward Jacquelin II as a Child.*

SEVENTEENTH-CENTURY ARCHITECTURE

The many Trade and Navigation acts passed by the British government to regulate economic relations with the colonies not only gave England a virtual monopoly on the colonial market, but made English culture the predominating force in colonial life. Both architecture and painting testify to this influence.

The simplest houses in England were built in what is known as the "half-timber" style. Large horizontal sills (the bottom support), vertical posts at the corners and at intervals along the wall, horizontal beams and diagonal cross braces for the exterior walls, interior partitions, and roof braces are typical characteristics. The early settlers naturally copied this construction. At first the frame and the material (stone, plaster, or earth) were left exposed, but the abundance of wood in New England encouraged the colonists to use long boards to sheath the frame and protect the interior from wind and rain. These horizontal planks—known as clapboards—were usually 4 to 5 inches wide and 4 to 6 feet long. Many of the seventeenth-century half-timber homes built in New England are still in existence.

Fairbanks House, Dedham, Massachusetts (1636), is typical of the simple, austere, and spacious clapboard houses of the early colonial period. The origi-

nal structure, built around the central heat source, the "hearth," consisted of a single room, loft, and chimney. The diamond-shaped panes are a distinguishing mark of the seventeenth-century window.

The Turner House, Salem, Massachusetts (1668). The high-pitched, shingled roof is another common feature of seventeenth-century New England architecture.

Details of gables of *Turner House*.

Parson Capen House, Topsfield, Massachusetts (1683). The overhanging second floor provides more space for sleeping quarters and simplifies waterproofing by reducing the number of exposed junctures. Builders often turned this overhang to decorative use, carving corners which enhanced the lines of the house. Here the pendents, or pendills, are shaped like inverted tulips.

Detail of second story and overhang of *Parson Capen House*.

Box stairs from interior of *Parson Capen House*.

Parlor of *Parson Capen House*.

Henry Whitfield House, Guildford, Connecticut (1639), is built of stone, a rarity among New England homes. Lacking the lime necessary to make mortar, New Englanders found it easier, and less expensive, to use the timber readily available in nearby forests.

Great Hall of *Henry Whitfield House*.

Bacon's Castle, Arthur Allen house, Surrey County, Virginia (1655). The more elegant architecture of the region is one expression of the elitism and aristocratic ideals encouraged by large plantations and concentrated wealth.

St. Luke's Old Brick Church, Smithfield, Isle of Wight County, Virginia (1632).

Detail of buttresses of *St. Luke's Old Brick Church*.

Pointed arch windows and ceiling of *St. Luke's Old Brick Church*.

Old Ship Meeting House, Hingham, Massachusetts (1681), retains most of its seventeenth-century design. The New England meetinghouse (the word *church* was shunned by the Puritans because it smacked of Popery) was a large, plain room (elaborate and ornate places of worship were thought to distract the mind from God), furnished simply with a pulpit and benches. The roof is hipped (i.e., instead of gables, the roof has four sides which taper toward the crest) and surmounted by a platform bearing a turreted belfry. The beams supporting the roof resemble the interior bracing of a sailing ship seen upside down. The name of the meetinghouse may derive from this physical distinctiveness or, as tradition holds, it may be that ship's carpenters carried out the work.

Beams from interior of *Old Ship Meeting House*.

Old Ship Meeting House, Hingham, Massachusetts (1681).

GRAVESTONES AND HANDICRAFTS IN COLONIAL AMERICA

The Puritans, with no great deeds to commemorate, and a preference for simple, unadorned houses of worship, had little interest in monumental sculpture. What preoccupied them was death, the inevitable end of life on this earth.

Thaddeus McCarty (1705). Flower design.

Hannah Ogden. Skull and crossbones and hourglass design.

Ann Mumford. The breasts on either side of the headstone stand for the milk of divine wisdom.

Nathaniel Rogers (1775). Portrait effigy.

Thomas Barrett (1779).

The four Holmes children all show the practice of including a portrait likeness of the deceased. The broken flowers show the loss on the family tree.

Woodcarvers, stonecarvers, and blacksmiths (i.e., metalworkers) satisfied the constant need for decorative embellishments on local buildings: a wooden Indian for the tobacco shops, a brightly colored mariner to advertise a marine supply store, and everywhere weather vanes.

Sea serpent weather vane (nineteenth century).

Carved wood bull (nineteenth century).

Rooster and other birds (nineteenth century).

Black man in top hat (1825–1850).

Mariner with sextant (1830–1840).

Grim Reaper (undated).

Carved wooden figurehead from a sailing ship (1830).

Mariner with sextant (1815).

EIGHTEENTH-CENTURY ARCHITECTURE

The predominant architectural style of eighteenth-century England, English Georgian, combines High Renaissance features of symmetry, horizontal emphasis, and classical forms with the current baroque penchant for dramatic effects. The designs of the Italian architect Andrea Palladio (1518–1580) were an important influence on style. Gentleman builders in the Colonies, looking to London for architectural ideas, found what they wanted in the numerous publications reflecting the increased interest in Palladian principles.

Although most of the private dwellings constructed in any period are intended only to provide shelter and comfort, public buildings are a different matter. In them the desire for elegance and grandeur often prevails over questions of utility. A public building, like a public servant, needs an impressive facade. Williamsburg, Virginia, at one time the capital of the largest and richest of the colonies, contains the finest examples of Georgian public buildings.

Governor's Palace, Williamsburg, Virginia (1706–1720), and wing (1749–1751). Like most of the other Williamsburg buildings, this one was destroyed by fire, but numerous surviving plans, prints, and the foundations made possible a complete reconstruction in 1930.

Garden, *Governor's Palace.*

Ballroom, *Governor's Palace.*

Capitol Building, Williamsburg, Virginia (1700–1705), presents a logical solution to the problem of housing the Commonwealth's bicameral legislature. The ornamentation is restrained and the buildings suggest quiet dignity and strength.

Interior, *Capitol Building*. The Governor's council met here.

In the colonial Georgian design symmetry and proportion are fundamental attributes. Doors are centered, windows and doors are equidistant. The small windows of the seventeenth century, with their diamond-shaped panes, are replaced by large-paned, double-hung sash windows. Roofs are lower, to conform to the classical emphasis on horizontality, and high-pitched gables are eliminated. The basement is made larger than the upper stories to provide a more stable base. Later modifications made the Georgian exterior more imposing, but the buildings never lost their comfortable interior.

The *Lee Mansion*, Westmoreland County, Stratford, Virginia (1725–1740), was the center of an immense 16,000-acre plantation. The building is solid, unadorned, imposing. Its strength comes from the symmetrical wings, the large chimneys, and the central staircase leading to the high entranceway.

Mount Vernon, west entrance facade, Fairfax County, Virginia (1757–1787), was designed by its owner, George Washington. There were no professional architects in America until after the Revolutionary War. After consulting books of models, gentlemen drew up their plans with the help of a professional draftsman, and hired good craftsmen to do the work.

Interior of *Mount Vernon*.

Isaac Royall House, west facade, Medford, Massachusetts (1747–1750), has a wooden exterior carved to imitate the stonework of its English models. Not only the facade, but the pediment and the Ionic pilasters around the doorway are made of wood. The Royall family patronized the painters of pre-Revolutionary times, notably John Singleton Copley and Robert Feke, but they supported the English when war broke out and lost all their possessions. In 1908 an association of New Englanders purchased the three-story, twelve-room Royall house and restored it to stand as a permanent record of colonial life.

EIGHTEENTH-CENTURY PAINTING

As the colonies increased in wealth and importance, opportunities for artists grew. The native painters were joined by European immigrants. Two of these men—Gustavus Hesselius of Philadelphia and John Smibert of Boston—significantly influenced the development of American art by introducing local artists to the latest European styles and techniques. In the latter half of the century their students, John Singleton Copley and Benjamin West, were to become the first American painters to gain recognition in Europe.

Henry Darnall III (circa 1710).

Eleanor Darnall (circa 1710).

The German-born Justus Engelhardt Kuhn (died in 1717) was active around Annapolis in the early eighteenth century. The two children of the Darnall family are posed in front of balustrade and garden typical of baroque portraits. Kuhn obviously has goals that are different from the limners'. His forms are more rounded and he surrounds his sitters with their possessions.

Maria Taylor Byrd (circa 1735).

The Englishman Charles Bridges, already past his prime when he arrived

in Virginia, remained in the colonies only about 5 years before returning to England. He was probably the artist responsible for this portrait of the second wife of Colonel William Byrd of Virginia.

Mrs. Samuel Wragg (Mary Du Bosc) (1708). Henrietta Johnston (active 1705–1728 or 1729) worked almost exclusively in pastels. This small portrait is a careful and precise bit of work barely the size of a piece of typing paper.

Bridges, Johnston, and Kuhn were, however successful, of limited influence on other painters because they chose to work in the less-traveled areas of the colonies. Boston and Philadelphia, the richest and most powerful cities, provided not only the commissions necessary to sustain professional activity, but the creative atmosphere essential to encourage native-born artists.

Gustavus Hesselius (1682–1755) came to America from his native Sweden in 1712. He began to work in the Philadelphia area, but a poor response persuaded him to move to Annapolis. In the late 1720s he returned to Philadelphia and remained there until his death in 1755. In the latter part of his life he painted very little, passing on most of his commissions to his son John (1728–1788).

Detail of head from *Self-Portrait*, Gustavus Hesselius (1740).

Self-Portrait (1740).

Reverend Abraham Keteltas (1758). Gustavus Hesselius may have begun this portrait, but his son John probably finished it, since it was not completed until 3 years after the death of the elder Hesselius.

Mrs. Lydia Hesselius (circa 1740), the artist's wife. Errors in anatomy and design mark the limits of Hesselius's skill.

Lapowinsa (1735). The portrait of the Delaware Chief Lapowinsa shows Hesselius at his best. Everything in the canvas is subordinated to the proper treatment of the face, which reveals a sad, beaten man. The Delaware Indians had just been forced to sign away their lands in the infamous "Walking Treaty."

Interior of State House (Independence Hall), Philadelphia.

Independence Hall, south facade, Philadelphia (1732–1753), was designed by Hamilton and Woolley. Design faults forced the removal of the tower a few years later, and the building stood without one until the late nineteenth century, when improvements in metal construction made it possible to finish the construction without danger.

John Smibert (1688—1751), born in Scotland and trained in Italy, came to America in 1728 with Dean George Berkeley, who wished to establish a college on Bermuda for the Christian education of the Indian natives. Although the venture failed, Smibert did not return to England, preferring to "be a major artist in America" instead of "a minor artist in England." A public showing of his work in 1730—the first art exhibition in the Colonies—was widely praised, and the attendant publicity propelled him to success. A few years later he secured his prosperity with an advantageous marriage. Smibert dominated Boston portraiture until his death in 1751. An architect as well, Smibert designed Faneuil Hall, Boston's "Cradle of Liberty."

Detail of Smibert from *Dean George Berkeley Entourage*.

Dean George Berkeley Entourage (1729), also known as *The Bermuda Group*. Dean Berkeley stands at right, his hand gripping the chair in which his wife is seated; Smibert pictures himself at left, looking out toward us. The most ambitious group portrait executed in America, the painting was for years the prize of Smibert's Boston studio. The careful and dignified arrangement of the figures, perfect examples of eighteenth-century composition, influenced every subsequent Boston painter.

Details of figures from *Dean George Berkeley Entourage*.

Dean George Berkeley Entourage (1729).

Daniel, Peter, and Andrew Oliver (circa 1730).

Jane Clark (1739). Lack of serious competition and declining powers may account for the increased stiffness and repetitious poses in Smibert's later portraits. It is possible, however, that sitters requested poses they had seen in other paintings.

Nathaniel Byfield (1730).

The Small Cowper Madonna (1505) by Raphael (1487–1520). This and the following examples of European and classical art suggest the artistic richness of Smibert's studio and help explain why he was so influential with young American artists.

Venus de Medici.

Portrait of Homer, marble copy.

Hesselius and Smibert made a significant contribution to American art both by introducing the latest European techniques and by teaching these new techniques to their students. Smibert's most successful pupil, Robert Feke, was perhaps the most important colonial painter of the 1740s. After Smibert and Feke died, John Greenwood (1727–1792) became the principal portraitist of the Boston area. He enjoyed his predominance only a short time, however, abandoning the Colonies unexpectedly in 1752.

The Greenwood-Lee Family group (circa 1747) is probably descended from Smibert's *Bermuda Group* through Feke's *Isaac Royall and Family*. Greenwood includes himself standing at the right of the picture.

Jersey Nanny (1748). Mezzotint engraving.

Sea Captains Carousing in Surinaam (circa 1755) is the earliest example of genre painting by a native American. A curiously crude and vulgar scene, it is far different from the quiet pictures of everyday life which the genre painters of the nineteenth century relished. Greenwood may be seen carrying the candle toward the door, at the right of the picture, as he goes off to bed. (There is no doubt a moral lesson in Greenwood's painting, although from such a distance in time, just what one is not easy to say.)

Detail of captains at table from *Sea Captains Carousing in Surinaam*.

Detail of captain Ambrose Page vomiting from *Sea Captains Carousing in Surinaam*.

Robert Feke (1707–1752) moved into Boston from Philadelphia in the 1740s, working there until the early 1750s. Although he remains a somewhat mysterious figure in American art, recent research shows that he significantly affected the development of portraiture both in Boston and in Philadelphia. John Hes-

selius learned more from Feke than from his father, Gustavus Hesselius (he may even have been apprenticed to Feke), and Copley was influenced by his work.

The *Self-Portrait* (circa 1730) bears out a contemporary remark by a doctor acquaintance who wrote that Feke "has exactly the face of a painter, having a long, pale face, sharp nose, large eyes—with which he looked at you steadfastly—long curled black hair, a delicate white hand, and long fingers."

Isaac Royall and Family (1741) derives its composition from Smibert's *Bermuda Group,* including the Turkish rug over the central table.

Detail of carpet from *Isaac Royall and Family.*

Isaac Winslow (circa 1748).

Mrs. James Bowdoin II (Elizabeth Bowdoin) (1748) is a typically idealized portrait of young womanhood. Although Feke recorded details with sure precision, his women are less individualized than those of Smibert.

Brigadier General Samuel Waldo (1748) is an elegant and fashionable portrait of an obviously successful man. Feke did not have to probe beneath Waldo's polished exterior; by presenting him as he wished to be shown, he tells us all we need to know about him.

Detail of bombardment of Louisburg from *Brigadier General Samuel Waldo.* The capture of the citadel of Louisburg in Nova Scotia was one of the great feats of King George's War (1744–1748).

Brigadier General Samuel Waldo (ca. 1730).

Self-Portrait (1748).

CLOSING ILLUSTRATIONS (under credits) *Isaac Royall House; Elizabeth Paddy* (anonymous); memento mori death's-head gravestone; *The Bermuda Group* (Smibert); *Edward Jacquelin II as a Child* (anonymous); sea serpent weather vane; *Mount Vernon; Turner House.*

QUESTIONS AND PROJECTS

I. Define or identify:

limner	patroon	clapboard
Elizabeth I	baroque art	buttress
memento mori	Georgian architecture	hipped roof
composition	gable	

II. Areas for additional study:

1 Portraiture. What is a limner? Describe a typical limner portrait. How does a limner painting differ from European painting of the same period? How does it compare with one by John Smibert, Gustavus Hesselius, or Robert Feke?

2 Architecture. Compose a brief definition of architecture. What does an architect do? How do the functions of an architect differ from those of a builder?

3 Painting. What is oil painting? What are the steps to completing a painting in oils? What technical difficulties does the medium have?

III. Opinion and judgment questions:

1 One group of critics maintains that American artists were created and developed by European immigrants, like Hesselius and Smibert; another group considers that art begins because a person feels a need to record what he sees and that this inner drive eventually creates artists. What merits do you find in these opposing views? What difficulties do they present? What implications do the two theories have for the appearance and growth of any national art tradition?

2 Limner portraits differ markedly from European portraits of the same period as well as from American portraits of the early and mid-seventeenth century. By what standards should a portrait be judged? May a limner portrait be considered "bad" because it does not resemble contemporary European portraits or modern portraits? What part should the artist's intention and training play in judging a work of art?

3 Despite the invention of photography, portraits are still executed today. What is the purpose of this kind of portraiture? Where can you find such portraits? What resemblances are there between portraitists of colonial times and contemporary portraitists?

IV. Projects:

1 Take a ride through your town. Notice the different building shapes, building materials, building groups, and so on. What can a knowledge of architectural history tell you about the growth of your city? What periods do the large public buildings belong to? What is the current state of the construction industry in your locality? In the residential areas, what influences can you see of early colonial styles? Are there homes in the Georgian colonial manner? (In what part of a city would you expect to find early colonial or Georgian houses or imitations of them?)

2 Visit a nearby business area. What kinds of signs do you find? How do they differ from signs used in colonial times? What do signs tell you about the community?

3 Visit a local cemetery. What sorts of gravestones does it contain? What comments can you make about the art of the cemetery? What sorts of symbols do you find on the grave markings? Can you make any judgments about the attitudes of a particular time period toward death and the departed? How would you characterize the burial practices in your community? Are there significant differences between religious groups? between ethnic groups?

4 Copy a limner portrait in pencil. Is it possible to do the painting justice with a drawing? Color the result, using crayons or watercolors. How does it compare with the original? Devise your own portrait in the limner style using a camera or some other art medium. What do these exercises tell you about the limner style?

BIBLIOGRAPHY

Blow, Michael (editor in charge): *The American Heritage History of the Thirteen Colonies,* American Heritage Publishing Co., Inc., New York, 1967. An excellent overview of the development of colonial America.

Miller, John Fitzhugh: *The Architects of the American Colonies or Vitruvius Americanus,* Barre Publishers, Barre, Mass. 1968. The only full-scale study of American builders and their designs prior to the appearance of professional architects after the Revolution.

Miller, John, C. (ed.): *The Colonial Image: Origins of American Culture,* George Braziller, Inc., New York, 1962. A collection of twenty-five first-hand accounts of colonial life.

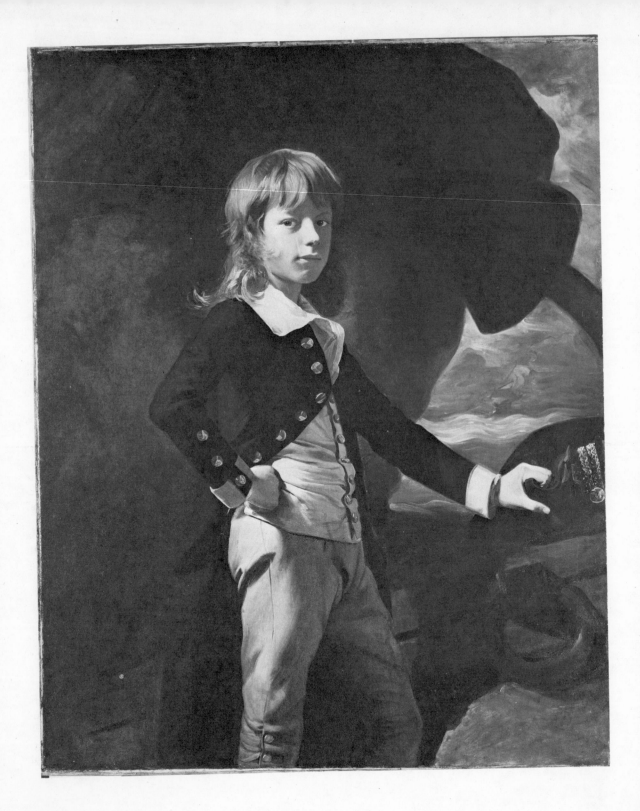

PROGRAM 3

AMERICA'S OLD MASTERS

It would give me inexpressible pleasure to make a trip to Europe, where I should see those fair examples of art that have stood so long the admiration of all the world. The Paintings, Sculptors and Basso Releivos that adorn Italy, and which You have had the pleasure of making Your Studies from would, I am sure, animate my pencil, and enable me to acquire that bold free and graceful style of Painting that will, if ever, come much slower from the mere dictates of Nature, which has hither to been my only instructor. . . . I think myself peculiarly unlucky in Living in a place into which there has not been one portrait brought that is worthy to be called a Picture within my memory, which leaves me at a great loss to guess the style that You, Mr. Reynolds [Sir Joshua Reynolds, the English painter], and the other Artists practice.

John Singleton Copley in a letter to Benjamin West,
November 12, 1766

Aerican art achieved its first international successes in the latter half of the eighteenth century. Three artists—John Singleton Copley, Benjamin West, and Gilbert Stuart—displayed a skill and a sensitiv-

John Singleton Copley, Midshipman Augustus Brine (1782). Courtesy of the Metropolitan Museum of Art, New York.

ity which brought them high praise on both sides of the Atlantic, earning them recognition as "America's First Old Masters."

OVERVIEW

The Period Approximately 1755 to 1800.

American Life The 10 years preceding the first battles of the Revolutionary War were characterized by provocation born of neglect and misunderstanding. Overwhelming victors in the Seven Years' War (1756–1763), the British naturally insisted that the colonists share the cost of removing the French menace. The colonists, however, were no longer in need of British military protection and demanded equal rights under the law. As a result of these opposing views, British colonial legislation of the period reads like a litany of grievances: the Quartering Act and the Stamp Act in 1765, the Townshend Act in 1767, the East India Act (which provoked the Sons of Liberty to retaliate with the Boston Tea Party) in 1773, the Coercive Acts and the Quebec Act in 1774. The Boston Massacre in 1770 further inflamed both sides. Lexington and Concord in the spring of 1775 proved to be the final straw. Even so, the war itself was far from the unanimous wish of the colonists. Indeed division at home, along with lack of foreign support, at first severely hindered the American cause, but the alliance with France in 1778 proved to be the turning point.

After the war the first attempt at national government under the Articles of Confederation ended in failure, forcing the states to devise another political framework. A constitutional convention, held in Philadelphia in 1787, produced a document which displeased every one of the delegates in some way, but nonetheless thirty-nine of the original fifty-five consented to sign it. Benjamin Franklin summed up their collective attitude: "I consent . . . to this Constitution because I expect no better, and because I am not sure it is not the best." After a heated ratification debate, the Constitution was accepted and the new nation set about governing itself.

American Literature In his *Autobiography* (1789) Benjamin Franklin (1706–1790) provides a portrait of the period as well as his personal story. Charles Brockden Brown (1771–1810) published *Wieland* (1798), the first American novel. The period is particularly rich in political prose. *The Federalist* (1787–1788) by Alexander Hamilton, James Madison, and John Jay is probably the best statement of American political theory. Jonathan Edwards (1698–1759) was the first important American philosopher.

International Events Although the Seven Years' War (1756–1763) ended the bitter rivalry between Great Britain and France in North America and established Great Britain as the foremost European power, the completeness of the victory became the cause of later defeat. By antagonizing both the colonists and the French, the British provoked them into an alliance which was a crucial factor in deciding the Revolutionary War. Shortly after the American victory, the French began their own revolution (1789).

CONTENTS OF THE PROGRAM *John Singleton Copley in America* This section gives an account of Copley's development from the early 1750s until his departure for Europe in 1774. Many critics believe that he achieved his most forceful and searching portraits during this period.

Benjamin West This section treats West's career, with emphasis on his early successes. West became part of the European art establishment at a very young age.

The Graphic Arts Engraving and printing during the eighteenth century are briefly surveyed, with particular reference to the work of Paul Revere.

Copley in England Copley excelled as a technician, but he never achieved the overwhelming success of his American days in his adopted country, partly because his single-minded ambition did not endear him either to patrons or to his fellow artists.

The Master Portraitist Gilbert Stuart was perhaps the most gifted portraitist of the eighteenth century.

Note: This organization somewhat obscures Benjamin West's important influence on Copley's career (since it suggests that Copley was the leader rather than West, who was in the 1760s one of the most influential and highly regarded painters in Europe), but it reflects the high esteem in which Copley is now held. Gilbert Stuart, of course, was unique, an exceptional artist who inspired no imitators and left no followers.

VIEWER'S GUIDE

PRE-LOGO ILLUSTRATIONS *George Washington* (Stuart, Athenaeum version); *Boston Massacre* (Revere); *The Death of General Wolfe* (West); *Epes Sargent* (Copley); *Watson and the Shark* (Copley).

JOHN SINGLETON COPLEY IN AMERICA

Like many of this country's artists, John Singleton Copley (1738–1815) was self-taught. Setting himself up as a portraitist while still in his teens, he found Boston, the largest and richest city in New England, to be an excellent location. So many local shipowners and merchants sat to Copley that his portraits became a kind of New England coat of arms. In the 1770s, however, political unrest, coupled with Copley's long-standing desire to leave America for the more agreeable artistic climate of England, determined him to leave the Colonies for good. After several months in Italy studying the Old Masters, Copley settled permanently in England. *Watson and the Shark* (1778) gave his career a tremendous critical boost, but Copley failed to capitalize fully on his success. A tremendously ambitious man, he inadvertently mismanaged his fellow artists, and their antagonism may have cost him the royal patronage which would have allowed him to leave portraiture and concentrate on history painting. His last years brought him further disappointments and increasing bitterness.

The Berkeley Group (1729) by John Smibert (Program 2).

Cotton Mather (1727) is a mezzotint portrait—the first to be printed in the Colonies—by Peter Pelham (1697–1751), John Singleton Copley's stepfather. The mezzotint remained in vogue until the early nineteenth century.

Portrait of Copley (1783–1784) by Gilbert Stuart. Stuart's portrait shows Copley around the time of the successful exhibition of *The Death of Major Peirson*.

Reverend William Cooper (1743) and *Reverend William Welsteed* (1753). Trained as an engraver in England, Copley's stepfather, Peter Pelham, formed a partnership with John Smibert soon after his arrival in the Colonies: Smibert would execute oil portraits of public figures and Pelham would engrave copies of them for general sale. In 1743 Pelham engraved this portrait of the Reverend Mr. William Cooper. In 1753 his stepson took the plate, burnished out the face, the collar, and the last name of the earlier sitter and produced a new work: the portrait of the Reverend Mr. William Welsteed. Using another's work for inspiration, called fair-copying, was a common practice in the eighteenth century, although it was seldom that the same plate served both artists.

Galatea Triumphs upon the Waves, (Eighteenth-century engraving by Augustinius after Gregorio Lazzarini).

Galatea's Triumph upon the Waves (1754) is Copley's version of the scene, with changes appropriate to the American audience (notably clothes for Galatea).

Details from *Galatea's Triumph upon the Waves.*

Anatomy drawing (1756). The most striking evidence of the effort Copley expended learning his craft is the book of anatomical drawings and texts he composed for his personal use. He kept the book with him throughout his career, referring to it for all questions on bone and muscle structure.

The Gore Children (circa 1755). Despite the title, the names and family relationships of the children are not known.

The Greenwood-Lee Family (1747) by John Greenwood. (Program 2).

Compared details of standing figures from *The Gore Children* and *The Greenwood-Lee Family.*

Daniel, Peter and Andrew Oliver (1730) by John Smibert.

Detail of the young man from *The Gore Children.*

Elizabeth and James Bowdoin (1760) by Joseph Blackburn. Born in England, Blackburn was active in the Colonies between 1752 and 1763. His skillful and delicate rococo portraits significantly influenced Copley, who quickly surpassed him in power. Blackburn probably returned to England in the early 1760s.

Isaac Royall's Daughters (Mary and Elizabeth Royall) (1758) shows Blackburn's influence, but Copley's use of color and his skill at tonal contrasts were far greater than Blackburn's.

Detail of pet dog from *Isaac Royall's Daughters.*

Detail of girls from *Isaac Royall's Daughters.*

Epes Sargent (1759–1761) was a well-to-do merchant known for his outspoken views. Copley, although barely out of his teens, demonstrates his con-

siderable skill in the ease with which he captures Sargent's strong, clear gaze. [John Singer Sargent (see Program 9) was one of Epes Sargent's descendants.]

Joseph Barrell (1765, pastel).

Self-Portrait (1770, pastel). In 1769 Copley married Susanna Farnham Clarke, the daughter of a wealthy Boston tea merchant. His fashionable wig and his rich, elegant clothes clearly indicate how well he had established himself in Boston society. Soon, however, his father-in-law's political views—he was a well-known Tory—became an embarrassment and helped compromise Copley's career in America.

Mary Tappan (Mrs. Benjamin Pickman) (1763) indicates the great improvement Copley had made in rendering three-dimensional forms in space. But such advances were not made without expense. Copley worked slowly—sometimes to the sitter's great annoyance. *Mrs. Daniel Sargent* (1763, not shown here), a portrait nearly identical to this one, required almost 100 hours of sitting.

Detail of face from *Mary Tappan*.

Paul Revere (1768–1770). Revere (1735–1818) was a successful engraver and highly regarded silversmith long before he became a hero of the Revolutionary War.

Detail of teapot from *Paul Revere*.

Paul Revere (1768–1770).

Detail of face from *Paul Revere*.

Nicholas Boylston (1767) exemplifies the semicasual poses which Copley often used. The details, however, have all been chosen to help describe the sitter's social and economic position.

Detail of face from *Nicholas Boylston*.

Mrs. Thomas Boylston (1766). Nicholas Boylston's mother retains at 70 the firm face and dark hair of her youth. Copley, an expert at rendering flesh tones, took equal care to capture the luster of Mrs. Boylston's brown satin dress. The Boylston family, like many others in the Colonies, split over the political questions of the day. Thomas Boylston, acknowledged to be the wealthiest Bostonian of pre-Revolutionary times, and his wife were Tories who supported the English government; Nicholas stood with the agitators.

Mrs. Ezekiel Goldthwait (1770–1771) was well known for her parties in Boston. Her round, heavy body, with its corpulent arms, is emphasized by the many circular motifs—the fruit, the table, the sitter's cap. The chiaroscuro and the darker colors are typical of Copley's work in this period.

Detail of hand and peaches from *Mrs. Ezekiel Goldthwait*.

Mr. and Mrs. Thomas Mifflin (1773). Many of Copley's best portraits have a natural, unposed quality about them.

Young Lady with a Bird (Mary Warner) (1767) was sent to the yearly exhibit of the Society of Artists of Great Britain in London. To his disappointment the picture was faulted for his choice of subject, although in technical execution Copley's work was among the finest at the exhibition. The belief that his art was not equal to that of European painters was a major factor in Copley's decision to leave America.

BENJAMIN WEST

Born in Pennsylvania the same year as Copley, Benjamin West (1738–1820) showed such precocious drawing talent that his parents, despite their Quaker suspicion of art, sent him to study in Philadelphia with the best native and European artists: William Williams, John Wollaston, and Gustavus Hesselius. At age 21, in 1759, his patrons (West was extremely personable and found benefactors wherever he went) rewarded his efforts by sending him to Italy for 3 years of study. In Rome West discovered neoclassicism. On his return trip to Philadelphia, West stopped in London for a brief visit, but he was so immediately and completely successful that he never did return to the United States.

Self-Portrait (circa 1771).

Self-Portrait (1740) by Gustavus Hesselius (Program 2).

Born in Wales, William Williams (1727–1791) turned up, after a series of extraordinary adventures, in Philadelphia in 1747 and became West's first teacher. "It was to [Williams's] books and prints I was indebted for all the knowledge I possessed of the progress which the fine Arts had made in the world, and which prompted me to view them in Italy," said West.

Deborah Hall (1766) is Williams's delightful tribute to one of the beauties of the period.

Thomas Mifflin as a Boy (circa 1758), painted when West was just 20, is a solid promise of the future.

Return of the Prodigal Son (undated) by Bartolomé Esteban Murillo (1617–1682). Murillo, Diego Velásquez, and Diego Ribera were the finest Spanish painters of the seventeenth century.

Detail from *Return of the Prodigal Son*. The first painting West saw in Philadelphia was a painting by Murillo similar to this one.

Agrippina Bearing the Ashes of Germanicus (1768), West's first history painting, brought him royal patronage and secured his position in British art circles.

Detail from *Agrippina Bearing the Ashes of Germanicus*.

Detail of background from *Agrippina Bearing the Ashes of Germanicus*. West's composition generally conforms to the pattern shown here. A central group forms a bridge between the other parts of the picture. The stiff, posed figures were exceptionally popular in the latter part of the eighteenth century, no doubt because they imitated so well the frozen figures of classical statuary.

Cupid Stung by a Bee (1774).

The Death of General Wolfe (1770). General James Wolfe (1727–1759), one of the most popular and aggressive English officers of the Seven Years' War, became a national hero in 1759 for his victory in the crucial battle fought on the Plains of Abraham outside Quebec. The defeat ended France's chances for a colonial empire in the New World. The scandal over West's refusal to clothe his figures in classical dress drew attention away from his skillful organization of the scene, but it made *The Death of General Wolfe* the sensation of the annual Academy exhibition.

Detail of Wolfe and soldiers from *The Death of General Wolfe*.

The Death of General Wolfe (1770).

Detail of the dying Wolfe from *The Death of General Wolfe*.

Details of the witnesses to Wolfe's death from *The Death of General Wolfe*.

The Apollo Belvedere is a Roman copy in marble of a Greek statue of the fourth century B.C. Upon seeing this statue of Apollo, West cried, "My God! How like a Mohawk!"

Detail of Indian from *The Death of General Wolfe*.

Colonel Sir Guy Johnson (1776) was the British agent for Indian affairs during the Revolutionary period. The Indian standing behind him may represent his secretary, the Mohawk chief Joseph Brant, a man of outstanding leadership whose name is unfortunately linked to some of the most savage massacres of the Revolutionary War.

Penn's Treaty with the Indians (1771) commemorates the popular story of a treaty with the Indians which assured them equal rights and freedoms in the territory. There is no record of such an agreement, which, if it ever existed, certainly was not honored.

THE GRAPHIC ARTS

Mr. Richard Mather (1670), the first woodcut done in America, was executed by John Foster (1648–1681).

Baptismal Certificate (1826), woodcut and stencil by an anonymous artist.

The Thirty-fourth Psalm (1801), in German.

Cotton Mather (1727) by Peter Pelham.

A Prospect of Boston (1722) by William Burgis (active 1716–1731). This engraving of Boston Harbor was intended as a true representation, yet the arrangement of the boats makes the view aesthetically pleasing as well as informative.

Fresh News (1775) is a local broadside composed and published by John Anderson. The broadside was the normal way of publicizing news flashes during the Revolutionary War period.

The Boston Massacre (1770) by Paul Revere is one of the most famous and inflammatory pieces of colonial propaganda. Revere copied his engraving from a more artistic version by Henry Pelham, Copley's half-brother, but his addition of "Butcher's Hall" over the building at the right and his speed (Revere's version was on the streets a full week ahead of Pelham's) enabled him to capture the public's attention.

Amos Doolittle (1754–1832) was an experienced engraver of maps, bookplates, and other prints. With the painter Ralph Earl (1751–1801), he produced a series of four prints depicting the first battles of the Revolutionary War. Earl sketched the scene and then Doolittle engraved it.

A View of the Town of Concord (1775) shows the British troops marching into Concord and deploying. One group burns stores in the background while two officers reconnoiter in the foreground.

A View of the South Part of Lexington (1775) pictures the British troops re-

treating toward Boston while being harassed from behind walls and trees by the colonial irregulars.

A Skirmish in America between the King's Troops and General Arnold (1780), an engraving by an anonymous artist, records the Battle of Ridgefield, one of the minor engagements of the war.

Revere did not confine himself to violent events. *A View of Boston and British Ships Landing Their Troops* (1770) achieves its purpose—to rouse the colonists to the British threat—without excessive drama. Revere's engraving was begun in 1768, when British troops were landed to restore order following the troubles over enforcement of the Stamp Act (1765).

The Able Doctor or *America Swallowing the Bitter Draught* (1774) is a line engraving by Paul Revere, copied from a British original especially for inclusion in the *Royal American Magazine*. The scene shows Lord North, the British Prime Minister, forcing tea down America's throat. Revere's only addition to the scene is the word TEA on the teapot.

COPLEY IN ENGLAND

John Hancock (1765). When John Hancock sat for this portrait, he was not only a successful lawyer but the recent heir to the fortune of his late uncle Thomas Hancock. He was, however, a more contradictory character than his well-known signature on the Declaration of Independence would suggest. Despite his wealth and his active espousal of American liberties, he resisted Copley's entreaties for several months before finally settling accounts.

Detail of wife and son from *The Copley Family*.

The Copley Family (1776) shows how Copley learned from his direct contact with European art. His colors are warmer than in his American pictures, and he has taken a freer approach to the composition. He has placed himself in the back, holding some papers which may suggest future plans. His son, John Singleton Copley, Jr., shown in the center looking up at his mother, served as Lord High Chancellor during Queen Victoria's reign and finished his career as Baron Lyndhurst.

Detail of Copley and father-in-law from *The Copley Family*.

Detail of wife and children from *The Copley Family*.

Detail of wife, children, and father-in-law from *The Copley Family*.

Watson and the Shark (1778) was Copley's first venture into history painting. Brook Watson, a successful merchant and briefly Lord Mayor of London, commissioned the painting to commemorate an incident of his youth: he was attacked by a shark in Havana Harbor and maimed so severely that he lost a leg. Copley exhibited the painting in a special pavilion, charged admission, and made a tidy profit in addition to Watson's commission. Later he painted additional versions in an effort to capitalize on the picture's popularity.

Detail of Watson and shark from *Watson and the Shark*.

Watson and the Shark (1778).

31

Sketch of black sailor for *Watson and the Shark*. Copley worked up the painting carefully, making many detailed preparatory studies.

Borghese Gladiator (placed horizontally for comparison with Watson).

Details of figures from *Watson and the Shark*.

Watson and the Shark (1778).

Details from *The Death of Major Peirson* (1783) records an incident from 1781: the death of the British commander on Jersey Island just as his men had succeeded in turning back the invading French soldiers.

Details of figures from *The Death of Major Peirson*.

Mrs. Seymour Fort (1778) is one of Copley's best English portraits. His technique is more polished, but he displays the same attention to significant details of dress and character which make his American portraits so pleasing.

The Three Youngest Daughters of George III (1785), commissioned by the King, gave Copley a chance to win court patronage, an honor toward which all artists in England aspired—and, on occasion, conspired. The picture was given a scathing review by a fellow academician, John Hoppner, and Copley was to wait 25 years before another royal commission came to him. Hoppner's savage attack on the painting was probably motivated by a combination of jealousy at having to share court patronage with another artist and anger over Copley's decision not to exhibit his paintings in the regular Academy Hall.

Details of *The Three Youngest Daughters of George III*.

Midshipman Augustus Brine (1783) demonstrates the brilliance of Copley's mature technique, particularly his ability to use light and color to suggest character.

Paul Revere (1768–1770).

The Conference of the Treaty of Peace (1782) by Benjamin West. This unfinished oil sketch shows the five American representatives—John Jay, John Adams, Benjamin Franklin, Henry Laurens, and William Temple Franklin—at the conference table where they met with the British negotiators during September 1782. The British delegation's refusal to pose prevented West from completing the painting.

The American School (1765) was painted by Mathew Pratt (1734–1805), one of the many Americans who studied in West's London studio. The artists are not identified, although West himself is believed to be standing at the left, ready to offer comments on his student's draftsmanship. In fact, if not in name, West's studio was the first American Art Academy. Charles Willson Peale, John Trumbull, Gilbert Stuart, Ralph Earl, Washington Allston, and Samuel F. B. Morse all studied with West.

THE MASTER PORTRAITIST

Gilbert Stuart (1755–1828) was a sensual man in an era noted for austere leaders and righteous indignation. Born in his father's Rhode Island snuff mill, Stuart never lost his delight in the product, or his admiration for the social class which

primarily consumed it. His early portraits attracted the attention of a Scottish painter, Cosmo Alexander, who took him to Edinburgh to study, but Alexander's death forced Stuart to return to New England. In 1775 he moved back to London to study with Benjamin West. By 1787 Stuart's inability to handle money had burdened him with so many debts that he ran away from London and started fresh in Ireland. Six years later new and pressing creditors determined him to return to the United States. Stuart spent the rest of his life exercising his craft for wealthy and sometimes not very discriminating patrons in New York, Philadelphia, and Boston. He turned out many lackluster works during his American career, perhaps as a result of age and frequent drink (his speed of execution probably owes as much to his drinking habits as to his aesthetic sense), but his best portraits testify to a unique and marvelous skill.

Portrait of Copley (1783–1784). Stuart was enthralled by the possibilities of rendering the texture of flesh with his oil paints. Always a fast worker, he concentrated on the face, often to the detriment of the rest of the body. Although his preoccupation with faces makes Stuart one of the most limited painters in American art, in his speciality he was without peer.

The Skater (1782). An easy and incessant talker, Stuart was a master at drawing out his sitters on their favorite subjects. On this particular occasion Stuart found that he and his subject, William Grant, shared an interest in ice skating. When the first sitting was over, they went to skate on the Serpentine, a man-made lake in London's Hyde Park, and their outing prompted Stuart to create this highly unconventional view of his subject as a skater.

Mrs. Richard Yates (1793).

Mrs. Perez Morton (1802) was the gifted but unhappy wife of Senator Perez Morton of Massachusetts. She and Stuart found, for a time, a measure of happiness in their frequent meetings. Stuart's portrait is a perfect example of his technique. Instead of first drawing the figure in charcoal, Stuart begins by sketching directly in oil, delineating the large masses of color with no detail. Once he had finished the face, however, he tended to lose interest, as he did here. The portrait was never completed.

George Washington (1795) is one of the three basic portraits of the first president of the United States from which Stuart made over 100 copies. This one, which shows the right side of Washington's face, is called the Vaughan portrait, after Samuel Vaughan, an American living in London who owned the portrait for several years.

George Washington (1796), adapted from the Athenaeum portrait (see next entry), is a full-length portrait without great distinction; the body seems stiff and disproportionate. This portrait is known as the Landsdowne after the Pennsylvania estate where it was displayed for many years.

George Washington (1796), the Athenaeum version, is the most famous of Stuart's Washington portraits. The work was commissioned by Martha Washington, but Stuart never finished it; indeed he refused to finish it. Instead he delivered a copy, keeping the original to make additional copies—at least seventy are known—which he referred to as his "hundred-dollar bills," a reference to the usual selling price. (His daughter claims that it took him less than 2 hours

to complete a copy.) After Stuart's death the unfinished original was obtained by the Boston Athenaeum, hence its designation.

During his sitting for the Vaughan portrait Washington maintained his customary phlegmatic trance despite Stuart's constant efforts to draw him out. However, during the second sitting Stuart discovered the President's great interest in horses, and by keeping the conversation on horses, Stuart was able to elicit the vital spark which enabled him to paint a successful portrait.

Death on a Pale Horse (1802) by Benjamin West. As West grew older, he gradually evolved in the direction of freer composition and greater movement. His inspiration is often biblical, as in this picture, and frequently considers the irrational and gloomy side of human nature. The century kept pace: the writers and artists of the romantic period (late eighteenth and early nineteenth centuries) emphasized the irrational side of human nature which the Neoclassicists had tried to restrain.

CLOSING ILLUSTRATIONS UNDER CREDITS *The Death of General Wolfe* (West); *Boston Massacre* (Revere); *Watson and the Shark* (Copley); *Mrs. Seymour Fort* (Copley); *Epes Sargent* (Copley); *Mrs. Richard Yates* (Stuart).

QUESTIONS AND PROJECTS

I. Identify or define:

"Old master"	mezzotint engraving
Seven Years' War	Tory
Stamp Act	chiaroscuro
Intolerable acts	Boston Massacre
Articles of Confederation	Townshend Act
neoclassicism	patronage
history painting	antiquity

II. Developmental questions:

1 What is engraving? In what respects is it similar to photography? What is photoengraving? What are the uses of engraving today?

2 Give the main characteristics of neoclassicism. How and when did the movement start? Who were its principal advocates?

3 How did newspapers and magazines develop in the United States? What is the relationship of the colonial broadside to the present newspapers, for instance?

4 Who were the principal painters of Western Europe during the latter part of the eighteenth century? How does their work compare with that of Copley, West, and Stuart?

III. Opinion and judgment questions:

1 Certain critics maintain that a portrait should be the mirror of the soul, that the portraitist must grasp the sitter in his entirety, with qualities and limitations together. These people see the portraitist as a highly perceptive individual capable of judging human nature. Other critics dismiss portraiture and portraitists because a portraitist,

in order to maintain himself, must please his patron. Is it possible to reconcile these views or are they mutually exclusive? Must a portraitist be either an irresistible genius or a spineless hack? Moreover, how can we know when a portrait painted two centuries ago successfully captures the man and when it captures the prettified façade? Compare Copley's portraits with any contemporary portraits you choose.

2 Copley studied anatomy extensively, as his book of anatomy drawings indicates. His only nude, however, is the figure of young Brook Watson in *Watson and the Shark*. Of what use is a knowledge of anatomy if the figures composed by an artist are always clothed? What knowledge of anatomy do Copley's portraits suggest? Do they reflect greater or less knowledge than Stuart's or West's work?

3 Study as many of the history paintings (in color) of Copley and West as you can. Compare the two artists from the point of view of line, color, and composition. Which one is the clearer draftsman? the more expressive colorist? the more dramatic conceptualizer? What are the qualities and limitations of each artist? Which of their paintings (one for each) do you consider to be the most successful in terms of the particular artist's goals and abilities?

IV. Projects:

1 Copy in pencil or trace one of Copley's portraits. How does the result compare with the original? Color it in with watercolors or marking pens. How does the colored drawing compare with the original? What qualities are present in Copley's work that are lacking in yours?

2 Visit the children's section of the library or of a bookstore. Find artists whose work interests you. Who are they? What other books have they done? What qualities of their work make them good illustrators? What process do they use? The same exercise may be used on books for adults. What medium do artists for adult books use? How does their work differ from that directed at children?

3 Cartooning is also a graphic art. Examine the comic books of a large newsstand. What comments can you make about the quality contemporary draftsmanship? What artists appeal to you? What qualities of their work do you find especially interesting? Compare their work with that of the graphic artists—in particular Paul Revere, considered in this program. Compare the work of Amos Doolittle with a contemporary cartoonist from the Sunday comic section.

BIBLIOGRAPHY

Arendt, Hannah: *On Revolution*, The Viking Press, Inc., New York, 1963. An examination of the great revolutions—American and French—of the late eighteenth century.

Frankenstein, Alfred: *The World of Copley*, Time-Life Books, New York, 1970. Excellent art reproductions and a readable text, with one chapter devoted to Benjamin West, by one of America's most perceptive art historians.

McKetchum, Richard (editor in charge): *The American Heritage Book of the Revolution*, American Heritage Publishing Company, Inc., New York, 1958. An interesting account of the War of American Independence with many fine illustrations.

THE YOUNG REPUBLIC

PROGRAM 4
THE YOUNG REPUBLIC

The greatest motive I had or have for engaging in, or for continuing my pursuit of painting, has been the wish of commemorating the great events of our country's revolution. I am fully sensible that the profession, as it is generally practiced, is frivolous, little useful to society and unworthy of a man who has talents for more serious pursuits. But, to preserve and diffuse the memory of the noblest series of actions which have ever presented themselves in the history of man; to give to the present and the future sons of oppression and misfortune, such glorious lessons of their rights, and of the spirit with which they should assert and support them, and even to transmit to their descendants, the personal resemblance of those who have been the great actors in those illustrious scenes, were objects which gave a dignity to the profession, peculiar to my situation.

John Trumbull to Thomas Jefferson, then Ambassador to France, 1789, declining an offer to serve as his private secretary.

Like the political leaders of the Revolution, the planners and designers of the young United States turned to the democracies of Greece and Rome for suitable models. The simple, elegant architecture of classical times

Rembrandt Peale, Porthole Portrait of George Washington (1778–1860). Courtesy of North Carolina Museum of Art.

provided the inspiration for the Federal style, which predominated in American public architecture from 1785 to 1810. Meanwhile painters trained in history painting turned to commemorating the great men and the great events of the Revolution.

OVERVIEW

The period Primarily from 1770 to 1835, but including a brief consideration of trompe l'oeil painting from 1795 to the present.

American Life The War of 1812 (1812–1815) ended Great Britain's attempt to reconquer the former American Colonies. Among the conflict's memorable incidents were the burning of Washington in 1814 (partly in retaliation for the burning of Toronto by American troops), the Battle of New Orleans (which gave Andrew Jackson a national reputation), and the British bombardment of Fort McHenry (which inspired Francis Scott Key to compose "The Star-Spangled Banner").

Thomas Jefferson's purchase of the Louisiana Territory provided Americans with a vast, unexplored wilderness stretching to the headwaters of the Missouri River. By 1815 the population had reached 7,500,000.

American Literature The two best-known literary figures of the early nineteenth century, Washington Irving (1783–1859) and James Fenimore Cooper (1789–1851), were widely praised in Europe as well as in the United States. Irving published several volumes of satire and history, including *The Sketch Book* (1819–1820) containing such classics as "Rip Van Winkle" and "The Legend of Sleepy Hollow." Cooper turned the exploits of the early wilderness guides into legend in the Leatherstocking Tales, including *The Last of the Mohicans* (1826) and several other novels, notably *The Spy* (1821), an extremely popular story of the American Revolution.

International Events The Monroe Doctrine (1823), which warned European nations to stay out of the affairs of South America, was evidence of the nation's growing strength (although it is doubtful whether the Americans could have enforced it without the support of the British navy).

Napoleon Bonaparte, after his final military campaign ended at Waterloo, was permanently exiled to the small island of St. Helena in the south Atlantic. The second French Revolution (1830) ended the Bourbon dynasty and brought the middle class to power.

CONTENTS OF THE PROGRAM *Architecture* Thomas Jefferson's Monticello and the U.S. Capitol Building are representative examples of the Federal style, the principal architectural style of the period.

Painting John Trumbull's history paintings of the American Revolution and Charles Willson Peale's many-faceted career are principally discussed.

Sculpture Horatio Greenough's controversial neoclassical projects are con-

trasted with Hiram Powers's highly successful portrait busts and allegorical nudes.

Trompe l'oeil painting The primary aim of the trompe l'oeil painter is to "fool the eye" of the spectator and make him think he is looking at a real scene when in fact he is looking at a painted representation of it. The Peale family, William Michael Harnett, and John Frederick Peto are the major representatives of a continuing American tradition.

VIEWER'S GUIDE

PRE-LOGO ILLUSTRATIONS *The Artist in His Museum* (Charles Willson Peale); *Exhibition Gallery of the Louvre* (Morse); *The Signing of the Declaration of Independence* (Trumbull); *George Washington* (the Athenaeum portrait); *The Battle of Bunker's Hill* (Trumbull).

ARCHITECTURE

Thomas Jefferson (1743–1826) designed his country home near Charlottesville, Virginia, to please only himself. *Monticello,* however, became the starting point of the Federal style. As built in 1770 from a plan based on Andrea Palladio's Villa Rotonda, Monticello was a simple adaptation from classical Roman models. Jefferson's 5-year stay in France as Minister and Ambassador (1784–1789) permitted him to study Roman architecture more closely. After his return to Virginia he took steps to eliminate every indication that Monticello was a two-story building. He lowered the roof, removed the second colonnade on the west portico, and, most importantly, moved the second-floor windows down until they were flush with the second floor. Inside the building he gave free rein to his inventiveness, installing unique devices like dumbwaiters and coordinated double doors.

Monticello (1770–1809). North facade.

Villa Rotonda, Vicenza, Italy (1575), by Andrea Palladio (Program 2).

Monticello. North facade.

Monticello's projecting portico and colonnaded face are key features of the Federal style. Other notable marks are the crowning balustrade, the continuous entablature, a low-pitched roof (colonial Georgian preferred a very high-pitched roof and fancy gables), and the dome mounted on its octagonal drum.

State Capital of Virginia, Richmond (1785–1789) (aerial view).

Jefferson's design was based on a Roman temple, the Maison Carrée in Nîmes, France. Jefferson was so fascinated by the beauty of the Maison Carrée that he used to sit and gaze at it for hours at a time.

Maison Carrée (Nîmes, France).

State Capital of Virginia, Richmond (engraving).

Plans for *The Rotunda* of the University of Virginia.

The Pantheon (Rome, Italy).

The buildings of the *University of Virginia* (1822–1826) were Jefferson's last significant architectural undertaking. His design for the central library Rotunda and the series of professors' houses and classrooms, which extend at right angles from the library foundation, show his love for, and appreciation of, classical styles.

The Rotunda (University of Virginia, Charlottesville, Virginia). Based on the Pantheon in Rome, Jefferson's original plan for the library called for a circular building with slight rectangular projections on opposite sides.

University of Virginia (lithograph, 1856). In 1851 an annex (just visible at the extreme left in this lithograph), was built onto the Rotunda. After the library was gutted by fire in 1891, the building was rebuilt according to the original plan and the annex was removed.

Congress Hall, Old House of Representatives (Samuel F. B. Morse, 1821).

Aerial view of Washington, D.C.

Pierre L'Enfant's plans of Washington, D.C. (1791).

U.S. Capitol (Thornton's version).

U.S. Capitol (Latrobe's version).

Dome and entrance of *U.S. Capitol* today.

Aerial view of *U.S. Capitol*, showing additions and modifications.

Detail of corn capitals added by Latrobe.

U.S. Capitol.

English-born Benjamin Latrobe (1764–1820) was the first professional architect in the United States. President Thomas Jefferson liked his work and used his influence to bring Latrobe both public and private commissions. In 1803 Latrobe was named architect of the Capitol. The building had been designed by Dr. William Thornton (1759–1828), an English physician from the West Indies, but Thornton's lack of architectural education disqualified him from overseeing the work. After the original Capitol building was burned by the British troops during the War of 1812, Latrobe took charge of the reconstruction. He remodeled the interior, redesigned the portico, and added the domed roof and the cupolas on each wing. But despite his extensive and original reworking of Thornton's design, Latrobe received his greatest publicity for replacing the acanthus leaves on the Corinthian capitals with ears of corn, leaves of tobacco, and other native plants.

PAINTING

John Trumbull (1756–1843), a graduate of Harvard at 17, served in the Colonial Army from the time of the skirmishes at Lexington and Concord until January 1776, when he resigned in anger over a question of seniority. In 1780 he went to London to study with Benjamin West, but after a few months, he was imprisoned as a spy, apparently in retaliation for the arrest and execution of Major John André. West's influence saved his life, but Trumbull spent 8 months in confinement.

In 1783, under West's guidance, Trumbull began work on a series of paint-

ings depicting significant events from the War of Independence. His paintings brought him honor as the "Painter of the Revolution," but little money. In 1817, however, Congress commissioned him to paint four large murals based on scenes from his earlier series for the Capitol Rotunda. Trumbull spent 8 years on the work, but the Rotunda murals were much less successful than the small originals. The $32,000 commission, however, paid off his many debts.

The Death of General Warren at the Battle of Bunker's Hill (1784), the full title of Trumbull's painting, is customarily shortened to *The Battle of Bunker's Hill.* Trumbull was criticized for showing the death of the American commander rather than the heroic exploits of the American forces, who inflicted tremendous casualties among the British attackers before they ran short of powder and were compelled to withdraw. But Trumbull's conception is human rather than nationalistic and patriotic. Moreover, even if the glory of victory is absent, the American spirit of resistance is given a strong portrayal in the stalwart figure of Captain Thomas Knowlton, standing behind the fallen Warren.

Detail of lower right-hand corner figures from *The Battle of Bunker's Hill.* The composition derives its power from the asymmetrical placing of the figures, the contrasts of light and dark (the alternating areas of shadow accentuate the movement toward the pinnacle marked by the wind-whipped battle flags), and the movement upwards from right to left. Trumbull's picture is not intended as a journalistic, eyewitness account, faithful to the exact course of the battle, but as an artistic rendition of the *feeling* of the encounter. Trumbull and Copley show a similar appreciation of the dramatic in their history paintings.

If the composition is contrived, however, the details are not. Trumbull, whenever possible, included exact likenesses of the participants, either drawing them from life or copying them from portraits. In some cases when the participant had died since the battle, he used the son as his model.

Surrender of General Burgoyne at Saratoga (1817) and *Signing of the Declaration of Independence* (1817) are two of the four historical subjects Congress commissioned Trumbull to paint for the rotunda of the new Capitol. (The version of *The Signing of the Declaration of Independence* (1786–1797) shown here is the small oil painting, not the mural.)

Detail of Drafting Committee (John Adams, Roger Sherman, Robert Livingston, Thomas Jefferson, and Benjamin Franklin) presenting the Declaration of Independence to John Hancock, President of the Continental Congress, from *The Declaration of Independence.*

Washington at Verplanck's Point (1790). In the spring of 1790, Trumbull solicited subscribers to his series of the significant incidents of American history which would include both oil paintings and engravings. To execute the project properly, he traveled about the eastern United States sketching and painting the principals of the Revolutionary period. To thank General Washington and his wife for their support of his undertaking, Trumbull painted this small likeness of Washington. He later made a large copy of the portrait to hang in the Philadelphia City Hall. The City Hall portrait was Trumbull's first important public commission and was one of the few large-scale efforts which proved as satisfactory as the small original.

Washington (Athenaeum version, 1796) by Gilbert Stuart (Program 3).

The son of an English forger and embezzler pardoned on condition that he emigrate to the American Colonies, Charles Willson Peale (1741–1826) was an American original. Painter, inventor, silversmith, naturalist, soldier, physical cultist, he married three times and fathered seventeen children (besides adopting three more), many of whom became successful artists. Peale tried his hand at oil painting, watercolors, sculpture, etching, and mezzotint engraving and was competent in all. He created the nation's first public art gallery, as well as its first natural history museum. The extent of his vitality is evident from the fact that he was courting still a fourth wife when he died at age 86.

Originally a saddler by trade, Peale saw his first oil painting on a business trip to Norfolk, liked what he saw, began to paint, and soon began advertising himself as a sign painter. He studied briefly with Copley, and the results were so impressive that a group of Marylanders put up the money to send him to England to study with Benjamin West.

After his return to America in 1769, Peale, the only portraitist in the Annapolis area, established a profitable portrait business. In 1776 he and his family moved to Philadelphia.

Six years later he opened a picture gallery with a display of military leaders of the American Revolution. The venture prospered, and in 1794 Peale expanded it to include a natural history museum. In 1795 he helped found the first art school in America. The school was forced to close, however, as a result of the scandal set off when Peale took the place of a model who failed to show up and posed nude for a life drawing class (although "nude" in this case may only mean that he removed his shirt).

George Washington (1777) is Charles Willson Peale's second portrait of Washington. Altogether Peale and his family painted Washington on some fourteen occasions.

Family Group (painted for the most part in 1773, but reworked and completed in 1808) pictures the artist's growing family. His first wife Rachel (seated center) holds one of his daughters while his mother (far right) holds another. His brother St. George is at left, sketching, and a second brother, James, smiles at him. Charles holds the palette in the background, next to his sister Margaret. Another sister, Elizabeth, sits at the right next to their mother.

Detail of figures at left from *Family Group*.

The Artist in His Museum (1822) is a self-portrait of Charles Willson Peale as he invites us into the natural history section of his museum in Philadelphia. Admission fees for the Independence Hall location (from 1802 on) brought Peale a good income. He painted little on commission after 1800, preferring to send prospective sitters to James or Rembrandt Peale while he occupied himself with the natural history exhibits.

Detail of palette from *The Artist in His Museum*.

Detail of Peale from *Exhuming the Mastodon*.

Exhuming the Mastodon (1806) reflects the interest in science which came to dominate the latter part of Peale's life. In 1801 he heard that a farmer in upstate

New York had uncovered the bones of a huge animal in a water-filled pit. Peale immediately paid the man $300 and launched the first archaeological dig in this country.

Washington (C. W. Peale, 1795).

The Porthole Portrait of Washington (Rembrandt Peale, 1795). Rembrandt Peale (1778–1861) had precocious talent and was his father's favorite pupil. He executed the *Porthole Portrait of Washington* when he was only 17. His effort was second only to Gilbert Stuart's Athenaeum portrait in popularity, and Rembrandt Peale made seventy-nine copies of it (in addition to thirty-nine copies of his father's portrait from the same sitting). In his later years, he capitalized on his status as the last surviving portraitist of Washington, touring with a speech describing the event. Four Peales actually took part in the famous three-day sitting: James Peale (C. W. Peale's brother) made a miniature and Raphaelle a profile sketch.

George Washington (1786). The French sculptor Jean-Antoine Houdon (1740–1828) was one of the many foreign artists commissioned to commemorate the great men of the new nation. Houdon, who had previously executed a portrait bust of Benjamin Franklin, visited America in 1785 to model the statue, later completing it in France. His *Washington* was well received, although faulted by some for disproportionately thin legs.

SCULPTURE

Horatio Greenough (1805–1852) was the first native-born American to make sculpture his profession. In 1827 he went to Italy to study. Like most of the other American sculptors of the period, he remained there for most of his career.

For an American sculptor, living in Italy brought the opportunity to observe at first hand the great statuary of Europe and to study with excellent teachers. Even more important, however, it gave access to excellent Italian artisans and marble cutters. These craftsmen who actually carved and completed the statues were the mainstay of American sculpture during the nineteenth century. Working with marble was a difficult, physically taxing activity. Greenough himself found the effort of finishing one of his early marble statues (that is, he removed the final quarter inch of stone) so tiring, so time-consuming, and so tedious that he never again attempted it. What made possible this division of labor was the "pointing machine," an ingenious mechanical device which permitted even unskilled workers to transfer a design from artist's plaster model to marble. Thus even though the workmen did the major part of the actual labor, they were given no recognition as artists since the truly creative act was thought to be the preparation of the initial plaster model.

George Washington (1833–1841). In 1832 Congress awarded Greenough the commission for a monumental statue of George Washington. Greenough modeled the head of his Washington from Houdon's famous work (Congress had written that into the commission). He realized, however, that the country

wanted not only a monument but an inspiration, and he tried to duplicate, in grandeur and nobility, the famous statue of Zeus by the finest of Greek sculptors, Phidias.

The statue was completed and shipped to Washington in the fall of 1841. Derided as a disaster, or a joke, it was scorned by nearly everyone. Greenough's contemporaries had little appreciation of his classical conception of the statue; all they knew was that he had failed to show Washington in a recognizable pose and in a normal costume. As with the Armory Show in 1913 (see Program 13), critics had a field day. There were endless complaints that Washington was too modest to show himself half naked. One wit proclaimed that Washington was saying, "Here is my sword—my clothes are in the Patent Office yonder."

Detail of head and torso from *Washington*.

Detail of throne and side view of Washington from *Washington*.

Washington (1833–1841).

Film of the Hiram Powers Gallery of the National Collection of Fine Arts, Washington, D.C.

Hiram Powers (1805–1877) discovered, perhaps accidentally, that nudity combined with morality was a surefire recipe for success with the American public. The demeanor of his most famous nude, *The Greek Slave*, is magically transformed from sensuous to serious by the short chain which binds her to the post and the cross which reveals her Christian faith. She is not displaying herself, she is enduring display. Regardless of what she is wearing, she has a pure soul and that purity of soul, effectively announced by Powers's advance publicity, brought overwhelming success. The statue was finished and exhibited in London in 1845—and sold for $4000. Six years later it was the sensation of the Crystal Palace Exhibition. In between, *The Greek Slave* toured America, grossing some $23,000. Powers also made six copies of the statue, selling them all for an average of $4000 each.

Powers was blessed with an excellent organizational sense, and he obtained full value from it. Eventually some twelve assistants were on hand to help him turn out his much sought-after products.

Samuel F. B. Morse (1791–1872), known to every school child as the inventor of the telegraph and the telegraphic code, set out to become an artist, not an inventor. He established himself as a portraitist in New York City, but disappointment over the lack of public response to his ambitious history paintings was a major reason for his return to science. He exhibited the first telegraph apparatus in 1837, although several years passed before he was able to get the invention patented and begin development.

Detail of paintings hung on the wall from *Exhibition Gallery of the Louvre* (1832).

Detail of artist and student from *Exhibition Gallery of the Louvre* (1832).

Congress Hall, Old House of Representatives (1821) is a monumental group portrait. All the congressmen were drawn from life, a tremendous achievement in itself, but not many people cared to see it and no one was very much interested in buying it. Morse finally had to let the painting go for only $1200, less than half what he had been asking.

TROMPE L'OEIL PAINTING

Trompe l'oeil painting is a special form of still-life. In ordinary painting, particularly in landscapes, we know we are not looking at the real thing because there is no need to change focus to shift our gaze from near objects to far. In addition the objects do not change their relationship when we move. But if the painter reduces the depth of a composition sufficiently, he can eliminate these visual checks and successfully trick us into believing we are looking at real objects. This kind of painting, called *trompe l'oeil* or "fool the eye" painting, was particularly popular in the United States during the latter half of the nineteenth century.

The Staircase Group (1795). Charles Willson Peale surrounded this life-size portrait of sons Raphaelle and Titian (who died a few years later) with a real doorframe and even built a bottom step to increase the illusion. For years it remained one of the highlights of the Peale museum. Among the many visitors taken in, it is claimed, was George Washington, who bowed politely to the painted images as he passed the picture.

Detail of step from *The Staircase Group.*

After the Bath (1823).

Raphaelle Peale (1774–1825), C. W. Peale's eldest son, was immensely talented (perhaps the most able of the family), and capable of masterful still-lifes when not drinking or concocting witty remarks. Tradition has it that Peale's ill-tempered and jealous wife was so angry at seeing what appeared to be a naked model behind the crisp white sheet in the corner of Peale's studio that she tried to snatch the covering away and scraped her knuckles badly.

Detail of foot from *After the Bath.*

Detail of hand from *After the Bath.*

After the Bath (1823).

William Michael Harnett (1848–1892) was first an engraver of table silver. His paintings pass through three distinct periods, beginning with small still-lifes of mugs and pipes on tabletops and culminating in huge canvases like the four versions of *After the Hunt.* As a result of neglect during his lifetime, only about one-third of his 500 paintings are still known to exist.

After the Hunt (1885, Palace of the Legion of Honor, San Francisco). Acclaimed at the Paris Salon of 1885, this version of *After the Hunt* amused and confused the patrons of Theodore Stewart's New York salon from 1886 to 1918. Its exceptionally skillful composition was a significant influence on other trompe l'oeil painters.

Detail of pistol from *The Faithful Colt* (1890).

Emblems of Peace (1890).

John Frederick Peto (1854–1907) devoted his career to still-lifes and trompe l'oeil painting. He lived his entire life in the Philadelphia area except for a brief stay in Cincinnati. Harnett was his model and guide, and for many years Peto's paintings were mistaken for Harnett's. To make the confusion complete, forgers often added Harnett's signature to Peto's work. It was not until the late 1940s that Peto began to receive recognition in his own right.

Details from *The Poor Man's Store* (1885).
Detail of books from *The Poor Man's Store*.
After Night Study (1894).
Old Reminiscences (1900).
The Artist's Card Rack (Michael Harnett, 1879).
Plywood (1974) by John Clem Clarke (born 1937).

CLOSING ILLUSTRATIONS (under credits) *Greek Slave* (Powers); Monticello; University of Virginia (Rotunda); Richmond Capitol; U.S. Capitol; *The Artist in His Museum* (Peale); *The Battle of Bunker's Hill* (Trumbull); *The Declaration of Independence* (Trumbull—Yale version); *Washington at Verplanck's Point* (Trumbull); *Washington* (C. W. Peale); *The Athenaeum Washington* (Stuart); *Olympian Washington* (Greenough); *Exhibition Gallery of the Louvre* (Morse); *Family Group* (C. W. Peale); *After the Bath* (Raphaelle Peale).

QUESTIONS AND PROJECTS

I. Identify or define:

Monticello	capital
Federal style	mural
rotunda	Phidias
Pierre L'Enfant	pointing machine
colonnaded porch	tour de force
pediment	entablature
classical orders	balustrade

II. Developmental questions:

1 American architecture. Give the main features of the Federal style. What were its principal uses? How does it differ from colonial Georgian? Can it be called a distinctly American style?

2 Classical architecture. Classical Rome and Greece provided the inspiration for the Federal style and for the Greek Revival which followed. What are the main attributes of classical architecture? What principles motivated classical architects? What building materials did they prefer? Name some of the outstanding examples of classical architecture.

3 American art. What were the principal problems facing American artists during the latter part of the eighteenth century and the early part of the nineteenth? What sort of art did the public prefer? What were the goals of American artists of this period?

III. Opinion and judgment questions:

1 Nineteenth-century American sculptors often chose to follow classical precedents. Horatio Greenough's *Washington* is a perfect example of the attempt to present current experience in classical form. Given Greenough's goals, can it be considered a successful work? What kind of an audience was he appealing to? In your opinion, what values does *Washington* represent? Compare it with other sculptural monuments which you have seen.

2 What is the appeal of trompe l'oeil painting? Is it art? Which activity would require more skill, history painting or trompe l'oeil painting? Can you find any similarity, any common goal, in the two kinds of painting?

3 Both the Federal style of architecture and the Greek Revival buildings were inspired by classical models. What motivated the choice? Using specific examples, compare the elements of ancient architecture with the Federal style. Did this architectural style successfully fulfill the needs of the new nation? Explain.

IV. Projects:

1 Visit the public buildings of your community. Do you find any remnants of the Federal style? What distinctions can you make concerning the age of the buildings from the architectural styles? from the building materials?

2 Take a trip through a fashionable residential section of your community. Are there any houses in the Federal or Greek Revival styles? Do you find any adaptations from these styles? Are there any examples of earlier colonial styles? You might also visit other parts of the residential community and see how the elements of the same styles are incorporated in a more subdued way, to give a touch of class without the price.

3 Choose the outstanding event of American history between 1765 and 1790. How would you compose a painting to communicate the importance of this event? What values do you wish to suggest? If you had to choose another medium to express your ideas, which one would it be? How would you translate your conclusions into the new medium?

4 Find examples of trompe l'oeil painting in your area. What effect do they have on you? What uses could you find for them? Illusionist techniques are frequently seen in other media. What examples do you know of? What expressive value do they have?

BIBLIOGRAPHY

Ardvist, Ralph K. (editor in charge): *The American Heritage History of the Making of the Nation,* American Heritage Publishing Company, Inc., New York, 1968. A well-illustrated history of the United States from the end of the Revolution to the beginning of the Civil War.

Frankenstein, Alfred: *After the Hunt: William Harnett and Other American Still Life Painters, 1879–1900.* University of California Press, Berkeley, 1953. An excellent account of the trompe l'oeil tradition in American painting.

————: *The Reality of Appearance,* New York Graphic Society, Greenwich, Conn., 1970 A catalog published in conjunction with an exhibition of American still-life/trompe l'oeil painting in 1970.

Guinness, Desmond, and Julius Trousdale Sadler, Jr.: *Mr. Jefferson, Architect,* The Viking Press, Inc., New York, 1973. A brief, well-illustrated look at the architectural accomplishments of Thomas Jefferson.

Peterson, Merrill: *Thomas Jefferson and the New Nation,* Oxford University Press, New York, 1970. A good one-volume biography of Jefferson.

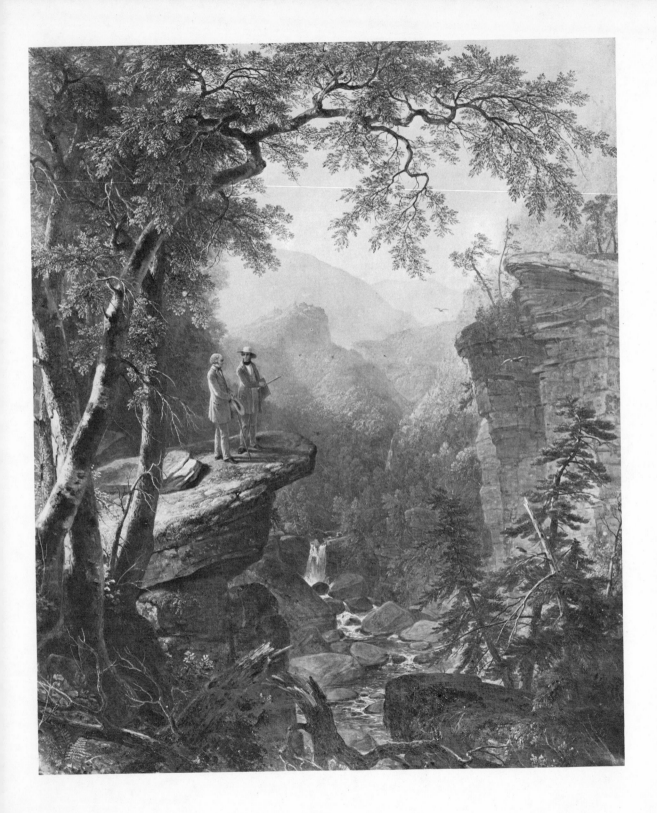

PROGRAM 5

PRESERVING THE LANDSCAPE

Poetry and Painting sublime and purify thought, by grasping the past, the present and the future—they give the mind a foretaste of its immortality, and thus prepare it for performing an exalted part amid the realities of life. And rural nature is full of the same quickening spirit—it is, in fact, the exhaustless mine from which the poet and the painter have brought such wondrous treasures—an unfailing fountain of intellectual enjoyment, where all may drink, and be awakened to a deeper feeling of the works of genius, and a keener perception of the beauty of our existence.*

Thomas Cole, "Essay on American Scenery" (1835)

There is yet another motive for referring you to the study of Nature early—its influence on the mind and heart. The external appearance of this our dwelling place, apart from its wondrous structure and functions that minister to our well-being, is fraught with lessons of high and holy meaning, only surpassed by the light of Revelation. It is impossible to contemplate with right-minded, reverent feeling, its inexpressible beauty and grandeur, forever assuming new forms of impressiveness under the varying phases of cloud and sunshine, time and season, without arriving at the conviction

* *Sublime is used as a verb meaning "to purify."*

Asher B. Durand, Kindred Spirits (1849). Courtesy of the New York Public Library, Astor, Lenox, and Tilden Foundations.

> *That all which we behold*
> *Is full of blessings*
> *that the Great Designer of these glorious pictures has placed them before us as types of the*
> *Divine attributes, and we insensibly, as it were, in our daily contemplations,*
> *To the beautiful order of his works*
> *Learn to conform the order of our lives.*
>
> *Asher B. Durand, second letter on*
> *landscape painting* (1855)

After consolidation came new expansion. In 1845 Louis O'Sullivan, a New York journalist, suggested that westward expansion was inevitable, that it was the "manifest destiny" of the United States to control the land between the oceans. This dream of continental domination encouraged American artists to celebrate the wilderness, the land in its primitive state, with romantic awe and religious reverence. Architects and city planners sparked national and community efforts to establish college campuses and planned communities.

OVERVIEW

The Period Approximately 1825 to 1900.

American Life Nineteenth-century Americans were probably less interested in preserving the landscape than they were in acquiring the land—and exploiting it. Manifest Destiny, despite its spiritual connotations, was largely a justification of the mechanics of expropriation and theft. Only a few raised their voices to protect the countryside.

The 1840s were the first great decade of expansion beyond the Mississippi. In 1846 President Polk settled the boundary of the Oregon Territory at 49°. Two years later, after a scarcely justifiable war with Mexico, the country was awarded Texas, along with California and the southwestern territories. From 1820 to 1861 the value of farm produce increased fivefold, primarily because of new plantings by settlers in the West.

By effectively destroying the backward economy of the South, the Civil War unleashed the energy of the nation. Many more settlers moved west, aided by the government. The Homestead Act of 1862 awarded 160 acres to any settler for a nominal fee. Immense grants of land adjoining the right-of-way encouraged railroads to move west. Between 1850 and 1900, 250,000 miles of track were laid. By linking the scattered parts of the country, these railroads fostered a national economy and enabled the government in Washington to maintain control over far-flung areas.

American Literature William Cullen Bryant (1794–1878) celebrated the land in his many poems. Ralph Waldo Emerson (1803–1882), the intellectual force behind the transcendentalist movement, published his important and influential *Essays*. Nathaniel Hawthorne (1804–1864) studied the Puritan concepts of guilt and sin in novels like *The Scarlet Letter* (1850) and *The House of the Seven Gables*

(1851). Henry David Thoreau (1817–1862) gave voice to a traditional strain of American individualism in *Walden* (1854).

International Events As the United States expanded toward the West, the South American countries led by Simon Bolivar and Bernardo O'Higgins began to throw off the Spanish colonial government. Great Britain fought a silly war with Russia and Turkey in the Crimea (1854–1856) for which she received only some very quotable poetry and Florence Nightingale. Prussia gave notice of her military strength with a lightning victory over Austria in the Seven Weeks' War (1866), then followed with a similar defeat of France in 1870–1871. In the Far East Commodore Perry forcibly opened Japan to foreign trade (1854).

CONTENTS OF THE PROGRAM *The Hudson River School* Thomas Cole and Asher B. Durand, the leaders of America's first school of landscape painters, are discussed as well as two artists who were influenced by their work, Jasper Cropsey and George Inness.

Luminism A second group of landscape painters, called "luminists" because of their special interest in light and atmosphere, included John Kensett, Fitz Hugh Lane, Martin Johnson Heade, and Sanford Gifford.

Second Generation of the Hudson River School; Frederic Edwin Church The art of both landscape schools is apparent in the work of Frederic Church. At times delicate and detailed as the luminists, Church made his reputation with huge and spectacular scenes of nature's greatest phenomena.

Landscape Architecture Andrew Jackson Downing and Frederick Law Olmsted turned attention toward effective utilization of urban space and preservation of natural wonders.

VIEWER'S GUIDE

PRE-LOGO ILLUSTRATIONS *Owl's Head, Penobscot Bay, Maine* (Lane); *Crawford Notch* (Cole); *The Delaware Water Gap* (Inness); *Kindred Spirits* (Durand); *Niagara Falls* (Church).

THE HUDSON RIVER SCHOOL

Thomas Cole (1801–1848) was not the "father of American landscape painting" as critics since James Fenimore Cooper have periodically tried to maintain (Thomas Doughty preceded him), but his vision of the American wilderness as both the great testimony of the nation's worth and potential, and the ideal expression of a deep religious feeling brought new honor and vigor to the landscape tradition. The Hudson River School was the direct result of Cole's efforts.

The English-born Cole came to the United States in 1818. In 1825 a summer sketching trip up the Hudson River produced several landscapes which he brought to New York City after failing to find local buyers. The story goes that John Trumbull spied the three canvases on display in a framer's shop and gave a cry of admiration: "This young man has done what all my life I attempted to do in vain." He then bought one of the paintings for $25. In 4 years Cole sold enough paintings to go to Europe for 3 years of travel (1829–1832).

After returning from Europe Cole settled in the Catskill Mountains to devote himself to painting the surrounding countryside. On his frequent sketching trips, he compiled great quantities of notes on light and colors to be used to work up the final painting in his studio. For Cole the purpose of art was to ennoble and to instruct. Given his aims, it is no wonder that his paintings changed from simple landscapes into didactic series like *The Course of Empire* (1836), the five immense paintings which established his reputation.

Schroon Mountain (*The Catskill Mountains*) (1838) is based on a pencil sketch made on a clear day in June of 1836, but Cole has changed the season to autumn (no doubt to make use of the brighter colors) and added a storm (seen passing off on the right). The trees in the foreground are dramatically parted, as though to draw our gaze through them to the pinnacle beyond. Cole typically includes much foreground detail, and he frequently inserts a human figure to indicate scale. Cole's original sketch depicts the area as much less wooded and less wild than in the final painting. He has altered the natural appearance of the scene in order to express his emotions in the face of nature. His personal approach to landscape painting is contained in a letter, written to Asher B. Durand during this time: ". . . I never succeed in painting scenes, however beautiful, immediately on returning from them. I must wait for time to draw a veil over the common details, the unessential parts, which shall leave the great features, whether the beautiful or the sublime, dominant in the mind."

Crawford Notch (*The Notch of the White Mountains*) (1839).

Detail of horseman and cabin from *Crawford Notch*.

The Hay Wain (1821). John Constable (1776–1836) is the antithesis of Thomas Cole. His quiet landscapes, like *The Hay Wain*, are the simplest kind of representation of daily life in England. There is no drama; indeed there is scarcely any activity.

The Ford (1636) by Claude Lorrain. Claude Gellée, called Claude Lorrain (1600–1682), established early his reputation as a landscape painter and spent his life confirming it. His peaceful scenes are in distinct contrast to Cole's dramatic confrontations.

Washington Allston (1779–1843), one of the most important representatives of romanticism in American painting, gave his countrymen a lesson in the expressive use of color. He sought the *sublime*, an emotion that lifted the spectator beyond the limits of normal life toward the mystery of eternity. Cole and his followers were greatly influenced by Allston's richly colored compositions.

In *Moonlit Landscape* (1819), one of his most suggestive and highly praised paintings, Allston orchestrates the light and the environment to evoke a sensation of mystery and wonder. The delicate blend of colors and the eerie light of the moon transform an everyday happening into a mysterious encounter.

Detail of *Landscape with Tree Trunks* (1827–1828) by Thomas Cole.

Cole, who both loved and feared the wilderness, frequently includes deformed or dead trees in the foreground. His entire output shows a fascination with decay and death.

Detail of *Elijah in the Desert* (1818) (Allston).

Elijah in the Desert (1818) is 4 feet by 6 feet, almost twice the size of *Moonlit Landscape,* and makes the desolate landscape even more forbidding than it seems in this reduced image. Once again demonstrating his mastery of color, Allston mixes lights and darks, cool blues, and warm browns to create a mood of anguish and desolation. Profound sentiments of this sort are typical ingredients of Cole's work as well.

Landscape with Tree Trunks (1826–1828) by Thomas Cole.

Schroon Mountain (1833) by Thomas Cole.

Engraving of William Cullen Bryant (1794–1878).

Poet, critic, essayist, and editor, Bryant was one of the many intellectuals who encouraged writers and artists of the United States to examine the American experience. After a brief career as a lawyer in Great Barrington, Massachusetts, he moved to New York, where he became editor-in-chief of *The New York Evening Post.* He remained throughout his life one of the foremost advocates of public causes.

Detail of *View near Tivoli, Morning* (1832) (Cole).

View near Tivoli, Morning (1832) is, in Cole's words, a "picturesque bit that I found in my rambles among the Apennines." Although the painting includes two staples of the romantic vision, countryside and ruins, it is a calmer, less dramatic vision than Cole's American works.

The Course of Empire (not shown). From 1834 until 1836, Cole completed five large paintings which he called *The Course of Empire.* The series was greeted by enthusiastic praise; James Fenimore Cooper called it "the work of the highest genius this country had produced."

The Voyage of Life was first imagined by Cole in 1836, but it was not until 1839 that he was able to find a patron—the New York banker and collector Samuel Ward. Ward's untimely death, however, prevented Cole from completing his work the way he had planned. He therefore composed a second *Voyage of Life* series (seen here). Cole's allegorical descriptions for the series show how earnest he was in his teaching. He knew his audience: *The Voyage of Life* was his most popular work.

Childhood (1841). "The dark cavern is emblematic of our earthly origin, and the mysterious Past. The Boat, composed of Figures of the Hours, images the thought, that we are borne on the hours down the Stream of Life. The Boat identifies the subject in each picture. . . . Joyousness and wonder are the characteristic emotions of childhood."

Detail of *Youth.*

Youth (1842). "The scenery of this picture—its clear stream, its lofty trees, its towering mountains, its unbounded distance, and transparent atmosphere —figure forth the romantic beauty of youthful imaginings, when the mind magnifies the Mean and Common into the Magnificent, before experience teaches what is the real. . . ."

Manhood (1842). "Trouble is characteristic of the period of Manhood. In Childhood there is no cankering care; in Youth no despairing thought. It is only when experience has taught us the realities of the world, that we lift from our

eyes the golden veil of early life: that we feel deep and abiding sorrow; and in the picture, the gloomy, eclipse-like tone, the conflicting elements, the trees riven by tempest, are the allegory; and the Ocean, dimly seen, figures the end of life, to which the voyager is now approaching. The demon forms are Suicide, Intemperance, and Murder, which are the temptations that beset men in their direst trouble. The upward and imploring look of the voyager, shows his dependence on a Superior Power, and *that* faith saves him from the destruction that seems inevitable."

Old Age (1842). "The stream of life has now reached the Ocean, to which all life is tending. The world, to Old Age, is destitute of interest. There is no longer any green thing upon it. The broken and drooping figures in the boat show that Time is nearly ended. The chains of corporeal existence are falling away; and already the mind has glimpses of Immortal Life. . . ."

Distribution of American Art Union Prizes (1847). Lithograph by J. H. Matteson. The American Art Union and similar organizations encouraged American artists to paint American scenes.

In 1839 an enterprising New York painter and dealer named John Herring founded the Apollo Association, a new kind of cultural organization. For a 5-dollar fee, each member received an engraving and a ticket for the annual lottery. The Association used the money to buy paintings by American artists and each year distributed them to lucky ticket holders. The Apollo Association proved such a great success that in 1844 Herring changed its name to the American Art Union, with William Cullen Bryant as its first president. Subscriptions were sold not only in the principal cities but in the smaller towns as well. In 1844, ninety-four pictures were distributed at the lottery. In 1848 over half a million spectators came to see the paintings in the Art Union's New York gallery, and the 16,000 subscribers received an engraving of *Youth* from Thomas Cole's *Voyage of Life* series. Professional jealousies and the law, however, eventually ended this prosperity. A group of artists brought suit against the Art Union, charging it with operating an illegal lottery. The courts agreed, and in 1852 the Art Union closed. The Union tried unsuccessfully to continue with the gallery alone but the loss of a chance at receiving a "free painting" was a deathblow. Nonetheless, before they were closed down, the American Art Union and similar organizations helped create a public following for American art and American artists. The years from 1850 to 1875 were prosperous ones for American artists.

The Oxbow (*The Connecticut River near Northampton*) (1846). Cole first painted this scene in 1836 as a much-needed change from his work on *The Course of Empire*. He later made several copies, of which this is one.

Detail of Cole at work from *The Oxbow*.

Asher B. Durand (1796–1886), born in rural New Jersey of Dutch and Huguenot descent, became an apprentice to Peter Maverick, an engraver near Newark, at the age of 16. In 1821 he formed a partnership with Maverick and went to New York City to open a new office. Durand's reproductions of John Vanderlyn's famous nude, *Ariadne,* and of John Trumbull's *Signing of the Declaration of Independence* established him as an engraver. He began to paint por-

traits in the 1830s, but the sudden death of his friend and patron, Luman Reed, caused him to turn his skills to landscape paintings. He sought simpler designs than Cole—his compositions are seldom dramatic— and he often made direct sketches in oils. (In 1841 the manufacture of oil paints in collapsible metal tubes reduced the difficulties of painting landscapes on the spot.) Durand's style was probably more typical of the Hudson River painters than Cole's was, and his *Letters on Landscape Painting* (1855) contain the most important statements of Hudson River School principles.

Kindred Spirits (1849), painted the year after Cole's death, depicts Cole and William Cullen Bryant standing in the middle of the nature both of them loved. Durand, like Cole, sought to reveal something of the spiritual world, but whereas Cole used dramatic confrontations, Durand preferred simple statements like this one.

Detail of Cole and Bryant from *Kindred Spirits*.

Catskill Clove (1866).

Detail from left side of *Catskill Clove*.

Detail from right side of *Catskill Clove*.

Detail of central portion from *In The Woods* (1855).

The French painter Gustave Courbet (1819–1877) pioneered in the development of a naturalistic style of painting. He rejected both neoclassicism and romanticism and declared that only realism was democratic.

Roe Deer in the Forest (circa 1840). Although often more finely detailed and even more savage, French landscapes of the nineteenth century generally lack the vast panoramas of the Hudson River School.

Jasper Frances Cropsey (1823–1900), a very bright light among Cole's successors, effectively commercialized the Hudson River panoramic style. Originally an architect, he began painting in 1842. From 1856 to 1862 he lived in London where he enjoyed an immense popularity as a painter of American scenes. After 1875 he devoted himself almost exclusively to autumn landscapes.

Autumn on the Hudson River (1860) is an extremely large canvas (some 5 feet by 9 feet) with the detailed foreground and wide vista common in Hudson River School paintings. Cropsey began to paint his landscapes in England, where the autumn colors are not nearly so varied nor so bright as they are in the northeastern United States. Partly as a way of shocking his audiences, he loaded his canvas with every bit of color he could, and his paintings were highly appreciated by the English. When he returned to America, he went on painting autumn scenes.

George Inness (1825–1891) grew up during the heyday of Thomas Cole and Asher B. Durand. Never really a member of any school, he drew from all styles, which seemed to improve and extend his way of seeing and thinking. Season, light, and style play a significant role in his landscapes.

In *The Delaware Water Gap* (1861) Inness was beginning to move away from the finely detailed, perfectly laid-out pictures in the fashion of the still very popular Hudson River School. His style moved forwards and backwards to a marked degree. He recognized his own fluctuations. "I have always felt that I have two opposing styles, one impetuous and eager, the other classical and ele-

gant." He painted over twenty views of the Delaware River, always looking down at a point where the river cuts through the hills and always including both the marks of human enterprise—the train at left and the rafts on the right—and of nature—the grazing cows.

Detail of boat from *The Delaware Water Gap*.

The Lackawanna Valley (originally *The First Roundhouse of the Delaware Lackawanna and Western Railroad at Scranton*) (1855) was commissioned by the railroad as an advertisement. His first version ruled unsatisfactory by the special railway committee, Inness reluctantly modified the painting to include all four of the railroad's locomotives and to make the letters D. L. & W. clearly visible on the nearest of the four. Inness was not entirely pleased with the result, although he recognized that it had "power." The committee was not perfectly happy either and sold the painting. Inness ran across it 30 years later in a Mexico City "curiosity shop" and bought it back.

Hillside at Etretat (1865) is representative of the many landscapes Inness painted in France and in Italy.

LUMINISM

John Frederick Kensett (1816–1872), like Durand, came to painting by way of the engraver's craft. Both men were exceptionally accomplished draftsmen, but Kensett added a fine sense of color to his drawing skill. In 1848, after 4 years of study in Europe, he returned to the United States to settle down in New York City. John K. Howat summed up Kensett's activities in New York from 1848 to 1872. "In summer he traveled, sketched and socialized; in winter he painted larger pictures based on sketches, attended to business matters and socialized." In the middle and late nineteenth century, artists considered themselves respectable businessmen, and like a good businessman Kensett kept in touch with his clients. He worked often and hard. After his death, over 600 works remaining in his studio brought more than $136,000 at public auction. The prices speak eloquently not only of Kensett's talent, but of the high public demand for art.

Detail from *Marine off Big Rock*.

Marine off Big Rock (1864) is one of several paintings Kensett did of Beacon Rock in Newport Harbor. The broad expanse of water, the rocks jutting out of the harbor, and the crisp white sailboat in the center of the picture are typical of the many Kensett renditions of this particular part of the local geography.

Landing at Sabbath Day Point, Lake George (1850).

Lake George (1869). Kensett obtains excellent dramatic effects from the mountains and the island thrusting out of the placid waters. Many critics consider this calm, quiet picture Kensett's finest achievement.

Detail of mountains from *Lake George*.

Fitz Hugh Lane (1804–1865) was born in Gloucester, Massachusetts. In 1832 he moved to Boston to study lithography with the Boston publishers Keith and Moore, for whom he later worked as a lithographer. Around 1848 Lane returned to Gloucester, making his home there for the rest of his life. Despite paralysis of

the legs, he traveled extensively. Although there is no direct evidence that Lane was acquainted with Emerson's work, (see below), it is difficult to believe that he could have missed the philosopher's many lectures in Boston and Gloucester, and his paintings suggest that he adopted Emerson's conception of the artist as a "transparent eyeball."

Owl's Head, Penobscot Bay, Maine (1862) shows the predominance of sky typical in Lane's seascapes (the horizon is customarily very low) and the precise placement of each object. Lane has changed the actual topography to balance the composition, moving the distant headland (to the left of the ship) over from the other side of the point.

Owl's Head demonstrates the art of Lane's maturity. First, the view from a distance creates a sense of detachment. The figure in the foreground directs our attention into the painting, toward the ship standing in past Owl's Head. The scene we witness is a simple one—a ship enters a harbor—and yet Lane's manner of presenting the action—the reddish colors, the solitary man on the beach, the white-sailed ship, the vast sky, the rippled water—adds a sense of mystery to this everyday activity. Many of Lane's paintings after 1850 conceal a profound sentiment in a simple presentation.

Detail of ship from *Owl's Head.*

Although *A Maine Inlet* (sometime in the 1830s) has long been attributed to Lane, the foremost Lane scholar in America, John Wilmerding, has recently prepared an excellent case for assigning it to William T. Ranney (1813–1857), a Connecticut-born painter who specialized in Western scenes. This removal of one of Lane's paintings shows again how important connoisseurship—the ability to distinguish one painter's style from others—is to art history. If we are to understand a single artist's development or the development of art as a whole, then we must know who actually painted what pictures.

Details from *A Maine Inlet.*

Details from *Coast Scene with Figures* (1869) by John Kensett.

Coast Scene with Figures (1869) by John Kensett appears almost to be a conversation between the figures at left and the waves curling toward the beach. This is one of Kensett's best-known pictures.

Ralph Waldo Emerson (photograph). Poet, philosopher and popular lecturer, Emerson (1803–1882) was the most important figure in American transcendentalism, despite the fact that he consistently refused to be considered one of the transcendentalists. The reason for his great influence on them was that he caught the essence of the movement in his writings. Some of his diary notes during his trip to Europe in 1832–1833 perfectly capture his lifelong convictions. "There is a correspondence between the human soul and everything that exists in the world; more properly everything that is known to man. . . . The purpose of life seems to be to acquaint man with himself. . . . The highest revelation is that God is in every man." The work of the luminists often suggests this intimate connection between the human soul and natural phenomena. The romantic grandeur of Thomas Cole, of course, presumes a similar relationship, but for the luminists the relation is quieter, more intimate, and as a result their paintings attain a special kind of spiritual power. The most successful luminist paintings are, in a spiritual sense, unfathomable.

Detail of Emerson's eye from the previous photograph of Ralph Waldo Emerson.

Sanford Robinson Gifford (1823–1880) was particularly impressed by the landscapes of J. M. W. Turner. Gifford's paintings show a concern for light and color values similar to Turner's.

The Ruins of the Parthenon (1868) is almost an exercise in architectural drawing. Unlike paintings of the Hudson River area, this one features strong direct sunlight. Every detail is crisp and precise, yet the final view, although photographic in its detail, still betrays the presence of the artist.

Detail of columns and broken marble from *The Ruins of the Parthenon*.

Detail of face from *James McNeill Whistler* (1885) by William Merritt Chase (Program 9). Whistler shared Gifford's preoccupation with light.

Venice (1843) by J. M. W. Turner. Turner (1775–1851) sought in his later years to capture the countless changes of light and atmosphere.

Kauterskill Falls (1862). Gifford depicts the area at twilight, as the setting sun converts the hues by degrees all across the valley.

Martin Johnson Heade (1819–1904) spent much of his life traveling, both in the United States and abroad. One of his major undertakings was a voyage to South America in the company of an amateur naturalist to prepare the illustrations for a textbook on hummingbirds. Always fascinated by birds and by nature (he admitted to being struck at an early age by an "all-absorbing hummingbird craze"), Heade gathered material for some of his finest paintings during the trip.

Details from *Approaching Storm, Beach near Newport*.

Detail of rocks and waves from left side of *Approaching Storm, Beach near Newport*.

Detail of clouds, sailboats, and figures from center of *Approaching Storm, Beach near Newport*.

Detail of rocks, sand, and waves from left side of *Approaching Storm, Beach near Newport*.

Approaching Storm, Beach near Newport (circa 1860–1870). The strange, angular rocks of Heade's painting suggest a moonscape rather than an American beach. The darkening sky and muted colors, combined with the strange physical shapes, turn this otherwise natural scene into a grim and forbidding presence.

Orchids and Hummingbirds (1875). (This print is reversed.) The textbook on hummingbirds was never published, but Heade executed many of the plates and used his notes to compose many later paintings.

Detail of hummingbirds from *Orchids and Hummingbirds*.

Details from *Orchids and Hummingbirds*.

SECOND GENERATION OF THE HUDSON RIVER SCHOOL; FREDERIC EDWIN CHURCH

Frederic Edwin Church (1826–1900) studied with Thomas Cole for 2 years. Cole naturally encouraged his pupil in the direction of the large heroic landscape,

but Church was equally influenced by the German natural scientist Alexander von Humboldt (1779–1859), who asserted in his many writings that the physical makeup of a region determines the character and the development of its inhabitants. The concept of Manifest Destiny represents a similar kind of attitude. After his early success, Church began to travel in the Western Hemisphere. In a sense he became an explorer, bringing back exciting vistas from his journeys to the remote and exotic regions of the world. His paintings were considered to be so accurate that schoolchildren were taken on field trips to view them. Samuel F. B. Morse had tried to create the same kind of educational travelogue in his *Exhibition Gallery of the Louvre* (see Program 4), but the American public found nothing startling about a room full of pictures. Church succeeded where Morse had failed, drawing thousands of spectators to his natural history tour. By the end of the 1870s, however, Church's grand art had begun to fall from favor.

Details from *Heart of the Andes*.

Heart of the Andes (1859). Special care was lavished on the details of the foreground as well as on the mountain, and the manner of exhibition was intended to present the painting as a perfect replica of the real thing. Trees and plants placed at each side of the huge canvas heightened the sensation of reality. One critic called Church's work "the finest painting ever done in America." The price tag seemed to justify such claims: William T. Blodgett purchased it for the extraordinary sum of $10,000.

Photograph of Frederic Edwin Church.

Details from *Niagara Falls*.

Niagara Falls (1857). Unlike previous painters of the falls, Church thrusts the spectator out over the water, depriving us of all support and making the power of the surging water seem overwhelming. In London the noted art critic John Ruskin refused to believe the rainbow was part of the painting and not an aberration of local light. His mistake confirmed Church's skill.

Details from *Niagara Falls*.

Cotopaxi (1862) was one of several versions Church painted of the Peruvian volcano's eruptions. Much of Church's later work is in the style of *Cotopaxi* with very bright, often garish colors.

Rainy Season in the Tropics (1866) (incorrectly titled *Morning in the Tropics* in the program) was painted in Jamaica, where Church, recovering from the shock of the death of his two eldest children, had come under the influence of the philosopher Louis Figuier, who believed that all natural phenomena were simply a prelude to man's appearance. Church's renewed optimism takes the form of the glittering rainbow which dominates the foreground.

Detail of trees at right from *Rainy Season in the Tropics*.

Detail of mountains at left from *Rainy Season in the Tropics*.

Rainy Season in the Tropics (1866).

Heart of the Andes (1859).

Details of *Heart of the Andes* seen through a tube.

Heart of the Andes (1859).

Olana. In 1867 Church, his wife, and their infant son left the United States for a world trip which would last a year and a half. They brought back countless artifacts from their travels, and in 1869 Church began work on a place to hold

them. The site he chose was Mount Merino, a high hill beside the Hudson River about 125 miles from New York City. In describing the place, he wrote to his friend, the sculptor E. D. Palmer, "About an hour this side of Albany is the Center of the World—I own it." Two architects were hired to submit plans, but in the end it was Church aided by Calvert Vaux (1824–1895), former partner of Andrew Jackson Downing, who took charge of the project. The name Olana may have been chosen from a similar site in Persia, or it may be a corruption of the Arabic *al'ana*, meaning "our place on high."

Windows and face of *Olana*.

Main entrance hall of *Olana*.

Calvert Vaux (photograph).

Details from plan of Downing-Vaux home.

LANDSCAPE ARCHITECTURE

America's first important landscape architect, Andrew Jackson Downing (1815–1852), and the architect Alexander Jackson Davis (1803–1892) joined their talents to popularize the cottage style of domestic architecture in the middle third of the nineteenth century. Downing's designs suited the house to the owner and adapted the landscape to human needs without destroying it. Such commonsense views appealed to the American desire for practicality (indeed they are still very attractive). In the 1840s Downing's proposal for a large park in the center of New York City encountered great opposition. Land speculators naturally opposed any plan to remove such choice land for building, and they were joined by many other critics, but Downing's idea was finally accepted, although the city dragged its feet on executing the project for several years. Downing himself died at 37 in a steamboat accident on the Hudson River, but his ideas were carried forward by Davis, Vaux, and Frederick Law Olmsted, Sr. (1822–1903).

The Lackawanna Valley (1855) by George Inness.

Frederick Law Olmsted (photograph around 1858). An eye weakness kept Olmsted from obtaining a regular university education, but he traveled widely and observed carefully. His account of his travels through the South on the eve of the Civil War is cool, lucid, precise. In 1856 he was appointed Superintendent of Central Park. The following year he and Calvert Vaux submitted a new plan for the park. Their design was accepted, and Olmsted was given the charge of supervising and coordinating the construction. The completion of the project brought respectability both to public parks (in the early part of the century, parks had been identified with the aristocrats of Europe) and to landscape architecture, and encouraged similar undertakings in other cities.

U.S. Capitol Building, Washington, D.C. (aerial photograph).

Plaza Hotel and Central Park, New York City (contemporary photograph).

Central Park in the nineteenth century (lithograph).

New York skyscrapers and Central Park (contemporary photograph).

The opening of Central Park (lithograph).

Details of plans for Morningside Park, another of Olmsted's New York projects.

Niagara Falls (1835) by Samuel F. B. Morse (Program 4). Olmsted also helped preserve Niagara Falls from land spectulators.

CLOSING ILLUSTRATIONS (under credits) *Owl's Head, Penobscot Bay, Maine* (Lane); *Catskill Clove* (Durand); *Delaware Water Gap* (Inness); *Kindred Spirits* (Durand); *Niagara Falls* (Church); *Rainy Season in the Tropics* (Church); *The Lackawanna Valley* (Inness); *Orchids and Hummingbirds* (Heade); *Coast Scene with Figures* (Kensett); *Schroon Mountain* (Cole).

QUESTIONS AND PROJECTS

I. Define or identify:

Hudson River School	idealized composition
luminism	sublime
landscape painting	pantheism
ecology	allegory
Manifest Destiny	brushwork
transcendentalism	painterly
atmosphere	romanticism
Gustave Courbet	

II. Developmental questions:

1 Landscape painting. When and why did it become a suitable subject for artists? What is the value of landscape painting? What possibilities does it give the artist for self-expression? Who are some of the best-known landscape painters?

2 Luminism. Who are the luminist painters? What similarities do their paintings have? How does their view of nature compare with that of the Hudson River School? Is there any correspondence between the development of American landscape painting and the course of American history in the nineteenth century? What qualities do you appreciate in the Hudson River painters and in the luminists?

3 Landscape architecture. What are its goals? Its techniques? What is the relation between the recent ecology movement and landscape architecture?

III. Essay and opinion questions:

1 It has been said that history painting failed to interest Americans in part because the country had no history and that landscape painting was successful because the vast possibilities of the land were a major factor in the decision to settle in the New World and the desire for land dominated the American outlook. In this view, the concept of Manifest Destiny is an expression of this need. What validity does this comment have? What evidence do you find in the paintings of the Hudson River School and of the luminists that the land held some spiritual importance for them?

2 Photography became widespread during the 1850s (over 3 million daguerreotypes were made in 1853). Many artists looked upon the new medium as an enemy. For what reasons would they fear photography? What changes in painting in the latter

half of the nineteenth century might be explained by the development of photography?

IV. Projects:

1 Take an excursion to the country and look for scenes that would attract a painter. Remember to consider the time of day when considering a scene's suitability. If you are a photographer, you might actually take pictures and compare them. See whether you can find a typical Hudson River and/or luminist landscape. What does a real countryside tell you about these two schools?

2 Visit the parks in your community. For what purposes were they built? What human interests and human needs are satisfied? How does the form of the park reflect the period during which it was built?

3 Develop a definition of landscape architecture by consulting the encyclopedia and by visiting local places where landscape architecture has been employed. Are there regular landscape architects in your community? If not, who would take charge of this kind of work?

BIBLIOGRAPHY

Fabos, Julius Gy, Gordon T. Milde, and Michael V. Weinmayr: *Frederick Law Olmsted, Sr.; Founder of Landscape Architecture in America.* University of Massachusetts Press, Amherst, 1970. A short, well-illustrated consideration of Olmsted's career.

Flexner, James Thomas: *American Painting of the Nineteenth Century,* G. P. Putnam's Sons, New York, 1970. Flexner is an excellent writer and art historian, one of the first to study American art in depth.

Huntington, David C.: *The Landscapes of Frederic Edwin Church, Vision of an American Era,* George Braziller, Inc., New York, 1966. A sympathetic account of Church's life and career.

Lynes, Russell: *Artmakers of the Nineteenth Century,* Atheneum Publishers, New York, 1970. A highly readable account of the development of art and the life of the artists in nineteenth-century America.

THE
CREATION
OF A
SELF-IMAGE

THE CREATION OF A SELF-IMAGE

Paint pictures that will take with the public—never paint for the few, but the many.
William Sidney Mount

. . . our social and political characteristics . . . will not be lost in the lapse of time for want of an Art record rendering them full justice.

George Caleb Bingham

Early in the nineteenth century, American artists began to show a special interest in depicting the commonplace episodes of daily life. While the landscape painters and the sculptors were seeking grandiose images in the romantic or neoclassical vein, the genre artists, both painters and sculptors, concentrated on portraying exactly and minutely the behavior of their contemporaries in the performance of their day-to-day activities. The artists discussed in this program are certainly not the first to have recorded the everyday doings of Americans, but they are the first to be widely recognized and rewarded for

Pieced-work quilt by Jane Winter Price (second quarter of nineteenth century). Courtesy of Textiles Division, Smithsonian Institution.

their work. Partly as a result of the genre artists we look back on the period from 1830 to 1860 as a kind of American idyll, when the country was still moving at a leisurely pace and the people were pleased and optimistic. In this view the Civil War shattered a tranquil nation, altering and destroying forever this utopia. Unfortunately the truth is less poetic. The genre artists were recording a life pattern that was dying out before their eyes, being replaced by an economy supported by heavy industry.

OVERVIEW

The Period Approximately 1825 to 1900.

American Life A two-way movement was evident during the nineteenth century. In the West settlers were moving into the new lands while in the East farmhands and immigrants from Europe were moving to the city to take advantage of higher wages and better employment. The former Northwest Territory (Ohio, Indiana, Michigan, Illinois, and Wisconsin) received more than 2 million settlers between 1825 and 1845, almost doubling its population. Iowa grew from a few settlers to more than 150,000 people from 1832 to 1844. By 1860 over 4.5 million people (about 15 percent of the population) were living in cities of 10,000 population or more, as compared with 182,000 (0.3 percent) in 1800.

After the Civil War, the rate of expansion increased. With ample land to speculate on, with the discovery of gold and silver in California, Nevada, Colorado, and Utah, with the increased need for transporting manufactured goods, farm produce, and travelers; and with no income tax to dilute the profit, it was not surprising that the postwar period became famous as the time of the "robber barons."

American Literature Herman Melville (1819–1891) is best known for *Moby Dick* (1851), a highly poetic investigation of the human spirit, but short stories like "Benito Cereno" and "Bartleby the Scrivener" (1856) are equally instructive about the American character. Walt Whitman (1819–1892) expressed the optimism and the energy of the century in *Leaves of Grass* (first published in 1855, but revised and enlarged several times afterwards). Mark Twain (1835–1910) gives a rich account of life in the middle states in his autobiographical *Life on the Mississippi* (1883).

International Events Great Britain underwent great changes, with two long overdue and wide-ranging voting reforms (1832 and 1867) reflecting the internal pressures for social reorganization. France boiled over into revolution in 1830 and 1848, suffered through a bloody civil war in 1871, and finally formed a republic in 1873. In the southern part of the continent, the Conte di Cavour, Foreign Minister of Piedmont, masterminded the union of the territories of the Italian peninsula under a single monarch while Giuseppe Garibaldi provided dynamic military leadership.

CONTENTS OF THE PROGRAM *Literary Genre* John Quidor painted episodes from novels and stories by American authors rather than scenes from contemporary life.

American Genre William Sidney Mount, Richard Caton Woodville, George Caleb Bingham, John Rogers, and Eastman Johnson depicted Americans, and particularly rural Americans, in their everyday affairs.

Genre in the Graphic Arts The lithography firm of Currier & Ives put out a print on almost every facet of American life. George Eastman's portable, easy-to-use camera gave the photographer a matchless power to record in minute detail the faces and the activities of his contemporaries.

Quilts This craft may also be considered an American art form.

VIEWER'S GUIDE

PRE-LOGO ILLUSTRATIONS *The Painter's Triumph* (Mount); *Cornhusking* (Johnson); daguerreotype of *Woman and Child* (anonymous); *Abraham Lincoln* (Rogers); *Fur Traders Descending the Missouri* (Bingham).

LITERARY GENRE

John Quidor (1801–1881) was a fantast, a romantic artist whose images flow out of a rich imagination. Most of his paintings are based on episodes from the novels of Washington Irving and James Fenimore Cooper. Although Quidor never subordinated himself to the writer, delving into his own subconscious to elaborate on their suggestions, his approach was so personal and so eccentric that he inspired no followers. Never able to gain much from the sale of his paintings, Quidor supported himself by decorating fire engines.

Rip Van Winkle at Nicholas Vedder's Tavern (1839). Although Irving's "Rip Van Winkle" provided the inspiration for this work, Quidor's painting is a personal rendering and as such distinct from the story and literature.

The rounded, strangely colored forms resemble jolly, mischievous elves more than solid Dutch burghers. There is a strong suggestion of caricature in the stances and gestures, along with a kind of romantic energy and fervor. Each group of characters offers a vignette of New York colonial life—the sharp trickster conversing with Nicholas Vedder in the left foreground, the portly schoolmaster reading his newspaper at the back, the contemplative smokers in foreground and background, and the jokester blowing smoke at the sleeping tavern mistress—while Rip leans against the tree at right, a man apart. Quidor had a special fondness for this particular figure, which reappears in several of his paintings (he stands at the extreme left in *The Return of Rip Van Winkle*).

Detail of pipe smoker in foreground and Rip Van Winkle leaning against tree from *Rip Van Winkle at Nicholas Vedder's Tavern.*

Detail of other smokers puffing from *Rip Van Winkle at Nicholas Vedder's Tavern.* Vedder is the round man with one eye cocked toward his sharp-beaked friend.

Detail of schoolmaster and newspaper and signboard from *Rip Van Winkle at Nicholas Vedder's Tavern.*

Detail from *The Return of Rip Van Winkle* (1829). (The camera cuts out Rip's son leaning against a tree on the left and part of the crowd at the right.)

This painting is the first known display of Quidor's swirling curves and bright colors. He has reimagined the scene from Rip's point of view, giving us a nightmare of fluid, grotesque, and somewhat blurred forms (note particularly the grinning, vaguely disquieting faces of the children who crowd about the bewildered Rip).

The Money Diggers (1832), from another Washington Irving story, is one of the best examples of Quidor's unique ability as a colorist. In this well-orchestrated, finely executed, highly dramatic composition Quidor's love of contorted body shapes and disturbing colors is put to good use. The mild ironies and gentle satire of Irving's stories, no doubt a reflection of Quidor's sentiments, are effectively conveyed in this painting.

Detail of branch and man at left from *The Money Diggers*.

Detail of black man scrambling from the treasure pit from *The Money Diggers*.

Detail of the middle man from *The Money Diggers*.

The Money Diggers (1832).

AMERICAN GENRE

William Sidney Mount (1807–1868) was born on Long Island and studied art at the newly formed National Academy of Design in New York City. His first efforts were portraits and religious paintings, but he discovered that what truly interested him was the rural life in which he had grown up. His scenes of life in the eastern United States are an excellent record of nineteenth-century life in that area.

The Long Story (1837) is a *conversation piece*, a painting not so much intended to tell a story as to suggest stories, to encourage the response of spectators.

Mount agreed with one critic that it was his "most finished composition" (to that date), and it is easy to see why the artist was pleased with it. The figures and the environment are very precisely rendered. Mount, unlike Quidor, seeks a clear, natural presentation. There is no dramatic orchestration, no satiric exaggeration. Mount records a typical instant of rural life as he had experienced it.

A curious detail of the painting is that there is no eye contact among the three men. It is as if each one were in his personal world, physically present but mentally absent. Facts like these, of course, were noted by Mount's viewers and commented on. It seems that each detail was selected for a specific and a special reason. The bill for the Long Island Railroad (on the wall in the background) was not chosen at random, but for a purpose, although we may often do no more than speculate, at this distance in time, on what that purpose might have been.

The third man, standing with his back to the stove, also listens to the story. This particular type of figure (called "Mount's Mysterious Stranger" by the critic Alfred Frankenstein), standing somewhat removed from the action, recurs often in Mount's work.

Detail of standing man and sitter from *The Long Story*.

Detail of storyteller from *The Long Story*.

Boys Caught Napping in a Field (1848) is one of many Mount paintings depicting truancy and retribution. The anecdotal quality of such scenes was their principal attraction in the nineteenth century—and a bother to critics, who were put off by such apparently trivial subjects—but today we no longer understand the narrative details and therefore appreciate Mount's work as art rather than as illustration.

Detail of napper and boy waking him from *Boys Caught Napping in a Field*.

The Painter's Triumph (*Artist Showing His Own Work*) (1838) has the hard, clear surface typical of Mount's work. His design is very precise although his treatment of bodies is somewhat stiff, in the manner of the American self-taught artist.

Mount not only caught the characteristic dress and manner of his rural neighbors, he also poked fun at their foibles. The storyteller in *The Long Story* is a quaint item of local color or a dreadful bore, probably depending on whether we are seeing him or listening to him. *The Painter's Triumph* contrasts two modes of life in a way that speaks in favor of neither. The painter in bright yellow vest and lace shirt proudly shows his art to the red-shirted (the normal color of flannel workclothes) farmer who seems caught between his technical ignorance and his sincere desire to praise the work. In the background a reminder of classical perfection, the Apollo Belvedere, seems to turn away in disdain. The satiric message is clear; the artist and farmer of America are equally ignorant of true art. Mount gently mocks the pretensions of the artist and the ignorance of the rural connoisseur, in a way that is revealing of human nature without being destructive of the human spirit. He treated everyone with an even hand, chiding all but antagonizing none.

Detail of painter and farmer from *The Painter's Triumph*.

Detail of farmer's face from *The Painter's Triumph*.

The Painter's Triumph (1838).

Detail of right side of *The Painter's Triumph*.

Detail of Apollo Belvedere turning away from *The Painter's Triumph*.

The Power of Music (*Music Hath Charms*) (1847), one of Mount's most celebrated works, so impressed the man who received it that he paid Mount $25 more than the artist had asked.

In 1847 the French publishers and art dealers Goupil, Vibert & Company opened an American office. Their representative, William Schaus, contracted with Mount to issue a large color lithograph of *The Power of Music*, which they circulated under the title *Music Hath Charms*. Eventually ten of Mount's paintings appeared in lithographic form, and the popularity of these works made Mount at least as well known abroad as he was at home.

Goupil and Vibert, however, showed a distinct preference for Mount's paintings of black Americans, perhaps because minstrel shows and "Ethiopian operas" were in vogue. Mount's renderings of black musicians may thus have contributed to European stereotypes regarding black life in the United States, even though his work is considerably removed from the exaggerations of the minstrel shows.

Detail of black man from *The Power of Music*.

Detail of musicians inside the barn from *The Power of Music*.

Banjo Player in the Barn (1855). Mount was extremely interested in music (he even patented a violin which he claimed possessed a better tone than any other), and several of his paintings depict musical activities.

The Banjo Player (1856). Although Mount was most enthusiastic about his genre scenes, he also executed several hundred portraits. This one was commissioned by Schaus with the idea of making a color lithograph of it.

Eel Spearing off Setauket (1845), which critics have called Mount's masterpiece, is based on his experience as a boy. A black man named Hector introduced him to the technique and the pleasures of eel (or flatfish) fishing. What makes the painting so captivating is the total concentration of the boat's occupants—the boy in the stern staring intently toward the water ahead, the dog with his ears perked up, and the black woman with her spear just entering the water. The glassy water, essential for a clear view of the bottom, contributes to our impression that an action has been frozen in the middle of its execution.

Detail of black woman and spear from *Eel Spearing off Setauket*.

Detail of boy in stern of boat from *Eel Spearing off Setauket*.

Detail of the two men from *Bargaining for a Horse*.

Bargaining for a Horse (1835) was one of two pictures Mount painted for his New York patron, Luman Reed. A widely circulated engraving of the scene helped build the picture's popularity. It is the classic confrontation between city dweller and farmer. Both men practice the indirect method of bargaining, paying more attention to their whittling than to the horse. Critics praised the scene as a superb expression of "pure Yankeeism."

Details from *Cider Making* (1841). Remarkably detailed and direct in execution, the picture gives an accurate account of the mechanics of cider production. One recent art historian has suggested a possible political significance behind the rural realism. According to Joseph Hudson, the picture commemorates the successful presidential campaign of William Henry Harrison, whose campaign slogan was "Log Cabin and Hard Cider." Two facts apparently support this contention: the painting was commissioned by one of Harrison's principal backers and the date 1840 (the election year) is prominently displayed on the cider barrel in the foreground (even though the painting was executed in 1841).

Richard Caton Woodville (1825–1856) was slated to become a physician and follow his father in the profession, but he persuaded his family to allow him to study art instead. Although he worked mainly on pictures of life in America, he spent his career working in Europe.

Detail of the wedding party from *The Sailor's Wedding*.

Detail of the justice of the peace and the best man from *The Sailor's Wedding*.

The Sailor's Wedding (1852) shows Woodville at his best. The figures are not only exactly rendered and precisely integrated into the picture space, but each one possesses a special characteristic which sets them off as individuals. The focus of attention is the young sailor and his demure bride, but it is the surrounding activity that gives the painting its dramatic force; on one side is the

best man, leaning graciously (and obsequiously) toward the old justice of the peace, surprised in the middle of his simple meal; on the other are the parents of the bride and the spinster daughter, with the family servants or perhaps passersby crowding in at the door.

George Caleb Bingham (1811–1879) grew up in Missouri, on the edge of the Western frontier. After an unsuccessful attempt to establish himself as a portraitist in Washington, D.C., he returned to Missouri to begin painting the local scenes which established his reputation. A politician as well, he served in the Missouri legislature from 1846 to 1850.

Woodboatmen on a River (1854) is a nocturnal scene, with the moon rising just over the cabin of the boat. The indistinct features of the boatmen, blurred by the firelight, add to the mystery of the night.

Jolly Flatboatmen in Port (1857) is a reworking of one of Bingham's favorite subjects: boatmen dancing. The figures are more clearly drawn, the colors are brighter (indeed they border on the garish), and the sky is harder than in his earlier treatments. Bingham's stay in Düsseldorf (1856–1861) made him better able to perform like a professional painter, but in general his newly acquired technical skill did not improve his work. His best paintings fall in the 10-year period from 1845 to 1855.

Fur Traders Descending the Missouri (1845) is in many respects Bingham's best painting. Originally titled *French Trader and His Halfbreed Son*, the picture was conceived as a tribute to the French trappers who played a prominent role in the early exploration, and exploitation, of the Western wilderness. The hazy, indistinct background, the clumps of trees in the middle ground, and the calm, mirrorlike sheet of water envelop the boat and its occupants in a kind of mystery. The animal sitting in the bow (it may be a cat, a raccoon, or even a bear cub) is reduced to a silhouette, suggesting a presence without revealing it. Moreover the shadow is disproportionate to the animal's actual size. The two men are made more striking by a similar elongation. Bingham worked up his paintings from pencil studies and sketches, building up in that way a group of characters to draw on when needed. In 1851 he painted *Trappers' Return*, a second version of this scene, using the same original sketch of the paddler but making a new one of the boy. His figures are rounder, there is more detail, and in some ways the treatment of boat and passengers is more realistic, but the painting lacks the poetic feeling of the first version. *Fur Traders Descending the Missouri* is the way our mind imagines the romance of the early wilderness man whereas *Trappers' Return* marks the clear reality. As the evocation of a period in American history, *Fur Traders Descending the Missouri* remains unsurpassed.

Detail of boy from *Fur Traders Descending the Missouri*.

Detail of man with paddle from *Fur Traders Descending the Missouri*.

Detail of the successful candidate announcing the result from *The Verdict of the People I* (1854–1855).

Detail of the central portion from *The Verdict of the People I*. Bingham played an active role in Missouri politics for 30 years, and political events remained one of his principal subjects. Despite his lack of formal art study, Bingham was extremely adept at handling crowds. He learned some simple

rules of composition and applied them unobtrusively but firmly and consistently. Primarily he arranges his people in small groups, usually pyramidal in shape, and then integrates them through lighting and movement. Here, for example, the street divides the composition down the middle and the shadow from the building at left creates a dark line between foreground and background, increasing the illusion of depth. The winner announces the results from the porch, the losers sit in a small group in the center. On each side of this somber group are happy voters: the smiling gentleman walking toward us on the left and the dancer at right.

Detail of the street from *The Verdict of the People I.*

Detail of the honest voter from *The Verdict of the People I.*

Detail of a reveler from *The Verdict of the People I.*

Detail of losers from *The Verdict of the People I.*

County Election I (1851–1852). There are more elaborate characterizations in this painting than in *The Verdict of the People I:* the happy drinker at left, the voter trying to get his drunken friend to the polls, the man trying to make a deal at left center, the dapper gentleman presenting his card (he is probably electioneering) to the next man in line to vote, the voter being sworn in, the clerk cleaning his nails with the quill pen, the three farmers talking by the stairs, and so on. The successful integration of these vignettes from everyday life gives the painting considerable charm.

The Wood Boat (1850). Bingham's characters frequently look directly at us, as if they were judging us at the same time as we are observing them. Curiously it is typical of animals to watch intruders in the same way. They watch until they are satisfied there is no danger or until the intruder gets too close, when they flee.

The Squatters (1850), like *The Wood Boat,* could almost be termed a group portrait.

Map of Europe / Close-up of Düsseldorf.

The Spearbearer (*The Doryphorus*) (fifth century, Roman copy after Greek original).

The Emigration of Daniel Boone (1851) shows the famous wilderness man in the center of the picture (wearing the rolled-brim hat), leading settlers through the Cumberland Gap. Bingham has heightened the drama of the picture by blasting the trees at each side of the picture in the manner of Thomas Cole.

John Rogers (1829–1904) was a rarity among artists, a genre sculptor. A draftsman by profession, he was persuaded by the Panic of 1857 to turn back to his original vocation as an artist and went to Europe to study clay modeling. It did not take him long after his return to this country to become a success. From 1860 to 1893 he sold over 80,000 plaster statuettes, usually some 18 inches to 30 inches high, for an average price of $14 each.

Checkers Up at the Farm (1875), one of Rogers's most popular groups, eventually sold some 5000 copies.

Coming to the Parson (1870), the most popular of Rogers's groups, sold over 8000 copies. It enjoyed particular success because of its appropriateness as a wedding gift.

The Wounded Scout / A Friend in the Swamp (1865), a clear statement of

Rogers's abolitionist and Unionist sympathies, includes allegorical overtones: a copperhead snake, the symbol of the Southern sympathizer in the North, prepares to strike the black man's leg.

Wounded to the Rear: One More Shot (1865). This idealized tribute to the soldiers who stood fast against the Confederates during the early defeats of the Civil War became a popular memento of the war.

The Slave Auction (1859), Rogers's first professional offering, was not a success. Although the group gave him a large measure of personal satisfaction, stores were afraid to display it for fear of offending customers from the South. Slavery was such a controversial issue that Rogers lost half his audience by taking a stand against it.

Taking the Oath and Drawing Rations (1866), one of the most admired of Rogers's works, records a postwar incident in Charleston, South Carolina. A southern lady reluctantly takes the oath of allegiance to the Union in order to obtain the food she needs to feed her child and the servant boy with the basket. (The illustration reverses the true position of the figures; this explains why the lady appears to be taking the oath with her left hand.)

The Council of War (1868) shows Lieutenant General U. S. Grant, President Lincoln, and Secretary of War Stanton during their meeting to decide on Grant's proposal for the future course of operations (Lincoln is shown examining Grant's map). Todd Lincoln considered Rogers's treatment of the president "the most lifelike portrait of [his] father in sculpture."

Abraham Lincoln (1892) was not one of Rogers's standard models for sale at $6 to $20 but a larger-than-life plaster statue for which the sculptor won a bronze medal at the World's Columbian Exposition in 1893.

Eastman Johnson (1824–1906), another of the painters trained in Europe, specialized in the "portrait interior," which showed several members of a family seated naturally in a room of their house. After 1880 Johnson abandoned genre pictures, devoting himself to portraiture. For all practical purposes the Civil War killed genre painting; Johnson was the only artist to achieve any significant postwar success.

Detail of *Old Kentucky Home* (1859).

Old Kentucky Home (originally titled *Negro Life in the South*) (1859) has nothing to do either with Kentucky (the scene is actually Washington, D.C.) or with the famous song. Johnson's original title, however, was edged out by the popular response to the painting, which made him a celebrity overnight. Johnson, unlike John Rogers in *The Slave Auction*, took no sides in the slavery question. Throughout his career he always tended to stand aloof, to let the material speak for itself.

Details of slaves from *Old Kentucky Home*.

In the Fields (mid-1870s) shows a freer composition than *Old Kentucky Home*. Johnson did not apply a high finish to the many genre scenes he did in the 1870s, considering them "finished studies" rather than completed paintings. This study of cranberry pickers demonstrates the free handling and bright color of Johnson's genre pictures on Nantucket Island. His enthusiasm for outdoor painting parallels that of Winslow Homer and the French impressionists.

Detail of old man and young girl from *Cornhusking* (1860).

Detail of young couple from *Cornhusking*.

Cornhusking (1860). This genre scene is given the same high degree of finish as *Old Kentucky Home*.

The Old Stage Coach (1871) was suggested by a broken-down wagon Johnson had seen in the Catskills, but he actually painted the picture on Nantucket. He built his own vehicle in a field and posed children from the island to create the effect he sought.

Detail of boys on top of the stage from *The Old Stage Coach*.

The Boy Lincoln (undated) is a charcoal sketch study for Johnson's painting *The Boyhood of Lincoln* (1867).

GENRE IN THE GRAPHIC ARTS

Nathaniel Currier (1813–1888) began an apprenticeship in lithography at 15 and at 20 went into business for himself. His first published lithograph, a scene of a burning hotel, indicates his awareness of contemporary audience needs. In 1852 he hired James Merritt Ives (1824–1895) as his bookkeeper, but it was not until 1857 that the firm Currier & Ives was created. The business blossomed and went on prospering until after the death of the partners. For half a century Currier & Ives provided the United States with a scene for every taste. Eventually they published over 7000 prints.

Life of the Fireman: Night Alarm (1854).

Details from *Home to Thanksgiving* (1867).

American Express Train (1864).

Detail of riverboats from *Low Water in the Mississippi* (1868).

Detail of people dancing from *Low Water in the Mississippi* (1868).

Emigrants Crossing the Plains (1866).

Detail of wagons from *Emigrants Crossing the Plains* (1866).

Details from *Taking the Back Track* (1866).

American Farm Scenes #1 (1853).

Detail of pitcher from *The American National Game of Baseball* (1866).

The American National Game of Baseball (1866).

PHOTOGRAPHY

Just as lithography means "writing with stone," photography means "writing with light." The Frenchman Nicéphore Niepce (1765–1833) is credited with obtaining the first image that may be called a "photograph." The new process, discovered in 1822, was termed heliography, or "sun writing." In 1826 Louis Daguerre (1789–1851) heard of Niepce's work and suggested a partnership. Working from Niepce's original idea, Daguerre discovered that iodized silver spread thinly over a metal plate would retain an image focused on it. His simple process enjoyed a wide success. But since it created only a positive image, it permitted no copying. Henry Fox Talbot's calotype, which gave a negative

rather than a positive plate and permitted copying, was the first major step toward modern popular photography.

The Photographer (John Rogers, 1878) was sold with a companion piece, a mother and child group. The two statuettes were intended to be placed at opposite ends of a mantle or a table, but they did not sell well and were withdrawn in the early 1890s.

Daguerre's camera.

Ad for photography gallery.

Woman and Baby (1850). Daguerreotype by an unknown photographer.

Caricature of photographer and patrons.

John Quincy Adams (1848). A. S. Southworth (1811–1894) and J. J. Hawes (1808–1901).

Lemuel Shaw, Chief Justice (1851). Southworth and Hawes.

Unknown Woman. Calotype.

George Eastman (1854–1932) was a businessman rather than an inventor. In the 1870s he perfected a film emulsion and began marketing—superbly—a camera which was simple in design, accurate, and inexpensive. The camera itself sold for $15, about the same as the cost of a Rogers sculpture group, and a roll of 100 exposures cost $10. Eastman originated the Kodak trademark (he liked the letter *k* because he thought it was hard to forget) and the slogan "You press the button and we do the rest."

George Eastman on the way to Europe (1890). Taken by Fred Church using a #1 Kodak, the same kind of camera as in Eastman's hands.

Ad for Kodak box (1889). The first Kodak cameras were boxlike wooden affairs which contained a prepacked roll of 100 exposures. When the roll was exhausted, the amateur photographer sent the camera directly to the Kodak processing laboratory. The film was removed, developed, and printed, another roll was placed in the camera, and the loaded camera and the finished pictures were returned to the owner.

QUILTS

Quilting Party (1813). John Lewis Krimmel.

 Baby Blocks.
 Triangles.
 Crazy Quilt.
 Feathered Star.
 Diamond Star.
 Rose Wreath.
 School House.
 Wedding Ring.
 Noonday Lily.
 Log Cabin.
 Bursting Star.
 Double Irish Chain.

POST-PROGRAM ILLUSTRATIONS *American Express Train* (Currier & Ives); *County Election I* (Bingham); *The Old Stage Coach* (Johnson); *The Wood Boat* (Bingham); *Bargaining for a Horse* (Mount); *The Photographer* (Rogers); *Low Water in the Mississippi* (Currier & Ives); *John Quincy Adams* (daguerreotype by Southworth and Hawes); *The American National Game of Baseball* (Currier & Ives); *Old Kentucky Home* (Johnson).

QUESTIONS AND PROJECTS

I. Define or identify:

caricature	Leatherstocking Tales
Washington Irving	Andrew Jackson
crazy quilt	the Mexican War
lithography	daguerreotype
calotype	tintype
dry plate	Apollo Belvedere

II. Developmental questions:

1 Lithography. Describe the lithographic process. What is the difference between a lithograph and an etching? Is lithography still an acceptable artistic medium? What contemporary methods are similar to lithography? Is the lithograph as important today as it was in the nineteenth century?

2 Photography. What is the "camera obscura"? In what way is it a precursor of photography? How does the photographic process work? Who invented photography? What physical problems needed to be overcome in order to "invent" the photographic process? What were the important steps in the development of photography from its earliest days to the present (concentrate on basic requirements)?

3 Genre painting. Using the illustrations in Chapter 6 of *Art America,* define genre painting in your own words. How is genre painting different from history painting?

III. Essay and discussion questions:

1 Genre painting was largely confined to the period preceding the Civil War. What qualities inherent in this kind of work would make this limitation understandable? What differences in pre- and post-Civil War periods would explain the change in public taste? in artistic inspiration? in artistic aspiration?

2 Photography has made tremendous progress during its nearly 150 years of existence. Yet there are still critics who question whether photography may be considered an art. These detractors usually emphasize the mechanical origin of the photograph and minimize the photographer's role in the creation of the picture. In your opinion, is it correct to consider photography an art, on a par with painting, sculpture, and the other fine arts? Use examples to justify your conclusions whenever possible.

IV. Projects:

1 Search the countryside for activities which convey for modern times what Mount and Bingham conveyed for the nineteenth century. Try to capture the feeling of their paintings. What do your choices tell you about genre painting? What do they explain about Mount and Bingham? What conclusions might be drawn about modern tastes and needs? What is today's equivalent of genre painting?

2 Genre sculpture. John Rogers was the best of the genre sculptors in his day. Do genre sculptors still exist? What sort of popular sculptures can you find in your community?

3 Insofar as genre scenes satisfied public curiosity about other people's lives, photography has taken over the genre scene and photojournalism was, until the advent of television, one of the major markets of the professional photographer. Look through old *Life* or *Look* or *Collier's* magazines at the library. In what ways did the pictorial magazines satisfy the American need to have knowledge and information about other parts of the country? What divisions did *Life* magazine make of American society? Are these distinctions still valid today? What were the social distinctions reflected in the paintings of the genre artists of the nineteenth century?

4 Survey the popular magazines of the forties and fifties, from the era when the movies were still the dominant entertainment medium. Compare them with the contemporary magazine scene. What insights does this survey give you about the evolution of American life? Particularly interesting are comparisons between magazines which were published then and are still published now. The evolution of *Life* magazine from its beginnings in the thirties to its demise in the seventies is particularly interesting.

BIBLIOGRAPHY

Gernsheim, Helmut: *A Concise History of Photography,* Grosset & Dunlap, Inc., New York, 1965. A brief survey illustrated with photographs from the Gernsheim collection.

Lynes, Russell: *The Tastemakers,* Harper & Brothers, New York, 1954. An examination of the vagaries of taste and culture in nineteenth-century America.

Newhall, Beaumont: *The History of Photography from 1839 to the Present Day,* Museum of Modern Art, New York, distributed by Doubleday, Garden City, N.Y., 1964. A comprehensive look at the development of photography by one of America's best-known historians of photography.

Williams, Hermann W.: *Mirror to the American Past: A Survey of American Genre Painting 1750 to 1900,* New York Graphic Society, Greenwich, Conn., 1973.

PROGRAM 7

EXPLORING THE WILDERNESS

I have for a long time been of the opinion, that the wilderness of our country afforded models equal to those from which the Grecian sculptors transferred to the marble such inimitable grace and beauty, and I am now more confirmed in this opinion, since I have immersed myself in the midst of thousands and tens of thousands of these knights of the forest; whose whole lives are lives of chivalry, and whose daily feats, with their naked limbs, might vie with those of the Grecian youths in the beautiful rivalry of the Olympian games.

George Catlin writing from the mouth of Yellowstone River, 1832, after returning from his first trip into Indian country

During the nineteenth century, Americans not only explored the wilderness, they pacified and divided it. While they labored, a curious circular development was taking place in the popular conception of the Indian and the Western frontier. The exaggerated, often fantastic accounts

Charles B. Fevret, Osage Warrior (1804). Courtesy of the Henry Francis du Pont Winterthur Museum.

brought back by the first explorers were gradually put to rest by the skillful, eyewitness renderings of traveling artists like Catlin, Karl Bodmer, and Alfred Jacob Miller. Their accurate depictions, however, were in their own turn swept aside by a flood of stories and illustrations originating in the East which began to create a mythical "Wild West" as far from the actual truth as the first accounts of explorers. The Indian wars and the range wars, rich in dramatic confrontations and colorful participants, greatly contributed to this transformation. In recent years, however, the misleading interpretations originating in the artists and writers of the early twentieth century have finally been exposed.

OVERVIEW

The Period Approximately 1800 to 1925.

American Life The American Indians, the original occupants of the land so much admired by the painters of the Hudson River School, captivated the artists discussed in this program. With few exceptions, the Indians greeted the first white men hospitably, extending them the proper courtesies and dignities. Those who followed the first explorers, however, sought land rather than friendship. In a scenario repeated all across the land, provocation by land speculators and settlers brought retaliation by the Indians, resulting in government intervention and another Indian defeat. Many politicians in Washington admired the Indians, but few supported their rights. Despite his belief in equality, Thomas Jefferson initiated policies that would eventually strip them of their lands. Nor was "Jacksonian democracy" any better. Passed by a mere five votes thanks to the support of the president, the Indian Removal Act of 1830 provided for the relocation across the Mississippi River of the Indian tribes of the southeastern United States.

Because the Plains Indians were excellent horsemen fighting on terrain best suited to cavalry encounters, they resisted more successfully than their Eastern comrades. Best known of the clashes between Indians and soldiers is the Battle of the Little Big Horn (1876), which cost the lives of some 250 men of the Seventh Cavalry Regiment, but the history of the West is dotted with bloody names: the Sioux Uprising of 1862, the Fetterman massacre of 1866 (eighty-one troopers were surrounded and killed in 15 minutes), the Battle of Wounded Knee (1890) (which marked the end of Indian resistance). Modern historians now generally agree that the white man was no less savage and violent than his Indian opponent.

American Literature Many writers described the hardships and the glories of life on the Western frontier. Francis Parkman (1823–1893) gave the first great historical account of the Far West in *The Oregon Trail*. Bret Harte (1836–1902) helped popularize the West with stories like "The Luck of Roaring Camp" (1870). A. B. Guthrie's recent novel *The Big Sky* (1947) gives an excellent description of the life of mountain men in the 1840s. Willa Cather (1862–1937), who grew up in Nebraska, painted a realistic picture of life on the plains in *My Antonia* (1917).

International Events The westward expansion of the United States was matched in the latter half of the century by the European nations. Great Britain, France, Germany, and Italy began a final frantic wave of colonization in Africa and the Far East. Determined to regain the prestige lost in the disastrous Franco-Prussian War, France sought so frantically to obtain a colonial empire that she almost went to war with Great Britain in 1898 over a minor incident near Fashoda on the Upper Nile.

CONTENTS OF THE PROGRAM *The First Indian Portraits* Charles de Saint-Mémin and Charles Bird King painted Indian chiefs visiting the Eastern seaboard. Thomas Crawford and Horatio Greenough pictured the Indian as a noble savage in order to express the meaning of the white civilization imported from Europe.

Visitors to Indian Country As the settlers moved west, so did the artists. Karl Bodmer, John Mix Stanley, Charles Wimar, Titian Ramsay Peale, Seth Eastman, and Alfred Jacob Miller all painted the Indian in his natural surroundings.

George Catlin The greatest of the Indian painters, Catlin produced hundreds of portraits and landscape scenes during the 8 years he spent living in and traveling through the Great Plains.

Popularizing the West Charles Russell and Frederic Remington created the Western image for mass consumption, popularizing the history of the American West through their many dramatic paintings, drawings, and sculptures.

Landscapists of the Far West Enthusiastic about the beauty of the wilderness, Thomas Moran and Albert Bierstadt put forth a grandiose vision of the Western lands.

The Photographers After the Civil War, pioneer photographers like William Henry Jackson, Carleton E. Watkins, Timothy O'Sullivan, William Bell, and Eadweard Muybridge brought back reliable information about the Western landscape. Their photographs were artfully and sometimes dramatically composed, but their main virtue was accuracy. In this century photographers like Ansel Adams have turned Western landscape into an art form in which not facts but composition is of primary importance.

VIEWER'S GUIDE

PRE-LOGO ILLUSTRATIONS *Valley of the Yellowstone* (Moran); *Buffalo Chase* (Catlin); *Man of Good Sense* (Catlin); *Ah-jun-jon* (Catlin); *Fight for the Waterhole* (Remington).

Westward the Course of Empire (Emmanuel Leutze) (1861).

Meriwether Lewis (1807) (C. W. Peale) (incorrectly called Thomas Lewis on program).

William Clark (1810) (C. W. Peale) (incorrectly called Merriweather Clark on program).

Details of page from William Clark's *Journal*.

Charles Balthazar Julien Fevret de Saint-Mémin (1770–1852) was one of the many aristocrats forced to leave France during the Revolution. In the United States his childhood hobby of drawing and painting provided the answer to his financial needs. He had fine success in many cities on the Eastern seaboard, making and engraving inexpensive portraits with the aid of a "physiognotrace" which provided him with a life-size outline of the sitter's head. Saint-Mémin then filled in the details with brush or pencil. He produced more than 800 portraits before returning to France in 1814.

Portrait of Jefferson (1804). Despite his belief in human equality Jefferson was the source of the policies which became so destructive of Indian culture during the nineteenth century.

Osage Warrior (1804). The sitter may be costumed for one of the Indian dances which drew a good turnout from curious white audiences.

Detail of *Osage Warrior*.

Charles Bird King (1785–1862) was a gentleman who devoted his time to painting. He studied art in New York City and in London (where he roomed with Thomas Sully and took instruction from Benjamin West), later becoming a commercially successful portraitist in Washington. In addition to his Indian studies, he produced some very skillful trompe l'oeil paintings.

Young Omaha, War Eagle, Little Missouri and Pawnees (the two Indians at the right) (1821) were part of a delegation from the Missouri River tribes brought to Washington through the efforts of Indian Agent Major Benjamin O'Fallon. The purpose of these trips was to impress upon the Indian leaders both the power and benevolence of the national government.

Chief of the Little Osages (1804) by Saint-Mémin is a pencil sketch of a visiting Osage chief. Saint-Mémin's depiction did much to form the popular conception of the Indian as a noble human being. The visiting warrior turned out in fashionable coat, however, was far different from the savage in native regalia.

Shared Screen: *Chief of the Little Osages* and *Apollo Belvedere* (fourth century B.C.).

Apprenticed first to a wood-carver at 14, Thomas Crawford (1814–1857) sharpened his skills under the guidance of John Frazee (1790–1852), one of the best native American wood-carvers. He was widely and extravagantly praised by his fellow citizens, who sincerely believed that American sculpture was the equal of any other, but it became apparent to later generations that his talent was modest.

Detail of the Indian chief from *The Dying Chief Contemplating the Progress of Civilization* (1850–1856), the sculptural group on the pediment of the Senate wing of the U.S. Capitol Building.

Horatio Greenough (1805–1852) (Program 4).

Detail of Indian and tomahawk from *The Rescue*.

Detail of woman and child from *The Rescue*.

The Rescue (1837), an allegory of the pure strength of white civilization, stands as a naïvely ludicrous version of the struggle between white invaders

and Indian owners. What the men of the nineteenth century called Manifest Destiny appears to many today to be criminal fraud.

VISITORS TO INDIAN COUNTRY

The Swiss artist Karl Bodmer (1809–1893) accompanied Prince Alexander Phillip Maximilian, a German scholar deeply interested in the American Indian, on a long tour (1832–1834) through the country of the upper Missouri. A more practiced and accurate artist than George Catlin (see p. 84), Bodmer included the most significant anthropological details in his work.

Dance Leader of the Hidatsa Dog's Society (1834). In many Plains Indian tribes, the Dog Ceremony was the most important warrior dance and called for especially elaborate costumes. Only warriors who had taken scalps could participate.

Dance of the Mandan Buffalo Society (1834) depicts the ritual frenzy of a traditional ceremony to bring the buffalo nearer the village. Not only does Bodmer's composition effectively capture the hysteria of the dance, but his details of costume are so precise that his paintings please both artists and ethnologists. One of the friendliest and most cultured of the upper Missouri tribes, the Mandans were almost completely wiped out in a smallpox epidemic in 1837.

John Mix Stanley (1814–1872) began to devote himself to painting the West in 1842. By 1850 he had assembled a large gallery of paintings on Indian life. Reputed by many contemporaries to be a better artist than George Catlin (his command of technique is certainly superior), he lost all but five of his Indian paintings in a fire and his reputation has suffered considerably. Only about forty of his paintings remain in existence.

Black Knife, an Apache Chief (1846).

Despite Stanley's 15 years of painting and traveling in the West, Black Knife's horse seems to owe more to equestrian statues than to direct observation.

White Plume, Head Chief of the Kansa (1821) (Charles Bird King) has a dignified, noble expression with very little of the traditional Indian in it. He pursued a friendly policy toward the whites and became noted in later years primarily for his excessive weight.

Born in Germany, Charles Wimar (1828–1862) came to the United States in 1843. From 1846 to 1851 he served an apprenticeship with a painter near St. Louis, as a result of which he traveled extensively up and down the Mississippi River. After returning to Germany in 1852 to continue his art studies, Wimar began turning out paintings of Indian life for sale in the United States. He returned to St. Louis in 1856 and died of tuberculosis in 1862.

The Captive Charger (1854) was executed in Düsseldorf during Wimar's student days. Its precise draftsmanship and tight composition demonstrate the importance of German academic ideas in his training.

Details from *The Buffalo Dance* (1860).

Interior of a Mandan Earth Lodge (1834) (Bodmer) shows a spacious, clean,

and well-kept dwelling, whose large interior and solid construction allowed even the animals to live inside. Bodmer spent several days carefully sketching the details of the scene.

Titian Ramsay Peale (1799–1885), the youngest son of Charles Willson Peale (see Program 4), was principally a naturalist and illustrator of scientific texts. He participated in several government expeditions.

Sioux Lodges, 1819 is the earliest known depiction of the tepees used by the Plains Indians.

A career officer, Seth Eastman (1808–1875), saw duty in both the West and the South. At each post, he used his spare time to draw and paint Indian life. His most ambitious undertaking was the illustration of a six-volume study of the American Indian for the Commissioner of Indian Affairs (1850–1853).

Lacrosse Playing among the Sioux (1851) combines the dramatic landscape of the Western states with the ethnic detail of an Indian game.

Unlike many artists Alfred Jacob Miller (1810–1874) (incorrectly called Henry Jacob Miller in the program) was encouraged to develop his artistic skills. In 1836 he was operating a studio in New Orleans when a former British Army officer, Captain W. D. Stewart, invited him to serve as resident artist on an expedition to the Rocky Mountains. Miller not only became the first artist to record Indian life in the region beyond the Platte River along what was to become the Oregon Trail, but he was also privileged to record the fur trappers—the "mountain men"—during their heyday. Although Miller, a city artist with almost no knowledge of the wilderness, often passed over important details of dress and ceremony, his unique work remains a priceless record of the period.

Trapper's Bride (undated). The lush colors of the costumes and the sweet faces of the bridal party suggest that Miller's depiction is probably very far from the truth of such wilderness marriages. The public liked it, however, and Miller painted several versions of the scene.

Joseph R. Walker, a Leader among the Mountain Men (undated) smoothes the image of the fur trapper, leaving out the rough self-reliance which made such men unique in their time. As in *Trapper's Bride*, sweetness takes the place of truth. Miller was best not at these specially toned images of wilderness life, but at the quick pencil and watercolor sketch in which he could capture the feeling of what he observed with a few strokes.

GEORGE CATLIN

George Catlin (1796–1872) heard many stories of Indian life in the early colonial days during his youth in New York and even acquired a tomahawk scar on his cheek during one playful reenactment of the times. By 1828 he was supporting himself with portraits of the wealthy and the important. He did not consider the work very challenging, although he did enjoy the prestige. The sight of a delegation of Plains Indians passing through Philadelphia on the way to Washington, D.C., completely changed his life. In the spring of 1830 Catlin arrived in St.

Louis, determined to become the painter-historian of the Plains Indians. With the help of the government Bureau of Indian Affairs, he spent 2 years recording likenesses of the Indians from nearby tribes and of visiting chiefs on their way to call on the president in Washington, D.C. In 1832 Catlin set off up the Missouri River toward the mouth of the Yellowstone. During the 3-month trip he visited the Sioux and the Arikara as well as completing the first known portraits of the Blackfoot and the Crow Indians. Altogether he traveled over 1500 miles, painting some 135 pictures (although the paintings were often composed in a kind of pictorial shorthand which allowed Catlin to complete them later in the quiet of his St. Louis studio). In 1834 Catlin made a second trip, journeying this time to the southern Great Plains. As a result of these two trips he produced several hundred paintings and drawings. He spent the remainder of his life publicizing his work—and the life of the American Indians—on both sides of the Atlantic.

A master at capturing a likeness in a few quick strokes, Catlin was probably at his best in portraiture. He never learned to render perspective (although often faithful to the landscape), but his energy and enthusiasm usually offset any technical shortcomings.

Portrait of Catlin (1849)(by William H. Fisk).

Mother and Child (undated) of the Assiniboin tribe.

Sioux Dog Feast (undated). The Sioux intended to honor their guests (shown sitting in top hats at the back of the tent) by serving them great helpings of dogmeat, but Catlin and his friends were unable to do more than sample the food before laying it aside. Fortunately their hosts, for whom the meat was a great delicacy, took no offense at this reluctance and happily consumed the rejected portions. Catlin found such dog feasts, which were carried out with religious solemnity, common among the Plains Indians. The tribes considered the sacrifice of their most faithful animal an expression of deep friendship.

Steep Wind (*Tak-teck-a-da-hair*), brother of The Dog (1832). For the Plains Indians, most of whom had never before seen a painter, there existed a superstitious fear that Catlin might be a magician, that his art might produce evil effects. One such superstitious Indian named The Dog, taunted Catlin's sitter, Little Bear, because Catlin had painted him in semiprofile. "Little Bear is but half a man," sneered The Dog. In the ensuing fight Little Bear was killed and The Dog fled. Catlin avoided the anger of the friends of the deceased by distributing presents and condolences. After his departure, however, Little Bear's friends, regretting their restraint, went in search of The Dog. Not surprisingly The Dog had long since departed, but they found his brother, Steep Wind, and killed him instead.

Mint, an Indian Girl (1832) is the portrait of one of the most socially prominent and beautiful of the Mandan women. Despite her gray hair, she is only 12 years old.

She Who Bathes Her Knees (*Tis-se-woo-na-tis*) (undated) was a member of the Cheyenne tribe of the lower Missouri.

Comanche Village, Women Dressing Robes (1834). The dwellings of the southern Plains Indians, called wigwams, are made of buffalo skins from the

plentiful herds in the area. The wigwam of the chief is shown in the center. The women are cleaning buffalo hides in the foreground, and meat is being dried on the wooden racks visible between the wigwams.

Mandan War Party in Council (1832). Catlin came across these survivors of a small war party near the mouth of the Yellowstone River. Having lost several of their number, and all of their ponies, in a fight with a neighboring tribe, they were returning home by the safest, most roundabout way when Catlin sketched them.

Catlin Feasted by the Mandan Chief Four Bears (undated) records the honor granted to the painter by the second chief of the Mandans. The curious protocol of the meal, according to Catlin, was that he ate alone. Four Bears took no food, merely sitting by to see to his guest's needs and preparing the pipe to be smoked at the conclusion of the meal.

Three Blackfoot Men (1855).

Vapor Baths of the Hidatsa (undated). This Indian equivalent of the sauna bath served to remove distinctive body odors before a hunt. Heated stones were doused with water to create a hot vapor to induce sweating. When the bather was perspiring freely, he would leave the bath and cool himself suddenly by a plunge into the river.

Winter Hunting on the Upper Missouri (1832) shows a buffalo hunt in midwinter.

White Cloud (*Wah-pe-kee-suck*) (1932), a Sac and Fox Indian, was one of the leaders of the Blackhawk party. Also called "the Prophet," he shows by the unusual way he wears his hair (it is longer and combed differently) that he wishes to create a favorable impression on the white men with whom he deals.

Man of Good Sense (undated).

Buffalo Chase with Bows and Arrows (1830) gives an accurate description of the usual Indian method of hunting the buffalo with bow and arrow. The rope trailing behind the pony of the Indian on the right was called a lasso and served as a sort of safety device. If the rider was thrown for any reason, he could grab the rope, which was knotted at intervals for easier gripping, stop the pony, and remount him.

The Light (*Ah-jun-jon*) *Going to and Returning from Washington* (1832–1833) is a before-and-after view of the effect of civilization on the visiting Indian. For The Light, who completely altered his dress and manner during his stay in the capital, the return to Assiniboin life was not a happy one. His companions found his stories of white life impossible to believe and quickly turned against him, calling him a liar. Although disgraced and discredited, Ah-jun-jon went on telling his stories, which were in fact true. In time he acquired a considerable reputation as a medicine man. The richness of his imagination became so well known that the other members of the tribe began to consider him a wizard. One of them, terrified by his stories, killed him to free the tribe of his too powerful medicine.

A Bird's Eye View of a Mandan Village (1832) shows the typical encampment of the Mandans. The lodges are 40 to 60 feet in diameter, covered with earth to keep the interiors cool, and grouped so close together that there was barely

room to walk or ride between them. The village, numbering several hundred dwellings, was surrounded by a palisade for protection.

POPULARIZING THE WEST

Charles M. Russell (1864–1926) dreamed of becoming an Indian fighter during his boyhood in St. Louis. His father tried to end his son's infatuation with the West by sending him to Montana to work on a friend's sheep ranch, but Russell stayed on and went to work as a wrangler, drawing and painting in his spare time. In the late 1880's he began to sell his art work, but it was not until after his marriage in 1896 that he settled down to produce a steady stream of good paintings.

The War Party (1898). Russell took a very sympathetic view of the Indian, depicting his nobility and courage with the same consistency as Remington in portraying the bravery of the cavalry trooper. (Unlike Remington, Russell considered the noble Indian the symbol of the Old West.) He knew Indian life at first hand, having spent the winter of 1888–1889 with the Blood Indians, a tribe of Blackfeet living in Canada.

Photograph of Charles Russell.

Photograph of Frederic Remington.

Frederic Remington's dramatic scenes of Western life practically created the mythical "Wild West" for audiences of the late nineteenth and early twentieth centuries. An Easterner by birth, Remington (1861–1909) went west in his early twenties to try sheep ranching. Although his business venture turned out badly, Remington began drawing what he saw around him. Soon he was illustrating scenes from the Indian wars for *Harper's Weekly*, and by the 1890s he was earning a comfortable living.

Bronco Busters (illustration). The two Remington sketches pay tribute to the cowboy's riding skill.

Stampeded by Lightning (undated) presents a dramatic incident in the cowboy's life.

A Dash for Timber (1889). Eight brave and acrobatic cowboys (the one holding his companion up on the left and the one twisting almost completely around in order to fire at their pursuers seem to defy customary physical laws) race toward the trees that will give them a chance for shelter and defense. Remington expressed the courage and tenacity of the cowboy and the trooper so convincingly that a generation grew up seeing the West as he had idealized it. By systematically eliminating any suggestion of meanness from his representation, Remington laid the foundation for the cowboy's glorification in books and in films. The horses are shown much more satisfactorily and more realistically than the riders. Through constant study, Remington acquired a skill second to none in portraying the horse. He once suggested that his epitaph should read simply, "He knew the horse."

Detail of cowboys from *A Dash for Timber*.

Fight for the Waterhole (1908) conveys the skill, determination, and stoic im-

passiveness of the cavalry troopers Remington idolized in life and idealized on canvas. Although he rode on patrol with the Tenth Cavalry in the Southwest, his only brush with combat came during the Spanish-American War in 1898, in which he took part as a war correspondent. There he learned what a great gap there was between his conception of military glory and the dirty, squalid, boring, terror-filled reality. Nonetheless, he never put such ideas into his paintings of the West. In fact he turned his back on the real West, which was becoming too tame and civilized, and spent the last decade of his life celebrating the virtues he thought appropriate to his personal vision of the period and its men. The manly, resourceful, dedicated Indian-fighting soldier became one of his favorite subjects.

When Guns Speak, Death Settles Disputes (Charles Russell, undated) takes up the romance of wrangler life in the rough days of the cattleman's West. Russell came to Montana when the land was still bleak and demanded a tough consitution from its inhabitants. Many years later, after he had acquired the artistry for which he became famous, the passage of time had softened the details in his memory. He was unaware of any discrepancy between what he had lived and what he painted, but it is obvious today that he was remembering the past and not recording it; anachronisms abound in his paintings, increasing as he delved further into the past. Both Russell and Remington dreamed of the West before they ever arrived there, and their boyhood dreams are never completely absent from their mature paintings.

Galloping Horse (1884) by Eadweard Muybridge. Remington often used photographs to compose his pictures.

The Bronco Buster (1895). In the mid-1890s, when his oil paintings were not selling, Remington took up sculpture because it seemed more challenging than magazine illustration.

Detail of cowboy's head from *The Bronco Buster*.

LANDSCAPISTS OF THE FAR WEST

Thomas Moran (1837–1926) was born in England, but grew up in the United States. Accounts of a government exploration party so aroused his curiosity that he joined the next expedition as guest artist, at his own expense. Moran found in the Grand Canyon of the Yellowstone the greatest challenge to his artistic skills and returned many times in later years to these scenes of wild splendor. Like Albert Bierstadt, Moran has often been criticized for his dramatic use of color, his tendency to idealize the landscape, and his desire for grandeur.

Mist in the Yellowstone (undated) demonstrates both Moran's continuing interest in the beautiful colors of the Yellowstone Valley and his love of dramatic compositions. He made his first trip to the Yellowstone in 1871, and the large painting he executed after his return, *The Grand Canyon of the Yellowstone* (1872), became the turning point in his career. Not only did the United States government purchase the work for $10,000, but Moran had the satisfaction of making a significant contribution to the congressional decision to establish Yellowstone National Park.

Castle Geyser (1872), one of the watercolors from the survey of 1871, is a finished work rather than a preparatory sketch. As with Moran's other works, including the oil paintings, it is not simply an objective rendering of the natural scene, but a subjective analysis. Moran believed that "an artist's business is to produce for the spectator of his picture the impression produced by nature on himself."

Albert Bierstadt (1830–1902) first visited the West in 1859, journeying as far as Wyoming. The sights inspired him to begin composing large paintings of dramatic Western vistas. Within 5 years his landscapes commanded up to $25,000. Bierstadt performed for the national scene what Frederic Church carried out for the international. Their careers followed a similar course. Extravagantly praised and rewarded at an early age, both artists fell from public favor by the latter part of the century.

Thunderstorm in the Rocky Mountains (1859) is a product of Bierstadt's first Western trip. His pictures are always organized for maximum dramatic effect.

Detail of deer from *Thunderstorm in the Rocky Mountains*.

Thunderstorm in the Rocky Mountains (1859).

Mount Corcoran (1877) was painted for the American art collector William Wilson Corcoran, founder of the Corcoran Gallery in Washington, D.C.

The Rocky Mountains (1864) established Bierstadt as the foremost painter of Western landscapes. Its exhibition across the hall from Church's *Heart of the Andes* at the Sanitary Fair (for the benefit of Civil War wounded) did no harm. The following year Bierstadt's masterpiece was sold for a reported $25,000. It is typical of his large paintings. Bierstadt begins with a real locality, modifying it by additions and eliminations until he has created a design which conveys a mood even more than a sense of place. The spirit of the West is in the picture, rather than the West itself. Critics found the size and the clarity of Bierstadt's work breathtaking in the 1860s, but by the 1880s they were criticizing its imprecise detail and grandiose conception.

Detail of the Indian camp from *The Rocky Mountains*.

The Rocky Mountains (1864).

The Last of the Buffalo (1889) started a heated controversy when the judges selecting the American entry at the Paris World's Fair rejected it. This slight was a dramatic reminder of how far Bierstadt had fallen. It is estimated that there were about 550 buffalo left in the United States when he completed his painting. The following year the Battle of Wounded Knee brought the Indian wars to a close. Bierstadt's subject, like his audience, was disappearing.

Detail of skull, Indian, and buffalo from *The Last of the Buffalo*.

The Last of the Buffalo (1889).

Chichester Canal (1830) by J. M. W. Turner. Turner's watercolors were an important influence on Moran's style.

Great Spring of the Firehole River (1871), one of the watercolor sketches Moran executed on the spot, is sprinkled with notes on color for use in working up the finished oil painting. It is a freer, more spontaneous and, in some ways, more dramatic treatment of the subject. The watercolor sketches of the Western artists all share the virtue of spontaneity, conveying even today the excitement they felt in such a strange, grand, and breathtaking wilderness.

Grand Canyon of the Yellowstone River (1893–1901) is a larger and later version of the painting purchased by the government in 1872.

THE PHOTOGRAPHERS

William H. Jackson on Glacier Point, Yosemite (1871). Anonymous.

Mammoth Hot Springs, Gardiner's River (1871) by William Henry Jackson (1843–1942).

Middle Park, from the Mouth of the Blue River (1874) by William Henry Jackson.

Tower of Babel (after 1880) by William Henry Jackson.

Yosemite Valley from the "Best General View" No, 2 (about 1866) by Carleton E. Watkins (1829–1916).

Navaho Village—Ruins of White House, Canyon de Chelly, Arizona (1873) by Timothy O'Sullivan (1849–1882).

Unidentified photograph.

Black Canyon of the Colorado River (1873) by Timothy O'Sullivan.

Unidentified photograph.

"Karnak," Montezuma Ridge, Nevada (1868) by Timothy O'Sullivan.

Tenaya Canyon (undated) by Eadweard Muybridge (1830–1904).

Yucca Draconis (about 1880) by Carleton E. Watkins.

The Rocky Mountains (1864) by Albert Bierstadt.

Detail of Indian encampment from *The Rocky Mountains.*

The Mount of the Holy Cross (1874) by William Henry Jackson.

Mountain of the Holy Cross (1875) grew out of still another expedition to the West, in 1874, and won Moran a gold medal at the Centennial Exposition in Philadelphia. Moran's use of colors was less flamboyant than Bierstadt's, and his compositions make less use of figures inserted for contrast. Perhaps for this reason his reputation withstood the onslaught of the new art of the Impressionists.

Detail of foreground stream from *Mountain of the Holy Cross* by Thomas Moran.

The Mount of the Holy Cross (1874) by William Henry Jackson.

White Branches, Mono Lake, California (1950) by Ansel Adams (born 1902).

Granite Crags (1943).

Mount Williamson from Manzanar, Sierra Nevada, California (1944) by Ansel Adams.

POST-PROGRAM ILLUSTRATIONS *Osage Warrior* (Saint-Mémin); *Young Omawhaw, War Eagle, Little Missouri and Pawnees* (King); *Lacrosse Playing among the Sioux* (Eastman); *The Captive Charger* (Wimar); *Thunderstorm in the Rocky Mountains* (Bierstadt); *The Bronco Buster* (Remington); *Black Knife, an Apache*

Chief (Stanley); *Winter Hunting on the Upper Missouri* (Catlin); *Chief of the Little Osages* (Saint-Mémin); *White Plume* (King); *Interior of a Mandan Earth Lodge* (Bodmer); *Mist in the Yellowstone* (Moran); *Comanche Village, Women Dressing Robes* (Catlin); *Bucking Broncos* (Remington); *Fight for the Waterhole* (Remington).

QUESTIONS AND PROJECTS

I. Define or identify:

Lewis and Clark expedition Indian Removal Act of 1830
George Catlin National Park System
physiognotrace Plains Indians
Oregon Trail wet-plate photography
Wounded Knee watercolor

II. Developmental questions:

1a The Indians. Of the Eastern Indians, who were the most important tribes? Where did they live? What were their accomplishments?

1b Plains Indians. Who were the most important tribes? Who were the best-known leaders of the Plains Indians? Where were the tribes located originally? Where are their reservations now?

2 The settlement of the West. What were the principal routes to the West Coast? How long did the journey take? What were the principal attractions for settlers? What was the rate and the course of settlement? What was the "frontier"?

3 Photography. The photographers who visited the West did not confine themselves to landscape. Edward S. Curtis, in particular, recorded the Indians and their life. What other photographers captured Indian life with the camera? How does their work compare with that of the artists? What qualities of the photograph are absent in a painting and vice versa?

4 Fighting in the West. What were the Indian wars? What were the range wars? What were the boomtowns? Who were some of the noted personalities of the West?

III. Discussion and opinion questions:

1 In addition to providing material for the artists discussed here, the American West has been the subject of many books, films, and television programs. There seems to be no unanimity of opinion about what sort of people the Indians were. How, then, are we to be able to judge the truth of Western settlement, Indian life, and the relations between Indian and white man? Who has captured the true image of the West, Catlin or Bodmer? Catlin or Remington? Bierstadt or Moran? the landscapists or the photographers?

2 Landscape photography was an important source of information about the West in the late nineteenth century. What is the chief value of landscape photography as opposed to landscape painting? What decisions must a photographer make that a painter need not? It has been said that photography cannot be an art because the photograph is produced by mechanical means, that the scenery simply appears on the film according to inviolable laws of physics and chemistry so anyone can take a photograph. A landscape painting, however, requires translation by the artist; he must filter his vision of the land through his brush onto the canvas. Is it true, then, that photography is not an art? In what ways may a photographer make his presence felt?

What is the "art" of landscape photography as opposed to the "art" of landscape painting?

3 Compare Catlin's *Buffalo Chase* with Remington's *Fight for the Waterhole*. What do the two paintings suggest about the artists' perception of Western life?

IV. Projects:

1 Find out what Indian tribes live or lived in your area. If they are no longer there, where are they? Who were the great leaders of the tribe(s)? What names did they give to natural features, cities, or other areas?

2 Every state in the Union has set aside some natural area to serve as parks for recreation. What parks are near you? Are there any national parks or national forests or national wildlife preserves? What other natural wonders are found in your region?

3 The nineteenth century was a period of expansion. Consult a history book to find out how the government encouraged settlement of the West. Notice particularly the Homestead acts, the land grants to the railroads, the methods of treating with the Indians. Advocates of removing the land from the Indians maintained that the land should be given to men who cultivate it and help feed the rest of the country. Since the Indians were hunters rather than farmers, they argued that the Indians should be dispossessed. Is this a valid argument? What were the first roads like? How were they built? Was private capital or public money used for road construction?

4 Look through Catlin's two-volume work on the *North American Indians*. How does his view of Indian life compare with what you have been taught in school or seen in the movies and on television?

5 Try to find early photographs of your community or your region of the country. How has the countryside changed since these photographers worked? Who were the first photographers of your area? Why did they take these pictures? What happened to them? Were any of them painters as well?

BIBLIOGRAPHY

Catlin, George: *Letters and Notes on the manners, customs and conditions of the North American Indians, written during eight years travel (1832–1839) amongst the wildest tribes of Indians in North America*, Dover Publications, Inc., New York, 1973. This is a paperback reprint of the 1844 edition.

Curtis, Edward S.: *The North American Indians*, Aperture, New York, 1972. A selection of photographs by Curtis (1868–1952), one of the foremost photographers of the American Indian.

De Voto, Bernard: *Across the Wild Missouri*, Houghton Mifflin Company, Boston, 1947. A history of the fur trade, illustrated with works by George Catlin, Alfred Jacob Miller, and Charles Bodmer.

Garcia, Andrew: *Tough Trip through Paradise 1878–1879*, Houghton Mifflin Company, Boston, 1967. A first-person account, told in simple, undramatic language, of life among the Indians in the upper Yellowstone and upper Missouri.

Newhall, Beaumont, and Diana E. Edkins: *William H. Jackson*, Morgan and Morgan, Dobbs Ferry, N.Y. 1974.

THE
VISIONARIES

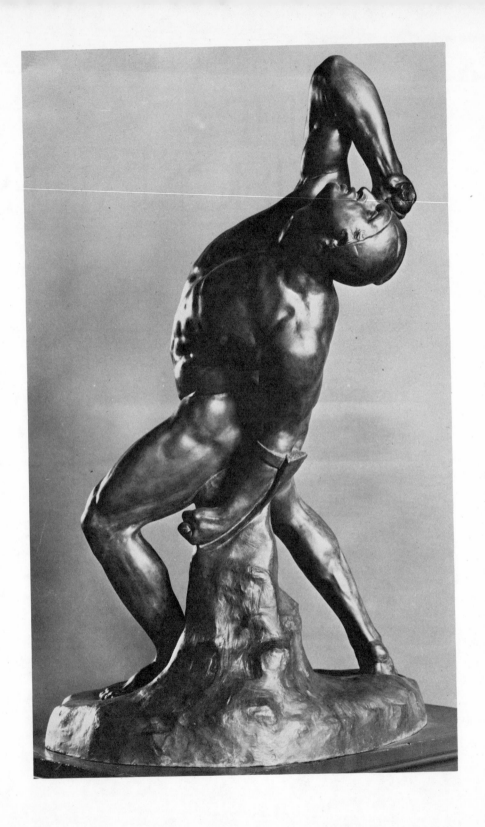

PROGRAM 8
THE VISIONARIES

Imitation is not inspiration, and inspiration only can give birth to a work of art. The least of a man's original emanation is better than the best of a borrowed thought. . . . The new is not revealed to those whose eyes are fastened in worship upon the old. The artist of today must work with his face turned toward the dawn, steadfastly believing that his dream will come true before the setting of the sun.

Albert Pinkham Ryder, ''Paragraphs from the Studio of a Recluse'' (1905)

The romantic movement of the first half of the nineteenth century valued personal expression and deep feeling above traditional craftsmanship. The visionary artists discussed here are in important respects later-generation romantics. Their work is a kind of underground movement obscured by the flashy and ornate productions of one of the most materialistic periods in American history.

William Rimmer, The Dying Gladiator (nineteenth century). Courtesy of the Museum of Fine Arts, Boston.

OVERVIEW

The Period Approximately 1850 to 1910.

American Life The industrial expansion of the latter part of the century was greatly aided by the work of engineers and inventors. The Remington typewriter made its appearance in 1874, the telephone was patented in 1876, the phonograph in 1877, the incandescent light in 1878, the motion-picture camera in 1893. The discovery of oil-drilling techniques created the petroleum industry and provided a new fuel—gasoline. By 1895 the automobile was in use, and the airplane got off the ground in 1903. Great organizations were formed to exploit these and other inventions. The transcontinental railroad, completed in 1869, linked the entire country. The U.S. Steel Corporation, the first billion-dollar corporation, was formed in 1901. As big business grew, so did labor. The American Federation of Labor came into existence in 1886, the first Interstate Commerce Act was passed in 1887, and the Sherman Antitrust Act in 1890 (although it did not possess real power until Theodore Roosevelt's time).

American Literature Edgar Allan Poe (1809–1849) showed the same delight in the bizarre and the grotesque as the visionary artists. Such tales as "The Cask of Amontillado," "The Tell-Tale Heart," "The Gold Bug," and "The Murders in the Rue Morgue" have alternately captivated and terrorized millions of readers. Ambrose Bierce (1842–1914) is remembered today chiefly for his cynical wit (and for having disappeared mysteriously in Mexico), but he was also a master of the tale of terror, as he showed in *In the Midst of Life* (1892), a collection of his short stories. A mild recluse for most of her life, Emily Dickinson (1830–1886) composed hundreds of short poems drawn from a serious inner turmoil, only two of which were published during her lifetime.

International Events Labor organized in response to the increased power of management. In every country, theoreticians of socialism, anarchism, and communism found ardent supporters. Within half a century the dreamers of the masses had achieved signal successes in almost every country in the world.

CONTENTS OF THE PROGRAM *Fantasy and Imagination* George Inness (see Program 5 for his connection with the Hudson River School) used color and setting to establish a predominant mood. Elihu Vedder was a prolific artist, noted for his book illustrations and for his discomforting juxtapositions of reality and fantasy.

A Tormented Soul William Rimmer demonstrated his mastery of anatomy in statues of power and energy and expressed his fears in paintings of understated terror.

Inner Voices Albert Pinkham Ryder and Ralph Blakelock drew fantastic images from their rich subconscious.

PRE-LOGO ILLUSTRATIONS *Toilers of the Sea* (Ryder); *Flight and Pursuit* (Rimmer); *The Questioner of the Sphinx* (Vedder); *Indian Encampment* (Blakelock); *The Dead Bird* (Ryder).

FANTASY AND IMAGINATION

George Inness (1825–1894) (Program 5).

> George Inness sitting in front of one of his paintings (photograph, 1885).
> *The Delaware Water Gap* (1861) (Program 5).
> Detail of the river bend from *The Oxbow* (1846) by Thomas Cole (Program 5).
> Details from *The Lackawanna Valley* (Program 5).
> *The Lackawanna Valley* (1855).
> *Hillside at Etretat* (1876) (Program 5).
> *Autumn Oaks* (circa 1875).
> *The Coming Storm* (1878).
> *Pool in the Woods* (1890).
> Detail of wagon and trees from *Rainbow in the Berkshire Hills* (1869).
> *The Mill Pond* (1889).
> *Peace and Plenty* (1865). Inness celebrates his joy at the end of the Civil War with this large scene (approximately 6½ by 9½ feet) of a tranquil valley at dusk. The harvest wagon heading home symbolizes the harmony between man and the land.
> In *The Monk* (1873) Inness shifts from the emotional content of the landscape to the relation between the land and the solitary figure in the lower right foreground. "Poetry," Inness once said, "is the vision of reality. . . . [The aim of a work of art] is not to instruct, not to edify, but to awaken our emotion. . . . [The greatness of a picture] consists in the quality and the force of this emotion." Inness was deeply influenced by the religious mysticism of Emmanuel Swedenborg. Although *The Monk* reflects his religious concerns, the picture also appeals for its enigmatic tone.
> Detail of the foreground figure from *The Monk*.
> *The Monk* (1873).
> *Sunset in the Woods* (1891) was painted, according to an accompanying note by Inness, "to represent an effect of light in the woods toward sundown, but to let the imagination predominate."
> *The Clouded Sun* (1891), a simple representation of rural America, shows again Inness's tendency to concentrate on atmosphere and feeling rather than on precise detail.
> *Grey Day, Goochland, Virginia* (also known as *Goochland, West Virginia* and *Goochland*) (1884) shows a ruined kiln amidst the light, hazy colors of an autumn day.
> Elihu Vedder (1836–1923) moved to Italy for what he thought was a tempo-

rary stay, just long enough to enable him to find a style, and wound up remaining there for the rest of his life. He was a vastly praised, widely honored artist during his lifetime.

Ideal Head (1872).

The Lair of the Sea Serpent (1864). Exclude the serpent folded over the mounds of sand and the painting is a completely ordinary seascape. Vedder's painting is like a snapshot of the unknown, all the more powerful for its undramatic design. The artist confirms that the serpent exists, but he leaves us to ponder *how* it exists. Vedder's irreverent friends, among them George Inness, liked to refer to the painting as "The Big Eel." It was rumored that the sight of a dead eel washed up on the beach inspired Vedder to make the painting.

The Questioner of the Sphinx (1863), like *The Lair of the Sea Serpent*, combines the real with the fantastic. More than any other Egyptian artifact, the sphinx seems to embody the meaning of a civilization; it is our contact with a glorious past, a silent witness to disunion, decay, and destruction. In addition the sphinx is another phantasm of the unconscious, a mysterious and potentially frightening force. Vedder contrasts the stern, blank monument with the furtive, terrified, slightly mad eyes of the kneeling suppliant. The painting was so popular that in the 1890s the Pabst beer company used it in their advertising.

The Lost Mind (1864–1865), like many of Vedder's paintings, gives physical form to an emotional state. But this one was less successful than the previous two, possibly because it leaves too little to the imagination. Moreover the strange clothing, conventionally disturbed features, and desert background seem too contrived. Vedder's cronies used to refer to it as "The Idiot with the Bath Towel."

The Cup of Death (1884) is one of the illustrations Vedder prepared for a special edition of *The Rubaiyat of Omar Khayyam*.

The five murals for the Library of Congress were executed in 1895–1896 and put in place in March 1896. Vedder received $5000 for his work. He ended his brief career as a muralist with a mosaic *Minerva* for the Washington Library.

Government (1895–1896). The illustrations here are all from the Library of Congress, Washington, D.C.

Anarchy (1895–1896).

Good Administration (1895–1896).

Corrupt Legislation (also known as *Bad Government*) (1895–1896).

Peace and Prosperity (1895–1896).

A TORMENTED SOUL

The paintings and sculpture of William Rimmer (1816–1879) are among the most powerful and mysterious creations in the history of American art. Rimmer, whose father believed himself the lost Dauphin of France miraculously saved from the guillotine, was brought up with a mixture of aristocratic pride and paranoid fear. He showed a precocious talent for sculpture, but the demands of earning a living compelled him to give up art. Fortunately he was able

to return to it in his mid-forties, although without much greater success than in his early years. It was not until after his death that Rimmer's ability was finally recognized.

Flight and Pursuit (1872) is a penetrating study of nemesis: each action engenders its contrary. The figure near us, poised in mid-flight, is shadowed by a similar figure, mysteriously cloaked, who races across the open passageway in the background. At the same time an ominous shadow is visible just behind the runner. The strange design, curiously arrested motion, and disturbing colors make this painting a haunting experience. It has been suggested that John Surratt's role in the assassination of President Lincoln provided Rimmer with the idea of the painting.

Detail of pursuer from *Flight and Pursuit* (1872).

Fighting Lions (1871) demonstrates again Rimmer's predilection for scenes of violence and high drama.

Detail from *Fighting Lions*.

Detail from *Fighting Lions*.

The Dying Centaur (1871). Rimmer's art frequently concentrates on the violent clash of human life and the forces which oppose it.

Anatomical Drawing (1877). Rimmer was so versed in the body and its muscles that he was, like Rodin in France, falsely accused by critics of making his statues from plaster casts taken directly from the model.

Detail from *The Falling Gladiator* (1861).

Although *The Falling Gladiator* (1861) again dramatizes the pathos and the bitterness of defeat, it suggests as well nobility of soul and purpose. Rimmer's figures, beset by violent opposition and inevitably doomed, resist to the last instant.

INNER VOICES

The best-known of the visionary painters, Albert Pinkham Ryder (1847–1917) was a pure artist, innocent of all knowledge of business or economics. He depended on his friends for such matters. Ryder's minimal needs were easily satisfied by the occasional sale of a painting. Particularly fascinated by the sea and by moonlight, Ryder crossed the ocean several times, but primarily to observe the changing quality of light. He was basically self-taught, one of the few American painters of the period never to have studied in Europe.

Self-Portrait (probably early 1880s, although since Ryder seldom signed his paintings and never dated them, and since he often worked on them for years, it is difficult to assign dates to them) shows the intense gaze that Ryder turned on the world about him. Even in his portrait he prefers large masses of color to fine detail.

The Dead Bird (1890–1900). In this tiny painting, some 4 inches by 10 inches, the thick impasto and the orange hue give the bird a disconcerting palpability. Ryder's best paintings recreate the sensations and the feelings of his memories.

Toilers of the Sea (1884) was exhibited with a poem: "Neath the shifting skies / O'er the billowy foam / The hardy fisher flies / To his island home."

Moonlight (1885). All of Ryder's many nocturnal seascapes resemble one another. Indeed the formula was so simple—a dark boat, geometric clouds, yellowish moonlight—that forgers found it easy to capitalize on Ryder's popularity. It has been estimated that there are as many as five to ten times as many fake Ryders as true ones, although recent improved methods of detection now make it easier to distinguish the true Ryders.

Moonlit Cove (1890).

Self-Portrait (circa 1880).

Landscape with Trees and Cattle (1929).

In the Stable (undated).

Landscape with Trees and Cattle (1929).

Grazing Horse (1914) is one of Ryder's landscapes, but even here in this simple composition, we can sense a tension, as if something were not quite right.

Moonlight Marine (undated), one of Ryder's best-known works, is the principal model, along with *Toilers of the Sea*, for Ryder forgers. The dark colors, like the many cracks, may be partly the result of incorrect color mixing (Ryder never worried about the long-term consequences of his combinations of material), but they often also add a special power to Ryder's seascapes. He was not interested in capturing physical features in a photographic way, but in suggesting mental phenomena.

Toilers of the Sea (1884) (Ryder).

Moonlight (1885) (Ryder).

Detail from *Jonah and the Whale* (Ryder).

Jonah and the Whale (exhibited first in 1890, but greatly modified afterwards). The scene is organized for maximum dramatic effect. God and Jonah oppose one another on a diagonal down the trough of the waves near the center of the painting, while the ship curls strangely around the crashing water.

The Flying Dutchman (1887–1890), based on Richard Wagner's opera, depicts the ghost ship being hailed by a passing vessel. The story of the Dutch sea captain condemned to sail the ocean until the unselfish love of a woman should set him free, is a well-known European legend.

Siegfried and the Rhine Maidens (1875–1891) shows Ryder at his pictorial and visionary best. The wild, apparently windswept lines of the trees and bushes are bathed in a strange, provocative moonlight. Ryder has not only caught the drama of the fateful meeting between the hero and the Rhine maidens who will enlist his aid to recover the stolen Rhine gold, he has succeeded in conveying its tragic mystery as well.

Detail of rider from *Siegfried and the Rhine Maidens*.

Detail of maidens from *Siegfried and the Rhine Maidens*.

Siegfried and the Rhine Maidens (1875–1891).

Detail of Mary from *Christ Appearing to Mary*.

Christ Appearing to Mary (no date, but it was first sold in 1885).

Moonlight Cove (1890).

Detail from *Moonlit Cove.*

The Dead Bird (1890–1900).

The Race Track (or *Death on a Pale Horse*) (Ryder began the painting in the late 1880s and finished it around 1910) was suggested to Ryder by the suicide of a waiter at his brother's hotel; apparently the man killed himself after losing his life's savings at the races.

Photograph of Albert Pinkham Ryder in 1885 by Alice Baughton.

Ralph Blakelock (1847–1919) suffered more for his art than any of the other visionary artists. A slight, sensitive man, Blakelock refused to follow his family's wish that he become a physician. Between 1869 and 1872 he toured the American West, making hundreds of small sketches and drawings, the primary source of his later paintings. He married in 1877, and this union produced the nine children whose growing needs kept Blakelock under constant pressure to sell. In 1899 he broke down completely, without hope of cure, and was hospitalized for most of the rest of his life.

Moonlight (1893) by George Inness deals with the same subtle nocturnal light as in the canvases of Ryder and Blakelock. But moonlight did not fascinate Inness the way it did his two fellow artists: he includes considerably more detail than either of the others.

Moonlight (1885) (Ryder) (see above).

Moonlight (1891) shows how Blakelock, like Ryder, was preoccupied by the nocturnal and the mysterious. Many of his paintings are night scenes, often of Indians camped in the woods. The simple, undetailed composition suggests why forgers were drawn to Blakelock's work.

Indian Encampment (not dated) is best appreciated by comparison with the work of George Catlin, Albert Bierstadt, and other painters of the American West (see Program 7). Blakelock does not seek to record anthropological details, but to suggest his own deeply poetic response to the sight of real Indians.

Detail from *Moonlight* (1891) by Blakelock.

POST-PROGRAM ILLUSTRATIONS *Moonlight Marine* (Ryder); *Lair of the Sea Serpent* (Vedder); *Moonlight* (Ryder); *The Cup of Death*, illustration from *The Rubaiyat of Omar Khayyam* (Vedder); *The Dying Centaur* (Rimmer); *The Race Track* (Ryder); *The Clouded Sun* (Inness); *Grazing Horse* (Ryder); *Moonlit Cove* (Ryder); *Jonah and the Whale* (Ryder).

QUESTIONS AND PROJECTS

1. Identify or define:

 mysticism
 glazing
 Emmanuel Swedenborg
 wash
 mural

 Richard Wagner
 impasto
 underpainting
 pumice grinding
 pastoral

II. Developmental questions:

1 Mysticism. What does mysticism mean? What do mystics teach? What values are associated with mysticism? What do mystics seek?

2 Allegory. What is allegory? What is its purpose? How does it accomplish its goals? What are the drawbacks of allegory?

3 Visionary artists. What is a visionary? What does a visionary artist seek to express? What attributes do Inness, Vedder, Rimmer, Ryder, and Blakelock share? Do you know other artists who resemble these five? What European artists share common attributes with them?

4 Sculpture. Rimmer and Auguste Rodin. Who was Rodin? What kind of work is he noted for? What resemblances are there between his work and that of William Rimmer?

III. Essay and opinion questions:

1 Since the artists discussed in this chapter all sought different results from their art, is it valid to group them under the single term "visionary artist"? What does this designation do to your appreciation of these people? How can George Inness be both a visionary artist and a Hudson River landscapist? What is the value and what are the possible drawbacks of terms of classification like "visionary," "realist," "landscapist," "portraitist," and so on?

2 Compare one of George Inness's moody, emotional landscapes with William Rimmer's *Flight and Pursuit*. What do the two artists wish to express? What means do they use? Are their goals and/or techniques in any way similar?

IV. Projects:

1 Who are the contemporary descendants of the visionary artists? Where do you find their work?

2 Elihu Vedder's *Questioner of the Sphinx* was used in the 1890s as part of a beer advertisement. What other works of art can you find being used today as advertisements? How does this use affect our ability to "see" and appreciate the original work of art? What commercial products advertise with art works? What is the effect of using a work of art in an advertisement? How does it change your perception of the product? of the art work itself?

3 Mysticism and respect of supernatural forces are often part of a country's traditions. What mystical forces have played a role in the history of United States? Consider our currency, for example. What do such emblems of mystical forces as the eye in the pyramid express about human needs and desires?

4 Music has always been considered one of the great irrational forces, capable of pleasing human beings as well as animals. Investigate the development of music in the late nineteenth century. Compare, for instance, Verdi and Puccini, Bizet and Saint-Saëns, Weber and Wagner. Who were the most noted American composers? Look for parallels between music and art (particularly painting).

BIBLIOGRAPHY

Barzun, Jacques: *Darwin, Marx, Wagner: Critique of a Heritage*, Doubleday Anchor Books, Doubleday & Company, Inc., Garden City, N.Y., 1958. A well-written, provocative reconsideration of the major intellectual movements of the latter part of the nineteenth century.

Bridges, Leonard H.: *American Mysticism, from William James to Zen*. Harper & Row, Publishers, Incorporated, New York, 1970. A consideration of a little-understood aspect of American thought.

Goodrich, Lloyd: *Albert P. Ryder*, George Braziller, Inc., New York, 1959. A brief but interesting account of Ryder and his paintings.

Vedder, Elihu: *The Digressions of Vedder*, Houghton Mifflin Company, Boston, 1910. An amusing autobiography written by Vedder to entertain his friends.

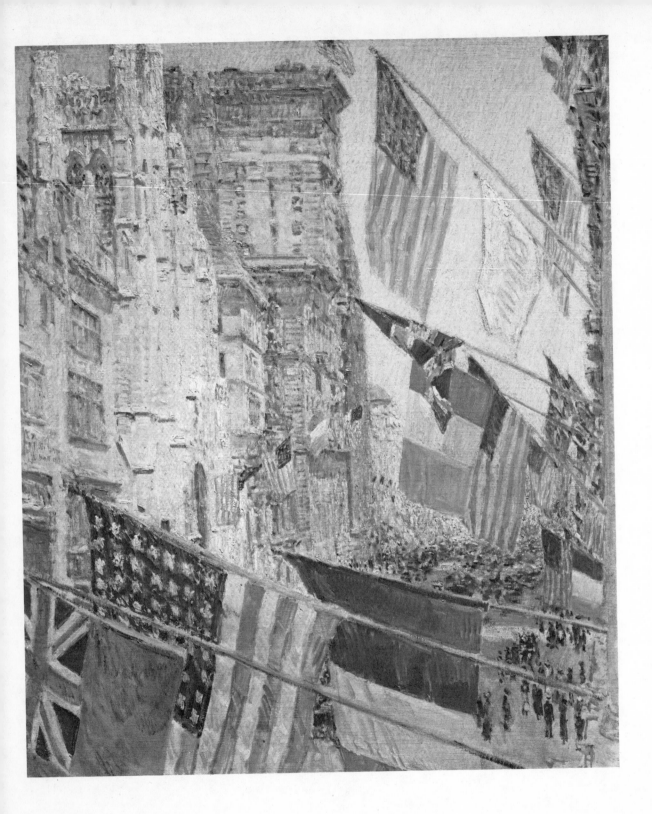

PROGRAM 9
THE EXPATRIATES

Nature contains the elements, in color and form, of all pictures, as the keyboard contains the notes of all music.

But the artist is born to pick, and choose, and group with science, these elements, that the result may be beautiful—as the musician gathers his notes, and forms his chords, until he brings forth from chaos glorious harmony.

To say to the painter, that Nature is to be taken as she is, is to say to the player, that he may sit on the piano.

That Nature is always right, is an assertion, artistically, as untrue, as it is one whose truth is universally taken for granted. Nature is very rarely right, to such an extent even, that it might almost be said that Nature is usually wrong: that is to say, the condition of things that shall bring about the perfection of harmony worthy of a picture is rare, and not common at all.

<div align="right">

James McNeill Whistler, "The Gentle Art of Making Enemies" (1890)

</div>

A fter the Civil War Americans began to visit Europe in ever-increasing numbers. Few of the important American painters of the latter half of the century failed to make the European trip. Some of them, pleased

Childe Hassam, Allies Day, May 1917. Courtesy of the National Gallery of Art, Washington, D.C.

with the favorable reaction to their work, remained. The others returned home, to a country whose wealthy patrons preferred to spend their money on European art. The well-educated and the wealthy seem to have agreed with Harvard's Charles Eliot Norton that "in America even the shadows are vulgar."

OVERVIEW

The Period Approximately 1855 to 1910.

American Life The materialism of the latter part of the nineteenth century, which made itself felt so obviously in the vast fortunes made by speculators and industrialists, also appeared in the government. The 1870s and the 1880s are remembered as the nadir of American political morality. The two terms of Ulysses S. Grant (1869–1877) established the federal government at the peak of national corruption. "Boss" Tweed of New York City managed to divert over $100 million in public funds before his gang was exposed and broken up in 1871. The election of 1876 was perhaps the most corrupt in the country's history. Samuel Tilden polled 250,000 more votes than his opponent, Rutherford B. Hayes, but well-placed bribes gave Hayes the edge in the electoral college by one vote, 185 to 184. Only the administration of Chester A. Arthur (1881–1885) showed anything approaching a sense of national responsibility.

American Literature Several authors expressed the cosmopolitan views which animated the well-to-do and the artistic. Henry James (1843–1916) fled the provincialism of New England, residing in Europe for most of his life and eventually becoming a British citizen in 1915. He wrote often of the clash between Americans and Europeans (see Program 10), notably in *The Ambassadors* (1903) and *The Portrait of a Lady* (1881). Henry Adams (1838–1918) probed in *The Education of Henry Adams* (1907) the relationship between European unity and American multiplicity. Edith Wharton (1862–1937) laid bare life in New York's High Society in *The House of Mirth* (1905) and *The Age of Innocence* (1920).

International Events The countries of Europe sought military alignments more avidly than social contacts. France, pursuing her policy of "revenge" against Germany for the defeat of 1871, picked up Russia (1892) and then Great Britain (1903, in the Entente Cordiale) as allies. Germany, spurred by Kaiser Wilhelm to dispute Great Britain's naval supremacy, began an arms race which had to begin all over again after the British *Dreadnought* (1906), the first modern battleship, rendered obsolete all previous capital ships. Russia continued to suffer internal strife, the Revolution of 1905 sounding an ominous prelude to the successful Revolution of 1917. Japan established herself as the leading military country in the Far East with victories over China in 1893 and Russia in 1905.

CONTENTS OF THE PROGRAM *Expatriates for Life* James McNeill Whistler, Mary Cassatt, and John Singer Sargent were American in name and origin, but European in style and artistic education.

Temporary Exiles William Chase and Frank Duveneck were among the many

American artists who learned their technique in European art academies. Unlike the first group, these artists returned to the United States, where, in order to practice their art, they were usually forced to support themselves by teaching.

The American Impressionists Impressionism originated in France, but its influence was great on many American students. J. Alden Weir, Childe Hassam, and John Twachtman were three of the outstanding American impressionists.

VIEWER'S GUIDE

PRE-LOGO ILLUSTRATIONS *Rose and Silver: La Princesse du Pays de la Porcelaine* (Whistler); *The Daughters of Edward Boit* (Sargent); *Winter Harmony* (Twachtman); *The Boating Party* (Cassatt); *Rainy Day, Boston* (Hassam).

EXPATRIATES FOR LIFE

James Abbott McNeill Whistler, to give his full name (1834–1903), had difficulty obtaining due recognition for his artistic originality for two rather similar reasons. First his apparently simple style was in fact the result of an agonizingly slow, highly wrought creative process, and second, as one of the wittiest men of a period which included Oscar Wilde among its eloquent voices, he often irritated artists and critics alike with his acerbic barbs. Whistler managed his life and his career with the flair of a great dramatic actor.

Following in his father's footsteps, Whistler enrolled at West Point, but in his junior year his scholarship and his conduct gave out together: he garnered 218 demerits (18 over the maximum) and flunked chemistry. (A fine storyteller, Whistler liked to single out the chemistry failure as the sole determining incident, claiming, "Had silicon been a gas, I would have been a major-general.")

In 1855 he set out for Europe to study art. He never returned to the United States. In Paris, Whistler was significantly influenced by the great French realist, Gustave Courbet, and by the newly arrived Japanese woodcuts. In 1859 he moved to London, but continued to visit Paris frequently.

In 1878, by now an established artist, he sued John Ruskin for libel over a particularly uncomplimentary review of his art. Whistler won the case, but the unsympathetic judge convinced the jury to vote token damages of 1 farthing and ordered Whistler and Ruskin to share costs. Although very controversial in his day, Whistler has proved to be one of the most important and successful artists of the late nineteenth century.

Lithograph of Centennial Exposition.
The Breakers, by R. M. Hunt.
The Main Hall, *The Breakers*, by R. M. Hunt.
The Billiard Room, *The Breakers*, by R. M. Hunt.
The Metropolitan Museum of Art, New York.
The Museum of Fine Arts, Boston.

John Singer Sargent in his Paris studio in 1885 (photograph).

Self-Portrait (1910) by William Merritt Chase.

Portrait of the Artist (1878) by Mary Cassatt.

Childe Hassam (photograph).

Julian Alden Weir (photograph).

John Twachtman (photograph).

Whistler Laughing (1884). Etching by Mortimer Menpes.

West Point Academy Program (1853) by Whistler. One of the cadets is Whistler.

The Black Lion Wharf (1859) was produced during one of Whistler's visits to Wapping, a rough section along the Thames frequented mainly by sailors. Whistler often went there to etch and to draw. In etching he preferred to draw directly on the copper plate, contrary to the more frequent practice of making preliminary drawings. When he painted the famous portrait of his mother, *Arrangement in Grey and Black No. 1*, he hung this same etching on the wall next to her.

Photograph of Paris.

Charles Baudelaire (1865) by Charles Nadar.

For centuries Japan had maintained a hostile attitude toward foreigners, refusing to enter into trade agreements with them. In 1854 Commodore Perry forcibly ended Japan's self-imposed isolation. Trade with Europe and the United States began, and Japanese woodcuts, exquisitely colored, expertly crafted, two-dimensional scenes, created a sensation among Western European artists. Whistler so admired the simplicity of Japanese design that he incorporated it into his art.

The White Girl (1862) was retitled by Whistler *Symphony in White No. 1* when a French critic referred to it as a *symphonie du blanc* ("symphony of white"). The model was Jo Hiffernan, Whistler's mistress, who lived with him for some 10 years and remained a faithful friend for life. She was, according to those who knew her, a robust and capable woman with beautiful reddish-brown hair, but Whistler converts her in this painting into an ethereal beauty.

This woodblock print by the eighteenth-century Japanese master Utamaro demonstrates the linear emphasis, subtle colors, and lack of vanishing point perspective which were a revelation to European artists of the 1860s.

The Golden Screen, Caprice in Purple and Gold No. 2 (1864) shows how the Japanese woodcut influenced Whistler's art. He uses the woodcuts here primarily as a means of adding color and giving atmosphere to the scene, but on occasion he based his entire composition on woodcuts. The model for this painting is again Jo Hiffernan.

Rose and Silver: La Princesse du Pays de la Porcelaine (1864) is a portrait of Christine Spartali, daughter of the Greek Consul General in London. Despite the fact that he had commissioned the work, the Consul dismissed Whistler's portrait as an exotic bit of Japanese stuff too dreadful to look at and refused to pay for it. Whistler later sold the painting to Frederick Leyland, who hung it in what later became Whistler's Peacock Room.

The Peacock Room (1876–1877), decorated by Whistler as a *Harmony in Blue and Gold*, featured enormous gold peacocks on the paneled walls and doors. Whistler exceeded his authority in redecorating the room (somewhat after the fashion of Gully Jimson in Joyce Cary's comic novel *The Horse's Mouth*) and so angered Leyland that artist and patron quarreled violently. One of the interior designers actually charged with the decoration suffered a nervous breakdown when he saw what Whistler had devised. Hearing of this misfortune, Whistler remarked, "Ah, yes, I do have that effect on some people." (The entire room except for Leyland's porcelain collection is now on display in the Freer Gallery of Art in Washington, D.C.)

Detail of fighting peacocks: Leyland and Whistler.

Arrangement in Grey and Black No. 1: the Artist's Mother (1872), popularly known as *Whistler's Mother*, is certainly one of the best-known of American paintings. It is so familiar, in fact, that we no longer notice Whistler's careful design and execution.

The portrait now hangs in the Louvre, the first painting by an American artist so honored. The title of the portrait, in keeping with Whistler's effort to liken his art to music, implies that the subject is of little importance to him (as he said himself).

Arrangement in Grey and Black No. 2: Thomas Carlyle (1872–1873) continues the same spare style as the first arrangement. Carlyle, the noted Scottish historian, began sitting to Whistler in the best of spirits, but as the sittings continued with no sign of progress, he became impatient and eventually left his clothes for someone else to sit in. Despite such problems, he liked the finished portrait very much.

Whistler's *Nocturnes* were conceived as tone poems of color. He makes no attempt to record in complete detail the night's events, but instead seeks to capture the feeling of the experience, the mood of the night. To gather the material necessary for his composition, he hired boatmen to row him about the river. The three men got along well together—J. M. W. Turner had been similarly rowed about by their father—and Whistler taught them the rudiments of painting in exchange for the principles of boatmanship. Although he actually spent hours preparing his works, Whistler, in imitation of Japanese technique, achieved such simplicity of style that his paintings sometimes appeared, to those unfamiliar with his aims, to be merely thrown together.

Nocturne: Blue and Gold, Old Battersea Bridge (1865) shows the wooden tower of the bridge, the boatman on the stern of his boat, and the remains of skyrockets floating down through the air. It is a painting of stillness and quiet; even the water has scarcely a ripple, and the embers of the fireworks confirm the peace of the evening.

Nocturne: Blue and Gold, Valparaiso (1866) is the result of Whistler's escapade to help the Insurrectionists of South America. At the Ruskin trial, Whistler defined a nocturne as "an arrangement of line, form and color." This harbor scene, which is an account of *harbors* rather than a description of *Valparaiso Harbor*, bears out his definition.

Nocturne: The Falling Rocket, Black and Gold (1875) was the painting that caused the trouble with Ruskin, who wrote, "For Mr. Whistler's sake, no less than for the protection of the purchaser, [the Grosvenor (the gallery where the painting was displayed)] ought not to have admitted works into the gallery in which the ill-educated conceit of the artist so nearly approached the aspect of wilful imposture. I have seen and heard much of cockney impudence before now, but never expected to hear a coxcomb ask two hundred guineas for flinging a pot of paint in the public's face." Whistler, always prone to intense self-doubt, was deeply wounded by Ruskin's gratuitous charges and initiated a suit for libel. He won the verdict, but having no money to pay the costs (Ruskin's many friends took up a collection to pay his), he was forced into bankruptcy.

James Whistler in Court (caricature by Max Beerbohm from a later trial, 1897).

Two details of *James Whistler in Court*.

Nocturne: Blue and Silver, the Lagoon, Venice (1880) was one of the few oil paintings Whistler made during his stay in Venice, 1879–1880. He spent his time etching and drawing in pastels.

Nocturne (1880). Determined not to come back to London with a series of standard tourist views of Venice, Whistler found many of his subjects in little-frequented, and often unidentifiable, corners of the city.

Arrangement in Grey: Self-Portrait (1871–1873).

Mary Stevenson Cassatt (1844–1926) was the first American woman to achieve international distinction as a painter. But her triumph came first in France, as a member of the impressionist group, rather than in the United States, and indeed both in style and training, she is more European than American.

Born in Philadelphia, Cassatt entered the Pennsylvania Academy of the Fine Arts in 1861, where she drew from plaster casts along with Thomas Eakins (although the two were not acquainted). In 1866 she persuaded her father to send her to Paris to study art. One day in 1873 she was so moved by the sight of a Degas pastel on display in an art shop that she intentionally altered her style to follow the direction taken by his. They met 3 years later and became friends. Degas invited her to exhibit with the impressionists and she happily accepted. In 1890 Cassatt, after viewing the largest exhibit of Japanese woodcuts ever shown in France, began to experiment with dry point and aquatint in an effort to obtain the appearance of the Japanese woodcut. The prints that resulted are among her finest achievements. Her eyes began to fail as a result of diabetes, and by 1914 she was no longer able to paint.

Self-Portrait (1880, watercolor) shows the influence of Degas and impressionism. Cassatt's association with the impressionists was one source of her strength. "Finally I could work with absolute independence without concern for the eventual opinion of a jury. I began to live."

Self-Portrait (1878) catches the haughty aloofness which marked Cassatt's personality. She was a woman among men, a foreigner in France, a lady among bohemians.

Photograph of Thomas Eakins (c. 1880) (Program 10).

Self-Portrait (1854–1855) by Edgar Degas. Degas (1834–1917) was a friend and associate of the impressionists, although he always refused to be considered one of the group, preferring to be known as an "Independent." Impressionism to his mind was an art of the country, while he was an artist of the city. A careful technician and a minute observer, Degas went so far as to measure his models with calipers. He was probably the finest draftsman of the latter part of the century.

Wild Poppies (1873) by Claude Monet.

Little Girl in a Blue Armchair (*The Blue Armchair*) (1878) was partly painted by Degas, whom Cassatt had met the year before.

Japanese woodcut.

The Boating Party (1893–1894) with its rich blues and solid forms leans more toward Manet than toward Degas. Once again Cassatt depicts a child, but this time in a family setting filled with the protected joys of infancy. She insists on masses of form and color, rendering the whole in a way that incorporates both Manet's solid forms and the two-dimensionality of Japanese woodcuts.

Detail of woman and child from *The Boating Party*.

Girl Arranging Her Hair (1886) is reputed to have sprung out of a quarrel. Degas claimed that women have no conception of "style," and Cassatt painted this picture to show him that she, at least, knew very well what style was. Degas recognized his error and traded her one of his pastels for the painting.

Baby in Dark Blue Suit Looking over His Mother's Shoulder (1889).

Central panel of mural *Modern Woman* (1893), Columbian Exposition.

Young Woman Picking Fruit (1892). This oil sketch was part of the preparation for the mural *Modern Woman*.

Mother and Child (1890). Cassatt, who never married, remained very close to her brother, sisters, cousins, and nieces—doing at least one portrait of everyone in her immediate family. She returned often to the theme of maternity. It was difficult, in the nineteenth century, for her to have both a family and a career as a painter. She chose painting, but once she had proved her ability in that area, she seems almost to have longed to duplicate it in the other. Once, in her old age, when asked whether she would marry if she could start her life again, she answered, "There is only one thing in life for a woman; it's to have children."

The Letter (1891) is one of ten aquatints which Cassatt created, in a slow and delicate medium, after visiting the great exhibition of Japanese prints in 1890. The result is a delicate blend of Eastern technique and Western environment. One of the prints, *Woman Bathing*, moved Degas to exclaim in admiration, "I do not admit that a woman can draw like that."

Utamaro print.

The Letter (1891).

The Havemeyer Collection in the Metropolitan Museum of Art, New York. Louise Elder was studying at a fashionable French boarding school when she met Mary Cassatt in the early 1870s. Their devotion to art made them friends immediately. Cassatt encouraged Miss Elder to buy a Degas pastel for 500 francs (about $100), and although the young woman sensed that she did not under-

stand Degas as well as Cassatt, she nevertheless bought the pastel. (Some 90 years later one of her heirs sold it for $410,000.) It was the beginning of a magnificent collection. Later, with her husband Henry O. Havemeyer, she was to augment it considerably. The best of their purchases were given to the Metropolitan Museum in 1929. Although both Havemeyers became respectable connoisseurs, much of the exceptional quality of the collection is due to Mary Cassatt's discerning eye.

Photograph of Mary Cassatt (1914). A young woman who met her in 1911 described her as "tall and gaunt, dressed in a shirt waist and a black skirt. But her strong face and her rapid, intelligent conversation gave me little time to notice externals."

John Singer Sargent (1856–1925) first studied drawing at the Academy of Fine Arts in Florence, and at 18 he went to Paris to continue his development in the atelier of Carolus-Duran. In 1883–1884 Sargent provoked a scandal with his realistic, unflattering portrait of a noted Parisian beauty, Madame Pierre Gautreau. As a result of this adverse publicity no one in Paris would sit to him for a portrait. It was not, of course, that they believed he had no skill, it was rather they thought he had too much and they did not care to be shown exactly as they were. Sargent was forced to move to London. In 1887 he made a highly successful excursion to the United States during which he painted several portraits of the wealthy residents of Boston and Newport. From then until his death in 1925 Sargent was reputed to be society's premier portraitist. Although after 1900 he tired of the drudgery of portraiture [he is reported to have exclaimed, in frustration, "No more paughtraits!"], he had too many friends and was too well known to retire altogether from the business.

John Singer Sargent in his Paris studio (1885). Photograph.

The Wyndham Sisters (1899) was a great triumph for Sargent. It is light, delicate, and ethereal; all three woman seem contained in a luminous cloud of beauty.

Mrs. Henry White (1883). Mrs. White, the wife of an American diplomat, chose Sargent both because she admired his work and because he was an American. Although Sargent showed well at the annual salon exhibitions, he had trouble establishing himself. The fact that he was not French was a hindrance; most of his commissions were from Americans.

Mr. and Mrs. Isaac Newton Phelps Stokes (1897) began as a portrait of Mrs. Stokes in evening dress, flanked by a Great Dane. Sargent substituted the tennis attire when he saw his sitter arrive straight from a tennis match and replaced the Great Dane with Mr. Stokes when the dog proved too difficult to control. There is little flattery in the treatment—the husband appears subdued, resigned, and none too happy in the shaded background, and his smiling wife, although radiantly sunny and energetic, has a head which appears rather small above her dark tennis coat. Sargent maintained that he set out to capture what he could see and left aside any suggestion of personal attitude. That many of his sitters seem a trifle ridiculous, like children posing in adult clothes, may simply be the proof of Sargent's cool accuracy. After all, Sargent was forced to leave

Paris because he was considered *too* realistic, which for his offended patrons meant *too* unflattering.

A curious anecdote seems to corroborate Sargent's talent for precise and complete recording. A Philadelphia psychiatrist saw at an exhibition a Sargent portrait of one of his former patients (who had died since it was painted). After long and careful examination the doctor remarked, "Now I understand for the first time what was the matter with him."

Detail of Mrs. Stokes from *Mr. and Mrs. Isaac Newton Phelps Stokes.*

The Daughters of Edward Boit (1882), a portrait of the four daughters of a well-known artist, at first seems to resemble Velásquez's *Las Meniñas* (Sargent, like Thomas Eakins [see Program 10], greatly admired Velásquez) in the disposition of the sitters, but on closer examination substantial differences appear. Each girl exists in a separate world, cut off from the others. Moreover the huge vases make the children appear physically tiny and emotionally distant. The spatial disposition of the children also suggests the self-centered nature of their world.

Detail of youngest daughter sitting on rug from *The Daughters of Edward Boit.*

Detail of two eldest daughters with vase from *The Daughters of Edward Boit.*

John Singer Sargent in his Paris studio (1885) with the portrait of *Madame X* hung on the wall.

Madame X (1884) is Madame Pierre Gautreau (born Virginie Avegno in Louisiana), the well-known wife of a Parisian banker. Sargent, fascinated by her disdainful haughty manner and her lavender skin, pressed her to sit for a portrait. Flattered by his attentions, she finally agreed, although refusing to commission the work. Sargent intended the portrait to be a tour de force which would make his reputation, and he applied himself furiously to the work. Surprisingly Madame Gautreau and her friends thought that Sargent showed her in a disagreeable fashion, and she refused either to buy the painting or to allow its exhibition under her name. Sargent changed the title to *Madame X* for the exhibition, but everyone knew the sitter's identity and the painting became the scandal of the 1884 Salon.

Detail of *Madame X* (1884).

Madame Gautreau (1891) by Gustave Courtois. The low-cut gown and the face in profile bear a resemblance to Sargent's version, but the portrait lacks the tension and excitement—the mouth has a slight smile and there is no dramatic curving of the torso and the arm—of the original.

Madame X (1884).

Detail of dance from *El Jaleo* (1882).

El Jaleo (1882). The idea for *El Jaleo* (the title is taken from a Spanish song) came from Sargent's trips to Spain, but the actual work, which spanned 2 years, took place in Paris with a French model for the dancer. Sargent, looking for a scene that would make a hit at the Salon, tried to make *El Jaleo* as dramatically compelling as possible. The dancer is particularly constructed to take our attention and hold it, with her bent right arm, swirling skirts, and controlled body.

The Spanish Cloister Room of the Gardner Museum in Boston, which was

decorated under the direction of Isabella Stewart Gardner to display *El Jaleo* in an imaginative and theatrical fashion.

Mrs. Isabella Stewart Gardner (1888) was one of the great Boston personalities of her time. An art enthusiast who maintained great discrimination in her taste and an imaginative hostess who took pleasure in shocking her guests, she demanded from Sargent a portrait that would outdo *Madame X* for originality. He did his best to comply. Mrs. Gardner always claimed it was his finest portrait, but the critics have been more restrained in their admiration. Mrs. Gardner, however, passionately admired both Sargent's work and Sargent (they remained friends for life). Her patronage was a significant help in his career.

Mrs. Isabella Gardner (1922) is one of the few portraits Mrs. Gardner permitted of her old age. When portraiture began to bore him, Sargent returned to watercolors, which he had used with great mastery in his youth, and this small portrait shows his ability in the medium.

Boston Public Library, designed by McKim, Mead, and White (1887).

Interior, Boston Public Library.

Four prophets from the *Frieze of the Prophets* (1892–1895) by Sargent in the Boston Public Library: Amos, Nahum, Ezekiel, Daniel.

Mural: Three fathers from Boston Public Library.

TEMPORARY EXILES

As a young artist in St. Louis, William Merritt Chase (1849–1916) showed such skill that a group of local patrons raised $2100 for him to study in Munich. "My God," he is reported to have said, "I'd rather go to Europe than to heaven." Chase painted mainly still-lifes, particularly fish (one critic has called him "The John Sargent of the English cod"), a few portraits, and many genre scenes. He was also an extremely influential teacher. Among his successful students were Charles Demuth, Edward Hopper, Georgia O'Keeffe, Charles Sheeler, and Marsden Hartley. Chase taught that the first goal of the artist is to depict *exactly* the appearance. ". . . When the outside is rightly seen, the thing that lies under the surface will be found on your canvas."

Self-Portrait (1910).

In the Studio (1880–1883). A new kind of artist, more European in his comportment, was returning to the United States after study abroad with the flamboyant, eccentric European artists.

A Friendly Call (1895) is a sharply defined, well-observed scene. Always a rapid worker, Chase often encouraged the students in his landscape class by saying, "Take plenty of time for your picture; take two hours if you like."

Another of the Munich artists, Frank Duveneck (1848–1919), spent almost 20 years painting in Europe.

The Turkish Page (1876) demonstrates the principal marks of the Munich style: a warm, dark background with brilliant highlights and a picturesque subject of everyday life.

Head of an Old Man (1877–1879).
Blossoms.

THE AMERICAN IMPRESSIONISTS

Impressionism began in France and no doubt enjoyed its greatest successes there. But many artists from the United States were influenced by the school. In 1895 a group of them exhibited under the name "Ten American Painters." The three most successful American impressionists, J. Alden Weir (1852–1919), Childe Hassam (1859–1935), and John Twachtman (1852–1902) were part of this group.

The Red Bridge (Weir, 1895).
Rainy Day in Boston (Hassam, 1885).
Allies Day (Hassam, 1917).
Rue Montorgueil with Flags (1878) (Claude Monet, 1840–1920). Monet was the starting point for impressionism. He influenced painters all over the world. His painting in the first exhibition (1874), *Impression: Sunrise*, gave the group its name.

Allies Day (1917).
Rue Montorgueil with Flags (1878).
Allies Day (1917).
Winter Harmony (Twachtman, 1900).

POST-PROGRAM ILLUSTRATIONS *The Wyndham Sisters* (Sargent); *Rose and Silver: La Princesse du Pays de la Porcelaine* (Whistler); *The Golden Screen, Caprice in Purple and Gold No. 2* (Whistler); fighting peacocks from *The Peacock Room* (Whistler); *Nocturne: Venice* (Whistler); *Venice from the Lagoon* (Whistler); *Nocturne: The Falling Rocket, Black and Gold* (Whistler); *Thomas Carlyle, Arrangement in Grey and Black No. 2* (Whistler); *Arrangement in Grey and Black, Portrait of the Artist's Mother* (Whistler); *The Daughters of Edward Boit* (Sargent); *Mr. and Mrs. Phelps Stokes* (Sargent); *Madame X* (Sargent); *Portrait of Mrs. Gardner* (Sargent); *Rainy Day in Boston* (Hassam); *The Red Bridge* (Weir).

QUESTIONS AND PROJECTS

I. Identify or define:

expatriate	Japanese woodcut
Paris Salon	nocturne
Salon des Refusés	etching
aquatint	drypoint
Charles Baudelaire	avant-garde

II. Developmental questions:

1 Art collecting. For what reasons would American collectors prefer to purchase European works rather than American art? In what ways were the European and the American attitudes toward art different? To what might these differences be attributed? What is an art collector? Who collects art? For what reasons does a person purchase and collect art works?

2 The purpose of art. What was the prevailing idea about the purpose of art (particularly painting) in the nineteenth century? What is narrative art? What is "art for art's sake"? Who were the principal exponents of "art for art's sake"? What was their purpose? Is this kind of art still in vogue today?

3 European study. What are the art centers of Europe? Who were the principal European artists of the period discussed in Program 9? For what reasons would American art students wish to study in Europe? What opportunities were available for study in the United States?

4 Impressionism. What was impressionism? How did the name come into being? Who were the principal impressionist painters? Was there any common trait linking them? What was the importance of impressionism in the development of art? In what ways does the impressionist approach add to your awareness of your surroundings?

III. Essay and opinion questions:

1 Although James Whistler, Mary Cassatt, and John Sargent studied and worked almost exclusively in Europe, they are still termed American artists. How is it possible to justify this classification? Is there anything about their art that might be called typically "American"? What makes a person an "American artist"?

2 The French impressionists and the American luminists both concerned themselves primarily with the rendering of light and atmosphere in landscape painting. Compare their work. What similarities and differences do you find? To what do you ascribe these particularities? To what extent does the difference in location and climate and the difference in artistic tradition account for the different viewpoints of the two schools?

3 Compare *The White Girl (Symphony in White No. 1)* by James McNeill Whistler with John Singer Sargent's *Madame X*.

4 Compare *Nocturne in Black and Gold* by Whistler with *The Death of General Wolfe* by Benjamin West.

5 Compare Sargent's *The Daughters of Edward Boit* with John Singleton Copley's *The Gore Children*.

IV. Projects:

1 Examine several paintings by impressionists, either French or American. Try to develop a clear idea of how they worked, what sort of scenes they liked, and what kind of treatment they preferred to give. Where might they find suitable subjects in your community? What time of day would they have preferred to paint?

2 Every region of America has produced artists to record and express its nature. What local artists have painted your community, state, or region? What is their background? When did they work? What kind of local support did they receive?

BIBLIOGRAPHY

Ballinger, Richard M., and Herman York (eds.): *The Illustrated Guide to the Houses of America,* Hawthorn Books, Inc., New York, 1971. A pictorial introduction to the most popular styles of American home architecture.

Davidson, Marshall B. (author and editor in charge): *The American Heritage History of Notable American Houses,* American Heritage Publishing Co., Inc., New York, 1971. Contains essays on Richard Morris Hunt and Louis Sullivan as well as excellent illustrations of houses from every period of American history.

Prideaux, Tom: *The World of Whistler,* Time-Life Library of Art, Time-Life Books, New York, 1970. Excellent illustrations and a readable text make this a good introduction to Whistler's life and work.

Schneider, Pierre: *The World of Manet,* Time-Life Library of Art, Time-Life Books, New York, 1968. Includes a chapter on the French impressionists.

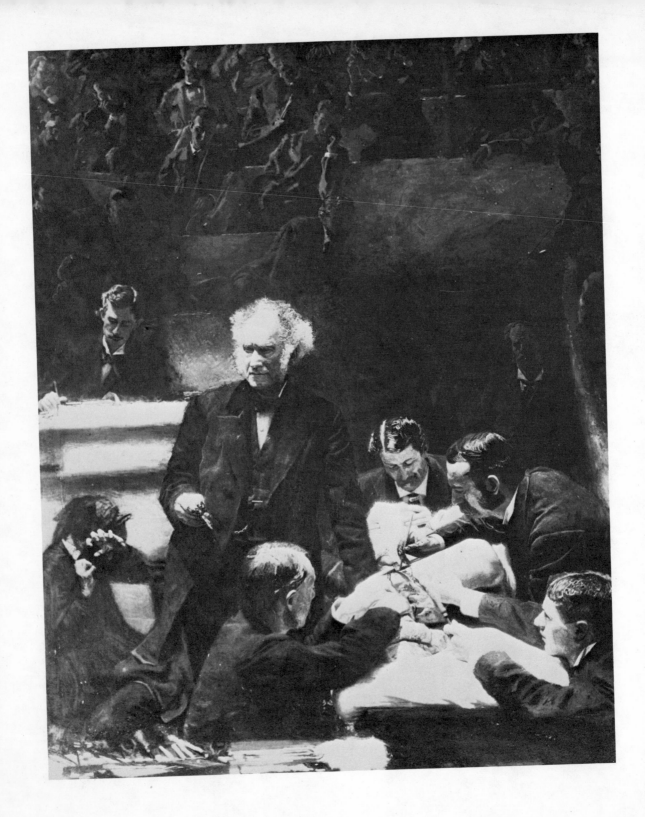

PROGRAM 10

THE EPIC OF THE COMMON MAN

. . . when you paint, try to put down exactly what you see. Whatever else you have to offer will come out anyway.

<div align="right">

Winslow Homer

</div>

If America is to produce great painters and if young art students wish to assume a place in the history of the art of their country, their first desire should be to remain in America, to peer deeper into the heart of American life, rather than to spend their time abroad obtaining a superficial view of the arts of the Old World. . . . It would be far better for American students and painters to study in their own country and portray its life and types. To do that they must remain free of any foreign superficialities. Of course, it is well to go abroad and see the works of the old masters, but Americans . . . must strike out for themselves and only by doing this will we create a great and distinctly American art.

<div align="right">

Thomas Eakins

</div>

Vastly different in training, style, and subjects, Winslow Homer (1836–1910) and Thomas Eakins (1844–1916) nonetheless achieved a "distinctly American art." Their realistic portrayals of Americans and

Thomas Eakins, The Gross Clinic, 1875. Thomas Jefferson University, Philadelphia.

American life, although at first misunderstood or undervalued by the public, encouraged other American artists to train and work on this side of the Atlantic.

OVERVIEW

The Period Approximately 1855 to 1910.

American Life The second half of the nineteenth century brought extraordinary changes to the country. The Civil War (1861–1865), which scarred a generation of Americans, was a turning point both in the history of the nation and in the conduct of war. For the first time railroads transported large numbers of troops rapidly and efficiently, ironclad ships fought each other (to a standstill), and balloons carried war into the air. The decades after the war were a wide open period of growth. Fortunes were made and lost overnight. The new Bessemer process for making steel was one of the many postwar technological advancements which, by 1910, was to change the United States from a rural, agricultural nation into a major industrial power. The cities grew and flourished. But the drive for wealth and success brought with it ugliness, exploitation, and misery, and eventually encouraged nostalgia for the pre-Civil War days when life was calmer and more enjoyable.

American Literature Mark Twain (1835–1910) gave the period a name with his novel *The Gilded Age* (1873). In *Huckleberry Finn* (1884) Twain captured the essence of the life that was disappearing, and his story "The Man That Corrupted Hadleyburg" (1900) is a classic study of hypocrisy and greed. Twain's contemporary, Henry James (1843–1915), traced some equally revealing portraits of the national character in *Daisy Miller* (1879) and *Washington Square* (1881). The most important book of the century, however, was written by an Englishman, Charles Darwin (1809–1883). Set forth in *The Origin of Species* (1859), Darwin's view that man is a lucky animal started a controversy that has never been completely settled. His concept of evolution disturbed many writers and artists of the period (the awareness of human limitations is a constant presence in the work of both Homer and Eakins), but it delighted businessmen. "Survival of the fittest" became the justification of every kind of unethical and inhumane business practice.

International Events England spent most of the period under the rule of Queen Victoria, the longest-reigning monarch in English history. France had two more revolutions (1848 and 1871) before forming a republic. Italy and Germany became unified countries, the latter by the hand of Otto von Bismarck and Prussia. Russia and the Austro-Hungarian Empire continued to decline in power and efficiency, moving toward disastrous collapse in World War I.

CONTENTS OF THE PROGRAM *Winslow Homer* Homer is discussed first not only because he was born 8 years before Eakins, but because he was by far the more successful of the two during his lifetime. A brief mention of Mathew Brady's photographic work during the Civil War is included.

Thomas Eakins Largely disregarded by contemporary critics and patrons, Eakins has continued to rise in esteem since his death.

VIEWER'S GUIDE

PRE-LOGO ILLUSTRATIONS *Portrait of Mrs. Eakins* (Eakins); *The Swimming Hole* (Eakins); *Eight Bells* (Homer); *The Gulf Stream* (Homer); *Snap the Whip* (Homer).

WINSLOW HOMER

Born in Boston in 1836, Winslow Homer found in his mother, a dedicated and proficient watercolorist, the first strong influence on his early development. At 19 he was apprenticed to a lithographer, but the long hours of work in a dark shop depressed him so much that when his apprenticeship was completed in 1857, Homer abandoned lithography and became a free-lance illustrator. During the Civil War he visited the Union Army on the eastern front and recorded his observations of camp life for *Harper's Weekly*. In 1862 he began to paint in oils.

The 1870s were a period of change for Homer. He turned his attention to rural children and Southern blacks and he took up watercolors. This new medium, little practiced by professional artists, helped Homer free himself from the linear emphasis of his wood-block training.

In 1881 Homer traveled to Europe, settling in an English fishing village near Tynemouth. The constant drama of the town's struggle with the violent North Sea so captivated him that the majesty of the human struggle with natural forces became the principal theme of his later work. In 1883 Homer moved permanently to Prouts Neck, Maine, a small fishing community. Able to work with few interruptions, he remained there except for occasional trips to the Adirondacks, the Canadian north woods, and the Caribbean, until his death in 1910.

Self-Portrait (Thomas Eakins, 1902).

Photograph of Winslow Homer (1910).

Winter, a Skating Scene (1868).

Detail from *The Beach at Longbranch.*

Winter, a Skating Scene and *The Beach at Longbranch* are examples of Homer's wood-block engravings. His precise powers of observation give his work a fine realistic atmosphere.

Home Sweet Home (circa 1863) is closely observed and carefully understated. There is no theatricality in stance or in gesture; we may only guess what the soldiers think, we cannot see it.

Mathew Brady (1823–1896) is the first great name in American documentary photography. During the Civil War he and his many assistants crisscrossed the battlegrounds, recording the effects of the war. The following photographs are representative of his work, even though it cannot be definitely stated, since

all photographs done by Brady or his assistants were published under Brady's name, that Brady actually took them.

The Ruins of Richmond (1865) is a detail of a photograph of the huge Gallego Flour Mill, burned during the Confederate retreat.

The Aftermath of Sedgwick's Assault, May 3, 1863, on Marye's Heights (1863) shows Confederate caisson wagons and horses destroyed by Union artillery. The two men are high-ranking Union officers.

Union Wounded after the Battle of Fredericksburg (1862).

Prisoners from the Front (1866) records, in the same fashion as *Home Sweet Home*, an incident of military life, but Homer transforms it into a tribute to the opposing forces. The Union officer, representative of Northern industrial might, has the calm, almost nonchalant attitude which great power affords. Standing defiantly opposite him is a Confederate officer, the essence of Southern pride. Homer suggests in the tension evident between the two men a reluctant admiration which honors both armies without glorifying either. The painting established Homer as an artist of talent. Of course fame had its drawbacks. To Homer's great annoyance, critics continued to praise the qualities of *Prisoners from the Front* long after its appearance, lamenting the changes in Homer's new work without understanding why he had made them.

Detail of Confederates from *Prisoners from the Front*.

Detail of Confederate and Union officer from *Prisoners from the Front*.

Croquet Scene (1866). Homer produced many scenes of the fashionable and genteel classes at play, and he particularly enjoyed painting pretty girls.

Detail of girl on right from *Croquet Scene*.

Detail of girl on left from *Croquet Scene*.

The Country School (1871) and *Snap the Whip* (1872: the Youngstown version) are companion vignettes of rural American life, the docile young students transforming themselves into the energetic participants of *Snap the Whip* during recess.

Details from *Snap the Whip*.

The Carnival (1877) was the product of one of Homer's vacation trips to Virginia after the war. He painted Southern blacks several times, partly because he admired them and partly because their bright costumes allowed him to experiment with color.

Detail of children from *The Carnival*.

Inside the Bar, Tynemouth (1884) was painted in America, but Homer brought the idea back from his stay in England. He found, in the fisherwomen of Tynemouth, qualities of courage and resourcefulness which he seems totally to have missed in America. The woman is larger and more powerful than Homer's American women, who are usually, as in *Croquet Scene*, delicate and demure. It is possible, however, that he somewhat idealized these unfamiliar people: the woman dominates her surroundings in a way that suggests a force of nature rather than an individual.

To the Rescue (1886) shows Homer's talent for effective understatement. As in many of his Civil War paintings, Homer shifts our attention from the dramatic physical struggle to its preparations.

The Life Line (1884) (painting) was as widely acclaimed as *Prisoners from the Front*. No small part of the painting's popular appeal was due to the way the young woman's water-soaked dress clings to her mature form. As he was to do more and more, Homer reduces the struggle for life to its simplest elements. The painting sold immediately for $2500, a large sum for Homer, whose oils usually brought only a few hundred dollars. Five years later he repeated the composition, but reversed the direction of the figures and retitled the new painting *Saved!*

Details from *The Life Line* (painting).

Lifeline (1884) is one of several etchings which Homer made between 1883 and 1889 of his best paintings. These inexpensive reproductions were one way to capitalize on a successful painting.

Eight Bells (1886 and 1890) emphasizes discipline and control. The oilskins and the nautical instruments indicate the men's respect for the power of the sea.

Detail of sky and figures from *Eight Bells*.

West Point, Prouts Neck (1900). Human figures are completely absent; we see only the play of natural forces, waves over rocks, sunlight on clouds, sky against sea.

Winter Coast (1890). The small human figure (in the left middle ground) marks the scale of the scene, but this painting, like the previous one, is essentially a seascape.

The Lookout—"All's Well" (1896) insists on the order and vigilance of shipboard life. Homer was particularly concerned with the bell itself, discarding several before he found one he liked.

Detail of water from *The Gulf Stream*.

The Gulf Stream (1899). Although surrounded by sharks reminiscent of the monstrous sea beast of Copley's *Watson and the Shark* (1778), the black fisherman lying on the deck of his dismasted sloop shows no sign of despair. Realist though he is, Homer has infused the scene with profound symbolic overtones.

Detail of the ship in the background from *The Gulf Stream*.

The Gulf Stream (1899).

Right and Left (1909), one of Homer's last works, is a meditation on the suddenness and the inevitability of death. One of his friends exclaimed upon seeing the picture, "Right and left!" hunter's jargon for killing two birds with twin discharges from a double-barreled shotgun. Homer liked the expression and kept it for the title.

Detail of hunter and quarry from *Right and Left*.

Right and Left (1909).

Detail of hunter from *Right and Left*.

Adirondack Guide (1894) is a watercolor from one of Homer's trips to the mountains of northeastern New York.

Detail of guide from *Adirondack Guide*.

Adirondack Guide (1894).

Palm Tree, Nassau (1898), *Under the Coco Palm* (1898), *Rum Cay* (1898–1899), and *The Turtle Pond* (1898) are representative watercolors from Homer's periodic trips to the Caribbean. His watercolors sold very well, usually for $175 to $200.

After his death, their value increased considerably. *Under the Coco Palm* was given to a Prouts Neck contractor in payment for some work. Its sale in 1920 brought enough money to send the contractor's son through medical school.

THOMAS EAKINS

Unlike Homer, Thomas Eakins underwent long and rigorous art training. Sometimes called a "scientific realist," he studied art as if it were a scientific discipline, spending years studying the human body in detail before he ever attempted a full-scale painting. The Philadelphia-born Eakins studied at the Pennsylvania Academy of the Fine Arts (1861–1866) and at the Ecole des Beaux-Arts in Paris (1866–1870). In 1870 he spent 6 months in Spain, where the paintings of Velásquez and Ribera introduced him to new and brilliant techniques for using light.

In 1882 Eakins was appointed director of the art school of the Pennsylvania Academy of the Fine Arts. He was a respected and successful teacher, but his insistence on allowing female students to draw from the male nude in mixed classes produced devastating results. Proper Philadelphia parents of the period looked upon the fine arts as good training for young women whose only choice for a career lay between marriage and spinsterhood. They considered drawing to be a social grace, not a professional activity, and had therefore no wish for a more rigorous and comprehensive course. A thorough professional, Eakins refused to alter his methods and resigned. Fortunately an inheritance allowed him to continue painting pictures he believed in. Despite belated attempts at recognition during the last 15 years of his life, when Eakins died his house was filled with unsold paintings.

Self-Portrait (1902).

Photograph of Thomas Eakins from around 1879.

The sketch of a rower shows Eakin's preoccupation with the physical interplay of objects. His elaborate analyses of perspective lines, undertaken as part of his preliminary work, might almost be considered finished works in their own right.

The Biglen Brothers Turning the Stake (1873), one of the many paintings Eakins devoted to sports, shows not only his love of physical activity, but his passion for a solid mathematical foundation. His pictures draw much of their unique strength from his solid grounding in anatomy, perspective, and physics.

The Gross Clinic (1875) is one of Eakins's largest paintings, some 8 feet long and 6½ feet high. The picture was intended for the Centennial Exposition, but Eakins, who pursued realistic effects quite as single-mindedly as he sought correct physical relationships, shocked doctors and artists alike by showing blood on Dr. Gross's scalpel and an open wound on the patient's thigh. For this unprecedented accuracy he was termed a "butcher," the picture was labeled "unfit" for a mixed audience, and it was excluded from the committee's display. (Ironically Dr. Gross was not one of Eakins's detractors. He never consid-

ered himself a "knife man" and was wholly pleased with his portrayal.) The painting was moved to the medical section, but even there it caused a disturbance. The picture Eakins began with high hopes was eventually sold for a mere $200.

Detail of the incision from *The Gross Clinic*.

The Gross Clinic (1875).

Detail of doctors and patient from *The Gross Clinic*.

The Anatomy Lesson of Dr. Tulp (1632) by Rembrandt and *The Maids of Honor (Las Meniñas)* (1657) by Velásquez. The work of Velásquez had a great influence on Eakins.

Detail of painter from *Las Meniñas*.

Detail of doctors from *The Gross Clinic*.

Detail of scalpel from *The Gross Clinic*.

Detail of painter and brush from *Las Meniñas*.

The Gross Clinic (1875).

Detail of the doctor and a student from *The Gross Clinic*.

Detail of patient's mother from *The Gross Clinic*.

Detail of doctors and incision from *The Gross Clinic*.

The Gross Clinic (1875).

The Agnew Clinic (1889), although even larger than *The Gross Clinic*, lacks the stunningly dramatic composition of the earlier picture and therefore does not affect us so profoundly. The even distribution of light and the horizontal emphasis deprive Dr. Agnew of the heroic strength of Dr. Gross. The white coats of the operating team testify to the great changes in antiseptic practice in just 14 years.

Portrait of Mrs. Eakins (1899) and *Lady with a Setter Dog* (1885) are both portraits of Eakins's wife, Susan Hannah Macdowell, whom he married in 1884. These two portraits, done 15 years apart, help explain why so many sitters rejected his work. The anguish and despair apparent in Mrs. Eakins's face are scarcely the sort of emotion that a well-to-do patron of the arts would care to display to family or guests. Such intimate glimpses of the inner person were shocking to well-bred Philadelphians. Notice particularly, in *Lady with a Setter Dog*, how Eakins makes use of the hand lying across the open book, the curve of the sitter's body, and the large dark eyes gazing toward us to create a melancholy atmosphere. We prize the human qualities that Eakins reveals, but his contemporaries thought otherwise. He had few commissions; his sitters were often friends and former students—and some of them even refused his work. (The illustration of *Lady with a Setter Dog* is reversed.)

The Girl with a Big Hat (Lilliam Hammitt) (1888).

Margaret (1871), Eakins's favorite sister, was a frequent subject.

Miss Van Buren (1885). The head turned to one side, the supporting arm, the slight slouch, all suggest some inner turmoil. Eakins, constantly at odds with his society, was quick to notice a similar alienation in his sitters. (This illustration is reversed.)

Professor Henry A. Rowland (1891). Eakins, an enthusiastic mathematician, took particular pleasure in crowding the frame with mathematical notations.

William Rush (1756–1833) was America's first outstanding sculptor. His figureheads in particular were known all over the world.

Self-Portrait (1822) by William Rush.

Schuylkill Chained (1828) by William Rush.

William Rush Carving His Allegorical Figure of the Schuylkill River (1877) by Thomas Eakins. Rush used a nude model for his allegorical statue, *Water Nymph and Bittern* (1809). A well-bred young Philadelphia woman agreed to pose for him, but even though she was accompanied by a chaperone at all sittings, Philadelphia society was outraged. Eakins, who became embroiled in a similar controversy, no doubt recognized a kinship with the sculptor.

Eakins worked with photographic pioneer Eadweard Muybridge on studies of people in motion. Eakins's technique of using a single camera was an important improvement on Muybridge's multiple camera setup and led directly to the motion-picture camera.

Man Walking (1884) by Eakins.

Detail from *Man Walking*.

The Swimming Hole (photograph, 1883), by Eakins.

The Swimming Hole (1883) glorifies two of Eakins's passionate interests: the outdoor life and the nude figure. He has included himself in the lower right-hand corner.

Details of nude figures from *The Swimming Hole*.

The Swimming Hole (1883).

Photograph of Walt Whitman by Eakins (1892).

Walt Whitman (1888). Whitman's praise for Eakins was equaled only by Eakins's admiration for Whitman's poetry. "I never knew but one artist," said Whitman, "and that's Tom Eakins, who could resist the temptation to see what they think ought to be rather than what is."

POST-PROGRAM ILLUSTRATIONS *Portrait of Mrs. Eakins* (Eakins); *The Gross Clinic* (Eakins); *The Carnival* (Homer); *The Swimming Hole* (Eakins); *Eight Bells* (Homer); *Prisoners from the Front* (Homer); *The Gulf Stream* (Homer); *Snap the Whip* (Homer); *Max Schmitt in a Single Scull* (Eakins) (1871) (not shown in the body of the program); *Adirondack Guide* (Homer); *Rum Cay* (Homer).

QUESTIONS AND PROJECTS

I. Identify or define:

wood engraving	Pennsylvania Academy
Harper's Weekly	of the Fine Arts
life drawing	engraving
perspective	chiaroscuro
Herbert Spencer	theatricality
realism	Charles Darwin

II. Developmental questions:

1 Realism. Drawing on whatever examples you wish, devise a suitable definition of realism. (As an aid in preparing your definition, consider the contrary of realism as well as realism itself.) What do realistic artists seek to convey with their work? Who are some important realistic painters?

2 Art education. What are the usual courses for an art student? What is the purpose of life drawing? What does it teach? Is it possible to gain the same information and develop the same skills without life drawing?

3 Perspective. What is perspective? Is there more than one kind of perspective? Is perspective an absolutely necessary part of an artist's technique? Where did perspective originate?

III. Essay and opinion questions:

1 Realism, according to Eakins, is a way of looking at things. Homer and Eakins are both called "realists," yet their paintings differ in many respects. What differences and what similarities do you find? Is it possible to include both men in a single definition of realism? What evidences can you find in their work of their difference in training? How does an artist learn his craft best?

2 Eakins never lost his enthusiasm for the nude figure as a method of teaching. Yet he painted very few nudes and those he did are not the works for which he is best known. Of what use are rigorous anatomy and life drawing studies if most of a painter's figures are clothed? Is life drawing necessary for a portraitist?

IV. Projects:

1 Look around your community for the sort of subjects that would interest Homer and Eakins. After you have found suitable material for them, consider how they would treat it. (It might be instructive to consider how they would treat each other's subjects.) Be sure to include a justification of your choice. As a more advanced project, you might indicate composition and color.

2 For Eakins light was "the big tool." Investigate the artistic possibilities of light. First, take a three-dimensional object—a bust or some kind of artifact—and experiment with different ways to light it. What is the purpose of light? How does Eakins use light in his paintings? Does his use of light differ from Homer's? Examine several pictures. What direction is the light coming from? How do the shadows help you "see" the scene?

3 Eakins used photographs as aids in composing his pictures. In what way did photographs help him in *The Swimming Hole*? Look at other paintings, by Eakins or other artists. What insights could photographs provide that the artist might not be able to give himself? Would a photograph be helpful in portraiture?

BIBLIOGRAPHY

Flexner, James Thomas: *The World of Winslow Homer,* Time-Life Library of Art, Time-Life Books, New York, 1967. Contains a chapter on Thomas Eakins as well.

Horan, James D.: *Mathew Brady: Historian with a Camera,* Crown Publishers, Inc., New York, 1955. Excellent collection of Brady photographs and a good biography.

PROGRAM 11
THE WORLD'S COLUMBIAN EXPOSITION

He could now, undisturbed, start on the course of practical experimentation he long had in mind, which was to make an architecture that fitted its functions—realistic architecture based on well defined utilitarian needs—that all practical demands of utility should be paramount as basis of planning and design; that no architectural dictum, or tradition, or superstition, or habit, should stand in the way. He would brush them all aside, regardless of commentators. For his view, his conviction was this: That the architectural art to be of contemporary immediate value must be plastic; all senseless conventional rigidity must be taken out of it; it must intelligently serve—it must not suppress. In this wise the forms under his hand would grow naturally out of the needs and express them frankly, and freshly. This meant in his courageous mind that he would put to the test a formula he had evolved, through long contemplation of living things, namely that form follows function, which would mean, in practice, that architecture might again become a living art, if this formula were but adhered to.

"The Autobiography of an Idea" (1923–1924), by Louis Sullivan.
(The "he" refers to Sullivan, who wrote the book in the third person.)

The Lincoln Memorial. Photo courtesy of the National Park Service.

The 1890s are one of the fabled periods of frivolity and prosperity, somewhat similar to the 1920s. The World's Columbian Exposition proclaimed the country's debt to Europe, but it also proved its independence and distinctness. American architects were to spend the next few decades in a final flurry of adapting European models to the new country. At the same time, however, Louis Sullivan, symbol of a native American response to architectural needs and problems, shines out as the mark of the move toward an American art more firmly rooted in the life and the new traditions of the United States.

OVERVIEW

The Period Program 11 focuses on the 1893 Columbian Exposition, but the discussion of architecture and sculpture extends over a period from approximately 1870 to 1923.

American Life In 1890, when bidding began to determine the site of the Great Exposition to celebrate the 400th anniversary of the discovery of America, the population of the United States stood near 63 million people, an increase of some 13 million during the previous decade—almost 5 million of which was due to immigration. Chicago, the fastest-growing city in the Midwest, won the contest, sealing the contract with a $5 million down payment.

The Fair itself was a great success. More than 27 million people visited the Exposition during its 6-month run, and some 22 million paid admissions were recorded. Little Egypt introduced fairgoers to the belly dance, politely advertised in the original French as the *danse du ventre*. The Great Wheel, designed by George Washington Ferris and Buffalo Bill's Wild West Show were also great attractions.

American Literature Stephen Crane (1871–1900) touched on the perils of the urban environment in *Maggie: A Girl of the Streets* (1893) and on the horrors of the Civil War in *The Red Badge of Courage* (1895). The historian F. J. Turner (1861–1932) contributed a classic idea to American history in a paper entitled "The Significance of the Frontier in American History" (1893). The local-color movement, to be echoed in later twentieth-century art and literature by the regionalists (see Program 15), featured excellent writers like Sarah Orne Jewett (1849–1909) with stories of New England, Joel Chandler Harris (1848–1908), who wrote of life, both black and white, in Georgia, and Bret Harte (1836–1902), one of the first writers of the West.

International Events In France one of the most celebrated cases of judicial injustice began: In December 1894 Captain Alfred Dreyfus was found guilty of passing military secrets to the Germans. The repercussions from the case were to occupy the country for some 12 years, culminating in 1906 with a pardon and full rehabilitation for the wrongly accused Dreyfus. In the Far East Japan fought a brief war with China, obtaining the Liaotung Peninsula, Formosa, and the Pescadores in the peace settlement.

CONTENTS OF THE PROGRAM *Architecture* A discussion of the most important architects of the late nineteenth century—Richard Morris Hunt, H. H. Richardson, Louis Sullivan, and the firm of McKim, Mead, and White—is intermingled with an examination of the architecture of the World's Columbian Exposition. The great engineering feat of the century, the Brooklyn Bridge, is briefly commented on.

Sculpture The Columbian Exposition provides the starting point for a consideration of the principal American sculptors of the late nineteenth and early twentieth centuries: Frederick MacMonnies, Daniel Chester French, and Augustus Saint-Gaudens.

Mural Painting The Exposition buildings featured miles of murals, and the decades around the turn of the century saw a revival of mural painting in the United States. The principal muralists considered here are John La Farge and Abbott Thayer.

Painting The painters whose works were shown at the Exposition include John Singer Sargent, James McNeill Whistler, Winslow Homer, George Inness, Thomas Moran, and Thomas Eakins. These artists are discussed in detail in previous programs.

Memorial Sculpture The program closes with a short excursion to Rock Creek Cemetery near Washington, D.C., to study Augustus Saint-Gaudens's statue for the Adams Memorial.

VIEWER'S GUIDE

PRE-LOGO ILLUSTRATIONS *Fine Arts Building* (Columbian Exposition); *Manufacturer's and Liberal Arts Building; * bird's-eye view of Columbian Exposition (drawing); *Woman's Building; Court of Honor* (logo).

ARCHITECTURE

Bird's-eye View of the Fair (contemporary lithograph).

The Court of Honor, World's Columbian Exposition (1893). The buildings around the artificial basin form an architecturally homogeneous group. All are in the classical-Renaissance style and all have a uniform cornice line. The strength of this grouping was largely responsible for the enthusiasm for classical architecture which prevailed in the country for the next three decades.

Detail of building entrance from *The Court of Honor.* This photograph shows the large pillars and cornice which were so enthusiastically commented on by visitors.

Richard Morris Hunt (1827–1895), the first of many American architects to study at the Ecole des Beaux-Arts, began his career in Paris as a government inspector of buildings. He could easily and profitably have remained there, but he felt drawn to the challenge of the United States. After several years of moder-

ate success Hunt firmly established himself as the architect of the wealthy with the great Vanderbilt chateau on Fifth Avenue (1879–1881). In 1888 he built the first of the great Newport palaces, Ochre Court, for Robert Goelet. By the close of his career he was the recognized leader of his profession.

The Administration Building Illuminated at Night (1893) (contemporary lithograph).

The Administration Building (photograph) World's Columbian Exposition, Chicago (1893). The Eastern architectural firms dominated the construction of the Exposition buildings. Under Hunt's direction, it was agreed that a uniform style—Renaissance and classical—and a uniform color—white—would prevail. Naturally the public blessed the finished product with the nickname "the White City."

The Fine Arts Building (now the Museum of Science and Industry) (1893) is the only Fair building still standing. At the close of the Exposition the White City became a colossal white elephant—a fire destroyed some of the buildings in the summer of 1894 and the rest were eventually torn down and their materials sold. The Fine Arts Building, however, was bought by the city and used to house the Field Museum of Natural History until 1920. In 1932 the entire structure was modernized and reopened as the Museum of Science and Industry.

The designer of the Fine Arts Building, Charles B. Atwood (1848–1895) joined Burnham and Root in 1891 after several years of work and study in the eastern United States. Appointed chief designer for the Exposition, Atwood participated in the planning of some sixty Fair buildings. The Fine Arts Building, however, is generally considered to be his own conception.

The Woman's Building (1893) was entirely designed and decorated by women. A recent graduate of the Massachusetts Institute of Technology, Sophia G. Hayden (1868–1953) was 22 when her design won the competition for the building. With her victory came $1000 and short-lived fame. Mrs. Potter Palmer, wife of the owner of the well-known Palmer House hotel, was the principal force behind the building and the exhibits. She selected Mary Cassatt (her adviser on modern painting for her collection) to decorate one end of the hall with a panel decoration entitled "Modern Woman." Mrs. Frederick Mac-Monnies, wife of the sculptor, carried out a companion panel, "Primitive Woman," on the opposite wall.

Detail of facade of *Woman's Building*.

Peristyle, Court of Honor (looking toward Lake Michigan).

Manufacturer's and Liberal Arts Building.

Monticello (1770–1800) by Thomas Jefferson (Program 4).

Free Library of Philadelphia (1927) by Horace Trumbauer (1868–1938). After opening his own office in 1892, Trumbauer did no more drawing of his own, preferring to turn over his commissions to the chief designer of the firm, Frank Seeborg. The full-size statuary of the Free Library used colored ceramics, one of the first attempts in the United States to imitate the multicolored statues of the Greeks.

Biltmore (1893–1895, designed by Richard Morris Hunt) near Asheville, North Carolina, cost well over $4 million to construct. George Washington Van-

derbilt, the younger brother of Cornelius and W. K. Vanderbilt, almost bankrupted himself in building it. The magnificent structure stands on a 130,000-acre estate in the middle of the Great Smoky Mountains. Although Hunt drew on the French Loire Valley chateaux for his design, the result is an original creation rather than an imitation. Frederick Law Olmsted designed the gardens.

The New York firm of McKim, Mead, and White, the best-known and most prestigious of the late nineteenth-century architectural firms, remains one of the magic names of American architectural history. Charles Follen McKim (1847–1909) and William Rutherford Mead (1846–1928) formed their partnership in 1872 with Stanford White (1853–1906) joining the firm 7 years later. Educated at the Ecole des Beaux-Arts in Paris, the three architects became the principal American exponents of refined design in the Beaux-Arts eclectic style. Like Richard Morris Hunt they built for the rich, and their tremendous prestige encourage Burnham to invite them to participate in the construction of the Exposition. The firm was particularly active in New York City, building Madison Square Garden, Columbia University, the Century Club, and the Metropolitan Museum of Art. They also designed private residences: their plan for the Newport house of Henry Taylor is credited with inaugurating a colonial revival.

The Villard Mansion, New York City (1885), established the firm's reputation. Stanford White, the architect chiefly responsible for the design, drew on the Renaissance palaces of Rome for ideas, but the essence of the beaux arts eclectic style is adaptation, not imitation. Built for the railroad financier Henry Villard, manager of the Northern Pacific Railroad, the mansion is actually five separate town houses. Villard occupied only one of the wings, although angry stockholders, believing the entire mansion to be his residence and convinced that he had misappropriated company funds to indulge his extravagant desires, gathered outside to protest. Ironically, Villard had moved in early, before construction was entirely finished, in order to save money being spent on hotels. Augustus Saint-Gaudens (see below) contributed an elegant sculpted clock to the sumptuous interior.

Daniel Hudson Burnham (1846–1912) and John Wellborn Root (1850–1891) were second only to Louis Sullivan in their ability to design attractive and efficient commercial buildings. Trained by American architects, they applied themselves directly to the problems of American urban design. The talented, mercurial Root provided the creative ideas while Burnham, a man of exceptional will and perseverance, was primarily concerned with the business details.

The Monadnock Building (1889–1891). Although Root had tried to persuade Mr. Aldis, the man in charge of the investment, in the direction of a more ornate structure, he finally gave in and designed a building without ornaments. The structure had a "floating raft" base, in which iron rails reinforced the concrete as a means of distributing the building's weight over a larger area and allowing for possible shifting of the porous Chicago ground. The strong metal skeleton, composed of cast-iron columns and wrought-iron beams, allowed the architect to create a ripple effect with the protruding bays of windows.

Photograph of John Root (1890).

Root was a gifted architect with strong personal preferences and a distinctive way of realizing them. Had he lived to carry out the planning of the Exposition, the course of American public architecture in the next half century would probably have been considerably different. At issue was the choice between native solutions to native problems and adaptation from foreign sources. The Chicago school produced a distinctly American kind of architecture; the Beaux-Arts-trained Eastern architects adapted European designs to express the aspirations and accomplishments of the new industrial millionaires.

The Monadnock Building (1889–1891).

Peristyle, Court of Honor, Columbian Exposition (1893).

Henry Hobson Richardson (1838–1886) was arguably the most influential American architect of the nineteenth century. A native of Louisiana, he found the beautiful buildings in Cambridge, Massachusetts (where he attended Harvard University), so captivating that he decided to become an architect. Why he chose to study architecture in Paris is a minor mystery to scholars. Richard Morris Hunt, the first American student there, had lived in France for several years prior to enrolling. When Richardson failed every entrance exam but mathematics on his first try, he may also have wondered about his decision. He succeeded the next year, however, and became the second American to enroll in the Ecole des Beaux-Arts. Returning to the United States in 1865, he opened an office in New York City, but in 7 years he gained only one commission. His career took a dramatic turn in 1872, when he won the design competition for the construction of Trinity Church in Boston. Richardson's design marked the beginning of a new style, strongly related to the French Romanesque, which has been termed "Richardsonian."

Trinity Church, Boston (1872–1889), considered Richardson's masterpiece, is one of the finest church designs in the United States. The design which won the competition, however, was drastically modified during the 5 years of construction. The coarse, rusticated stone, the curved arches, and the towers are considered the distinctive marks of the Richardson Romanesque. Later architects, however, continued to incorporate these superficial features in their designs, but neglected the essential unity and functionality of Richardson's work.

The Marshall Field Wholesale Building, Chicago (1884–1886), is an excellent example of the way Richardson adapted his designs to fit the needs of the patron. He treats the windows as important and necessary ingredients of the building rather than as superficial features which must be incorporated into a pleasing surface pattern. His windows are intended to light the interior first and to make an aggreeable aesthetic pattern second. That he succeeds in doing both is a mark of his skill.

Although the warehouse is only seven stories high, its vertical emphasis points the way toward the skyscrapers of the twentieth century. Other Chicago architects were influenced by the warehouse, but probably none to the extent that Louis Sullivan was. Richardson's lack of ornamentation gave Sullivan the idea for the strong vertical emphasis of the Wainright Building (1890).

Louis Sullivan (1856–1924), entered the Massachusetts Institute of Technol-

ogy (M.I.T.), the first architectural school in the United States, in 1872. His independence and his ambition, however, caused him to quit at the end of his first year. After working briefly in New York and Philadelphia, Sullivan moved to Chicago, where he began work as a draftsman in the office of William Le Baron Jenney, one of the most prominent Chicago architects. In 1874, he sailed for Europe to study at the Ecole des Beaux-Arts, but once again he became impatient and stayed less than 6 months. Returning to Chicago, Sullivan worked for several firms before joining Dankmar Adler in 1879. Two years later he became a full partner in the firm of Adler and Sullivan. In 1895 Sullivan dissolved the partnership with Adler, a decision which marked the beginning of his professional decline. Sullivan's commissions dwindled; he received some twenty during the twenty-nine remaining years of his career as compared to over 100 prior to 1895.

Detail of *Wainwright Building,* St. Louis (1890–1891). Designed by Louis Sullivan.

Wainwright Building, St. Louis (1890–1891). Although it appears in this photograph to be a slim, rectangular construction, the Wainwright Building is actually U-shaped. A narrow court on the north side of the building provides additional lighting for the offices around it. The division by colors—red granite at the base, followed by two stories of brown sandstone and red-brick piers from the third through the tenth floors capped by a top story and cornice of red terra cotta—works against the vertical thrust, but the building is Sullivan's first great triumph in steel-frame commercial construction.

The Crystal Palace, London (1851), by Joseph Paxton (1801–1865). Built for the Great Exposition in 1851, the Crystal Palace, constructed of iron and glass, made brilliant use of standardized, prefabricated parts. After the close of the Exposition, the palace was dismantled and rebuilt, in an enlarged version, on Sydenham Hill in southeastern London. In 1936 a fire completely destroyed the building, which then housed the Imperial War Museum. Sir Joseph Paxton, the architect, pioneered in using iron and glass as building materials.

Interior of the *Crystal Palace* (1851) (photograph).

The Eiffel Tower (1887–1889) by Gustave Eiffel (1832–1923) was the marvel of the Paris Exposition of 1889 and has since become one of the most famous sights of the city. Only its usefulness as a radio transmitter (the tower is over 1000 feet high), however, kept it from being torn down. Eiffel, like Paxton, was a great believer in the use of steel as a building material.

Woman's Building (1893) (Sophia V. Hayden).

Bird's-eye View of the Fair (emphasizing the Liberal Arts Building).

Detail of pillars and cables from the *Brooklyn Bridge* by John and Washington Roebling.

German-born John Roebling (1806–1869) a graduate at the Royal Polytechnic School in Berlin, emigrated to the United States in 1831. As an engineer on canals in the eastern United States, he perfected the first steel cable, and established a factory to produce them. In 1846 he built his first suspension bridge in Pittsburgh, Pennsylvania, with cables from his own plant.

Washington Roebling (1836–1926) was born in Saxonburg, Pennsylvania.

After studies at Rensselaer Polytechnic Institute, he went to work for his father. The completion of the Brooklyn Bridge was the principal accomplishment of his career.

The Brooklyn Bridge (1869–1883). To connect Manhattan with Long Island, John Roebling conceived of a suspension bridge with towers 272 feet high and a central span some 1600 feet long to link the two areas. So daring and imaginative was his plan and so unlike any yet attempted that many architects declared the bridge an impossibility. His design was approved, however, and construction began. But John Roebling was injured during the preliminary work, contracted lockjaw, and died with the plans as yet only roughed out, leaving his son to assume complete responsibility for the work. The foundations were laid down in 1871. That same year the younger Roebling was stricken with caisson disease (the bends) and paralyzed from the waist down. Completely dedicated to the bridge work, he continued to direct construction from his home on Columbia Heights, where his wife kept watch on the bridge through a telescope and kept him informed of its progress. Despite his infirmity, Roebling wrote orders to cover every aspect of the construction until its completion in 1883.

Detail of ferris wheel from *Bird's-eye View of the Fair*.

Administration Building during construction (R. M. Hunt).

Detail of the *Transportation Building* (Sullivan).

Transportation Building, Columbian Exposition, Chicago (1893). The structure somewhat resembles a passenger coach, with its long, low profile and raised central section—an appropriate choice in view of the fact that the main displays featured Pullman coaches and other railroad equipment.

The rounded arches and the high bays are typical features of Sullivan's commercial buildings.

Detail of the Golden Doorway from the *Transportation Building*. The series of recessed half circles covered in gold leaf were one of the most popular sights of the Fair. The building and the doorway have perhaps received more attention than they deserve because they were so markedly different from the rest of the edifices. The French in particular praised Sullivan's design, awarding him three gold medals for architectural excellence.

Detail of cornices and spandrels from the *Wainwright Building*.

Detail of upper facade and cornices from the *Guaranty Building*.

The *Guaranty Building*, Buffalo, New York (1894–1895). Again Sullivan created a U-shaped design with a light court in the back. Unlike the Wainwright Building, however, the Guaranty Building (later the Prudential Building) makes clear its steel skeleton. The vertical piers, for example, are almost completely shorn of their masonry padding. The curved arches at the top of the vertical risers, capped by the round windows and overhanging curved cornice, draw the eye upwards, increasing the sense of vertical extension. The building is slimmer, lighter, and more striking than the Wainwright Building. It was the last design made by Adler and Sullivan.

Detail of facade from the *Guaranty Building*.

Detail of round top windows and cornice from the *Guaranty Building*.

Carson Pirie Scott Building, Chicago (1899–1904, addition 1906). The continuous spandrels emphasize horizontality and suggest the commercial nature of the building. The huge window displays lead toward the main entrance at the corner of the block. The first two stories are decorated with elaborate cast-iron sheathing, featuring intricate scrolls and interlaced leaves.

Detail of Chicago windows from *Carson Pirie Scott Building*.

Security Bank of Owatonna, Minnesota (1907–1908), is probably the best example of Sullivan's designs during his last 20 years as an architect. By using great sweeping arches and delicate surface decoration, Sullivan turned an essentially boxlike building into a beautiful display of modern commercial life. The interior of the building illustrates the meaning of "form follows function." Sullivan adorns the business apparatus, thus converting business activity into something unique and pleasurable.

Lincoln Memorial, Washington, D.C. (1923). Henry Bacon (1866–1924) began his career as a draftsman for McKim, Mead, and White in New York City. He designed buildings over a wide range—public and commerical structures, churches, hospitals, libraries, and private dwellings—as well as monuments of varied nature.

Detail of entrance to the *Lincoln Memorial*.

The *New York Public Library* (1897–1899). The architects, John Merven Carrère (1858–1911) and Thomas Hastings (1860–1929), learned architectural principles at the Ecole des Beaux-Arts in Paris and put them into practice drawing plans for McKim, Mead, and White. They drew on French models, particularly the seventeenth-century facade of the Louvre, for their design of the New York Public Library.

City Hall, San Francisco (1912–1915), by Bakewell and Brown.

New York Post Office Building (1912) by McKim, Mead, and White.

The Palace of Fine Arts, San Francisco (1915) by Bernard Maybeck. Built for the Panama-Pacific Exposition, the peach-colored palace resembles something out of the romantic paintings of Thomas Cole. Maybeck was one of the most prominent West Coast architects during the first half of the twentieth century. Educated at the Ecole des Beaux-Arts in Paris, he worked with Carrère and Hastings in New York before moving permanently to California in 1899. His design for the First Church of Christ, Scientist, in Berkeley is one of the most untraditional examples of church architecture in the United States.

Details of Corinthian columns and cornices from the *Palace of Fine Arts*.

Pennsylvania Station (1910, demolished 1964) by McKim, Mead, and White.

Interior of *Pennsylvania Station* (1910).

Entrance to Columbian Exposition (1893).

SCULPTURE

Frederick MacMonnies (1863–1937), a protégé of Augustus Saint-Gaudens, entered the Ecole des Beaux-Arts in 1884. Twice recipient of the Prix d'Atelier, the

highest honor open to a foreigner, MacMonnies eventually left the school to study privately in the studio of Jean Alexandre Falguière. His honorable mention for a statue of Diana in the Salon of 1889 brought him several commissions, among them a life-size statue of Nathan Hale (1890). He spent most of his professional life in Paris.

The *Triumph of Columbia* (1893) cost considerably more than the $50,000 MacMonnies received for it, but he more than compensated for his loss through the increase in commissions brought about by the fountain's critical success. Also called "The Barge of State," the ship was made of staff and did not survive long after the close of the Exposition. The allegorical figures were led by a winged Fame. The eight powerful rowers represent the arts (music, architecture, sculpture, and painting) and the industries (agriculture, science, commerce, industry) while the helmsman is Father Time. Columbia, with the torch of enlightenment in her hand, sits atop the high throne.

The *Columbia Fountain* (1893).

Detail of winged figure of Fame on prow from the *Columbia Fountain* (1893).

Detail of rowers and Columbia from the *Columbia Fountain* (1893).

The *Greek Slave* (1846) by Hiram Powers (Program 4) was the first popularly accepted nude sculpture in the United States. (This image is reversed; the young woman should actually be looking to her left.)

The *Bacchante with an Infant Faun* (1893). This monumental salute to drink, standing almost 7 feet high, was inspired by a Parisian model named Eugenia. MacMonnies finished the work in Paris soon after his return from completing the *Triumph of Columbia* and gave the original to the architect, Charles McKim, who placed it in the courtyard of the Boston Public Library (which he and his firm had designed in 1887). Bostonians, however, found the statue too sensual and declared it unsuited for public display. McKim reluctantly removed the statue and offered it to the New York Metropolitan Museum of Art. The American Purity League and the Social Reform League tried to prevent the museum from acquiring it, but the trustees refused to give in and the *Bacchante* is still on display there. One critic noted that had MacMonnies substituted a rattle for the grapes, he would have made a good deal less trouble for himself.

Daniel Chester French (1851–1939) lived in Exeter, New Hampshire, and Cambridge, Massachusetts, before moving to Concord, Massachusetts, in 1867, arriving at a time when the town's prominence in national affairs far exceeded its size. Ralph Waldo Emerson lived there, as did Bronson Alcott and his daughter Louisa May, the author of the extremely popular *Little Women* (1868). Thoreau and Hawthorne had lived there, as had James Russell Lowell and the feminist Margaret Fuller. Abigail Alcott gave French some instruction in clay modeling, but he received his first professional instruction from William Rimmer (see Program 8) in Boston. In 1873 French's design won the local competition to choose a monument to the men who fell at Concord Bridge in 1775. In 1875, his success stimulating his ambition, French went to Italy to study, one of the last of the American sculptors to choose Rome or Florence rather than Paris.

The Republic (1893) originally faced MacMonnies's *Triumph of Columbia* across the artificial lake in Jackson Park. Made of staff like all the other sculptures at the Columbian Exposition, *The Republic* stood 65 feet high. French and his workmen put the statue together section by section and then covered the finished product, except for the head and arms, with gold leaf.

The Republic (1916). This is a smaller gilded bronze copy now standing in Jackson Park.

French at work on the monumental head of *The Republic*.

Falling Gladiator (1861) by William Rimmer (Program 8).

Henry Ward Beecher (1891) by John Quincy Adams Ward.

John Quincy Adams Ward (1830–1910), one of America's outstanding nineteenth-century sculptors, was best known for his realistic statues.

The Minute Man (1874) was modeled on the *Apollo Belvedere*, with the exception of the forearms, which French took from a Connecticut farmer. The costume was contributed by families in the Concord area, as was the old plow. Although French received no fee for his work, the Concord city officials agreed to cover his expenses, and he finished the statue in Boston in a rented studio. By the time of the unveiling, however, he had already departed for Italy.

Photograph of Ralph Waldo Emerson.

Ralph Waldo Emerson (1879) was modeled in Concord after French's first stay in Europe. Emerson is said to have commented to French during the sittings, "You know, Dan, the more it resembles me, the worse it looks."

Lincoln (1922), carved out of twenty-eight blocks of marble by the noted Piccirilli brothers of New York City, weighs over 170 tons. The statue was carefully planned as part of the Lincoln Memorial, where it was to be displayed, and French modeled his statue to take best advantage of the overhead light that Henry Bacon, the architect, intended to provide. But alterations in the design of the monument changed the lighting so drastically that French's *Lincoln* lost his statesmanlike demeanor and took on an expression of quizzical confusion. The problem was finally solved by placing powerful electric lights above the statue in such a way that the strong eye shadows and facial modeling of the light are restored. (Unfortunately this illustration was taken with front lighting and restores the look of bewilderment that French wished to avoid.)

The *Low Library* (1901–1906) by McKim, Mead, and White.

Alma Mater (1902–1903) stands in front of the Low Library of Columbia University, built by McKim, Mead, and White.

Mercury Group from Grand Central Station terminal.

Daniel Chester French (1905). This bust was executed by Mary Cresson French, the sculptor's wife and niece of Augustus Saint-Gaudens.

Augustus Saint-Gaudens (1848–1907) was born in Dublin, Ireland, the son of a French father and Irish mother. He began his career as a cameo cutter, showing such obvious talent that his father sent him to Paris to continue his studies. He remained there 5 years. His first important and successful commission, a commemorative portrait of Admiral Farragut (1881), established Saint-Gaudens as the premier sculptor in the United States. He never afterwards

lacked commissions. Often working with Stanford White and Charles McKim on their great architectural projects, Saint-Gaudens exerted a lasting influence on the succeeding generation of American sculptors.

Augustus Saint-Gaudens (1920–1924) by John Flanagan (1865–1942). Flanagan, who worked in Saint-Gaudens's studio for 3 years before leaving to study in France, is best known for his medals. His bust was begun in 1905 and abandoned in 1907, when Saint-Gaudens became ill. Flanagan returned to the work in the 1920s, completing it in 1924.

Diana (1892), Saint-Gaundens's only nude figure, was created to stand atop Madison Square Garden. A similar version was displayed on the Agricultural Building at the Columbian Exposition.

Saint-Gaudens's work aroused a few strains of moral indignation, but she was too high and New York was too sophisticated for the kind of turmoil that developed in Boston over MacMonnies's *Bacchante.*

Photograph of Augustus Saint-Gaudens.

Lincoln (1887). Saint-Gaudens had seen Lincoln campaigning in New York City, and he had as well the life mask and casts of Lincoln's hands to work from. His *Lincoln* is both a naturalistic portrait and an ideal representation, a suggestion of the ideals embodied in the man.

The *Farragut Monument* (1881) is a realistic yet restrained portrayal of Admiral David Farragut, the naval officer who was best remembered for his cool conduct at the Battle of Mobile Bay. As the Union flotilla sailed into the Confederate-held harbor, Farragut, to get a better view of the action, climbed into the rigging and cried to his subordinates, "Damn the torpedoes! Full speed ahead!!" The base of the statue was created by Stanford White, Saint-Gaudens's good friend.

The *Shaw Memorial* (1884–1896). Colonel Robert Shaw was killed in 1863 leading a company of black Federal soldiers in an attack on a Confederate fort in Charleston Harbor. Saint-Gaudens began the work as his first major undertaking after the *Farragut Monument*, but he continually put it aside to work on more lucrative commissions. The memorial gradually evolved from an equestrian monument into a bas-relief that became almost freestanding. He modeled the heads of the soldiers on men he found all over the Eastern seaboard, from Boston to New York. He was meticulous about his work, often throwing out the finished portrait when it did not give the effect he sought. As a result these heads are among the finest of his achievements.

The Angel of Death Staying the Hand of the Sculptor (1891–1892) by Daniel Chester French is a marble copy of the original bronze of 1891–1892, which stands in Forest Hills Cemetery, Boston.

MURAL PAINTING

Stevenson Memorial Angel (1903) by Abbott Thayer (1849–1921). Thayer studied in New York and in Paris. During his European stay he began to concentrate on

figure painting, eventually arriving at the idealized female figure for which he is chiefly remembered. He created large numbers of madonnas, virgins, and youthful girls with angelic demeanor and wings to match. Fascinated by the protective coloring of animals in the wild, Thayer made an extended study of this phenomenon. His color theories were successfully applied to military camouflage in both world wars.

Anahita, Flight of Night, study for the New York State Capitol mural (circa 1878), by William Morris Hunt (1824–1879). This preliminary study is all that remains of Hunt's murals, which were acknowledged a superb work by critics. The older brother of Richard Morris Hunt the architect, Hunt was educated in Europe. After his return to the United States he settled in Boston.

Florence Protecting the Arts (circa 1894) by Abbott Thayer.

Athens, mural for Bowdoin College (1893–1894) by John La Farge.

Like William Morris Hunt, John La Farge was born into the upper class, descending on both sides from aristocratic refugees of the French Revolution. He began to study art as a way of improving his taste rather than as a means to becoming a professional, self-supporting artist. His facility with the brush was exceptional, however, enabling him to combine vastly different examples from past practice in pleasing, graceful compositions.

Modern Woman (1893) by Mary Cassatt. Photograph of the Columbian Exposition mural (Program 9).

Sketch of a woman picking fruit for *Modern Woman* (1893) by Mary Cassatt.

Center panel of *Modern Woman* (1893) by Mary Cassatt.

PAINTING

The Daughters of Edward Boit (1882) by John Singer Sargent (Program 9).
The Golden Screen (1864) by James McNeill Whistler (Program 9).
Eight Bells (1886 and 1890) by Winslow Homer (Program 10).
After a Summer Shower (undated) by George Inness (Programs 5 and 8).
Castle Geyser (1872) by Thomas Moran (Program 7).
The Agnew Clinic (1889) by Thomas Eakins (Program 10).
The Gross Clinic (1875) by Thomas Eakins (Program 10).

MEMORIAL SCULPTURE

The *Adams Memorial* (1886–1891). For the tomb of his wife Marian, Henry Adams commissioned Saint-Gaudens to sculpt a figure which would symbolize "the acceptance, intellectually, of the inevitable." He was pleased with the finished statue, although he considered it largely meaningless to his countrymen. The work is strikingly different from other works of the period, and from Saint-Gaudens's other pieces, which were models of realism. One critic has called it "the most abstract image of the nineteenth century."

Series of views of the *Adams Memorial.*

POST-PROGRAM ILLUSTRATIONS. *The Fine Arts Building; The Woman's Building; Peristyle, Court of Honor; Columbia Fountain* (MacMonnies); *Athens* (La Farge); *Florence Protecting the Arts* (Thayer); *The Angel of Death Staying the Hand of the Sculptor* (French); *Lincoln* (French); *The Free Library of Philadelphia* (Trumbauer); *Security Bank of Owatonna* (Sullivan).

QUESTIONS AND PROJECTS

I. Identify or define:

steel-frame construction spandrel
Gustave Eiffel Chicago School
mural eclecticism
beaux arts style Roman classicism
Greek Revival architecture

II. Areas for additional study:

1 The Columbian Exposition. What is the purpose of an international exposition? How is it organized? What were some important expositions of the nineteenth and early twentieth centuries? What did they accomplish? In what ways may the Olympic Games, for example, be considered an international exposition? How do contemporary expositions compare with the Columbian?

2 Sculpture. Compare the methods of making a bronze sculpture with those of stone. What are the essential differences in the processes? What advantages does bronze have over stone? What are some of the drawbacks of using metal?

3 Steel-frame construction. When were the first steel-frame buildings constructed in the United States? What advantages did steel-frame construction offer? What other materials needed to be developed before the modern skyscraper became a possibility?

4 Mural painting. What are the major differences between a mural painting and an easel painting? Can one be said to be "better" or more effective than the other? Why? Does each serve a specific function? Can they be substituted for each other? Do the two have different technical problems?

III. Opinion and judgment questions:

1 Louis Sullivan claimed that the neoclassical-Renaissance architecture of the Columbian Exposition had a profoundly negative effect on the development of American architecture over the next 50 years. What evidence can you find to support his judgment?

2 The sculptors of the early Republic and those of the Columbian Exposition both prized the works of Greece and Rome, but their sculptures were considerably different. Compare, for example, Horatio Greenough's neoclassical style with the firm realism of Augustus Saint-Gaudens.

IV. Projects:

1 What expositions have been held in your region? What were their most important contributions? What was their effect on the community? What remains of their buildings? In the absence of any great exposition, consider local celebrations, such as the Bicentennial Celebration, or some other festival to commemorate an important occasion, like the founding of the city or the state's admission to the Union. What pur-

poses do these celebrations serve? What kind of planning is necessary? How are the planning committees chosen? Who benefits from celebrations of this kind?

2 Visit the business section and try to determine what buildings were put up in the half century following the Columbian Exposition. What is their style of architecture? Do they bear any resemblance to the buildings of the Columbian Exposition?

3 Again visit the cemetery or refer to the notes from your previous visit. Consider the monumental statuary in terms of Saint-Gaudens's Adams Monument. What is the effect of comparing the two? What kind of funeral monument do you find most appropriate to the situation? Which one most satisfies you?

BIBLIOGRAPHY

Boorstin, Daniel J. (ed.): *American Civilization,* McGraw-Hill Book Company, New York, 1972. Thirteen essays, each on a different aspect of American life, by thirteen scholars from the United States and Great Britain.

Bush-Brown, Albert: *Louis Sullivan,* George Braziller, Inc., New York, 1960. A brief, well-illustrated consideration of the architecture of Louis Sullivan.

Craven, Wayne: Sculpture in America, Thomas Y. Crowell Company, New York, 1968. The best survey of American sculpture in recent years.

Time-Life Books (eds.): *Documentary Photography,* Time-Life Books, New York, 1972. A good but brief introduction to American documentary photographers.

PROGRAM 12

THE MELTING POT

Because we are saturated with life, because we are human our strongest motive is life,
humanity; and the stronger the motive back of a line, the stronger and therefore more
beautiful the line will be. . . . It isn't the subject that counts but what you feel about it.

Robert Henri, "The Art Spirit" (1923)

The exhibition of the Eight which opened at the Macbeth Gallery in New York City in 1908 originated as a protest against the National Academy of Design. Controlling the juries who organized the major exhibitions, and the committees who awarded the scholarships and prizes, as well as possessing considerable influence on purchases by dealers and museums, the Academy was a virtual dictator of aesthetic policy. Academy disapproval meant ruin. John Sloan summed up the frustration of himself and his colleagues with a bitter witticism: "The National Academy is no more national than the National Biscuit Company." The exhibition of the Eight, however, was vastly more successful than even its organizers had hoped. The works shown there validated a new

William Glackens, Chez Mouquin, 1905. Courtesy of the Art Institute of Chicago.

kind of realism and significantly extended the range of subjects an artist might choose from. Still, despite the revolutionary impact of their exhibition, the Eight never adopted a coherent, unified aesthetic policy. Anger, not aesthetics, united them for one important moment, and they never again exhibited as a group. They were in fact as varied in their style and technique as they were in personalities.

OVERVIEW

The Period Approximately 1905 to 1913.

American Life Between 1901 and 1910, 8,800,000 immigrants arrived in the United States from all over the world. Mostly poor workers, they settled in the city and began to work for meager wages that allowed them to live at a bare subsistence level. As cities grew, so did the slums and the miseries of the poor. In 1900, 40 percent of the population was living in the city; by 1910 it was 46 percent.

The brief but highly successful war with Spain in 1898 forced the United States to take a greater interest in world affairs. The peace settlement brought the country Puerto Rico, the Philippine Islands, and Guam. In 1902 construction on the Panama Canal began.

American Literature The progressive policies of Teddy Roosevelt had their counterpart in American literature. Upton Sinclair (1878–1968) reported the horrendous conditions of the meat industry in *The Jungle* (1906). The tragic fate of the underdog was recorded by Theodore Dreiser (1871–1945) in several novels: *Sister Carrie* (1900), *The Financier* (1912), and *The Titan* (1914). Frank Norris (1870–1902) showed men overwhelmed by circumstances and their environment in *McTeague* (1899), *The Octopus* (1901), and *The Pit* (1903). *Looking Backward: 2000 to 1887—American Socialism* by Edward Bellamy (1850–1898) greatly influenced the cause of socialism in this country.

International Events The Western European powers and the United States joined in establishing a favorable trade policy with China. Great Britain's construction of the first modern battleship, the *Dreadnought*, set off a new naval arms race with Germany. The Panama Canal opened for commerce in 1914, with the world on the eve of World War I.

CONTENTS OF THE PROGRAM *Robert Henri* The leader of the Ashcan School, Henri is more praised today for his teaching than for his painting.

The Realists of the Ashcan School The painters among the Eight who followed Henri's concept of realism—John Sloan, George Luks, William Glackens, and Everett Shinn—along with two of Henri's students, Guy Pène DuBois and George Bellows, are included here.

The Rest of the Eight The remaining members of the Eight—Ernest Lawson, Arthur B. Davies, and Maurice Prendergast—are examined.

The Photography of Social Protest Four photographers—Jacob Riis, Arnold Genthe, Lewis Hine, and Alfred Stieglitz—and their effect on the development of photography in America are discussed.

VIEWER'S GUIDE

PRE-LOGO ILLUSTRATIONS *Italian Family Seeking Lost Baggage, Ellis Island* (Hine); *Thomas Cafferty, Fisherman's Son* (Henri); *The Cliff Dwellers* (Bellows); *Early Morning, Paris* (Shinn); *Rooftops, Summer Night* (Sloan).

ROBERT HENRI

The leader of the Ashcan School, Robert Henri (1865–1928), was born Robert Henry Cozad. (He dropped Cozad to protect his father, who was forced to flee Nebraska after killing a man.) He began to study at The Pennsylvania Academy of the Fine Arts in 1886, the year Eakins resigned, and continued it in Paris, where he was strongly influenced by Manet. Returning to Philadelphia in 1891, Henri followed the course taken by most of his fellow artists and began teaching. His ability as a teacher was exceptional. He discouraged his students from imitating his style, stressing the importance of their own feelings.

New York Street in Winter (1902). Like Winslow Homer and Thomas Eakins, Henri believed that an artist should paint subjects with which he was personally acquainted, even though for him this meant painting city life in all its ugliness. The beauty of a back street in New York was found in ". . . the romance of snow-filled atmosphere and the grimness of a house."

Olympia (1863) by Edouard Manet (1832–1883). The boldness of this prostitute's gaze frankly proclaiming the depth of Parisian venality and corruption shocked the middle-class art patrons of Paris. Manet's painting was accepted for the Annual Salon, but carefully hung at the top of the wall in order to minimize public exposure. Although Henri considered his viewing of Manet's nude the high point of his trip, he appreciated Manet more for his somber "Spanish" palette, in the manner of Velásquez, than for his revolutionary pictorial style.

West 57th Street (1902). Henri painted street scenes and landscapes before turning exclusively to portraiture. Scenes like this one were mainly responsible for the tag "the Ashcan School."

Irish Girl (1913). Henri's major focus after 1910 was portraiture. To capture the spirit of the sitter, Henri felt that ". . . the color in her cheek is no longer a spot of red, but is the culminating note of an order which runs through every part of the canvas simplifying her sensitiveness and her health."

Celestina (1908). Henri had an obvious knack for capturing the joy of life on canvas. What he feels, we can see. In his time, however, critics and art patrons were disturbed and offended by Henri's selection of subjects from the lower classes.

Eva Green (1907). Fascinated by children, Henri was fond of saying, "I would rather see a wonderful little child than the Grand Canyon." This portrait, painted on Christmas Day, 1907, took him less than 2 hours. He worked consciously to improve his speed of execution.

Morelle in White (also called *Woman in White*) (1904). Although Henri stressed realism in his teaching, he tended to idealize many of the women who sat to him.

Blind Singers (1913). Spain, particularly Madrid, was one of Henri's lifelong passions.

Segovia Girl in Fiesta Costume (1912).

Laughing Child (1907), also called *Laughing Boy* and *Laughing Girl*, was among the paintings sold at the MacBeth exhibition in 1908. Henri often told his students that "the whole canvas should be like a laughing person coming into a room."

Thomas Cafferty, Fisherman's Son (1925). Henri spent his last summers in Ireland fishing for trout and painting the local inhabitants. After so many years in New York City, he seemed to enjoy a place where he could relax and didn't have to buy a newspaper.

THE REALISTS OF THE ASHCAN SCHOOL

The Ashcan School began in Philadelphia in the early 1890s. A small group of artists banded together to share the expense of hiring models for life drawing sessions. Dubbing themselves the Charcoal Club, they met several evenings a week to draw and to discuss art with Henri. Among those usually present were George Luks, John Sloan, Everett Shinn, and William Glackens, all of whom worked on the art staff of *The Philadelphia Press*. By 1900 several of the most important members of the group—Henri, Luks, Glackens, and Shinn—had moved to New York. In 1906 Henri became a member of the country's most prestigious and powerful art organization, the National Academy of Design. Henri's ideas on realism, however, were radically different from the artistic conventions accepted by the conservative Academy, and in 1907 these differences were clearly pointed out when the Academy refused to accept a painting by George Bellows, one of Henri's students, at its national exhibition. In protest Henri, himself a member of the jury, withdrew all his paintings from the exhibition and began organizing a rival show of contemporary American painting at the MacBeth Gallery in New York City. The old members of the Charcoal Club enthusiastically joined him, along with Arthur B. Davies, who shared Henri's disdain for the Academy, and two of Glackens's friends, Ernest Lawson and Maurice Prendergast. This group became known as "the Eight."

The most powerful realist of the Eight, George Luks (1867–1933) worked first in vaudeville before deciding to concentrate on painting. His first job, as an artist on *The Philadelphia Press*, was highlighted by a tour as war correspondent in Cuba (1895). Soon after his return, he was fired for excessive drinking and moved to New York, becoming a cartoonist for *The New York*

World. Always a heavy drinker, Luks spent his last years creating scenes in bars, eventually dying as a result of a barroom brawl.

Details of John Sloan (second from left) from photograph of The Studio (circa 1895).

Photograph of The Studio (circa 1895). Sloan, Henri, Glackens, Shinn, and Luks, all believers in physical prowess, were especially enthusiastic about boxing. This photograph taken in Henri's Studio at 806 Walnut Street, Philadelphia, shows George Luks as the boxer with his head lowered, and behind him (left to right) James Preston, John Sloan, and Everett Shinn.

Portrait of George Luks (1904) by Robert Henri. Although Henri considered Luks excessively loud and boisterous, he was able to appreciate him as a character. A master at uncovering significant details, Henri has caught a look in Luks's eye that confirms both his awareness that he is playing a role and his recognition that the spectator realizes it.

Self-Portrait (n.d.).

The Spielers (1905). (The title means "the dancers.") Luks, who was known primarily for his gruffness, shows a tender, understanding side in this depiction of two joyful slum children. Despite his obvious sympathy, his shabby people, with their untidy hair and clothing, shocked the public.

The Wrestlers (1905). To back up his demand that art have guts, Luks painted harsh subjects like these sweat-drenched athletes. The result is a lesson in expressive anatomy. Supremely confident in his abilities, Luks boasted he could paint with a shoestring dipped in pitch and lard, but his lack of concern with the mechanics of painting led him to use impermanent combinations, and many of his paintings, like those of Albert Pinkham Ryder, have deteriorated.

Girl in Orange Dress (circa late 1920s).

The Miner (circa 1925). Raised in a Pennsylvania mining town, Luks had firsthand knowledge of conditions around the mines. He painted the poverty-stricken miners many times.

John Sloan (1871–1951) grew up in Philadelphia, where he went to high school with William Glackens. He taught himself to draw well enough to get a job as an illustrator with *The Philadelphia Inquirer.* His poster work brought him national recognition. While studying with Thomas Anshutz at The Pennsylvania Academy of the Fine Arts from 1892 to 1893, he developed close friendships with Glackens, Luks, and Everett Shinn.

Perhaps the best practitioner of the realism typical of the Ashcan School, Sloan did not usually consider his art as a weapon of reform, but as the best means of capturing the vital pulse of the people and the city he loved. After 1919, when he began spending his summers in Santa Fe, he abandoned city scenes and took to recording the Spanish and Indian culture. A decade later he changed again, devoting his energy to painting nudes.

John Sloan (1906) by Robert Henri. Closest of all the Eight to Henri, Sloan was often teased for his slow execution.

Detail of boat and bathers from *South Beach Bathers.*

Detail of central bather from *South Beach Bathers.*

South Beach Bathers (1907–1908). Sloan was so captivated by his first sight

of South Beach that he immediately set to work recording his experience. "This Staten Island resort had few visitors compared to Coney Island, and gave better opportunity for observation by individual behavior." He eventually put the painting aside and did not finish it for another year.

Sixth Avenue and Thirteenth Street (1907). On June 12, 1907, Sloan recorded a walk along Sixth Avenue: "I painted starting 'a gray day, Sixth Avenue, Tenderloin Section.'" He was satisfied that *Sixth Avenue and Thirteenth Street* had captured the drab, shabby, happy, sad, and human atmosphere of the Tenderloin.

Backyards, Greenwich Village (1914). Painted during the period when Sloan occupied a studio in a loft on Sixth Avenue, this is his most famous characterization of the backyard scene. He never painted directly from nature, preferring to let his memory, ". . . after careful observation of material," provide his inspiration.

Sunday Afternoon in Union Square (1912) depicts a large socialist meeting in May 1912. Despite his avowed socialism Sloan never allowed his political beliefs to influence his paintings.

Detail of Yeats from *Yeats at Petitpas* (1910).

Yeats at Petitpas (1910). Sloan met John Butler Yeats, the Irish poet and father of William Butler Yeats, in 1909. Within a few months they became close friends, meeting frequently at a small restaurant, Petitpas. Seated from left to right are Van Wyck Brooks, J. B. Yeats, Alan Seeger, Dolly (Sloan's first wife), R. Snedden, Ann Squire, John Sloan, and Fred King.

Sixth Avenue Elevated at Third Street (1928) is a combination of vivid colors. Two el trains with violent yellow lights set against the blue sky of evening contrast with the delicate lights and shadows of the busy street below. Sixth Avenue had a "Coney Island quality" according to Sloan; for him it was "the Fifth Avenue of the poor . . . that furnished similar facilities at lower rates."

Rooftops, Summer Night (1906). In 1905 Sloan began a series of etchings, eventually known as the New York City Life set depicting everyday scenes around New York. The oppressive summer heat in the tenements frequently drove residents to the rooftops to sleep in the cool summer evening. This kind of scene held great appeal for Sloan: "I have always . . . liked to watch the people in the summer, especially the way they live on the roofs."

Detail of critics from *Connoisseurs of Prints*.

Connoisseurs of Prints (1905), the first of the New York City Life set, depicts an exhibition of prints that were to be auctioned at the American Art Galleries on 23d Street in New York.

Three A.M. (1909). This glimpse of common life, captured with utter fidelity to setting and character, grew out of Sloan's interest in a pair of young women across the street. Every morning, he observed, they would begin cooking at three o'clock. Despite his obvious fascination with them, he never spoke to them, and he never had any idea what the young ladies did.

The Unemployed (1913) was the cover of the March 1913 issue of *The Masses*, a socialist magazine. A member of the editorial staff, Sloan devised the simple, uncluttered layout.

The Great Subway Contractor—The Promised Loaf (1911) was donated to another socialist publication, *The Call*. Although Sloan was a socialist, he kept his political beliefs on a very personal level. A frequent contributor to socialist magazines, Sloan was more concerned with the treatment of his donations than with the political beliefs of the editors. On the back of this crayon and pen-and-ink drawing he wrote, "Comrade Gerber [the chairman of the local Socialist party in New York] I'd like you to share this with The CALL—they could give six columns perhaps—you are to use it as wide as you can possibly carry it." In the front margin he wrote, "Keep CLEAN and return to John Sloan."

Detail of man from *Turning Out the Lights.*

Turning Out the Lights (1905). Sloan's work expresses the deep tenderness of the sexual relationship between man and woman.

The Wake of the Ferry (1907). Sloan often used gray weather to play down the harshness of reality. Here the gleaming water against the dark shadows of the boat and the huddled figure create an intense lyric impression. Sloan recalled that the theme was "perhaps evoked by some nostalgic yearning for Philadelphia . . . the ferry, of course, is the first lap of the road home."

William Glackens (1870–1938) began his career as an illustrator for *The Philadelphia Record.* In 1892 he went to work for *The Press,* where he met George Luks, John Sloan, and Everett Shinn. Sloan considered him "the greatest draughtsman . . . this side of the ocean."

Sketch of skating rink.

The Luxembourg Gardens (1906). Glackens found suitable subjects everywhere. One of his favorite Parisian sites was this popular park in the center of the city.

Chez Mouquin (1905). The most famous of all of Glackens's work, *Chez Mouquin,* depicts one of the favorite restaurants of the Ashcan School painters. Whenever they could afford it, they enjoyed spending time there. James Moore, the proprietor, sits with one of his "daughters" (one of several young ladies who were in his constant company). Since the composition resembles Manet's *Bar at the Folies-Bergères,* it has been suggested that Glackens may have been paying homage to the French master here.

George Bellows (1882–1925) came to New York City from Ohio to study with Henri at the New York School of Art. One of Henri's most successful pupils, Bellows excelled at character studies which were full of strength and power as well as action.

The Cliff Dwellers (1913).

Forty-two Kids (1907) is similar to Eakins's *The Swimming Hole* (see Program 10), although Bellows manages to include forty-two city kids swimming in the river by a city dock. (Bellows painted very few nudes, believing that the amount of nudity should be dictated by the scene as it appeared in real life.)

Both Members of This Club (1909). One of the most famous of Bellows's works, this painting is a study of violence as well as an exercise in flesh tones. At this time, in New York only boxing between members of the same club was legal, hence the title. Notice the crowd watching the fight. Bellows includes

very little detail, preferring to subordinate the spectators to the physical drama of the event.

Guy Pène DuBois (1884–1958), the son of a literary and music critic, studied art with William Merritt Chase and Robert Henri at the New York School of Art. Returning from studying in Paris in 1907, he began working as an art critic and reporter for several magazines, eventually becoming editor of *Arts and Decoration*. His caricatures of the social elite provided a unique kind of social criticism.

The Doll and the Monster (1914). With swift, generalizing strokes, DuBois makes a biting comment on the upper classes.

Detail of champagne glass and couple from *Chez Mouquin*.

Detail of tightrope walker from *Hammerstein's Roof Garden*.

Hammerstein's Roof Garden (circa 1901) was located on the site of the Old Hippodrome (since converted to a parking garage). The strong parallel lines make a most unusual and original composition. Notice how Glackens portrays the tension of the moment with the arched back of the woman in the right-hand corner.

Everett Shinn (1873–1958) loved the variety of New York life. Attracted by every facet of the glamorous life of the wealthy, he was especially fascinated by the stage. For a time he even abandoned painting to devote himself to writing plays (he eventually turned out some thirty-five, none of them very good). He also worked briefly in Hollywood as a writer.

Hippodrome, London (1902). Like the English painter Walter Sickert, Shinn was a devotee of the theater and the music halls.

Early Morning, Paris (1905). Shinn did paint the grimmer sides of society. A French critic exclaimed, "They paint everything, even the ashcans," one of the many sources credited with naming the Ashcan School.

Detail of actress from *Revue*.

Revue (1908). By skillfully manipulating highlights, Shinn infuses this painting with the magic of the theater.

The Orchestra Pit (circa 1906). This unusual view of the actress's final bow, taken from the musician's point of view, uncovers another mysterious facet of the theater.

THE REST OF THE EIGHT

Arthur Bowen Davies (1862–1928) was noticeably similar in outlook to visionaries like Albert Pinkham Ryder, but whereas Ryder had a great fondness for the sea, Davies preferred to paint nymphlike figures dancing across elongated horizons. Although his style is far from the "New York realism" adopted by Henri, Sloan, Luks, Glackens, and Shinn, Davies was sympathetic to their fight against the established academies. After the Armory Show, which he helped organize, Davies began experimenting with a more abstract style of painting.

Valley's Brim (1910).

The Unicorns (1906) is typical of the dreamlike quality prominent in all of Davies's work. The three unicorns stand beside deep, still waters with a vast

mountainous country in the background. Two women attend the animals in some mysterious ceremony.

Madonna of the Sun (1910) shows Davies's continued attempt to recreate the beauty of Greek and Roman art although the positions of his figures owe much to the dancing style of Isadora Duncan.

Photograph of Arthur B. Davies.

Ironically Davies, who was a prolific artist and anxious for success, is best remembered as the organizer of the Armory Show. "One of the quirks of fate," his daughter recounts, "is that Father's greatest ambition was to be remembered as an artist rather than as an art promoter."

Exterior of the 69th Regimental Armory (see Program 13).

Armory Show, interior: view from Lexington Avenue entrance.

Armory Show, interior: Room H, foreign section. This was the section which Davies organized.

Dust of Colors (1920). After the Armory Show Davies modified his style. Cubism significantly affected his work, but this proved to be a superficial and not a fundamental change.

Details of figures from *Dust of Colors*.

Detail of central figure from *Dust of Colors*.

A Thousand Flowers (1922). In this tapestry Davies slips once again into his allegorical style.

Unidentified nude sculpture (undated). An artist of many talents, Davies worked in twenty different media, including wood, glass, and bronze.

Photograph of Arthur B. Davies.

Canadian-born Ernest Lawson (1873–1939) began his artistic career as an engineering draftsman in Mexico. Moving to New York in 1891, he came under the influence of the American impressionists (see Program 9). After settling in the Washington Heights area of New York City, he developed a style characterized by heavy pigments and strong colors. His impasto of intense colors moved James Huneker, critic for *The New York Sun* to call his work a "palette of crushed jewels."

Detail of tugboat from *Boathouse Winter, Harlem River* (1916).

Boathouse Winter, Harlem River (1916) (only the right side of the canvas is shown) is one of Lawson's many paintings of the New York River. He painted the river so frequently, in fact, that rumors arose of the existence of a Harlem River School of landscape painting.

High Bridge (1928). Despite his concern with color and texture Lawson was accused of failing to disguise the more rugged elements in his work. The rocks in his renderings look extremely hard and harsh. Some reminder of man—a shack, an abandoned rowboat, a rusting bridge—is always present to soften the harshness. But these were not considered fitting subjects by hostile critics, no better than Henri's ashcans. His "palette of crushed jewels" became a familiar trademark.

Maurice Prendergast (1859–1924) the "old man" of the Eight, first earned his living as apprentice to a showcard painter, sketching landscapes in watercolors in his spare time. He studied in Paris in the 1890s and was greatly in-

fluenced by Whistler (see Program 9) and Edouard Manet. The Armory Show encouraged Prendergast to a few experiments with nudes and portraits, but for the most part he remained aloof from current trends. Considered by some critics to be the best painter of the Eight, Prendergast was the embodiment of Henri's theory that the artist's character could be seen through his art.

Decorative Composition (1914) is a study for *Promenade*, one of two mural scene panels he painted for John Quinn.

Beach, St. Malo (1907). Prendergast relished painting the upper classes at play and often followed them about in their pursuit of good living. He made several trips to France, particularly to Saint-Malo, a resort area. One critic disparagingly called *Beach, St. Malo*, ". . . an explosion in a color factory" while another referred to the painting as "the product of much cider."

Central Park (1901). This pencil and watercolor portrays Frederick Law Olmsted's (see Program 5) transportation system with a carriage road, bridle path, and pedestrian walk in parallel tiers.

Detail of carriage path from *Central Park.*

The Promenade (1913). Several critics have tried to find a link between Prendergast's unique style and Cézanne, but the relationship is tenuous at best.

Best at Gloucester (1912–1914).

THE PHOTOGRAPHY OF SOCIAL PROTEST

By the turn of the century the invention of photoengraving permitted newspapers to use photographs to illustrate their pages, and in a very short time the photographer replaced the artist-reporter. One group of photographers took their cameras into the dreary tenements of the poor sections of the city, hoping that the sight of misery would encourage the government to improve conditions. Another group of photographers, led by Alfred Stieglitz, turned the camera toward the creation of fine art.

Steel Worker: Empire State Building (1931) (Lewis Hine).

Watching the Approach of the Fire (1906) (Arnold Genthe).

Italian Mother and Her Baby in Jersey Street, New York (1888) (Jacob Riis).

Danish-born Jacob Riis (1849–1914) was hired by *The New York Tribune* as a reporter in 1877. He used photographs to document his writing of the horrors of tenement life in New York. In *How the Other Half Lives* (1890) he documented the misery of the underprivileged. By perfecting a flash process, he was able to photograph the darkest and most unsavory slums.

Baxter Street Alley in Mulberry Bend, New York (1888).

Police Station Lodger, a Plank for a Bed (circa 1890).

Lewis Wickes Hine (1874–1940) grew up working long hours in a factory. He eventually earned a master's degree in sociology and began teaching in 1901. In 1903 Hine acquired his first camera and flash gun and began recording the life of the poor immigrant in the land of opportunity. In the hands of photographers like Riis and Hine, the camera became a powerful weapon for social reform.

Caught by the Camera (France, 1918).

Immigrants Going down Gangplank, New York, (1905).

Climbing into the Land of Promise, Ellis Island (1905).

Italian Family Seeking Lost Baggage, Ellis Island (1905).

Elderly Jewish Immigrant, Ellis Island (1905).

Mrs. Raphael Marenquin, New York (1911).

Little Spinner in Carolina Cotton Mill (1909).

Newsies Shooting Craps near Post Office. Midnight. Providence, Rhode Island (1912).

Indiana Glass Works, 9:00 p.m. (1908).

Polish Boy Taking Noon Rest in Doffer Box, Quidnick Mill (1909).

Carrying In a Boy in a Glass Factory, Alexandria, Virginia (1909).

Glass Blower and Mold Boy, Grafton, West Virginia (1908).

Newsies at Skeeter Branch, St. Louis, Missouri, 11:00 a.m. (1910).

Steel Worker. Empire State Building (1931).

Avenue of Girders, Empire State Building (1930).

Empire State Building (1930).

Lower New York Design (1931).

For 30 years Arnold Genthe (1869–1942) photographed celebrities—including presidents, movie stars, and industrialists. He considered himself a photographer of the "candid" moment although all he really did was take the picture when the sitter didn't expect it. Acutely conscious of art in his photography, he tried to achieve the kind of chiaroscuro found in Rembrandt's paintings. He is known today, however, for his early photographs of San Francisco, particularly Chinatown in 1894, and for his pictures of the great fire of 1906. Although all his equipment was lost in the first shocks, Genthe bought a simple box 3A Kodak Special in a shop and used it to record the disaster.

Chinatown.

(Chinatown).

(Chinatown).

Alfred Stieglitz (1864–1946) went to Germany in 1882 to study mechanical engineering. Purchasing a camera in a Berlin shop, he soon dropped his interest in engineering in favor of photography. He returned to the United States in 1890 and soon began working as the editor of *The American Amateur Photographer*. His lifetime purpose became the promotion of photography as an art form.

The Terminal (1893).

Georgia O'Keeffe (1923).

The Steerage (1907).

POST-PROGRAM ILLUSTRATIONS *Forty-two Kids* (Bellows); *South Beach Bathers* (Sloan); *The Wrestlers* (Luks); *Laughing Child* (Henri); *Newsies at Skeeter Branch, St. Louis, Missouri, 11:00 a.m.* (Hine); *Yeats at Petitpas* (Sloan).

QUESTIONS AND PROJECTS

I. Define or identify:

Ashcan School cubism

Edouard Manet National Academy of Design

realist *The Masses*

impasto Franz Hals

study

II. Developmental questions:

1 The Ashcan School. Can the works of the Ashcan School which have been labeled "realist" be considered objective? In what ways did Sloan and Henri use their paintings to reflect their political beliefs?

2 The Eight. Who are the artists known as the Eight? What were the reasons the Eight banded together? Did they have similar styles? subjects? Can the Eight be considered members of the Ashcan School? Explain your answer in detail.

3 Photography. Sloan, Glackens, Luks, and Shinn were trained as artist-reporters. What skills and techniques did they develop as artist-reporters which would influence their work? What developments in photography affected the newspaper industry?

III. Questions for further study:

1 Painting. Study the career of Sloan or Davies. Did their work (style or content) change? Many artists are influenced by other artists. Who influenced the artist? In which works do you see this influence?

2 Photojournalism. Did Riis and Hine consider themselves artists or their work as art? Compare in detail their philosophy with that of Stieglitz.

IV. Projects:

1 What area in your community would the Ashcan School paint if they were alive today? Allowing for changes in fashion, could any of the scenes created by Sloan, Henri, or Luks be seen today? What sporting events might be painted by Luks or Bellows? Would Shinn paint a rock concert? Explain your reasoning.

2 Visit a local newspaper office. Where does the local paper get its photographs? Is there a staff photographer? Is each reporter responsible for his/her pictures? What does he/she take into consideration when taking a picture for the paper? What does he/she look for when setting up a shot? Do they like posed pictures or candid shots? After talking to the reporter-photographer, do you think they consider themselves artists? or their work as art? How do photographs taken by the various press services (UPS, AP, etc.) appear in your local paper?

3 Social documentary. How effective were Hine's and Riis's attempts at reform? Did their photographs assist in passage of congressional legislation?

BIBLIOGRAPHY

Henri, Robert: *The Art Spirit*, compiled by Margery Ryerson, J. B. Lippincott Company, Philadelphia and London, 1939. A collection of Henri's notes, lectures, and letters on art.

Pollack, Peter: *The Picture History of Photography*, Harry N. Abrams, Inc., New York, 1969. A well-illustrated survey beginning with the earliest uses of light through the developments of photography in the middle sixties.

Riis, Jacob A.: *How the Other Half Lives; Studies among the Tenements of New York*, Hill and Wang, Inc., 1957. An appraisal of life in the slums.

Young, Mahonri Sharp: *The Eight: The Realist Revolt in American Painting*, Watson-Guptill, New York, 1973. An excellent examination of the Eight and their works with many illustrations.

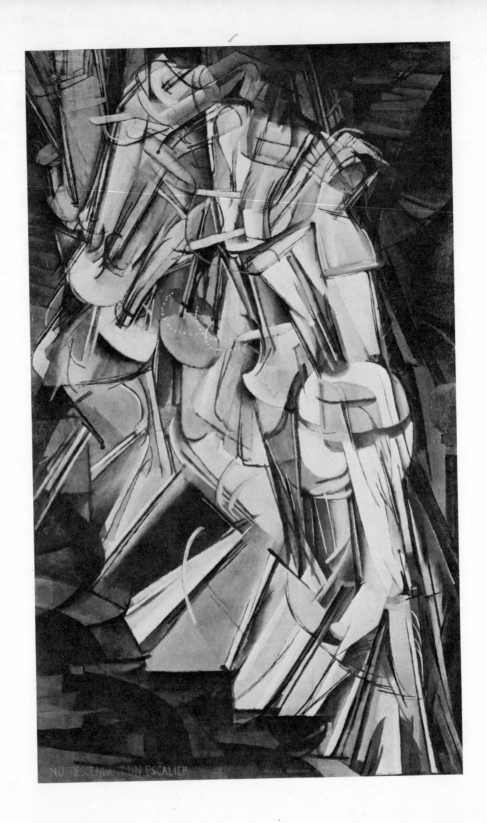

NU DESCENDANT UN ESCALIER

PROGRAM 13

THE ARMORY SHOW

The moral is that there is nothing final in art, no last word, and the main thing is not to be taken in on one hand, and not to be blind on the other.

Frederick James Gregg, ["Letting in the Light," "Harper's Weekly,"]
February 15, 1913

Whether you're 'anti' or 'for' it's the two sides of the same thing, . . .

Marcel Duchamp, 1961

Actors, musicians, butlers, and shop girls . . . the exquisite, the vulgar from all walks of life (came to see the Armory Show).

Walter Kuhn

By the end of the nineteenth century American art had matured greatly but was being overshadowed by its European counterparts. Collectors and critics disregarded native talent in favor of the academic art of England, France, and Germany. Traditional European art exerted such influence that

Marcel Duchamp, *Nude Descending a Staircase*, 1912. Courtesy of the Philadelphia Museum of Art.

159

many young American artists went abroad to study in the established schools and academies. It was not until a radical group of artists banded together into the Association of American Painters and Sculptors that this trend was reversed. In 1913 the Association mounted a large exhibition of American and European modern art which effectively forced a lethargic public to confront "art." The Armory Show thrust the American public and its artists into the twentieth century. The new and vital art forms revealed in this unique exhibition encouraged American artists to abandon Old World traditions in favor of New World experiments.

OVERVIEW

The Period 1910 to 1915. Some of Marcel Duchamp's work will be from as late as 1968.

American Life After years of immunity, American millionaires were finally coming under government scrutiny. A congressional committee under the direction of Arsène Pujo investigated the trusts and discovered that slightly more than a dozen financiers, among them J. P. Morgan and the Rockefellers, controlled corporations with a value of $22,245,000,000—a sum four times the entire national debt of Great Britain. The Sixteenth Amendment, legalizing a tax on personal income, went into effect, ensuring that some of the huge family fortunes in the country would grow less rapidly. Other forces worked to decrease the gap between haves and have-nots. Intellectuals took up the cause of socialism, and women across the country were demonstrating for the right to vote. In early 1914 Henry Ford surprised the business world by raising the workers in his factory from the standard wage of $2 a day to $5 a day. On the lighter side, jazz made its appearance in New York City and started a dance craze which threw a panic into moralists across the country. The most prominent of the nation's moral watchdogs, Anthony Comstock, president of the Society for the Suppression of Vice, met his match in a fight over the public display of a painting, entitled *September Morn*, which depicted a nude young woman, in a state of startled restraint, standing ankle-deep in a mist-filled lake. Comstock had the painting removed, but the manager of the art gallery put it right back in the window and *September Morn* became a public sensation almost as great as the Armory Show itself.

 American Literature The modernist trends which came to the United States with the Armory Show had their literary counterpart in three American expatriates. T. S. Eliot (1888–1965) and Ezra Pound (1885–1976) were soon to be among the foremost poets in the Western world. "The Love Song of J. Alfred Prufrock" (1917) marked out the road Eliot would follow, as did the first of Pound's *Cantos* (1917). Gertrude Stein (1874–1946) wrote *Three Lives* (1909), in which cubism and literary realism combine. These figures helped prepare the way for the great influx of American writers during the 1920s. At the same time other American writers sought a deeper national awareness, a desire that the American Scene painters of the 1920s and the 1930s shared. Robert Frost (1874–1963), Wal-

lace Stevens (1879–1955), and William Carlos Williams (1883–1963) captured a distinctly American quality in their poetry.

International Events Europe, despite constant international bickering, a tremendous armaments race, and actual war in the Balkans, scarcely believed in the possibility of imminent world war. In England life was still a continual pleasure for the members of the ruling class, but there was trouble in several areas. Emily Davison, a militant suffragette, seized the reins of the King's horse during the running of the Epsom Derby, felling horse and jockey successfully but injuring herself so seriously that she died a few days later. In France Stravinsky created a sensation with his ballet *The Rite of Spring*, featuring Vaslav Nijinsky in the principal role, and Marcel Proust published the first volume of *Remembrance of Things Past*. In Germany scandals and mysteries were the order of the day: several agents of the Krupp company were convicted of trying to influence government officials, Dr. Rudolph Diesel, inventor of the well-known engine, disappeared without a trace, and three more zeppelins crashed, bringing the total disasters to ten in 7 years. In Russia Rasputin continued to be the power behind the throne while Marxists inside and outside the country continued to work toward revolution.

CONTENTS OF THE PROGRAM *The Armory Show* The organization, contents, and effects of the first large-scale international exhibition of modern art in America are examined in detail.

Marcel Duchamp This brief examination of Duchamp's life and career emphasizes the artist's radical departure from accepted art practice and his important contribution to the development of modern American art.

VIEWER'S GUIDE

PRE-LOGO ILLUSTRATIONS "Bedlam in Art" (*Chicago Sunday Tribune*); "The New Idea . . . "; "Extremists in Broadsides of Lurid Color"; *Armory Show Poster*; *Armory Show Symbol*.

THE ARMORY SHOW

The importance of the International Exhibition of Modern Art, commonly referred to as the Armory Show, cannot be overestimated. By bringing together a large and representative selection of avant-garde art, the organizers hoped to force the American art world to deal with alternative art styles, and at the same time to promote the buying of works by American artists. Organizational responsibility for the show, which was sponsored by the Association of American Painters and Sculptors, fell to Arthur B. Davies, a well-respected American artist, whose many social and artistic contacts provided both the money and the expertise needed to assemble an exhibition as large as the Armory Show. Along

with fellow artists Walter Kuhn and Walter Pach, Davies assembled a vast quantity of American and European art works almost all of which had an avant-garde character. The show, whose prevailing theme was "modernism," opened in New York on February 17, 1913, consisting of over 1000 paintings, sculptures, and prints from Europe and America. Almost all the modern European artistic movements were represented, while the American entries were led by the Ashcan School and included some of the expatriates.

The show provoked a tremendous uproar. People who had practically no knowledge of or interest in art suddenly found themselves passionately discussing the merits of contemporary painting and sculpture. The average person, for the first time in many cases, began establishing personal criteria for art. For better or worse, modern art took its case directly to the public.

Whispering of Love by William A. Bouguereau (1825–1905). The paintings of Bouguereau, a highly respected teacher at the Académie des Beaux-Arts, came to symbolize official academy art.

The Horse Fair (1855) by Rosa Bonheur (1822–1899). Considered one of the outstanding exhibitors at the French Salons, Rosa Bonheur received high praise for the technical perfection of her work. Her talent was such that she earned official recognition, a rare honor for a woman artist in nineteenth-century France.

Self-Portrait (1659) by Rembrandt van Rijn (1606–1669) is an outstanding example of the baroque use of dramatic lighting and expressive brush work. Rembrandt gives us an insight into his personality as well as his abilities in this self-portrait from his late period.

Exterior of the 69th Regimental Armory (anonymous photograph). This was the site of the International Exhibition of Modern Art, which explains the origins of the nickname, the Armory Show.

Exterior of the 69th Regimental Armory (anonymous photograph). Another view of the same building.

Although Arthur Bowen Davies was primarily a painter, his social contacts and organizational ability were more important to the success of the Armory Show. For a more detailed biography see Program 12.

Arthur Davies (anonymous photograph).

Pine Tree Flag (1913). This early American symbol of the Revolution became the logo for the Armory Show.

Interior, Exhibition Hall, 69th Regimental Armory (anonymous photograph). As can be seen from this photograph, the interior of the building was partitioned into smaller sections.

The show was divided into two main sections, the American and the European. The European section was to create a tremendous controversy, while the Americans fared much better in the eyes of the public. Painters of the Ashcan School, the American impressionists, and the visionaries were looked upon sympathetically, if not openly accepted. There were, however, more radical American artists in the show, including members of Alfred Stieglitz's gallery "291" as well as some of the expatriates.

Moonlight Marine (undated) was one of the four works in the show by Albert Pinkham Ryder, a specially invited guest to the exhibition (see Program 8).

The Gypsy (1912) by Robert Henri. This work by Henri, leader of the Ashcan School, is typical of his style, both in use of loose and quick brushwork and in choice of subject matter (see Program 12).

Detail from *Sunday, Women Drying Their Hair* (1912).

Sunday, Women Drying Their Hair (1912) by John Sloan. Sloan, a member of the Ashcan School, tended to chose subjects from the life of the average city dweller. For a detailed biography see Program 12.

The Family Group (1911) by William Glackens. Bright colors and a harsh feeling of reality dominate this group portrait. Glackens, like other members of the Ashcan School, did not attempt to disguise or beautify his subjects, but painted life as he saw it (see Program 12).

Hemlock Pool (1902) by John Henry Twachtman (1853–1902). Twachtman, considered one of the outstanding landscape painters of the turn of the century, employed the diffused lighting and short brushstrokes typical of the impressionist school.

Landscape (1907) by Alfred Mauer (1868–1932). Maurer was greatly influenced by the postimpressionist movements in Paris during his visit in the early part of the century. *Landscape* is typical of Mauer's style.

Movement, Fifth Avenue (1912) was not in the Armory Show, but it is similar to the seven works by John Marin (1870–1953) that were included. Marin, in the tradition of Winslow Homer, tended to favor watercolors, as can be seen in this work (see Program 14).

Walter Kuhn (anonymous photograph). Kuhn (1880–1949), one of the founders of the Association of American Painters and Sculptors, was among the first to suggest the assembling of a large exhibition and was probably responsible for asking Davies to help organize the show.

A French artist associated with the impressionists, Edgar Degas (1834–1917) loved in particular to paint women. Widely known for his paintings and pastels of ballet dancers, he often turned to Parisian night life for subjects. Degas's compositions subtly blend soft light and color to create movement. The organizers considered Degas to be a classicist, probably because of his highly developed ability to draw.

After the Bath (circa 1890) shows Degas at his finest. Although this particular work was not in the show, it is typical of those that were.

Often considered the father of twentieth-century painting, Paul Cézanne (1839–1906) had a profound effect upon both European and American artists during the first two decades of the century. Usually grouped with several other late nineteenth-century artists called the postimpressionists, Cézanne painted with very short brushstrokes. This type of paint application helps to build the shape and form of images. In his *Self-Portrait* (1879–1882), we can see how the surface of the painting is beginning to break up and flatten out. It is the breaking up of the plane of the picture that will preoccupy much of this century's painting. Cézanne was considered a realist by the show's organizers.

Third-Class Carriage (1863) by Honoré Daumier (1808–1879). Although this particular painting was not in the show, a similar one with the same title was. Early in his career, Daumier worked as an illustrator for a Paris newspaper,

where he developed a quick sketchy quality that emphasized line, a trait he would never lose. Classified a romanticist for the show, Daumier's paintings have a very realistic quality that is reminiscent of the Ashcan School. Note that the painting is not finished and the grid the artist used is visible in the lower left corner.

Pierre Auguste Renoir (1841–1919) was another prominent member of the impressionist group. His paintings display a light and airy quality. He, also, was listed as a romanticist.

Detail from *Luncheon of the Boating Party* (1881).

Luncheon of the Boating Party (1881). Renoir uses his full mastery of light in this work. His quick brushwork and use of bright colors tend to give this painting a very soft and gay characteristic.

One of Arthur Davies's favorite artists was Odilon Redon (1840–1916). Redon was a member of the French symbolist movement. Like Daumier and Renoir, he was categorized as a romanticist for the show.

Flowers (n.d.). Redon treats common objects in such a way as to set them apart from our usual experience. Although basically a still-life, Redon's depiction of these flowers is anything but realistic.

Silence (1911). Here, Redon combines the gestures of silence with a unique setting. The oval frame enclosing the person is painted in such a manner as to suggest the womb. The title is indicative of the subject: back to the womb, the peace and silence of a small private chamber.

Exhibition Hall: Room H, Foreign Section (anonymous photograph).

Although the romanticists, realists, and the classicists upset the public, none was as controversial as the fourth group of artists—the Modernists. Included in this category were the contemporary artistic movements from Paris.

Constantin Brancusi's (1876–1957) sculpture *Mlle. Pogany* (1912) was considered an outrage. Brancusi's use of abbreviated form and his simplification of the face into geometric elements can be traced to his infatuation with African masks and other "primitive" art.

Vincent Van Gogh (1853–1890) was another artist associated with postimpressionism. Van Gogh worked in a heavy impasto style, as can be seen in *A Bugler of the Zouave Regiment* (1888). He managed to capture the bright pure colors of the impressionists while using an imagery that was very personal.

A close associate of Van Gogh, Paul Gauguin (1848–1903) was one of the founders of the French symbolist movement in painting. Gauguin was greatly influenced by the impressionists and oriental prints. *Still-Life with Head-Shaped Vase and Japanese Woodcut* (1889) uses a Japanese print as a motif. Like Cézanne, Gauguin tends to flatten the surface of the painting while using decorative patterns to give a feeling of space.

Georges Seurat (1859–1891) is best known for his development of pointillism. In *Les Poseuses* ("the Posers") (1888) we see how he uses small dots of paint to construct images. This is a small preparatory painting for a much larger work.

Pointillism is a method of painting in which the artist uses dots of pure color to construct images. The effect of placing these dots next to each other

enables the viewer to mix the colors from a distance creating a third color almost as pure as the first two.

Nude with Red Hair (1901) is a color lithograph by Edvard Munch (1863–1944). Munch, a Norwegian artist, was a principal member of an early twentieth-century artistic style called expressionism. His flowing line and contrasting colors create an emotional work. The harsh contrast of the figure with the ground effectively isolates the woman from the viewer.

Expressionism is a style of painting that developed in northern Europe around the turn of the century. The style is characterized by its distorted use of line, form, and color to emphasize the emotional quality of the narrative.

Wilhelm Lehmbruck (1881–1919) was a sculptor who was primarily influenced by the impressionists and classical Greek sculpture.

Standing Woman (1910) (mistakenly attributed to Maillol on the tape). Originally a plaster cast, now destroyed, this work survives only in a bronze copy. Lehmbruck combines the full robust modeling of the impressionists with a classical pose in this work.

Kneeling Woman (1911) was done a year after *Standing Woman,* and in many ways it is quite different. The statue is more linear and less full-bodied than the earlier work. However, there is still a classical element in the posing of the figure and in the gentle and graceful positioning of the hands and head.

Henri Matisse (1869–1954) was a founder of the Parisian art movement called fauvism. His use of bright colors and dynamic drawing gives his work a wild and erotic quality. Matisse excelled in several media including sculpture, painting, and print making.

The fauvists were a group of early twentieth-century artists who used large areas of flat bright colors in much of their work. Although their imagery was recognizable, the seemingly arbitrary use of colors caused a French art critic to dub them *Les Fauves* ("the wild beasts").

Blue Nude (1907) caused a tremendous stir at the Armory Show. Critics considered the figure well drawn, but the colors terrible. Through his use of line and color, the artist has managed to flatten the space in the picture. Yet for all its revolutionary qualities, the painting still shows a classical influence, especially in the pose of the figure.

The Back (1910–1912) is an example of Matisse's sculpture. This simple relief of a woman's back displays a certain inner tension that creates a dynamic effect. The broken surface of the piece is reminiscent of Cézanne and will be seen in the work of the cubists.

The ancient Greeks during the classical period (450–400 B.C.) prided themselves on their ability to create realistic sculptures posed in natural positions that emphasized simplicity of form and subtle expression.

Wassily Kandinsky (1866–1944) is said by many to be the first artist to paint a nonobjective work, a painting with no recognizable images. In *Improvisation #27* we see Kandinsky's concern for the nonobjective combined with his attempt to merge painting and music. The flowing of the shapes and lines, together with the title, reminds us of a musical composition.

Of all the modern art movements that were included in the Armory Show,

none created more controversy than cubism. The cubists developed a style of painting that dealt with the formal elements of art and made no attempt to create an illusion of reality. The most perplexing thing about cubism was that there were recognizable images in the paintings. Unlike Kandinsky, whose work could be dismissed as the ravings of a madman, the cubist painters used real objects, but distorted them, flattened them, and broke them up to such an extent that the public felt it was a hoax. The best-known cubist, Pablo Picasso (1881–1973), was born in Spain, but went to Paris at an early age. He began to experiment with geometric shapes in the first decade of the twentieth century, greatly influenced by Cézanne and primitive art, such as African masks.

In *Woman with a Pot of Mustard* (1910) the figure is broken up into planes, and the illusion of depth is done away with in typical cubist style. The title of the painting is derived from the small mustard pot to the right of the woman's head.

Man on the Balcony (1912) by Albert Gleizes (1881–1953). A second-generation cubist, Gleizes was a member of a large group of young artists, including some Americans, who were strongly influenced by Picasso.

Female Nude, charcoal on canvas (1910). Picasso has reduced the image in this work to a series of lines and shadows, flattening the form so completely that it merges with the ground. Yet at the same time, there is a feeling of a female figure present in the work.

Portrait of Kahnweiler (1910) by Picasso. Daniel-Henry Kahnweiler was the first Parisian art dealer to sell work by the cubists. By buying and exhibiting their art, he was able to supply them with much-needed public exposure.

Sunday, Women Drying Their Hair (Sloan) (Program 12).

Nude Descending a Staircase [#2] (1912) by Marcel Duchamp (see below).

Bedlam in Art (1913) from the *Chicago Sunday Tribune*. The harsh criticism and constant ridicule of the more radical works in the exhibition is typified by this article.

Nude Descending a Staircase [#2] 1912 (see below).

Rude Descending a Staircase or *Rush Hour on the Subway* (1913) from the *New York Evening Sun* was a parody of Duchamp's painting.

Theodore Roosevelt with "Uncle Sam" (anonymous drawing).

Theodore Roosevelt (anonymous photograph).

Five details from a cartoon entitled *Art at the Armory by Powers, Futurist* (source unknown). This satirical cartoon presented the author's version of the Armory Show.

Latest in Easter Eggs (1913). A cartoon from *Puck* magazine lampoons cubism.

Three details from a view in *The World* entitled *Nobody Who Has Been Drinking Is Let In to the Show*.

Art Extremists in Broadside (1913). Newspaper headline.

Beefsteak Dinner (1913) (anonymous photograph). To close the exhibition in New York, the organizers sponsored a dinner so that they could have some fun at the expense of the art critics and columnists who had lambasted the exhibition.

Menu (1913). Detail of the menu from the beefsteak dinner.
Silence (Redon).
Detail from *The King and Queen Surrounded by Swift Nudes* (1912) by Marcel
Duchamp (see below).
Poorhouse on the Hill (circa 1877) was the first Cézanne acquired by the Met-
ropolitan Museum of Art, and the first purchased by an American Museum.
Montross Gallery (n.d.), advertisement for the Montross Gallery.

MARCEL DUCHAMP

One of the most important and controversial figures in twentieth-century art
was Marcel Duchamp (1887–1968). Duchamp's constant striving to expand the
horizons of art led to a continual succession of new and innovative works of art.
He felt that art should be not only a visual experience, but a cerebral one as well.
A fondness for puns, a satirical wit, and a tremendous intellect enabled him to
create a conceptual art form. Duchamp took personal affront at the expression
"dumb like a painter," and did all he could to negate it. His great intellectual
prowess manifested itself in other ways as well. He was a chess master of inter-
national stature, and allusions to chess appear in many of his works.

Marcel Duchamp (photograph circa 1930).

Nude Descending a Staircase [#2] (1912). This painting, referred to as *The
Nude,* received more publicity than any other work in the Armory Show. In-
fluenced by his older brothers, Jacques Villon and Raymond Duchamp-Villon,
he adapted a cubist style. Unlike the cubists, who preferred to depict bodies at
rest, Duchamp here takes on the problem of movement. The painting, referred
to by one critic as "an explosion in a shingle factory," created such notoriety for
the artist that he was somewhat of a celebrity when he arrived in New York in
1915.

Bicycle Wheel (1913). This was the first of Duchamp's ready-mades. A
ready-made is a commonly manufactured article that is elevated to the realm of
art by being chosen by an artist or individual. In point of fact, this is an *assisted*
ready-made because it consists of two objects combined to create one piece. The
idea of the ready-made is Duchamp's most radical concept.

Bottle Rack (1914) is another example of a ready-made. Duchamp turns the
bottle rack, an object commonly used to dry bottles in French homes around the
turn of the century, into an object of art by placing it in an unfamiliar setting.

With Hidden Noise (1916). An assisted ready-made. *With Hidden Noise* con-
sists of a ball of twine compressed between two brass plates that are bolted
together. When Duchamp was assembling the piece, his friend Walter Arens-
berg placed an unknown object inside the ball of twine, which causes a rattle
when the object is shaken. Thus the title.

Fountain (1917). A ready-made. Entered by Duchamp in the Independents
Exhibition of 1917, an unjuried show in which anyone could exhibit, the *Foun-
tain* created a controversy. The organizers rejected the piece as not being a work
of art. In defense of his concept Duchamp wrote anonymously that "whether

Mister Mutt . . . made the Fountain . . . has no importance. He chose it. He . . . created a new thought for the object."

Traveler's Folding Item (1916). An assisted ready-made composed of a metal tripod with a typewriter cover on top.

Painted Bronze (1964) by Jasper Johns. Johns was greatly influenced by Duchamp (see Program 18).

Campbell Soup Cans (1961–1962) by Andy Warhol. Warhol, like Johns, found a great deal of inspiration in Duchamp's ideas (see Program 19).

Detail from *New York Dada Group*.

Detail from *New York Dada Group*.

New York Dada Group (1921), pen-and-ink drawing by Richard Boin. Dada (the name was a random word chosen from a French dictionary, meaning "hobbyhorse") was an artistic movement that developed during World War I. The Dadaists wanted to expose the folly of the world to man through absurd actions taken to extremes. Although they believed that Duchamp shared their views, he refused to join the group. He did, however, support their cause and contributed to several of their projects.

The Other (1916) (anonymous photograph). *The Other* was a group of artists and literary figures that formed around Duchamp's friend Walter Arensberg. Duchamp is seen standing with Arensberg to his left.

L.H.O.O.Q. (1919). Another assisted ready-made, *L.H.O.O.Q.* combines two of Duchamp's favorite devices, the pun and the ridicule of the sacred. He has in spirit defaced Leonardo da Vinci's great masterpiece the *Mona Lisa* by drawing a moustache and beard on the face. At the same time, he created a pun in the title. (L.H.O.O.Q. is actually an obscene sentence—*elle a chaud au cul*—which translates roughly as "she is hot to go.")

Detail of Duchamp and Arensberg from *The Other*.

Marcel Duchamp (1930). Photograph by Man Ray.

In Advance of a Broken Arm (1915). A common snow shovel that Duchamp converted to a ready-made. He inscribed on the handle *In Advance of a Broken Arm*, a pun on the ineffective use of the object.

Rotary Demisphere (1925). Inspired by mechanical apparatus and their workings, Duchamp used machines in several of his works of art.

Rrose Selavy (1920–1921). Photograph by Man Ray. *Rrose Selavy* was Duchamp's feminine alter ego. He created her as a pun—in French the name means "that's life"—and often signed works of art with her name.

Fresh Widow (1920). Carpenter's model. The pun is obvious in this piece, which is signed Fresh Widow Copyright Rose Selavy 1920. To enhance the pun, Duchamp replaced the glass with pieces of black leather.

Marcel Duchamp and the French Chess Team (photograph, c. 1934).

Marcel Duchamp Playing Chess with Composer John Cage (photograph, c. 1964).

Given: 1. The Waterfall, 2. The Illuminating Gas (1946–1966) is Duchamp's last and most complicated work. One of the conditions for installing the work in the museum was that the interior could not be photographed. The viewer must look through the cracks between the planks to see inside.

POST-PROGRAM ILLUSTRATIONS *Nude Descending a Staircase #2* (Duchamp); *Movement, Fifth Avenue* (Marin); *Blue Nude* (Matisse); *Mlle. Pogany* (Brancusi); *The Back* (Matisse); *Sunday, Women Drying Their Hair* (Sloan); *Kneeling Woman* (Lehmbruck); detail from *After the Bath* (Degas); *Moonlight Marine* (Ryder); *Fountain* (Duchamp); *Bicycle Wheel* (Duchamp); *Les Poseuses* (Seurat); *Female Nude* (Picasso); *Fresh Widow* (Duchamp); *L.H.O.O.Q.* (Duchamp).

QUESTIONS AND PROJECTS

I. Define or identify:

impressionism	Man Ray
postimpressionism	Walter Kuhn
pointillism	ready-made
cubism	roto-relief
fauvism	Dada

II. Developmental questions:

1 *European art.* Many different art movements from Europe were represented in the Armory Show. Can we consider one movement more important than another? What are the major differences between fauvism, cubism, and Dada? Which seems to be the most valid? Why? Which seems to have the most aesthetic appearance (which is the prettiest)? Can one movement be considered more visual or more painterly than another? Explain.

2 *Marcel Duchamp.* Duchamp is considered to be a modernist, yet he rejected some of the avant-garde movements. Does his work reflect a dependency upon avant-garde art? Is his form of modernism more valid than others? Why or why not? Compare and contrast Duchamp's paintings with Picasso's. How are they similar, and how do they differ? Compare Duchamp's ready-mades with Picasso's work. Are they at all similar in style or motivation?

3 Art criticism. We have seen how the reaction to the Armory Show was more negative than positive. Do you think the press overreacted to the exhibition? How do you interpret their reactions? Was it motivated by fear, jealousy, or perhaps ignorance? Explain your position thoroughly.

4 Art history. The Armory Show was conceived as an exhibition to further the cause of American art. Did it succeed? Was it successful in other ways? Did American artists suffer because of the inclusion of the European modernists?

III. Opinion and judgment questions:

1 Compare and contrast the works of the Americans, such as the Ashcan School or the visionaries, with the works of the European modernists, such as Picasso, Matisse, etc. Can they really be compared? Is one art form more valid than the other? Why? Does each type of art result from a particular need? Would American art of the period be out of place in Europe? Why?

2 The Armory Show generated a tremendous amount of controversy and hostility toward the more modern works of art. The public seemed to feel cheated and were generally outraged at the show's contents. Yet, some good did result from the exhibition. If you were a member of the organizing committee, what would you do dif-

ferently? Do you think that you could have changed the public's opinion without deleting any of the more radical art? Would you exclude the avant-garde works to avoid the resulting controversy? What exactly would you exclude, and what else would you include? Are there any nineteenth-century works that you would have included because of their modern and innovative character?

IV. Projects:

1 Assembling an exhibition of any size is a difficult and time-consuming task. Along with several other people, form an exhibition committee for an imaginary show using works of art from your neighborhood or from those illustrated in previous lessons. Delegate individuals to deal with problems of finding a suitable location for the exhibit, transportation for the art, security and insurance, assembling and printing a catalog, and designing the layout and the hanging of the works. What does this experiment tell you about the Armory Show? Do you think that the rewards justify the amount of work that precedes an exhibition?

2 Art criticism is an important form of communication. Attend a local art exhibition in your neighborhood or school and then write a review of it. You may wish to consult other reviews in art magazines and newspapers for some ideas as to how to approach the problem. Determine a criterion for judging the value of the works in the show and use that as a basis for your review. Should your reaction to the works presented be objective, or is it proper to allow your own prejudices to dictate the content of your review? Do you feel that your review should emphasize the negative, or positive, or both? What type of responsibility do you feel toward the people who will read your review? toward the artists involved with the show?

BIBLIOGRAPHY

Brown, Milton: *The Story of the Armory Show,* Princeton University Press, Princeton, N.J., 1955. A detailed account of the efforts behind the organization of the Armory Show. This book also includes a reproduction of the original exhibition catalog.

Hunter, Sam: *American Art of the 20th Century,* Harry N. Abrams, Inc., New York, 1973. A very good general text on most aspects of American art in the twentieth century.

Schwarz, Arturo: *The Complete Works of Marcel Duchamp,* Harry N. Abrams, Inc., New York, 1969. A complete catalog of all of Duchamp's work, with some interesting contextual comments.

Tomkins, Calvin: *The World of Marcel Duchamp,* Time, Inc., New York, 1966. An interesting account of Duchamp and the Armory Show.

AMERICA ACHIEVES AN AVANT-GARDE

PROGRAM 14

AMERICA ACHIEVES AN AVANT-GARDE

If Anything Is Done and something is done then somebody has to do it.
Or somebody has to have done it.
That is Stieglitz's way.
He has done it.

"Stieglitz" by Gertrude Stein

The biggest small room of its kind.

Marsden Hartley

The enormous impact of the Armory Show on American art tends to over-shadow earlier efforts on behalf of modernism. Several years before the exhibition the noted American photographer Alfred Stieglitz opened a small art gallery at 291 Fifth Avenue. Dedicated to the cause of modern art, "291" introduced contemporary avante-garde artists, both American and European, to the American public. Not only painters and sculptors, but pho-

Edward Steichen, Windfire, 1921. Courtesy of the Museum of Modern Art.

tographers too, were given a chance to show their work. Stieglitz's efforts were important in establishing photography as a "valid art form."

Another supporter of modern expression in art was Frank Lloyd Wright. His abandonment of revivalism in architecture, radically departing from traditional ideas of design, and his concern with functionalism and total harmony within a structure gave rise to a new architectural vocabulary and brought stylistic changes that had profound effects on the development of twentieth-century architecture, both at home and abroad.

Stieglitz's gallery and Wright's innovative architecture paved the way for the Armory Show and the eventual success of modern art in America.

OVERVIEW

The Period Approximately 1890 to 1930.

American Life As the country became richer and more powerful, it began to assert itself in foreign affairs, primarily to encourage the development of democratic institutions, but also to accumulate material benefit to the United States. With the Spanish-American War (1898) the concept of Manifest Destiny, so popular in the mid-century, was updated and expanded, becoming a kind of paternalistic exploitation known as the "white man's burden." The Philippines and other former Spanish possessions were taken under American protection as a result of this policy. In 1900 the United States championed the open-door policy in China, proposing that the country be divided into spheres of influence rather than partitioned. American foreign policy often enforced a theoretical international value, refusing compromise on principles. Shortly afterward the Boxer Rebellion—by young Chinese who wished to end foreign intervention—broke out. The United States contributed 2100 men to the expeditionary force which raised the siege of Peking in 1900.

At home the new intervention in foreign affairs brought some difficulties with it. Leon Czolgosz, a Polish immigrant and dedicated anarchist, shot President McKinley. In the 1920s the spirit of isolation redescended on the country, keeping the United States out of the League of Nations by a single vote. E. Potter Palmer, the Attorney General, captured headlines with his crusade against communism. The Red scare of 1919–1920 was a forerunner of the McCarthy Red scare of the 1950s.

American Literature Charles A. Beard (1874–1948) took a new and fruitful approach to American history in *An Economic Interpretation of the Constitution* (1913) and *The Rise of American Civilization* (1927–1930). H. L. Mencken (1880–1956) provided sharp-witted debunkings of American institutions and American life, but since he was nasty to everyone, no one took him very seriously. Sinclair Lewis (1885–1951) wrote *Main Street* (1920) and *Babbitt* (1922), adding two characters to the American conscience. Sherwood Anderson (1876–1941) influenced writers and artists alike with his *Winesburg, Ohio* (1919) and *Poor White* (1922). Stephen Vincent Benét (1898–1943) created two classics in *John Brown's Body* (1928) and *The Devil and Daniel Webster* (1939).

International Events The Great War, fought to end war, became instead, through the unrealistic terms of the Versailles Treaty, the source of World War II. The League of Nations, organized to prevent further conflict, lacked the power to control its members. The absence of the United States was an additional cause of weakness.

CONTENTS OF THE PROGRAM *Alfred Stieglitz and the "291" Group* Artists and photographers who were connected with Stieglitz's gallery "291" are discussed along with the magazine *Camera Work*.
Frank Lloyd Wright In the second section, Wright and his architecture are examined.

VIEWER'S GUIDE

PRE-LOGO ILLUSTRATIONS *Camera Work Frontispiece; Fog Horns* (Dove); *Georgia O'Keeffe* (Stieglitz); *Alfred Stieglitz* (Dorothy Norman).

ALFRED STIEGLITZ

Alfred Stieglitz (see Program 12), more than any other individual in America, fought for the acceptance of modern art. At first Stieglitz was primarily interested in photography. His magazine, entitled *Camera Work,* was dedicated to the idea that photography is a valid art form. In 1905, two years after publishing the first issue of *Camera Work,* Stieglitz opened the *Little Galleries of the Photo-Secession* at 291 Fifth Avenue, in New York City. Called "291" for short, the gallery provided a haven for photographers to exhibit their work. By 1908 the gallery had been expanded to include works by modern sculptors and painters. Eventually a group of young artists, American-born but greatly influenced by modern European art movements, came to be associated with "291" and Stieglitz.

 Interior of "291" (1914), a photograph by Alfred Stieglitz. This view of the interior of the *Photo-Secession Galleries* was taken during an exhibition of sculptures by Constantin Brancusi (see Program 13), one of the many Europeans to exhibit at the gallery.
 Interior of "291."
 Interior of "291."
 Virgin (1893) by Abbott H. Thayer (1849–1921), a member of the National Academy of Design. This painting is a good example of the type of work being done by academicians at the turn of the century.
 South Beach Bathers (1907–1908) by John Sloan (Program 12).
 Interior of "291."
 Alfred Stieglitz, Esquire (1908), a photograph by Alvin Coburn (1882–1966), a friend of Stieglitz who often contributed to *Camera Work*.

Italian Family Seeking Lost Baggage, Ellis Island (1905) by Lewis Hine (Program 12).

Photograph in the style of a Vermeer painting.

One of Stieglitz's earliest photographs is this one entitled *Sunlight and Shadows, Paula* (1893) taken in Berlin during his student days.

The Terminal or *Car Horses* (1893). This photograph, taken in New York, is one of Stieglitz's earliest experiments in capturing new and unusual environmental conditions. The work depicts a horse-drawn trolley on a winter day, and is one of the first photographs to be taken of a city street covered with snow.

Wet Day on the Boulevard (1894), another of Stieglitz's photographs showing the result of adverse weather conditions, captures the melancholy mood of a rainy day.

Night, New York (1896–1897). Constantly open to innovations and always in the forefront of new and revolutionary ideas, Stieglitz was one of the first photographers to take pictures at night. *Night, New York* is one of his first successful attempts at night photography.

The Steerage (1907). Unlike Riis or Hine (see Program 12), Stieglitz has done more than reproduce a real-life situation in this photograph. Thoughtful composition and carefully constructed tonal variations create a dramatic representation of this scene of immigrants waiting to disembark at Ellis Island. The thrusting diagonal created by the gangplank and the countermovement of the mast effectively divide the inner space of the composition, emphasizing the tight, cramped accommodations aboard ship. Stieglitz was a true master of choosing location and angle to create an effect.

Stieglitz's most complete series of portraits are of his wife, the artist Georgia O'Keeffe (see below). Not only do they delineate her personality and suggest her inner nature, they demonstrate as well Stieglitz's great compositional talents.

Portrait—Georgia O'Keeffe (1918) (photograph). Long slender fingers and a small, slender, graceful wrist give these hands an expressiveness, a uniqueness which makes them one of her most outstanding physical characteristics. Stieglitz, always sensitive to emotive traits in his subject, would often structure a portrait of O'Keeffe around her hands. In this work, for example, the stark white of the dressing gown heightens the expressive power of her hands.

Portrait—Georgia O'Keeffe (1920). In this unusual photograph, the hands express the mood of the composition. Stieglitz creates a gentle diagonal which moves our eyes from O'Keeffe's face to her hands. The work is dominated by her arms, but at the same time we remain aware of her face.

Portrait—Georgia O'Keefe (1919). This is a complete photograph, not a detail. Here Stieglitz uses just her hands to express the character of O'Keeffe.

In the 1920s and 1930s Stieglitz once again turned to unusual weather conditions, using them to explore nature as an abstraction in a series of landscapes called *Equivalent*. In many of these works, a low horizon line helps emphasize the vastness of the sky.

Equivalent, Mountains and Sky, Lake George (1924). The swirling clouds and darkened sky lend a dramatic aspect to this photograph of an upper New York

State resort area. The dark tone of the earth accentuates the brisk abstract movement of the clouds.

Equivalent (1930). The inclusion of the tree branch in the lower right corner of this photograph helps to identify the subject matter and keep it in perspective. By using this device Stieglitz is able to catch a moment of nature's fury in an abstract composition, while retaining the essence of the subject matter.

From the beginning the pages of *Camera Work* were filled with the works of American photographers. Although each artist had a unique and personal style, they all felt that photography transcended a mere mechanical process into the realm of fine arts. Stieglitz, always receptive to new photographers and their work, used the pages of *Camera Work* to expose promising talent to the public and to propagandize the aesthetics of photography. Many of the contributors to *Camera Work* went on to achieve national recognition.

Gertrude Kasebier (1852–1934), one of the founding members of "291," was introduced to photography while studying art at the Pratt Institute in New York City. In 1897 she opened a studio and soon established her reputation as a portrait photographer. Although she became a close friend of Stieglitz early in her career and helped him in his efforts to promote photography as a respectable art form, she eventually went off in a different direction, forming a rival group in company with Clarence White and A. D. Coburn called the Pictorial Photographers of America.

Blessed Art Thou among Women (1903). The soft focus and centralized composition of this photograph create a pictorial effect. Kasebier attempted to replace the romanticized blurry images of nineteenth-century photography with a work that more closely illustrated the camera's unique ability to record appearances clearly and precisely.

Portrait, Miss-N (1903). Here, too, we find that the photograph has a pictorial quality. The expressive pose and the unique treatment of the subject testify to Ms. Kasebier's portrait ability.

Another founding member of the Photo-Secessionists, Clarence Hudson White (1871–1925), was a prolific photographer with an international reputation. He was also a teacher, lecturing at Columbia University from 1907 until his death and establishing a summer school of his own with the help of the artist Max Weber.

Ring Toss (1903). Using our natural inclination to "see" things from left to right, White leads us back into the photograph by means of a diagonal movement originating in the ring stand at the lower left, extending through the rings on the floor, and culminating at the rear of the composition with the standing girl. The girl acts as a pivot, leading our line of vision to the more stable horizontal line created by the other girls on the bench and at the window. Using soft focus and sentimental subject matter, White created compositions that tended to be pictorial.

Joseph T. Kieley (1869–1914) was an associate editor of *Camera Work* and a good friend of Stieglitz. Trained as a Wall Street lawyer, he took up photography as a hobby, quickly became proficient, and soon developed an international reputation. The first American to be elected to the prestigious British society of

pictorial photographers, The Linked Ring, Kieley remained an active member of the international photography scene until his untimely death.

Portrait—Miss De C. (1905–1906). Creating a sharper image than either White or Kasebier, Kieley uses tonal variations to accentuate his compositions. Here, the stark white figure set against the dark background, and the elimination of middle tones, i.e., shades of gray, create a vivid image on a neutral ground.

Stieglitz received a tremendous amount of support for the "291" gallery from Edward Steichen (1879–1973). Although often associated with the pictorial photographers of "291," Steichen possessed a unique talent and an inquisitive nature which enabled him to transcend any one style. As a student of painting in Paris early in the twentieth century Steichen developed many close personal relationships among the European avant-garde artists. His contacts were eventually to help Stieglitz organize exhibitions of modern art at "291." After World War I, Steichen abandoned painting in favor of photography. His revolutionary approach to composition and setting soon established him as one of America's leading fashion photographers. Many of his portraits of famous people became popular standards, and his work often appeared on the cover of the most prestigious magazines, including *Life.* In 1947 he was appointed Director of Photography at the Museum of Modern Art in New York, a position he held until he retired in 1962 to devote his energies to the improvement of color photography. Throughout his life he strove to develop a full understanding of photography. He, perhaps more than any other individual, established a place for photography as a fine art in America.

Self-Portrait with Sister (1900). The grainy texture of this photograph gives it a softness characteristic of the pictorial photographers. Closing of the composition by cutting off the top of the hats accentuates the faces of the individuals, and establishing eye contact between the sitters and the viewer helps bring us into the picture.

My Little Sister with the Rose Colored Hat (1899). This simple but expressive photograph of the artist's younger sister is another work done in the pictorial style.

Detail of the cover design for *Camera Work* (1906). This photograph was conceived as a design for the cover of an issue of *Camera Work.* Steichen chose props, such as the pot in the woman's hand or her large earrings, to intrigue the viewer. Similar attention-getting devices constituted an important element in his fashion photographs of the twenties and thirties.

Portrait of Lady H. (1908). The muted color helps enhance the painterly effect of this early experiment in color photography.

Auguste Rodin (1908) detail of a photograph by Alvin Coburn. The accentuation of the artist's heavy brow, lined cheeks, and massive nose produces a ruggedness reminiscent of Rodin's sculpture of Balzac.

Balzac: Towards the Light, Midnight (1908) is one of a series of photographs that Steichen took of Rodin's massive statue of Honoré de Balzac, the famous nineteenth-century French critic and novelist. The low horizon line helps sil-

houette the statue, adding to the feeling of massive monumentality created by the dramatic nature of the moonlight.

Fashion Photograph for Vogue (circa 1924). Steichen abandoned the soft focus pictorial style in favor of sharp, precise images for his fashion photographs. Clear sharp images and simple but tasteful settings create an effect of regal elegance. Steichen's fashion photographs duplicate the chic quality of the models and their clothes.

Cheriut Gown (1927). Marion Morehouse, the wife of the poet E. E. Cummings, is the model for this expensive gown.

Fashion Photograph for Vogue (circa 1923). Although most of Steichen's fashion work was for *Vogue,* he also contributed to *Vanity Fair.*

Vogue Fashion: Black (1935). The use of the unique shape of a piano, which seems strangely out of place in this setting, combined with the dramatic use of lighting, helps develop an exotic and mysterious undertone in this work.

Vogue Fashion: White (1935).

Among his other achievements Steichen remained an accomplished portraitist throughout his career, recording the character and essence of many famous people. His insistence on natural expression from his sitters often led to uncharacteristic and revealing portraits.

Theresa Duncan: Reaching Arms (1921). In 1921 Steichen accompanied Isadora Duncan, the famous dancer, and her pupils to Athens. There, on the Acropolis, he did a series of photographs in which he captured the grace and charm of the dancers. During one of these sessions, Steichen called out to Theresa, Isadora's most gifted student, who was hidden behind a section of the ruins. Hearing him call, Theresa raised her arms in a graceful curve against the background of the Erechtheum, creating this composition which Steichen then photographed.

Wind Fire (1921). During the same session on the Acropolis, Steichen photographed Theresa as the wind caught her flowing garment, which seemed to change into a fiery apparition.

J. P. Morgan (1903) captures the mystery and power of one of America's most famous self-made men. The large knife seems an appropriate symbol of the rugged no-holds-barred personality common among America's early industrial giants.

Detail of the knife in Morgan's left hand from *J. P. Morgan* (1903).

Gloria Swanson (1924). Placing a piece of lace in front of her face for effect, Steichen took this photograph of Gloria Swanson. The lace effectively camouflages the feline eyes of Ms. Swanson, giving the work an aura of mystery.

George Bernard Shaw (1908), color photograph. The famous playwright, one of Steichen's favorite subjects, is seen here during a relaxed moment.

Henri Matisse (1909). Among Steichen's friends in Paris was the famous French artist Matisse (see Program 13). Taken in Matisse's Paris studio, this photograph shows him at work on his sculpture *La Serpentine.*

Greta Garbo (1928). Steichen's uncanny ability to put his sitters at ease and allow their true personality to emerge enabled him to take this photograph of

the famous actress. Positioning her arms to frame her head and placing her in a simple setting help make Garbo's face the dominating feature of the composition.

This photograph of *Carl Sandberg* (1936), the famous poet and biographer, was taken the morning after he completed his massive biography of Abraham Lincoln. The serene smile indicates a job well done while the multiple images suggest the many-faceted character of both the sitter and his subject.

Studio of Leo and Gertrude Stein (1907). (The image is reversed.) Among the earliest supporters of modern European art, the Steins used their wealth to help some of the poorer artists. The Stein family introduced Steichen to the avant-garde art movements in Paris.

Leo, Gertrude and Michael Stein (1906) (anonymous photograph taken in Paris). Of the three members of the Stein family pictured here, Gertrude, primarily because of her provocative prose style, remains the most famous.

Photo-Secession Members (circa 1906). A photograph by Frank Eugene, taken during a meeting of some of the key figures in the development of "291." Included in the picture are Eugene, Stieglitz, Henrick Kuhn, and Steichen.

Nude Woman (undated), wash drawing. Drawings by Auguste Rodin (1840–1917) constituted the first show of works by a modern European artist at "291." The sculptor established his reputation through his realistic sculpture, but his more abstract drawings set off a great controversy in New York.

The Thinker (1869–1879), cast bronze. Originally cast as part of a larger project (the *Gates of Hell*), *The Thinker* is probably Rodin's best-known work. The brooding man and his pensive pose are so familiar that the pose itself has become a cliché. Yet at the time of its execution the statue was a tremendous statement of realism, the pinnacle of nineteenth-century realistic sculpture.

The Kiss (1886–1889), carved marble. The romantic subject and the graceful handling of the intertwining figures typify the qualities that made Rodin's work famous. The statue, like many others including *The Thinker*, was done in multiple copies.

The Plumed Hat (1919), drawing. Henri Matisee (see Program 13), another of the European moderns who exhibited at "291," probably made this drawing as a study for a painting entitled *White Plumes*, also done in 1919.

Mlle. Pogany (1913) by Constantin Brancusi (Program 13). This was part of the exhibition of Brancusi's illustrated above in the interior view of "291." The show, mounted in 1914, capitalized on the popularity Brancusi gained as a result of the Armory Show.

At the Moulin Rouge (1892) by Henri de Toulouse-Lautrec (1864–1901). A member of the French aristocracy, Toulouse-Lautrec abandoned the social world of the upper classes because his deformed legs made him unfit for such a life. He turned instead to the seamy world of the working classes. At the Moulin Rouge, a Paris cabaret (or nightclub), Toulouse-Lautrec found subjects with whom he felt more comfortable. Often associated with the impressionists, he used a similar type of brushwork, but his unusual compositions, exotic subject matter, and use of a darker palette set him distinctly apart.

The Gypsy Woman with a Baby (1919) by Amedeo Modigliani (1884–1921). Modigliani, an Italian painter and sculptor, began his artistic studies in Italy, but moved to Paris in 1906, where he quickly made contact with members of the avant-garde art movements. He was greatly influenced by fauves, the early works of Picasso, and the sculpture of Elie Nadelman. His creation of flat elongated figures by the use of large areas of color caused Modigliani to be looked upon as one of the more radical artists to exhibit at "291."

View of the Isle of St. Louis, Paris in the Evening (1906). Henri Rousseau (1844–1910) worked for most of his life as a clerk for the French government. In 1885 he retired and, in spite of the fact that he had no artistic training, took up painting. His style, often called primitive, combines a world of fantasy with the naïve innocence of a child. The strange images, fresh approach, bright colors, and lack of concern for proportional accuracy are typical of primitive artists. They tend to paint the world as they *think* it is rather than as a retinal image. Rousseau was one of the artists who showed at "291."

Portrait of Gertrude Stein (1906) by Pablo Picasso (see Program 13), a close friend of Gertrude Stein. We can see Picasso's movement toward a cubist style in this portrait of the famous writer. The flat planes of color that form her body and head, the flattening of space, and the centralization of the composition are all characteristics of cubism.

Mont Sainte-Victoire (1885–1887) by Paul Cézanne (Program 13). Although Stieglitz was the first person to exhibit Cézanne's paintings in America, it was the influence that his works exerted in Paris on young American artists that was to have the most lasting effect upon American painting.

Children's Art (1912). These illustrations were taken from a newspaper review of an exhibition of children's art held at "291" in 1912. Stieglitz felt that all art had merit, even the works of little children, and therefore exhibited children's art as he would any other kind.

Detail from *Stieglitz at the Marin Exhibition.*

Stieglitz at the Marin Exhibition (1940) by Ansel Adams (born 1902) (Program 7).

Camera Work Frontispiece.

Old Canal Port (1914) by Oscar Bluemmer (1867–1938). One of a group of native American painters who were associated with "291," Bluemmer studied in Europe, where he was influenced by the fauvists, as can be seen in his use of bright flat areas of color.

Landscape (1907) by Alfred Mauer (Program 13). Mauer, like many of the other young artists, also exhibited at "291."

Oriental Synchromy in Blue-Green (1918) by Stanton Mac Donald-Wright, a member of the synchromist movement. Like many American modernists, he found the only place that would exhibit his works was the galleries of the Photo-Secession.

Early in his career Marsden Hartley (1877–1943) traveled to Germany to study painting. There he encountered both German militarism and the expressionist movement. His early works, done in the style of the German expressionists, contained a rich sampling of German symbols. After his return to the

United States, he began to combine European pictorial elements with American subject matter.

Portrait of a German Officer (1914). Fascinated by German militarism, Hartley often incorporated German army emblems and insignia into his paintings. In this work, painted on the eve of the First World War, the artist employs a kaleidoscope of Teutonic banners and symbols, overlapping and interweaving them in a dynamic composition. The lack of spatial development and the use of recognizable images in an abstract work are also typical of the expressionist movement in northern Europe.

Mount Katahdin, Autumn No. 1 (1939–1940). Hartley eventually returned to his native Maine, where he painted landscapes of the surrounding countryside. Although he had returned to traditional American subject matter, his use of flat planes and the reduction of the image to geometric patterns are characteristics developed during his encounter with European modernism.

Born in Russia, Max Weber (1881–1961) came to the United States with his family at the age of 10. He studied art at the Pratt Institute of Art and later in Europe. The first of the new generation to return from Paris, he began Stieglitz's education in the ideas and concepts of modern art. Weber was able to combine the new stylistic innovations of the European moderns with his own personality to produce a uniquely American type of cubism.

Chinese Restaurant (1915). Weber combines the fractured geometric images of cubism and the bright and daring palette of fauvism with the turbulent movement of futurism.

Rush Hour, New York (1915). Weber captures the hustle and turmoil of New York City's rush hour in this work by juxtaposing and overlapping geometric shapes.

Combining the monumental feeling of the city with a concern for machines and mechanisms, Joseph Stella (1877–1946) painted familiar New York landmarks in a style that shows the marks of both cubism and futurism. Stella, like Weber, managed to express the essential nature of the city in his works, although he did not paint in a realist manner.

Battle of Lights, Coney Island (1913–1914), seems to express the gay carnival atmosphere of Coney Island, an amusement park along the beach in Brooklyn, New York. Swirling shapes and images along with the contrasting of bright and dark hues create a feeling of rapid movement, similar to the approach of the futurists.

New York Interpreted: The Bridge (1920–1922). This painting of the Brooklyn Bridge (see Program 11), a subject that Stella painted often, is one in a series entitled *New York Interpreted*. A modern marvel of engineering, the graceful structure incorporates Gothic arches into its geometric pattern of cables, making it an ideal subject for a painting in the cubist style. Here Stella reduces the bridge to its mechanical elements while at the same time emphasizing the vertical thrust of the support towers. The swooping cables help to define the painting's spatial relationships, although the overall composition remains surprisingly flat.

Portrait—Georgia O'Keeffe (1923), photograph by Alfred Stieglitz.

Arthur Dove (undated), a photograph.

John Marin (undated), a photograph by Alfred Stieglitz.

John Marin (1870–1953) combined the formal elements of cubism and futurism with a personal form of expressionism in a highly individual artistic statement. Marin was born in America and educated there until his mid-thirties, when he went to Europe. It was in Europe that he met Steichen, who eventually introduced him to Alfred Stieglitz. The contact with Steichen and Stieglitz first exposed Marin to the artistic innovations being developed abroad, and after 1910 he began to incorporate European stylistic ideas into his paintings of American landscapes. These structural landscapes resemble more closely the works of the fauves, especially Maurice Vlaminck, than the works of Cézanne. Marin's synthesis of European avant-garde art movements with traditional American subjects helped establish modernism in the United States. Unfortunately, many younger artists, ignoring domestic developments in modern art, continued to look across the oceans for inspiration.

Looking up Fifth Avenue from Thirtieth Street (1932). Marin often turned to the streets of New York for subject matter. In this work, we see his interpretation of one of New York's most glamorous avenues. He uses the overlapping planes of cubism and the movement of futurism to depict an American scene.

Tunk Mountain, Maine (1945) demonstrates the structural nature of Marin's work. He uses blocks of color to build images and to lay out the composition. The painting, divided into three horizontal sections, employs angular forms to express the majesty and power of one of nature's monuments.

Pertaining to Stonington Harbour, Maine No. 4 (1926). Vigorous brushwork and an erratic linear rhythm help break up and disperse the images in this watercolor. At the same time the white border closes the composition, turning it back into itself and creating an overall effect of suppressed power and activity.

Region of Brooklyn Bridge Fantasy (1932). Unlike Stella, Marin chooses to depict the Brooklyn Bridge symbolically in this watercolor. Attention is given to scenery surrounding the bridge, while the structure itself is only hinted at by the use of a thick horizontal line representing the body of the bridge and thinner vertical lines that represent the supporting cables.

Unlike many of the artists associated with "291," Arthur Garfield Dove (1880–1946) did not abandon European modernism in favor of a more realistic approach that was traditionally American. His experiments with new and more abstract approaches to art led him to explore the use of collages. Eventually his painting became so abstracted as to be almost nonobjective. A collage is a work of art constructed from bits of material (paper, wood, cloth, etc.) that are fastened to a canvas or some other surface. Quite often these surfaces were painted, effectively combining the two art forms. The cubists were the first artistic group to make extensive use of the collage.

Goin' Fishin' (1926). Denim, bamboo, and bark on composition board. This collage is constructed of materials familiar to individuals who enjoy fishing. Dove uses parts from denim clothes as the central ground of the composition, surrounding them with pieces of a bamboo fishing pole; the final bit of bark enhances the association between the materials used and the act of going fishing. Dove's concern with the narrative content of the collage caused some of them to resemble three dimensional trompe l'oeil paintings.

Minotaure (1933). Pencil drawing with paper and cloth on wood. Originally

designed as the cover for a magazine of the same title, this detail of a collage by Pablo Picasso (see Program 13) emphasizes the artist's concern for texture as well as context.

Goin' Fishin' (1926). Detail of the upper half.

Abstraction Number 2 (1910). Dove was the first American artist to paint nonrepresentational forms, shown in this work of bright colors and nonrepresentational forms. The placing of the main image in the center of the composition is very similar to the cubist approach, but the use of rounded organic images and intense colors is not.

Ferry Boat Wreck (1911). Dove continued to paint in an abstract manner, though he never lost touch with nature. The title of his paintings became an integral part of the viewer's understanding of the work. In this painting the abstract images lend themselves to an easy interpretation once the subject is defined by the title. The blues and grays of the ground suggest the ocean, perhaps in the dark dawn, while the long black shapes resemble the gnarled and twisted wreck of a pier. The ferry is the oval shape at the left side of the composition.

Fog Horns (1929). Once again the title helps us to interpret the content of the work. Dove uses a palette of neutral grays, blues, and pinks to describe the fog and then imposes over this ground three oval shapes, formed of concentric rings, representing the sound of fog horns.

Portrait—Georgia O'Keeffe (1920). Photograph by Alfred Stieglitz.

Another American artist who often painted in an abstract manner was Georgia O'Keeffe (born 1887). Never having traveled to Europe in her youth, O'Keeffe acquired her knowledge of continental art trends from the exhibitions at "291" and from other American artists, such as Charles Demuth (see Program 15), who were influenced by the modernists. Her painting, ranging from total abstraction to expressive naturalism, remains very personal and original. Often her works seem cubist-oriented, but like Dove she never really succumbs to the harsh formalism of cubism. O'Keeffe often combines natural subject matter with bright and lively colors. Throughout her long and productive career, her work has consistently been directed toward herself and her own feelings.

Blue and Green Music (1919). Using nonvisual ideas as a basis for a visual statement, O'Keeffe combines flowing lines and exotic images to create a symphony of color.

Black Iris (1926). (This illustration is upside down.) Quite often O'Keeffe would translate the normal shape of flowers, trees, leaves, whitened bones, and other objects into her own conception of natural forms. In this work she catches the soft limpid quality of a flowering iris by using curving organic shapes.

Patterns of Leaves (1924). In this composition of overlapping leaves, the images are less abstract than those in *Black Iris*, although O'Keeffe uses the same soft colors.

Radiator Building—New York (1927). Always sensitive to her environment, O'Keeffe painted this work while she lived in New York. Sharp crisp edges delineate the skyscraper against a coal-blue night sky causing a subtle transition of color that effectively captures the mood of Manhattan at night.

Cow's Skull—Red, White and Blue (1931). O'Keeffe loves the West and often paints scenes inspired by the desert. The intriguing shape of a weathered cow's skull, whitened by the sun, is placed on a dark post to form an abstract cross framed in intense blues and reds, conveying a feeling of mystery and spirituality.

Paul Strand (born 1890), influenced by the machine art of the precisionists (see Program 15) and others, was one of the first photographers to realize the full potential of the camera. His constant experimentation with the close-up, candid shots, and cropped compositions gave him the skill necessary to record the harsh realities of life. Strand's unusual, yet realistic photographs had far-reaching effects on other photographers and artists who saw in his work an example of the pure photograph.

Wall Street (1915). The influence of hard-edge art such as cubism is apparent in this photograph of New York's financial district. The receding forms of the buildings, windows, and the people all walking in the same direction establish a diagonal line which causes the viewer to read the photograph from right to left rather than the more usual left to right. Reversing the normal sequence of seeing creates an inner tension, which is heightened by the contrasting of lights and darks.

Photograph in the style of a Vermeer painting.

Portrait (1916). Strand uses a high-contrast image that is sharp and clear to express the character of this old and worn woman. The top of the composition is cropped in the manner of Steichen's *Self-Portrait with Sister* (see above), but the close-up view and the sharp focusing heighten the emotional effect.

Blind Woman (1916). Strand, often choosing his subjects from the poorer sections of society, effectively destroyed the idea that a photograph has to be pleasant. Constantly aware of detail, he uses the close-up to establish the personality of this elderly blind woman. His inclusion of the placard proclaiming the woman's affliction and the metal license issued by the city of New York further clarify the woman's desperate situation.

Sandwich Man (1916). Strand captures the poverty of the man and his environment in this highly realistic photograph. The unusual placing of the main figure to the side of the composition further emphasizes the squalor of the scene.

Abstraction, Porch Shadows (1915). Like Stieglitz, Strand was interested in the abstract potential of photography, as can be seen in this photograph. The abstract nature of the shadows cast by a porch are embellished by juxtaposing light and dark tones.

FRANK LLOYD WRIGHT

"291" became the rallying place for avant-garde art in the United States. There, artists were free to examine and experiment with modernism in various forms derived from European art movements. Architecture, however, developed in the opposite way. While Americans were looking to Europe for inspiration in

the fine arts, Frank Lloyd Wright (1867–1959) was attracting the attention of European architects with his new and innovative concepts and designs.

Wright, in an attempt to abandon revivalism in architecture, formulated a new vocabulary of structural functionalism. Following the example of his early teacher, Louis Sullivan (see Program 11), he adhered to the principle that form must follow function, whether in a commercial structure or in a private home. Building on the traditions of such great American architects as Thomas Jefferson, Andrew Jackson Downing, and H. H. Richardson, Wright developed a theory of architecture that combined political ideology, environmental concerns, and functionalism. Wright felt that America must develop a new concept of building dedicated to the ideals of modernism—in other words, an architecture of democracy. To this end, he began to design monumental structures, centrally oriented and accented by clean sweeping lines. The austere but graceful vertical emphasis of his early commerical structure was a source of inspiration for some of the members of the great German school of design—*Der Bauhaus*.

Robie House (1909, Chicago, Illinois). The use of terraces and the low nature of the structure give this house a horizontal emphasis. The way the house merges with the ground and the intentional emphasis of the horizontal axis are characteristics of the *prairie house*. The prairie house, as designed by Wright, was reminiscent of the rolling plains of the Midwest. The low-slung nature of these houses tends to anchor them to the land, so that in many cases they almost resemble a hillock rather than a dwelling. This incorporation of the structure into the site is an idea Wright used over and over in his designs.

Robie House, Interior (1909, Chicago, Illinois). As can be seen in this view of the ground level interior of the Robie house, Wright returned to the American concept of using the hearth as the central structure in a home. The extensive use of glass, recessed behind the overhanging terrace, enables the interior to remain light and airy while maintaining a great deal of privacy.

Detail of *Robie House* (1909, Chicago Illinois).

Ho-o-Den (1893, Chicago, Illinois). Wright was influenced by many different sources, including Japanese architecture. This pavilion, built by the Imperial Japanese government for the Columbian Exposition (see Program 11), had a lasting effect upon Wright, and may well be the reason behind his tendency to open the interior space of his buildings.

Watts Sherman House (1874–1876, Newport, Rhode Island). This house by H. H. Richardson (see Program 11) is similar to structures built in America during the latter half of the nineteenth century. The use of natural materials such as shingles and the adaptation of the building to fit the site were typical concepts of Wright's designs.

Paul Hanna House, Interior (1937, Palo Alto, California). In this example of a prairie house, Wright uses a series of interlocking and connecting hexagons for the basic ground plan. Built of redwood and brick, the house reflects its location in northern California.

Paul Hanna House, Interior (1937, Palo Alto, California). Wright designed the interior of this house around the centrally located hearth.

Second Jacobs House (1948, Madison, Wisconsin). Extensive use of glass opens up the interior space of this prairie house that Wright built late in his career. The use of fieldstone as the basic structural material helps the house merge with the surrounding landscape.

Second Jacobs House, Interior (1948, Madison, Wisconsin). A concern for total design led Wright to construct many of the interior fixtures in his buildings, including the ones in this room.

Fallingwater (1936–1937, Bear Run, Pennsylvania). Cantilevered terraces and a dramatic setting help to make this house one of the high points in Wright's career. Built for the Kaufmann family as a summer home, this house is said to have cost over $175,000. Wright used slate (quarried from the site itself) and reinforced concrete as the primary structural elements.

Fallingwater, View from Below (1936–1937, Bear Run, Pennsylvania). The gentle sound of the waterfall is audible throughout the house. Wright positioned the building in such a manner that when ventilating windows are opened, the running water acts as a natural form of air conditioning.

Fallingwater, View of a Terrace (1936–1937, Bear Run, Pennsylvania). The use of cantilevered terraces was a major innovation in architectural design. Basically, the principle is quite simple. A central support, in this case the hearth, is built upon the living rock, from which rigid forms are suspended. The entire area of support is at one end of the form, making unnecessary any sort of posts or other type of vertical support. Wright was a pioneer in the use of reinforced concrete as a building material.

Fallingwater, View of the Living Room (1936–1937, Bear Run, Pennsylvania). (This illustration is reversed.) Wright made use of many innovations in the construction of Fallingwater. Besides using reinforced concrete, he developed a new type of casement window, used foam rubber and recessed fluorescent lights for the first time in a private dwelling, and invented a type of mitered glass that eliminated support posts at intersecting corners.

Taliesin West (1938–1959, Maricopa Mesa, Arizona). This was Wright's own home, built in the desert near Phoenix. Wright began a school of architecture, called the Taliesin Fellowship, and built this structure to house both his students and his family. Constructed of desert rock, redwood, and canvas, this elaborate prairie house blends well with the flat arid desert.

Taliesin West, Interior (1938–1959, Maricopa Mesa, Arizona). The light airy quality of this room seems to be well fitted to the surrounding environment. The use of redwood and canvas is made possible by the predominantly dry warm weather in Arizona.

The Guggenheim Museum (1946–1959, New York, New York). Wright's last building is a monument to himself as much as it is a museum. The design is a series of concentric circles that form an upside-down cone, positioned next to a more conventional administrative section. The flowing lines of the exterior and the monumentality derived from the massiveness of the building create a giant sculptural shape.

The Guggenheim Museum, Interior (1946–1959, New York, New York). This

view of the major interior space in the museum section of the structure enables us to see that Wright still relied upon a centrally oriented ground plan.

The Guggenheim Museum, Interior (1946–1959, New York, New York).

POST-PROGRAM ILLUSTRATIONS *Tunk Mountain, Maine* (Marin); *Goin' Fishin'* (Dove); *Mount Katahdin, Autumn No. 1* (Hartley); *Abstraction, Porch Shadows* (Strand).

QUESTIONS AND PROJECTS

I. Define or Identify:

Camera Work	pictorial
avant-garde	prairie house
Gertrude and Leo Stein	Frank Eugene
futurism	Alvin Coburn
abstract	Maurice Vlaminck
collage	modernism
cantilevered	expressionism

II. Developmental questions:

1 *Photography.* How did the photography of the early members of "291" compare with photographs from the nineteenth century? What was innovative about the photography at "291"? Can the works of Stieglitz, Steichen, etc., be considered fine art? Why? How did the works at "291" differ from those of Hine or Riis?"

2 *Painting.* Why are Dove, Marin, and O'Keeffe considered to be the most innovative painters from "291"? Does their art express more of the American tradition than the works of the other artists associated with the gallery? Do you interpret the use of traditional or American subject matter as an abandonment of modernism? Can an artist still remain a part of the avant-garde even though he relies upon tradition? Explain.

3 *Modern art.* Do you think that Stieglitz was a successful spokesman for modernism in America? How would you characterize his contribution to the course of modern art? What is the danger inherent in having only one individual speak for a larger group? Did Stieglitz fall into this trap? Explain.

4 *Architecture.* How did Frank Lloyd Wright's architecture differ from the more traditional concepts of building? Was Wright successful in developing a modernistic style of architecture? What positive qualities do you find in his buildings? Are there drawbacks to his designs? How might he have avoided them?

III. Opinion and judgment questions:

1 Two of the most important factors in the development of modern art in America during the first part of this century were the Armory Show and "291." How do they relate to each other? Could the Armory Show have been conceived without the groundwork laid by "291," and could "291" have succeeded in its struggle without the boost given by the Armory Show? Consider all the facts and developments in the American art world between 1900 and 1925 and see if you can determine whether or not modern art could have established itself without the Armory Show or "291."

2 We have seen how some of the early photographers at "291" searched for a "purer" photograph with their "pictorial" style. Paul Strand and Edward Steichen in his later work took a different approach, relying upon a sharper, more precise image. Which type of photograph seems to exploit the potential of the camera more fully? Is one style more "real" than the other? Can both types be said to be true to the nature of the camera? What role does subject matter play in determining the photographer's approach? Do some subjects seem more appropriate to one particular style?

IV. Projects:

1 Examine the architecture in your neighborhood and try to determine what buildings, if any, have been influenced by Frank Lloyd Wright's designs. Pick one building, either public or private, and try to reconstruct the basic ground plan in the spirit of Wright's architecture by using some of his ideas as well as your own.

2 Look at the fashion photographs in a current issue of *Vogue* or some other magazine, and see if you can distinguish between different styles of photography. Then, using your own camera and a friend as a model attempt to recreate some of the compositions in the magazine. Experiment with your own ideas, making use of lighting, setting, and props. If possible try to develop the photographs yourself. Once you have finished the project, contrast your experience with the results. Does creating your own photographs help you to appreciate the works of others?

BIBLIOGRAPHY

Brown, Milton: *American Painting from the Armory Show to the Depression,* Doubleday, Doran and Co., Inc. Princeton Univ. Press, Princeton, N.J., 1955. A good survey of American painting during the first third of the twentieth century.

Frank, Waldo, et al. (eds.): *America & Alfred Stieglitz,* New York, 1934. A series of essays by artists and writers associated with "291" dealing with their impressions of the gallery and the man behind its founding.

Green, Jonathan: *Camera Work,* Aperture, New York, 1973. A detailed account of the magazine and its contributors.

Rosenfeld, Paul: *Port of New York,* University of Illinois Press, Urbana, Ill., 1961. Fourteen essays dealing with the literary and artistic community in New York during the first quarter of the twentieth century. Rosenfeld, a renowned art critic, was an early supporter of Stieglitz and "291."

PROGRAM 15

POLITICS AND ART BETWEEN THE WARS

Slowly I began to feel how different from our own is the French or Paris mentality
Most French art—indeed most European art—is fluent, detached, critical, aware of its
artistry; while our best American art has always been sensitive, inhibited, romantic, pas-
sionate, naive in its realism, and often not too critical . . . of the problems of aesthetics. I
believe that when I returned to America (in 1926), I was more conscious than I had ever
been before of my own and of my American inner attitude toward life; and felt that the mo-
ment in my career had arrived when I need preoccupy myself less in self-probings, and
could allow my energy to flow into a more direct subconscious emotional expression of
life . . . I for one would be deeply unhappy anywhere else than in America. But this goes
not to the essence. Of course an American, if he be one, will create best in terms of his
America. But an artist . . . must probe and know his own depths and then he can ex-
press not only his America but the world's life which is in each of us.

George Biddle in the American Magazine of Art (1929)

Although there were many painters and many movements during the 1920s and the 1930s, American painting was generally dominated by three groups: the Modernists, the Regionalists (the American Scene paint-

Charles Sheeler, Upper Deck, 1929. Courtesy of the Fogg Art Museum, Harvard University, Cambridge, Mass.

ers are included among them), and the Social Realists. The Modernists, the smallest of the three groups, worked primarily with the new methods of abstraction which the Armory Show had introduced to American artists. The Regionalist painters sought to portray American subjects in a clearly discernible American style. The Social Realists shared this concern for American style and subject, but they found their material in a different location: among the poor, the dispossessed, and the unemployed. Whether Modernist, Regionalist or Social Realist, American artists were moving toward new and important expressions of the national character.

OVERVIEW

The tape covers primarily the painters who were active and prominent during the two decades which separated World War I from World War II.

National Life Prohibition, the strangest product of the nation's war effort, launched the decade on a note of moral rectitude, but it soon became apparent too many people liked drinking too much for the experiment to succeed. A distribution network was established to provide both clubs—"speakeasies"—and individuals with alcoholic drinks. Millions of dollars were spent to enforce an amendment which millions of citizens were violating. Large criminal organizations grew up to handle the business and to trim off the profits. Al Capone, the leader of the Chicago mob, is estimated to have turned a 60-million-dollar profit in 1927, mostly on the sale of beer.

The crash of the New York Stock Market in 1929 cut short the easy prosperity of the twenties and set off worldwide depression. Soon 8 million Americans were out of work. Franklin Roosevelt promised to end the misery, and a hopeful America decided to believe him. After a brief resurgence at the beginning of Roosevelt's first year in office, however, the economy slowed down again. It was not until 1937, when the Democrats began to apply the controversial economic principles advocated by John Maynard Keynes, that the economy turned upward for good.

American Literature American literature of the twentieth century is too rich and varied to permit a complete treatment, but these names stand out. F. Scott Fitzgerald (1896–1940) captured the frantic ideals of the "Jazz Age" in *The Great Gatsby* (1925) as well as the disintegration of the same crowd in *Tender is the Night* (1934). Ernest Hemingway (1899–1961) recorded the disillusionments of war in *A Farewell to Arms* (1929) and the anguish of the American expatriates —the "lost generation"—in *The Sun Also Rises* (1926). John Dos Passos (1896–1970) produced a monumental panorama of American life during the first three decades of the century in *U.S.A.* (1937). Sinclair Lewis (1930), Eugene O'Neill (1936) and Pearl Buck (1938) were awarded the Nobel Prize for literature.

International Events. Postwar inflation in Europe disrupted the economy of several countries, encouraging the emergence of strong leaders. In Germany, Adolf Hitler's National Socialist Party restored the economy, and then ruined the country by embarking on a disastrous course of military conquest. Italy,

equally beset by economic troubles, fell under the spell of Benito Mussolini's Fascist Party. In Spain the monarchy collapsed, eventually opening the way for a murderous Civil War (1936–1939) which cost more than a million lives. In France a Leftist coalition, the Popular Front, came to power in 1936.

CONTENTS OF THE PROGRAM *Modernist Trends* Stuart Davis and the Precisionists, such as Charles Demuth and Charles Sheeler, used American subjects to restate the European avant-garde artistic styles introduced in this country by the artists associated with Stieglitz's "291" (see Program Fourteen).

Painters of American Life Through their personal interpretations of natural scenes and typical American activities, Charles Burchfield and Edward Hopper depicted the hopes and disappointments of American life.

The Regionalists Thomas Hart Benton, Grant Wood, John Steuart Curry and Reginald Marsh (Note: Marsh is sometimes considered as a separate entity since he painted only urban subjects) each recorded typical aspects of life in distinct and separate parts of the country.

The Social Realists Photographers like John Vachon and Dorothea Lange, painters like Alexandre Hogue, Alexander Brook, Robert Gwathmey, Philip Evergood, Jacob Lawrence, Jack Levine, the Soyer brothers (Raphael, Moses, and Isaac) and Ben Shahn conveyed a truthful vision of suffering and despair in an economically depressed country.

VIEWER'S GUIDE

PRE-LOGO ILLUSTRATIONS *Welders* (Shahn); *Nighthawks* (Hopper); *Tornado* (Curry); *July Hay* (Benton); *Daughters of Revolution* (Wood).

MODERNIST TRENDS

Stuart Davis (1894–1964) was helped on his career by both parents. His father was art director of *The Philadelphia Press* (four artists from the Eight—Sloan, Glackens, Luks, and Shinn—worked for him) and his mother was a sculptor. In 1909 Davis began to study with Robert Henri in New York City, but soon moved away from Henri's kind of realism, in the direction of a more abstract imagery. He nonetheless retained the ability to pick out the significant details of the American environment. After the Armory Show he began experimenting with collage and with painted simulations of collage; his work became increasingly two-dimensional and abstract. Davis's work had a significant influence on commercial art.

Details of *Owh! in San Pao* ending on the Stuart Davis signature, opening up into a full view of *Owh! in San Pao* (1951). Reducing three-dimensional objects to a series of planes and colors is characteristic of Davis's paintings after 1928. In a typical work, like *Owh! in San Pao*, Davis groups abstractions of real

objects with words inserted to identify the flat surface of the painting. The intersecting planes, combined with effective color combinations, suggest a depth and distance which the yellow background denies. Although the eye cannot penetrate deeply, Davis's studied arrangement of colors and forms continually encourages the attempt.

Lucky Strike (1921) is from a series of cigarette packages.

Bull Durham (1921). Despite his identification with modern principles of abstract (nonrepresentational) painting, Davis always considered himself a realist. Study with Robert Henri trained him to discern and understand the significant details of what he observed. *Lucky Strike* and *Bull Durham* are precise transcriptions of real, recognizable objects as well as examples of painted collage.

Rapt at Rapaport's (1952). Davis's titles for his later paintings are often chosen to appeal to the ear. In *Owh! in San Pao* the assonance and the punctuation help create a mood; in *Rapt at Rapaport's* the combination of *r*'s, *p*'s, and short syllables suggest a musical rhythm.

Report from Rockport (1940) differs from *Owh! in San Pao* and *Rapt at Rapaport's* in its use of perspective lines and color to suggest a deep space. The garage in the center, for example, is set deep within the picture space. There are even recognizable forms, such as the gas pump and the building at right.

Something on the Eight Ball (1953) is a visual confusion effectively introduced by a title which is itself confused. "Behind the eight ball" is a colloquial expression indicating a desperate situation and suggests failure, whereas "something on the ball" denotes the ability to overcome adversity.

New York under Gaslight (1941) is filled with jokes: the pointing finger at the right, the fragment of DENTIST with the dented D, the sign at the right DIG/THIS/FINE/ART/JIVE.

THE PRECISIONISTS

Charles Demuth (1883–1935) studied art at The Pennsylvania Academy of the Fine Arts and in Paris. Of independent means, he was able to paint what he liked and he chose to follow the modern trends, aligning himself with the 291 group of Alfred Stieglitz. His later paintings are often concerned with the precise rendering of architectural forms and geometric shapes.

My Egypt (1927). Demuth, along with most other American painters influenced by cubism, adopted cubist-oriented space relationships while leaving aside the cubist preference for analytical planes. American architecture, with its straight lines and simple functionalism, lends itself very easily to this kind of treatment.

The Circus (1917). One of Demuth's many watercolors of circus performers and acrobats, *The Circus* emphasizes the tension and the drama of performance.

My Egypt (1927).

Collage (1920s) by Pablo Picasso.

My Egypt (1927).

Ici, c'est Alfred Stieglitz (1915) by Francis Picabia.

Poster Portrait: I Saw the Figure 5 in Gold (*Homage to William Carlos Williams*) (1928) is one of several poster portraits Demuth painted during the twenties. The portraits were intended to define the person by his accomplishments. Demuth based his portrait on a poem which Williams composed following an encounter with a fire engine on a summer night in New York City. Demuth has placed Williams's initials at the bottom of the portrait, his nickname (slightly cropped) at the top, and most of his middle name (Carlo) to the right, just above the glaring headlight and ART on the window pane at the extreme right. Paintings like this one had an impact on pop artists of the 1960s (see Program 19). Robert Indiana, for example, painted several variations on this theme of the figure 5.

Detail of W. C. W. from I Saw the Figure 5 in Gold.

Detail of Bill from I Saw the Figure 5 in Gold.

Charles Sheeler (1883–1965) was trained in commercial and industrial art as well as in the fine arts. He painted first in the broad, European style taught by William Merritt Chase (see chapter 9), but trips to Europe between 1904 and 1909, combined with the Armory Show in 1913, turned him toward a more modern approach. A photographer as well as a painter, Sheeler often used photographs to compose his paintings.

Detail of barn from White Barn (1916). One of Sheeler's early photographs.

Bucks County Barn (1923).

Shaker Buildings (1934).

Upper Deck (1929) is the model of all Sheeler's paintings of industrial forms. He worked carefully toward the final painting, eliminating and arranging material until he knew exactly what to include in the final version. Everything was subordinated to the clear, precise rendering of the objects.

Architectural Cadences (1954). Here Sheeler carries the geometric perfection of the real buildings into the suggestions of similar, imaginary buildings. The entire composition, by overlapping planes and spaces, joins real and unreal, present and future.

Classic Landscape (1931) was one result of Sheeler's photographic essay on the Ford River Rouge plant in 1927. A great admirer of industrialism, Sheeler suggests in this painting, as Demuth did in *My Egypt,* that America's highly functional industrial architecture possesses a special kind of beauty.

PAINTERS OF AMERICAN LIFE

Charles Burchfield (1893–1967) studied art at the Cleveland Art Institute not far from his native Salem. Unable to make a living with his art, he returned to Salem. He began making watercolors of locations around the town, but in his hands the rural calm of Salem life was transformed into disturbing evocations of natural phenomena. Service in the army during World War I changed Burchfield's approach, inspiring him to combine the fearful symbolism of his early paintings with the drabness and the squalor of the city.

Black Iron (1935) was painted to record the two iron bridges which were, for

Burchfield, "on a gray day the epitome of sinister darkness." During the period when Burchfield lived in Buffalo (1921–1943), he began to combine the morbid fantasy of his Salem years with the drab, squalid reality of the city. Although he was a painter of American life, Burchfield was never a true regionalist, and his attitude toward Buffalo and the surrounding area was scarcely clear-cut. Fascinated by the people and by the sights, he was at the same time disturbed by the waste of human life and resources. *Black Iron* conveys his ambiguous attitude.

Church Bells Ringing, Rainy Winter Night (1917) was "an attempt to express a childhood emotion": the fear inspired by a ringing church bell and a rainy night. Several of Burchfield's symbolic indicators of mood (he collected over twenty such motifs in a small notebook entitled "Conventions for Abstract Thoughts") are used. The church steeple, for instance, resembles a parrot's head with the blank eyes which Burchfield termed the "eyes of imbecility." Further down the steeple and repeated in the sky behind is a hooked spiral, the indication of "fear." The house on the right has peaked corners, doors, and windows to suggest "morbidness" while the smiling mouth on its facade stands for "fascination of evil." The house on the left, despite its cheery Christmas tree and candle in the window, has domed windows to indicate "melancholy" and the front door has crossed eyes, the symbol for "meditation" or "insanity."

Detail of smiling mouth motif from *Church Bells Ringing, Rainy Winter Night* (1917).

Over the Dam (1935).

Six o'Clock (1936), depicting "the supper hour in the kitchen of one of a row of identical factory workers' houses," suggests the care with which Burchfield observed life in Buffalo. The warm, well-lit interior, in sharp opposition to the cold snow and the dark row of houses, glows with a feeling of happiness and optimism.

Edward Hopper (1882–1967) is a perfect example of the dedicated artist who pursues his personal vision with single-minded devotion, despite the disapproval of the critics and the incomprehension of the public. Hopper grew up in the eastern United States. In 1908, after studying illustration and painting in New York City (the latter under the direction of Robert Henri and Kenneth Hayes Miller) and taking three trips to Europe, he settled in New York, where he continued to live and work for most of his life.

Office in a Small City (1953). Hopper dwells on the relationship between objects rather than on the detailed perfection of the objects themselves. Here the solitary man gazing out the window of his barren office suggests the loneliness, the "aloneness," which is a recurring theme in Hopper's work. His figures are frequently caught gazing intently at nothing in particular or turning their heads away from the viewer.

Early Sunday Morning (1930). The deserted streets, yellow shades, and long morning shadows suggest disquiet and disappointment. Compare this bleak series of storefronts and apartment windows with Mount's paintings of rural life in New York.

House by the Railroad (1925). Hopper's arrangement of shadow, light, and color on this forbidding house creates a mood of grim mystery.

Gas (1940). The human beings who appear in Hopper's paintings are considered as a simple part of the natural scene, of no greater significance or importance than the mechanical elements or the buildings. They convey their thoughts and moods by the way they stand or sit or walk rather than by the expression on their faces. The man in *Gas* is dwarfed by the pumps as he carries out his simple functions as attendant to the machines; in *Office in a Small City* the man looks out over the factories he is paid to administer.

THE AMERICAN SCENE—THE REGIONALISTS

Many American artists in the 1920s were inspired by the idea of creating an art that would fulfill Walt Whitman's desire for "a truly great native art growing out of American life." The American Scene movement began during the 1920s, although it was not until 1930 that critics recognized its importance. The American Scene painters consciously resisted foreign influences and concentrated on expressing the spirit of America. The critic Thomas Craven became the principal advocate of the American Scene movement, with Thomas Hart Benton its most articulate artist. Since Benton, Grant Wood, and John Steuart Curry believed that the artist should express the spirit of a particular region, their art was often grouped under the term *regionalism*. Their work has two important aspects. Their active refusal of foreign artistic influences represented the nationalistic, "America for Americans" side of the movement. On the other hand they were determined to take pride in American things, in the country's different ways of life, and to emphasize the qualities that distinguished the American spirit.

Thomas Hart Benton (1889–1975), a member of one of the most important political families in Missouri, was as much by his paintings as by his writings the principal artist of the American Scene movement. He received his early training in Paris and before World War I he was a frequent visitor at Alfred Stieglitz's 291 Studio. After the war, however, Benton concentrated on depicting American subjects in an American style. This was the essential feature of the American Scene movement.

Self-Portrait (1926).

Cradling Wheat (1938). After Benton moved permanently to Kansas City in 1935, he began painting scenes which were more clearly attached to an identifiable place and time. This depiction of cutting, shocking, and stacking wheat suggests the constant labor of the Missouri farmer's life.

In *Boomtown* (1928) Benton captured the spirit of American industry and enterprise. Borger, Texas, was one of the many oil towns which sprang up in the Southwest in the early part of the century. What gold was for the nineteenth century, oil became for the twentieth. The roughness and tawdriness of the buildings are scarcely attractive, yet Benton found the energy of the people an exciting facet of the American character. The dark cloud of oil smoke, however, suggests a measure of apprehension.

Detail of cars from *Boomtown*.

People of Chilmark (Essay in Composition) (circa 1922). Heavily influenced by the European baroque, Benton's style is marked by sinuous curves which he applies to create heavily muscled and rounded figures.

Huck Finn (1936). *A Social History of the State of Missouri,* Benton's mural for the state capitol in Jefferson City, Missouri, so expertly combines fact with fiction and history with personal recollection that many critics consider it the most successful composition of his career.

July Hay (1942). The lush flowers in the foreground and the bushes rising to the curving tree at the right help transform an otherwise realistic scene into a fantastic vision of rural life.

Detail of reclining Persephone and leering Hades from *Persephone* (1938–1939). Not only did Benton celebrate rural American life, he translated mythological and biblical episodes to recognizable American settings. In Greek myth, Persephone, daughter of the goddess Demeter, was abducted by her uncle Hades and taken to live permanently in the Underworld. Demeter, out of sorrow, ceased to perform her duties as goddess of agriculture. Crops withered. Finally a compromise was worked out: Persephone would spend 6 months in the Underworld and 6 months with her mother. The myth is classical, but the hairstyles and the physical types, no less than the fields and the farm equipment, are contemporary American.

People of Chilmark (Essay in Composition) (circa 1922).

Laocoön (1606–1610) by El Greco (1541–1614).

Detail of figures from *Laocoön*.

People of Chilmark (Essay in Composition) (circa 1922).

Born in Iowa, Grant Wood (1891–1942) lived most of his life in the vicinity of Cedar Rapids. He studied handicrafts and painting in Iowa City and Minneapolis, started a business which failed (1914–1915), and taught art in Cedar Rapids high schools for 6 years (1919–1925) before retiring to concentrate on painting. Following the great success of *American Gothic* (1930), Wood became a professor at the University of Iowa, founding a summer art colony at Stone City, Iowa, and worked on WPA projects.

American Gothic (1930) not only launched Wood on a decade of popular success, it gave a crucial boost to the American Scene movement. In the opinion of the art historian Matthew Baigell, "It was the right painting shown at the right time in the right place." *American Gothic* has remained popular over the years; today it is one of the most familiar paintings in American history, as well known as Whistler's portrait of his mother. Perhaps the reason for the painting's continuing power is a certain ambivalence in Wood's portrayal. He apparently began the portrait as a satire on rural Iowa attitudes, but the result is far from a simple satiric look at Midwestern life. The two faces are both stern and loving at the same time. As a result, they affect us in contradictory ways. (The farmhouse in the background actually existed, although Wood elongated the gable window to underscore the Gothic origin of the design.)

Woman with Plants (1929) is a sympathetic portrait of Wood's mother.

Daughters of Revolution (1932). (The narrator, like many others who have seen the painting and know the source of Wood's idea, mistakenly refers to it as

"Daughters of the *American* Revolution.") In 1926 the local chapter of the DAR (Daughters of the American Revolution) criticized Wood—unjustly, he believed—for having a stained-glass commemorative window for the Veterans Memorial in Cedar Rapids made in Germany. Wood expressed his view of the matter 6 years later with this portrait of three ladies and a teacup perhaps symbolic of the Boston Tea Party (notice the exquisite design of the cup, the clawlike hand holding it, and the scarcely natural angle of the wrist) standing in front of one of the most patriotic of American paintings: *Washington Crossing the Delaware* by Emanuel Leutze. The further irony is that Leutze, who grew up in the United States, painted his great tableau in Germany. For once Wood admitted that his painting had a satiric intent. Despite his candor, however, the DAR itself seems not to have been able to agree on the extent of his effectiveness. The Cedar Rapids chapter complained about the painting, but a censorship screening committee in Boston thought it hilariously funny.

Detail of Leutze's painting from *Daughters of Revolution* (1932).

Parson Weems' Fable (1939). (Wood borrowed his design from Charles Willson Peale's *The Artist in His Museum* (1822) (Program 4). Parson Weems, one of Washington's earliest biographers, first published the story of the cherry tree in 1806, in the *fourth* printing of his biography. Washington, who died in 1799, was no longer present to contradict the story, and the cherry tree episode has proved to be remarkably durable. Wood's painting was intended primarily as a wry comment on the Parson's adept stage-managing (notice the cherries decorating the curtain, the shadowy hand pulling back the curtain, and the Gilbert Stuart head on a boy's shoulders).

Detail of the central portion from *The Midnight Ride of Paul Revere* (1931). This further excursion into American history again presents the past with an ironic twist. The toylike horse (supposedly copied from a hobbyhorse), coupled with the compact, cartoonlike trees and buildings, makes the scene resemble something out of Walt Disney rather than the celebration of a great event in American history.

Spring in Town (1941).

John Steuart Curry (1897–1946) grew up in Kansas and, as Thomas Hart Benton once observed, "never forgot it." As a youth he was continually drawing. In 1921 he began working as an illustrator, but he was so intent on exploring every possibility of the subject that magazine editors stopped using him. From 1919 to 1936 he lived and worked in New York City, returning to the Middle West during the summer to take notes for future paintings. In 1936 he became Artist in Residence at the University of Wisconsin, the first painter to be so honored.

Country Baptism (1928). Curry's first important American Scene depiction, *Country Baptism,* was admired by the public but criticized by professionals, in part because it portrayed an event of scant interest to critics.

Detail of preacher and woman from *Country Baptism.*

Tornado (1929). Curry's best-known works celebrate the basic human values—courage, resolve, resourcefulness, strength, love—which many Americans believed were being lost in the industrial and urban expansion of the

post-World War I period. *Tornado*'s popularity, like Curry's popularity, owes much to its optimism: the dominant figure of the man suggests that the family will be saved.

Hogs Killing a Rattlesnake (1930).

Detail of hogs from *Hogs Killing a Rattlesnake*.

Hogs Killing a Rattlesnake (1930).

The Line Storm (1934) is a race between the huge dark cloud slashed by bolts of lightning which dominates the horizon and the small figures on the speeding hay wagon. In Curry's paintings the tension is created by a clearly defined opposition of natural forces.

The Mississippi (1935), a tribute to the continuing power of the human spirit, is one of Curry's most extravagantly optimistic statements.

Reginald Marsh (1898–1954) was born in Paris, the son of two artists. He was educated at various private schools in the United States, completing his academic studies at Yale (1916–1920), where he drew illustrations (particularly what became known as the "Marsh girl") for the *Yale Record*. After graduation he moved to New York City, supporting himself as a free-lance illustrator, and in 1923 he began to paint, both in oils and in watercolors. It was not until 1929, however, that Marsh began to do justice to his exceptional skill as a painter of the New York scene.

Hitler Escapes (1939) takes its title from the newspaper headline HITLER ESCAPES/AS BOMB/KILLS AIDS. This large watercolor, some $3\frac{1}{3}$ by 2 feet, shows the new appreciation of spatial depth, the simplified composition, and the more precise facial modeling which Marsh developed as a result of his mural experiences of the mid-1930s.

Detail of dancers from *Minsky's Chorus* (1935).

Detail of dancer's leg and spectator from *Minsky's Chorus* (1935).

Minsky's Chorus (1935). Burlesque shows, the naughty entertainment of the 1920s and the 1930s, fascinated Marsh throughout his career. Suggestion was the essence of burlesque. The burlesque show was conceived as a festival of brightly colored, scantily clad women who never went further than simulating the motions of the sexual act. Marsh often sketched during the performance, taking as much interest in spectators as in the spectacle. The men usually appear quiet and detached, often a little sad. No less detached, however, are the dancers, who frequently face the crowd with an impassive, neutral expression.

Swimming off West Washington Market (1940) (watercolor).

Negroes on Rockaway Beach (1934). The beach, always filled with a great variety of people engaged in a wide range of activities, was one of Marsh's favorite subjects. His beach pictures are always alive with energy and vitality, much the opposite of his burlesque pictures, in which everything seems frozen. Both locations, however, gave him the opportunity to observe and study the human body, an exercise he relished throughout his career. In 1954 he published a book on the figure entitled *Anatomy for Artists*.

Tattoo and Haircut (1932). Marsh painted many pictures of life around Fourteenth Street, starting when he was an illustrator for *The New Yorker* magazine. Although he rendered objectively the life he saw, his feelings of kinship and

sympathy are evident in his treatment. He satirized many people, but never the down-and-outers.

THE SOCIAL REALISTS

Photographers and painters alike sought to capture the harsh despair of the depressed 1930s, but they used different methods and had different goals. Photographers like John Vachon, Dorothea Lange, and others who worked for the Farm Security Administration mirrored the experiences they witnessed in clear, objective photographs. For them documentation seemed sufficient to make their point. The painters, on the other hand, observed life around them, filtered it through their imagination and then recomposed it. Their paintings tended to insist on the negative aspects of contemporary life. For the most part their pessimism was as pronounced as the optimism of the American Scene painters. Loosely designated social realists, or artists of social protest, they really followed their conscience rather than a particular aesthetic policy.

Missouri (1940) by John Vachon.

In a Camp of Migratory Pea Pickers (1936) (*Migrant Mother, Nipomo, California,* 1936) by Dorothea Lange (1895–1965) (Program 16). Lange's unpublished notes on the subject are as eloquent as the photograph. "In a squatter camp at the edge of the pea field. The crop froze this year and the family is destitute. On this morning they had sold the tires from their car to pay for food. She is 32 years old."

Detail of cow from *Drought-Stricken Area* (1934).

Detail of buzzard from *Drought-Stricken Area* (1934).

Drought-Stricken Area (1934) by Alexandre Hogue (born 1898). Hogue, who grew up in Texas and observed firsthand the deterioration of the land, has been called the "artist of the Dust Bowl." His "psychorealism" is intended to convey the feeling of heat and despair.

Georgia Jungle (1939) by Alexander Brook (born 1898). Brook grew up in Brooklyn. His early work featured commercially viable seminudes and still-lifes, but in the early 1930s he gave up traditional subjects to paint the everyday aspects of human existence.

Bread and Circuses (1946) by Robert Gwathmey. Gwathmey, an eighth-generation resident of Virginia, often painted the South's hard, dry earth and its poverty-stricken residents, black and white. He frequently uses ironic confrontations like the poster and poor farmer seen here.

Detail of poster with lions, tiger, and animal trainer from *Bread and Circuses*.

Philip Evergood (1901–1973) was born in the United States, but educated in England and France. In 1931 he settled in New York City, turning his attention to depicting social and political miseries.

American Tragedy (1937). In March 1937 United States Steel gave in to the demands of John L. Lewis and his union. The smaller steel companies proved more resistant. On Memorial Day, 1937, Chicago police attacked unarmed demonstrators at the Republic Steel plant in South Chicago, killing ten and injuring

nearly a hundred. Evergood based his painting on accounts and photographs which appeared in the newspapers.

Tombstones (1942) by Jacob Lawrence (born 1917). Lawrence, a black artist born in Atlantic City, New Jersey, drew on black life and black history for most of his paintings.

Raphael Soyer and his twin brother Moses were born in Russia in 1899, their brother Isaac in 1906. In 1912 the family was forced to emigrate to the United States. The Soyers were so miserably poor that the children had to work to help support the family. At night, however, the three brothers were able to begin art studies at the free drawing classes of the Cooper Union and the National Academy of Design.

Employment Agency (1937) by Moses Soyer. The stubbornness and the misery of Depression job seekers are fully portrayed here.

Transients (1936) by Raphael Soyer. "My art is representational by choice. In my opinion, if the art of painting is to survive, it must describe and express people, their lives and times." Raphael Soyer's work fulfills his statement. These men are waiting dully in a flophouse for sleeping space. Soyer discovered the man at left, Walter Broe, fishing for coins through a subway grating; discerning in him the perfect representative of the Depression, he included Broe in nearly all his East Side pictures.

Office Girls (1936) by Raphael Soyer. Many of Soyer's paintings depict the activities of women: shoppers, office workers, housewives. In the background he usually includes a bum to provide a contrast. Here, at the left, is Walter Broe again.

Detail of two men drinking in foreground of *How Long Since You Wrote to Mother?* (1935).

How Long Since You Wrote to Mother? (lithograph, 1935) by Raphael Soyer. Beginning in 1933 Soyer focused his attention on the derelicts and the "forgotten men" of the Bowery. Walter Broe is again one of his subjects.

Bus Passengers (1938, Paul Shulman Collection) by Raphael Soyer. This composition, one of two paintings with the same title, demonstrates again Soyer's interest in the expression of people waiting.

Waiting, Doctor's Office (1932–1933) by Raphael Soyer. Soyer found people easiest to sketch in waiting rooms.

Detail of woman from *Waiting, Doctor's Office* (1932–1933).

Jack Levine (born 1915) studied in Boston and at Harvard. He worked on the WPA Federal Art Project in 1935, but for the most part he has remained aloof from art groups and schools. Much of his best work is satirical.

Welcome Home (1946) is Levine's ironic farewell to military life. He said of the scene: "I don't think it's particularly a grim painting. I don't know how accurate it is. But I think that some people in the army could stand a little bit more criticism of this sort."

Gangster Funeral (1953) is much less sardonic than *Welcome Home*. With the passage of time, Levine has taken a more humorous, less biting view of life's inequities.

The Art Lover (1962), taking a negative view of the childish and snobbish art connoisseurs, suggests the origin of the negative attitude toward art which has long been typical of a certain part of the American public.

BEN SHAHN

Ben Shahn (1898–1969) was born in Lithuania, coming to the United States in 1906 with his family. He began his career as an artist with an apprenticeship in lithography in Brooklyn and continued to work in the medium until 1930. He studied at various art schools in the New York area and in Europe during two trips (in 1925 and 1927), where he discovered the art of Cézanne. Encouraged by Cézanne's example, Shahn began to move in the direction of simplified abstract forms. His series of gouaches on the Sacco and Vanzetti case brought him his first important recognition. In the latter part of the 1930s Shahn worked as a photographer with the Farm Security Administration (see Program 16) and as a poster maker for the Office of War Information in the 1940s.

The Passion of Sacco and Vanzetti (1931–1932) is part of a series of twenty-three representations of the various phases of the Sacco-Vanzetti case. In March 1921 Nicola Sacco and Bartolomeo Vanzetti, Italian immigrants and dedicated anarchists, were convicted of murdering two men during a holdup. The prosecution's mishandling of the case and the obvious hostility of the judge brought protests from all through the country. Defense committees were formed to seek a reversal of the verdict. The evidence against the two men was scarcely conclusive (although modern research now suggests that Sacco was probably guilty and Vanzetti innocent), but their anarchism coupled with the hysterical Red scare of 1920 ensured conviction. After 6 years of struggle, the defense exhausted its appeals. The two men were executed in August 1927.

Detail of the three members of the Lowell Commission from *The Passion of Sacco and Vanzetti*. The Lowell Commission was appointed by the governor of Massachusetts to examine the case and report whether it contained legal errors. Their negative finding ended the fight for Sacco and Vanzetti.

The Passion of Sacco and Vanzetti (1931–1932).

Miners' Wives (1948). Critics labeled Shahn a social realist, but the artist disagreed with such a neat category, preferring to call his style "personal realism. The distinction is that social realism is dictated from the outside; personal realism comes from your own guts."

Welders (1944) is one of five posters Shahn created for the CIO's Political Action Committee during 1943–1944. Used by the PAC in their voter registration drive, the poster carried the slogan, "For full employment after the war—register, vote!"

Conversations (1958).

Detail of hands from *Conversations* (1958).

Arts of the West (1932) by Thomas Hart Benton.

Drought-Stricken Area (1934) by Alexander Hogue.

POST-PROGRAM ILLUSTRATIONS *Black Iron* (Burchfield); *I Saw the Figure 5 in Gold* (Demuth); *House by the Railroad* (Hopper); *Upper Deck* (Sheeler); *Welcome Home* (Levine); *Church Bells Ringing, Rainy Winter Night* (Burchfield); *Tornado* (Curry); *Bloomtown* (Benton).

QUESTIONS AND PROJECTS

I. Define or identify:
Thomas Hart Benton Farm Security Administration
Sacco-Vanzetti case the American scene
precisionism social realism
regionalism

II. Questions for development:
1 *Stuart Davis.* Is the subject of Davis's paintings self-evident or do we need the title to interpret the work? What are some of the qualities that explain why Davis is considered a modernist? What other artist or artists you have studied are similar in their approach to art?
2 *Precisionism.* What are the major tenets of precisionism? How does the movement relate to cubism? What characteristics in the precisionists' work seems to be uniquely American? Can these traits be attributed to specific sources?
3 *The American Scene.* What basic views of art are associated with the painters of the American scene? Pick two or three major artists of the American scene and compare their approach to painting. How does their approach differ from that of the early precursors of the movement? What effect does this type of painting have on you? Explain.
4 *Social Realism.* How did the social realists differ in outlook from the painters of the American scene? Who were its principal artists? What kinds of subjects did they seek?

III. Opinion and judgment questions:
1 Compare and contrast the work of an American Scene painter with one of the Social Realists mentioned in this chapter. What characteristics of the American Scene movement made it seem trivial to many artists? Why has Social Realism remained more viable than American Scene painting? What makes these paintings, both American Scene and Social Realist, truly American? What do they have that paintings from another country would lack?
2 Artists like Stuart Davis painted in a nonrealistic manner. This approach to art is often referred to as abstraction. Can abstract art be defended? Put yourself in the position of the artist and try to respond the way he might. Abram Lerner, in Program 20, suggests that even parts of the American avant-garde are considered realistic. Is it possible for a painting to be both abstract and realistic at the same time? To what extent must an object be abstracted for the rendering to be considered abstract?
3 Stuart Davis and the precisionists were strongly influenced by modern European art. Is there a similarity between Davis's paintings and the works of the precisionists? To what extent are their works American in nature? Why?

IV. Projects:

1 Visit nearby museums and art galleries as a means of expanding your knowledge and awareness of modern art, particularly abstract modern art. To what extent does the larger size and color of the painting itself (as opposed to an illustration) affect your appreciation of it? your response to it? What similar traits do you find in the paintings? Is it possible to group them by similar traits?

2 What part of your town or region would a painter interested in depicting the typically American life find most inspiring or suggestive? Are there any local artists who specialize in scenes of local life?

BIBLIOGRAPHY

Allen, Frederick Lewis: *Only Yesterday,* Harper & Brothers, New York, 1931. A kaleidoscopic view of American life from the end of World War I to the crash of the stock market (available as a Bantam paperback).

Andrist, Ralph L. (editor in charge): *American Heritage History of the 20s and 30s.* Narrative by Edmund Stillman, with two chapters by Marshall Davidson. Pictorial commentary by Nancy Kelly. American Heritage Publishing Company, Inc., New York, 1970. An excellent introduction to American life between the two world wars, the book contains numerous photographs as well as short biographies of the most colorful characters of the period.

Baigell, Matthew: *The American Scene: American Painting of the 1930s,* Frederick A. Praeger, Inc., New York, 1974. This volume features in-depth treatment of the major artists of the American Scene movement—Thomas Hart Benton, John Steuart Curry, Grant Wood, Reginald Marsh—as well as an appreciation of the social realists. A fine book.

PROGRAM 16

ART FOR THE MASSES

The resources for art in America depend upon the creative experience stored up in its art traditions, upon the knowledge and talent of its living artists and the opportunities provided for them, but most of all upon opportunities provided by the people as a whole to participate in the experience of art. American art has a tradition that has endured through many changes, a usable past that is a powerful link in establishing the continuity of our culture. We must look to American scholarship to study and evaluate that tradition. American art today is searching for forms and symbols and allegories which will reveal the character of American life and the American people.

<div align="right">

*Holger Cahill, National Director of the WPA/FAP, in a speech
on the occasion of John Dewey's eightieth birthday (1939)*

</div>

The New Deal which Franklin Roosevelt had promised Americans in accepting the presidential nomination became a reality in the spring of 1933. For the first time the artist was treated like any other worker. Four government relief programs were eventually developed, the largest of which,

Tavern Sign, Bissell, 1777. Courtesy of the National Gallery of Art.

the Federal Art Project of the Works Progress Administration (known as the WPA/FAP) spent $35 million over an 8-year period. These programs put artists to work decorating public buildings, developing community art centers, documenting the conditions of the country, and recording the history of American design.

OVERVIEW

The Period Program 16 concentrates on government art projects between 1933 and 1943.

American Life The real New Deal began on March 16, 1933. On that day President Roosevelt sent to Congress a bill—later known as the Agricultural Adjustment Act (AAA)—containing a provision which departed radically from previous government practice and even went against a major tenet of American ethics: it provided for paying farmers *not* to work. Other government programs designed to raise prices and stimulate the economy followed: the Civilian Conservation Corps (CCC) to create jobs for 250,000 young men; the Federal Emergency Relief Administration (FERA) to aid state and local relief agencies; the Federal Securities Act to regulate stock issues; the Tennessee Valley Authority (TVA), the Home Owners' Loan Corporation (HOLC), the National Recovery Adminstration (NRA) and many others.

The private sector advanced its own remedies for restoring prosperity. Dr. Francis Townsend declared that the key to renewed prosperity was a monthly payment of $200 to all Americans over 60, with the understanding that the entire sum would be spent within 30 days on goods made in the United States. Father Charles E. Coughlin, the Catholic priest heard by millions across the country on his daily radio program, formulated another popular, but vague, plan for government reorganization. But Senator Huey Long of Louisiana went furthest. His Share Our Wealth program featured a guaranteed annual income of $2500, a homestead grant of $5000 to $6000 to each family, and free education through college. These ideas, however, were never translated into legislation.

American Literature James T. Farrell (born 1904) produced an exceptionally realistic portrait of the frustrations of growing up in Chicago in the trilogy *Studs Lonigan* (1935). William Faulkner (1897–1962) gave a personal and engrossing view of the South in a long series of novels, from *Sartoris* (1929) to *The Rievers* (1962). John Steinbeck (1902–1968) voiced the despair and frustration of the migratory workers in *The Grapes of Wrath* (1939). At the opposite end of the scale, John P. Marquand (1893–1960) dissected the upper class of New England and Boston in *The Late George Apley* (1937).

International Events The crash of the New York stock market had grave effects on the countries of Western Europe. Germany was one of the countries most severely affected, and the national slump of 1929 was a major factor in the rise of the Nazi party. In the early 1930s dictatorships became the rule in Europe: dictators held power in Italy, Germany, Russia, Turkey, Hungary, Poland, Portugal, Yugoslavia, Austria, Bulgaria, and Greece. (In the United States Huey

Long was the virtual dictator of Louisiana.) Fighting broke out in several countries: in Manchuria (1931), in Ethiopia (1935), in China (1937). After a series of successful aggressions, Germany finally went too far: the invasion of Poland in September 1939 marked the beginning of World War II.

CONTENTS OF THE PROGRAM *The Mural Program* The Federal Art Project sponsored over 4000 murals. The Ellis Island murals of Edward Laning and the Social Security Building (now HEW Building) murals by Ben Shahn are given particular emphasis here.
The Easel, Sculpture, and Graphic Arts Projects Many artists who achieved world prominence in the post-World War II period began their training in government-sponsored programs.
The Index of American Design Project Unemployed commercial artists were put to work copying typical products of American craftsmen from colonial times to 1900.
Photography The Farm Security Administration photographers compiled an impressive and moving portrait of the United States during the Depression.

VIEWER'S GUIDE

PRE-LOGO ILLUSTRATIONS *Migrant Mother* (Lange); WPA sculptor working on mother and child group; *Rehabilitation of the People* (Fogel); Index of American Design artist copying an early American stoneware jug.

The measures adopted for the relief of American artists were unique in the country's history, although they were not the first on this continent. A similar effort in Mexico in the 1920s had produced murals which visiting Americans likened to the great works of Renaissance Italy. In 1933 George Biddle, artist and former classmate of Franklin D. Roosevelt, wrote to the president suggesting that the government employ indigent artists to decorate its buildings. Roosevelt authorized the funding of a crash relief program, the Public Works of Art Project (PWAP), and placed it under the control of the Treasury Department. Directed by Edward Bruce, a dynamic, inspirational, and highly effective organizer, the project was successful, and its achievement led to the establishment of the Fine Arts Section of the Treasury Department. Bruce became director of the section, which remained in existence from 1934 to 1943, and oversaw the third Treasury program, the Treasury Relief Arts Project (1935–1939), as well. In 1935 President Roosevelt approached Bruce with an additional project for putting artists to work. It was a much more wide-reaching and ambitious program than the Treasury Department could oversee, however, and Bruce declined to take it under his control. Instead the government created the Federal Art Project, a division of the newly formed Works Progress Administration. Holger Cahill was named director. The WPA/FAP carried out the task of art relief for 8 years, before the

program was phased out and the personnel were absorbed into a new division of the government, the War Resources Board.

Partly because creative artists are misunderstood by bureaucrats and politicians, much of the art created under the government program was treated by the government as inconsequential. Murals were allowed to deteriorate, paintings and prints were sold or discarded, and sculpture was broken up. But even though the accomplishments of the artists were neglected, the WPA/FAP played an extremely influential role in the development of American art. It disseminated real art (as opposed to printed reproductions) throughout the country. Many art teachers in small communities, for example, had never seen a real oil painting. The WPA/FAP's art education projects helped stimulate public interest in art. The WPA/FAP played a role in the twentieth century similar to that played by the American Art Union in the nineteenth. Perhaps even more important, by bringing artists together the project encouraged an exchange of ideas and a more rapid development of artistic talent.

The government programs, originally set up to provide work relief, at first stipulated that 90 percent of the recipients must be eligible for relief, but the percentage was soon lowered to 75 percent. To qualify for relief, the recipient must have no property and no means of support; neither he nor his family, including in-laws, could have property, savings, or insurance that might be converted into cash. After a person was certified, eligible investigators still made surprise calls to verify that no change in economic status had occurred. Edward Laning, for example, was dismissed from one project because his wife held a part-time job which he had concealed from the relief examiner.

Maintaining America's Skills (1939), exterior mural for the WPA Building at the New York World's Fair (1939). Executed by Philip Guston (born 1913).

Members of the Artists' Union picketing.

THE MURAL PROGRAM

The Mexican Revolution provided the occasion for a reappraisal and a reevaluation of Mexico's history. A government program to instill a feeling of national pride brought about a revival of mural painting. Exceptional artists like Diego Rivera (1886–1957) executed a series of excellent murals, which were greatly admired by visitors to the country. In the early 1930s Rivera came to work in the United States, greatly influencing the young painters who came to watch him work on projects like the murals in Rockefeller Center (later destroyed because Rivera included a portrait of Lenin).

The New Freedom (1933) from the New Workers School. Executed by Diego Rivera (1886–1957).

The Flower Gatherers (1935) by Diego Rivera.

Members of the Artists' Union picketing (photograph). The Artists' Union, probably the largest association of artists ever formed in this country, had chapters in most major cities during the 1930s. Organized to obtain WPA/FAP jobs for its members, to improve salaries and hours, and to prevent dismissals, the Union, particularly in large cities like New York, was an important influence

on the conduct of the WPA/FAP. Picket lines formed to protest every reduction in funding, although the demonstration was frequently to publicize the issue rather than to prevent work. Most of the members believed in allowing complete artistic freedom, but they were for the most part interested in realistic representations with a special emphasis on social commentary. Their periodical, *Art Front,* was one of the most vital activities engaged in by the Union.

Poster for the Frontiers of American Art Show held at the De Young Museum in San Francisco (1939) made by the Graphics Arts Section of the WPA/FAP.

Maintaining America's Skills (1939), exterior mural for the WPA Building at the New York's World's Fair (1939). Executed by Philip Guston (born 1913).

Charts showing breakdown of WPA/FAP activities and employment at their peak on July 1, 1936.

Artists working on WPA/FAP mural in a school auditorium.

Close-up of artist working on auditorium decoration seen in previous photograph.

Edward Laning at work on one episode of his mural, *The Role of the Immigrant in the Industrial Development of America,* for the Aliens' Dining Room, Ellis Island, New York (1937).

Overall view of the Aliens' Dining Room on Ellis Island (1937). Until recently, the abandoned Ellis Island buildings and Laning's mural had been slowly deteriorating. Both have now been restored.

Artists working on *Building of the Union Pacific Railroad,* Ellis Island.

Detail of railroad workers from *Building of the Union Pacific Railroad,* one of the eight episodes of Edward Laning's mural for the Aliens' Dining Room, Ellis Island (1937).

Detail of workers from Edward Laning's mural for the Aliens' Dining Room, Ellis Island (1937).

Artist working on a mural of children's fairy tales for display in an elementary school.

Muralist making preliminary sketch.

Artist applying plaster in preparation for the execution of a mural in fresco.
Second view of artist applying plaster for fresco mural.

Artists working on mural for WPA/FAP project.

Artists working on mural.

Artist applying design to plaster in preparation for executing fresco mural.
Artist painting mural figure.

Artist at work on mural.

Detail of artists from previous illustration.

Artist applying paint to mural.

Ben Shahn (see Program 15) won the commission for the Social Security Building murals in a design competition with 375 artists. This was a Treasury Department mural and awarded Shahn $19,980 to paint the story of social security on the walls of the building's lobby. He began work in December 1941 and completed the project in June 1942. He was given artistic freedom to create and carry out the project once it was chosen, but his activities were closely scrutinized and the course of the project is in many ways typical of the WPA/FAP and

Treasury Department mural activities. A woman spectator, for example, charged him with creating art with "communistic implications," capping her argument with the information that her family had fought at the Battle of Lexington. "Mine," Shahn responded, "fought at the Battle of Jericho." A general chided him for working slowly, and a war contractor of handball courts complained to Edward Rowan, Bruce's successor as director of the Fine Arts Section, that Shahn's handball court was incorrectly proportioned. But not all the comments were unfavorable. A worker who had helped construct the building remarked: "Good job, bud, good job; that stone carving out in front of the building ain't got nothing to do with anybody!" Shahn became so enthusiastic over the work that he offered to paint the rest of the lobby walls for nothing. The government declined his offer.

Shahn decorated opposite walls of the lobby with murals which give the meaning of social security. On the west wall he portrayed *The Joys of Social Security*. The central panel depicts *The Family*, with *Home Building and Food* on one side and *Employment through Public Works* and *Education and Recreation for Children* on the other. Facing this mural Shahn placed *The Evils of Social Insecurity*, depicting groups that social security would most benefit: the old and the sick, the young and the poor, migratory workers. The panels are *Old Age and Disease, Child Labor,* and *Unemployment*.

Washington, D.C., from the U.S. Capitol Building to the Health, Education, and Welfare Building.

Detail of men building a bridge from *Employment through Public Works*.

Detail of bridge workers from *Employment through Public Works*.

Men waiting for work from *Unemployment*.

West wall: *The Joys of Social Security*.

Details of family and workers on steel girders from *The Joys of Social Security*.

Details of male spectator of handball game from *Education and Recreation*.

Detail of first player's face from the handball game in *Education and Recreation*.

Detail of second player's face from the handball game in *Education and Recreation*.

Detail of two participants in the handball game from *Education and Recreation*.

Details of basketball and handball games from *Education and Recreation*.

Details from *Home Building and Food*.

Details of grain pouring from combine spout in *Home Building and Food*.

Details of farmer inspecting grain and chick from *Home Building and Food*.

Detail of farm worker harvesting grain from *Home Building and Food*.

Harvesting grain from *Home Building and Food*.

Detail of worker filling out social security form from *The Joys of Social Security*.

Sick boys and nurse from *Child Labor*.

Two women and child.

Details of men waiting for work and worker and boy walking down railroad tracks from *Unemployment*.

Details of man, boy, and railroad tracks from *Unemployment*.
Details of waiting men and discarded machines from *Unemployment*.
Boys on crutches in foreground, breaker boys behind them from *Child Labor*.
Detail of sick man from *Old Age and Disease*.
Two women and sick man from *Old Age and Disease*.
Details of social security application from *The Joys of Social Security*.
Detail of harvested grain from *Home Building and Food*.
Details of *Social Insecurity*.

THE EASEL, SCULPTURE, AND GRAPHIC ARTS PROJECTS

In addition to adding brightness to government buildings and many hospitals, the Easel and Sculpture Division, by providing steady employment and a chance for artistic interaction, helped develop some of the outstanding artists of the 1940s and 1950s. Abstract expressionism in particular owes much to the WPA/FAP. In a major exhibition in 1940 at the Metropolitan Museum of Art in New York City, project artists, among them Jack Levine (second prize of $3000) and Marsden Hartley (fourth prize of $2000), won over $13,000 in award money. Many states, however, sought to ensure consistent production by using a quota system, a practice which seems to have strained a number of artists. An artist was normally required to turn in a watercolor or gouache in 3 weeks, an oil painting in from 4 to 6 weeks. The large projects even set up central workshops where artists worked in separate cubicles. It produced better supervision, but apparently less art. Surprisingly, the government did nothing to protect its investment, disposing of the art produced under its programs without much thought. It is estimated that the paintings Jackson Pollock was paid some $7000 to create would be worth over $400,000 today—if the government had not destroyed them.

Rehabilitation of the People (1939) by Seymour Fogel. Mural in the WPA Building at the New York World's Fair, 1939. (This photograph reverses the true positions of the figures.)

Artist working on mural of herons.

Mural panel, one of ten from the general subject *Aviation: Evolution of Forms under Aerodynamic Limitations* (circa 1936) painted by Arshile Gorky for the Newark Airport.

Artists at work on WPA/FAP mural.

Arshile Gorky (1905–1948) at work on the Newark Airport mural panel shown earlier (circa 1935–1937).

Oil on canvas mural by Stuart Davis for the radio studio of station WNYC in the Municipal Building of New York City (circa 1939). The mural is now on loan to the Metropolitan Museum of Art, New York City. (This photograph reverses the actual setting, as you can see by the radio station numerals on the microphone and the reversed name of the artist just above the center of the piano.)

No. 5, Third Theme (1963) by Burgoyne Diller.

Easel Division artist at work.

Peggy Bacon and Metaphysics (1935) by Alexander Brook.

I'm Tired (1939) by Yasuo Kuniyoshi.

Tornado (1929) by John Steuart Curry (Program 15).

An American Tragedy (1937) by Philip Evergood (Program 15).

Gangster's Funeral (1952) by Jack Levine (Program 15).

Bread and Circuses (1945) by Robert Gwathmey (Program 15).

Artist at work.

No. 1 (1948) by Jackson Pollock (Program 17).

No. 10 (1950) by Mark Rothko (Program 17).

Abstract Painting Grey (1950) by Ad Reinhardt (Program 17).

Dwarf (1947) by William Baziotes.

Hot Horizon (1956) by Adolph Gottlieb.

West 23rd (1963) by Jack Tworkov.

The Wave (1940) by Marsden Hartley (Program 14).

View of Children's Art Gallery, Washington, D.C.

Mural exhibition at the WPA Federal Art Gallery, New York City (1938).

WPA artists working on parts of the fountain group, *Light Dispelling Darkness* (1937) by Waylande Gregory, for the Roosevelt Hospital grounds in New Brunswick, New Jersey.

Abraham Lincoln (circa 1938), a plaster model for a sculpture completed and placed in the Lincoln Consolidated Training School in Ypsilanti, Michigan. Samuel Cashwan (born 1900), the sculptor, is pictured working on the base.

Abstraction (1938), a sculpture in painted iron, by David Smith, completed as part of the New York projects (Program 18).

Cat (circa 1940), a painted plaster work by Louise Nevelson, another one of the New York City projects (Program 18).

Children's art class at the University Settlement House, New York City (circa 1940).

Artist silk-screening a poster.

Poster workshop, Chicago, Illinois, part of the Illinois project.

Spectators at an exhibition of art made by children in the free art classes of the Jamaica, New York, public schools under the supervision of WPA/FAP teachers (1937).

Art exhibit of paintings by children in a New York City alley (circa 1938).

Children's festival (1938) held in Central Park, New York, by WPA/FAP.

Portrait and model.

Artist working on a portrait of an American Indian in headdress.

WPA/FAP life drawing class.

THE INDEX OF AMERICAN DESIGN PROJECT

The Index of American Design records the history of the handicrafts and popular and folk arts by artists and craftsmen of European descent practiced within

the borders of the United States of America from the earliest colonial times up until the end of the nineteenth century. It was felt that the ethnologists would take care of American Indian design, and other federal projects were investigating architecture. Special emphasis was given to regional and local crafts. A few highly particularized groups were singled out for examination in greater detail: the Shakers, the German settlers of Pennsylvania, the Mormons of Utah, and the Spanish of the Southwestern states. Thirty-five states established design centers, employing approximately 500 artists in the preparation of the plates. In all some 22,000 designs were completed over the 6-year life of the project. They are now part of the National Gallery of Art in Washington, D.C.

Romona Javitz, head of the picture collection of the New York Public Library, was first to express the need for a comprehensive illustrated guide to American design. Ruth Reeves, one of the artists working in the library, carried the idea for the creation of a comprehensive index to Edward Bruce, chief of the Treasury Department art projects, in the summer of 1935. The project was ideal for the employment of commercial artists, a group whose condition was often more desperate than that of the painters and sculptors. Bruce was not interested in so large a project, but Frances Pollak, a key figure in New York City's early relief projects, supported it. It was proposed for inclusion in the Federal Art Project of the WPA then in the process of formation, and the FAP director, Holger Cahill, was pleased to accept it. Cahill, who had been active in the project to restore Williamsburg, Virginia, viewed the Index as a way of preserving a part of the American heritage as well as a means for inspiring contemporary designers. Ruth Reeves became the first national coordinator for the Index, serving until the spring of 1936. Serious problems appeared—the lack of specialized training among the artists and the absence of rigorous standards were the most important—and the first year's work was largely wasted. Adolph Glassgold, who followed Mrs. Reeves as coordinator, put the project on firm ground with substantial reorganization. He established standardizing procedures which soon improved quality tremendously. He introduced Index artists to the technique of watercolor copying which Joseph Lindon Smith developed during an archaeological expedition to Egypt. This "Egyptologist's technique," as it was called, found ready acceptance in New England and New York, but other state organizations worked out their own techniques. Some groups used a special oil technique, for example. Drawings were used when color was not important, and even photography took care of some illustrations. Whatever the technique, Glassgold insisted on a high professional standard and the national office was quick to send back inadequately rendered plates for corrections. Better instruction and uniform application of high standards soon brought about a marked improvement in the work.

Index artist working on a watercolor illustration.

Eagle Weather Vane (gilded copper, nineteenth century).

Carousel Horse (wood, late 1880s).

Index artist copying a nineteenth-century weather vane.

Index artist executing a watercolor painting of an early American stoneware jug.

Jar with Lid from Portland, Maine (redware, early nineteenth century).

Virgin and Child from New Mexico (undated) is a three-dimensional representation of a saint or holy person called a bulto.

Civil War Drum used by the Ninth Regiment of Vermont Volunteers during the Civil War (circa 1860).

Dancing Girl, relief carving from a Sparks circus wagon (wood, 1900).

Gate, made by Hobart Victory Welton, of Waterbury, Connecticut (wood and iron, mid-nineteenth century).

Shaker Rug from Pleasant Hill, Kentucky (nineteenth century).

Wing Chair from New England (walnut and maple, upholstered with block-printed cotton, circa 1725).

Tablecloth from Massachusetts (homespun cotton, nineteenth century).

Silver teapot made by John Coney (1655–1722) of Boston (early eighteenth century).

Index artist executing a drawing of a combination crimping and flatiron.

The three articles—*Armed Rocking Chair, Child's Chair, Wood Dipper*—all from New York State (wood, nineteenth century), are examples of the simple, functional Shaker design.

The Shaker community in America was founded by Ann Lee, who arrived in New York City with eight followers in 1774. The basic tenets of Shaker society were common possession of property, celibacy, confession of sin, and separation from the world. The strictures against marriage made it difficult for the society to grow, since new members had to be recruited from outside the community, but the Shakers successfully maintained themselves until industrialization rendered their skill as craftsmen obsolete. Their designs, however, had a lasting influence on American architecture and furniture.

Detail of *Wood Dipper*.

Detail of *Child's chair*. Although Shakers practiced celibacy, they were willing to take care of children left in their charge and sought to educate them in the ways of the community.

Indian Shooting an Arrow Weather Vane (painted sheet metal, circa 1800).

Angel Gabriel Weather Vane from Massachusetts (copper and zinc, nineteenth century).

Cow Weather Vane from Boston (copper and zinc, nineteenth century).

Fish Weather Vane from Rhode Island (metal, undated).

PHOTOGRAPHY

Margaret Bourke-White (1906–1971), one of the highest-paid and best-known photographers of the 1930s and the 1940s, covered the world from A to Z. Acceptable in the elegant social circles, where she photographed such notables as President Roosevelt, she was equally successful at capturing the look of poverty-stricken Southern farmers during the Depression. During the Second World War and again during the Korean war, she served as a war correspondent–combat photographer among other exploits. She took the first pictures

of Moscow during a night air raid (she narrowly escaped injury from a nearby bomb explosion) and accompanied American heavy bombers on North African raids.

Details of upper section showing family and car from *At the Time of the Louisville Flood* (1937).

Detail of waiting flood victims from *At the Time of the Louisville Flood* (1937).

At the Time of the Louisville Flood (1937). The disastrous Ohio River flood in the winter of 1937, left 1 million homeless and killed over 400. This dramatic picture of victims from the black section of Louisville waiting to receive emergency rations at a flood relief station is equal in power to the best FSA work, although it was taken for *Life* magazine (appearing in the February 15, 1937, issue) and not for the FSA. Probably Bourke-White's most famous photograph, *At the Time of the Louisville Flood* has been used many times to illustrate the discrepancy between American dream and American reality.

The Farm Security Administration (FSA).

The Department of Agriculture, headed by Rexford Guy Tugwell, attempted to meet the rural economic crisis of the Depression in several ways, including low-interest loans and subsidies. Paying farmers not to work, however, displeased many members of the Congress, and Tugwell judiciously decided, partly as a result of Dorothea Lange's work in documenting labor conditions in California, to add a photographic section to the department responsible for administrating rural aid. (To give the new department more prestige, it was designated the "historical unit.") Tugwell appointed Roy Stryker, then an economics instructor at Columbia University, to head the division. Although not a photographer himself, Stryker had used photographs extensively in his classes to document for his predominantly urban students the actual situations behind the statistics they normally dealt in. Stryker organized the photographers, briefed them before they left, and welcomed them when they returned. The Resettlement Administration (later the Farm Security Administration) of the Department of Agriculture obtained in this way not only a full documentation of government programs and their effect, but even more important a pictorial account of the way the people continued to struggle, to fight, to hope during the desperate years of the Great Depression. The FSA photographs became the first to be known specifically as documentary photographs, and thus their photographers were the first documentary photographers. Clear, unrelenting precision is the hallmark of the FSA photographs.

Stryker once declared that his professional photographers could be divided into two schools: those like Walker Evans, who searched for the single comprehensive statement, and those like Shahn, who sought out likely situations and then snapped almost at random hoping to capture the fullness of the situation by a sort of photographic "accident" which would freeze the moment.

John Vachon (born 1907) went on to a successful career as a fashion photographer.

Originally from Chicago, Walker Evans (born 1903) refused the security of a safe and profitable career in one of the middle-class professions, preferring instead to live a marginal and precarious existence as a photographer. As a result,

he always lived on the brink of poverty, subsisting with the help of friends and occasional photographic assignments. His photographs—sharp, precise, often grim—resemble to a certain extent the paintings of Edward Hopper. Evans despised both Stieglitz and Steichen, the one for his artiness and the other for his commercialism, and although he later reconsidered his judgment, he developed his unique style in opposition to these acknowledged leaders of photography. Always Evans sought photographs of such simplicity and directness that their meaning would be obvious and their impact permanent.

Ben Shahn (1898–1969) bought his first camera, a Leica, in 1933 and got his first instructions in using it from Walker Evans, with whom he was then sharing an apartment: "f 9 for the bright side of the street, f 4.5 for the shady side!" Evans told him as he rushed off to an assignment. In 1935 Shahn went to work for the Farm Security Administration as a senior liaison officer with the main purpose of working on explanatory posters. He was soon taking pictures, however, and eventually contributed over 6000 negatives to the FSA files. Shahn's photographic work was of great importance to his later painting. He did not paint exact scenes from his photographs, but he incorporated events and attitudes he discovered with the camera into his murals and paintings (for example, the solitary handball player in the Social Security Building murals).

Dorothea Lange (1895–1965) began her photographic studies with Arnold Genthe in New York City. In 1920 she opened a portrait studio in San Francisco, was immediately successful, and remained primarily a portrait photographer until the Depression curtailed business. In early 1935 she assisted Paul Taylor in preparing a study of migratory agricultural workers. The successful integration of photographs and text persuaded the federal government to include a photographic section in the agency which it organized during the summer of 1935 to deal with farm labor problems nationally. Lange went to work for the Resettlement Administration (later Farm Security Administration) in 1935, continuing with them off and on until 1942.

Filling Station, Reedsville, West Virginia, June 1935, by Walker Evans.

Missouri (1940) by John Vachon.

Detail of boys from *Missouri*.

Steel Mill and Workers' Houses, Birmingham, Alabama, March 1936, by Walker Evans.

Squatter's Home, Arkansas, October 1935, by Ben Shahn.

Flood Refugees, Forest City, Arkansas, February 1937, by Walker Evans, shows damage from the great Ohio River flood depicted in Bourke-White's *At the Time of the Louisville Flood*.

Bud Fields and His Family, Hale County, Alabama, Summer 1936, by Walker Evans. The Fields family and the Burroughs family are studied at first hand in James Agee's *Let Us Now Praise Famous Men*.

Child and Her Mother, Wapato, Yakima Valley, Washington (1939), by Dorothea Lange.

Filling Station and Company Houses for Miners, Vicinity Morgantown, West Virginia, July 1935, by Walker Evans.

William Edward (Bud) Fields, a cotton sharecropper, Hale County, Alabama, Summer 1936, by Walker Evans.

Allie Mae Burroughs, wife of Floyd Burroughs, Hale County, Alabama, Summer 1936, by Walker Evans.

Lucille Burroughs, daughter of Floyd Burroughs, Hale County, Alabama, Summer 1936, by Walker Evans.

Floyd Burroughs, a cotton sharecropper, Hale County, Alabama, Summer 1936, by Walker Evans.

County Fair, Central, Ohio, August 1938, by Ben Shahn.

Street Scene, Circleville, Ohio, Summer 1938, by Ben Shahn.

Waiting outside Relief Station, Urbana, Ohio (1938), by Ben Shahn.

A Young Family, Smithland, Kentucky, October 1935, by Ben Shahn.

Rehabilitation Clients, Boone County, Arkansas, October 1935, by Ben Shahn.

Cotton Pickers, Pulaski County, Arkansas, October 1935, by Ben Shahn.

Ozark Sharecropper, Arkansas, October 1935, by Ben Shahn.

Picking Cotton, Pulaski County, Arkansas, October 1935, by Ben Shahn.

Lettuce Cutters, Salinas Valley, California (1935), by Dorothea Lange.

California (1939), by Dorothea Lange

Migrant Mother, Nipomo, California, 1936, by Dorothea Lange, epitomizes the plight of workers in California.

Berenice Abbott (born 1898), a native of Ohio, studied and worked in Europe from 1921 to 1929, doing several portraits of important avant-garde art figures. Returning to New York, she worked as a photographer, joining the WPA/FAP as Supervisor of the Photographic Division in 1935. Her contribution to the project was a photographic study of New York City. The photographs seen here are all contained in *Changing New York* (1939).

Detail of street from *Seventh Avenue Looking North from 35th Street* (Manhattan, December 6, 1935).

Washington Square Looking North (Manhattan, April 16, 1935). The Washington Arch, celebrating the Centennial of Washington's inauguration, was erected in 1892 by McKim, Mead, and White.

The Flatiron Building (Broadway and Fifth Avenue, Manhattan, May 18, 1938).

McGraw-Hill Building (Manhattan, May 25, 1936).

Cheese Store (276 Bleecker Street, Manhattan, February 2, 1937).

Newsstand (Southwest corner of 32d Street and Third Avenue, Manhattan, November 19, 1935).

"El" Station Interior, Sixth and Ninth Avenue Lines, Downtown Side (Columbus Avenue and 72d Street, Manhattan, February 6, 1935).

It is impossible to calculate the exact cost of the programs, but these figures prepared by Dr. Francis V. O'Connor provide a realistic estimate.

Public Works of Art Project (PWAP), 1933–1934

400 murals
6800 easel works
650 sculptures $1,300,000
2600 print designs

Treasury Section of Painting and Sculpture (SECTION), 1934–1943

1100 murals $2,570,000
300 sculptures

WPA Federal Art Project (WPA/FAP); 1935–1943

2500 murals
108,000 easel works $35 million
17,700 sculptures
11,200 print designs

Treasury Relief Art Project (TRAP), 1935–1939

89 murals
10,000 easel works $833,700
65 sculptures

Total for All Federal Programs:

4089 murals
124,800 easel works $39,703,700
18,715 sculptures
13,800 print designs

POSTPROGRAM ILLUSTRATIONS *Eagle Weather Vane*; WNYC mural (Davis); *Bud Fields* (Evans); *Building of the Union Pacific Railroad* (Laning); *Welders* (Shahn); *Missouri* (Vachon); Arshile Gorky working on Newark airport mural; Spectators at an exhibition of art made by children; Artists at work on school auditorium; Poster workshop, Chicago, Illinois; Artist working on mural of herons; *Carousel horse*.

QUESTIONS AND PROJECTS

I. Identify or define:
 WPA/FAP f stop
 fresco Ellis Island
 serigraphy (silk-screen process) mosaic
 mosaic right-angle viewfinder
 Farm Security Administration Treasury Department Art Projects

II. Developmental questions:
1 Mural painting. What are the uses of mural painting? What kind of surface is employed? What differences are there between easel painting and mural painting? What is fresco? What is fresco secco?
2 Print making. What are the principal techniques of print making? How is print-making used in everyday life? What are the advantages of print?
3 Photography. What other photographers were prominent during the 1920s and the 1930s? In what fields were photographers primarily employed? What changes have

occurred since then in the photographer's professional standing? What developments in the camera and in film were significant in widening the photographer's range?

4 The Great Depression. What was the state of the American economy in the 1920s? What conditions of investment prevailed then which are no longer in force? How did the sudden fall in stock prices affect the nation's economy? How did the recession spread to Europe and the rest of the world?

III. Opinion and judgment questions:

1 The federal relief programs for creative artists—writers, painters, actors, and musicians—produced uneven results. Critics have claimed that this means that the programs were a failure. What standards are appropriate for judging such work? What role should the people have in rendering judgments? What are the advantages to a renewed program of government support of the arts?

IV. Projects:

1 Look around your community to find out whether any government artists worked on murals or sculpture or contributed work to the local museum. Are people in your community at all aware of the origins of the art work? What is their attitude toward any mural or sculpture still on display?

2 Do further reading on American antiques. American Heritage has a number of volumes dealing with American designs. There is also an abridged version of the Index of American Design and a recent, well-illustrated work called *Treasury of American Design*, which give an excellent introduction to the subject.

3 What pictorial information, either photographs or art work, exists on the history of your community? What does it tell about the development of your region? Who were the most important and the most significant people who provided information on the area? Do you have any family photographs that would be helpful?

4 The Federal Writers' Project produced a series of frequently exceptional guides to the individual states. Such guides are filled with information unavilable in any other books and might provide an excellent starting point for the study of your community or for comparing the present state of the region with that in the Depression. There are also mile-by-mile descriptions of U.S. Highway 1, the Ocean Highway from New Jersey to Florida, and the Oregon Trail from Missouri to the Pacific Coast.

BIBLIOGRAPHY

Allen, Frederick Lewis: *Since Yesterday*, Harper & Brothers, New York, 1940. A continuation of Lewis's book on the 1920s, *Only Yesterday* (also a Bantam paperback).

Cochran, Thomas C.: *The Great Depression and World War II: 1929–1945*, Scott, Foresman and Company, Glenview, Ill., 1968. An excellent overall picture of the period.

Hornung, Clarence P.: *Treasury of American Design*, Harry N. Abrams, Inc., New York, 1972. A pictorial survey of popular folk arts based upon the watercolor renderings of WPA/FAP artists.

O'Connor, Francis: *The New Deal Art Projects: An Anthology of Memoirs*, The Smithsonian Institution, Washington, 1972.

Terkel, Louis [Studs]: *Hard Times*, Pantheon Books, Inc., New York, 1970. Interviews with people who knew the Depression at first hand.

PROGRAM 17

ABSTRACT EXPRESSIONISM

The twentieth century—what intensity, what activity, what restless, nervous energy:

Arshile Gorky, 1931

Every deep artistic expression is the product of a conscious feeling for reality. This concerns both the reality of nature and the reality of the intrinsic life of the medium of expression.

Hans Hofmann, 1948

There is a train track in the history of art that goes back to Mesopotamia.

Willem de Kooning, 1950

The attitude that nature is chaotic and that the artist puts order into it is a very absurd point of view, I think. All we can hope for is to put some order into ourselves. When a man plows his field at the right time, it means just that.

Willem de Kooning, 1950

With the advent of abstract expressionism in the 1940s the long struggle to develop a truly American art form that the world would recognize as a significant artistic statement reached fulfillment.

Mark Rothko, Blue, Orange, Red, 1961. Courtesy of the Hirshhorn Museum and Sculpture Garden.

Growing out of a tradition of European influences and American innovations, this highly abstract style of painting was looked upon by many as the art of the future.

Not only did abstract expressionism create new criteria for judging art, it also established a new artistic center. New York City, for decades the stronghold of American art, would with the development of the movement, take its place among the leading art centers of the world. No longer did American artists emigrate to Paris, London, and other bastions of the European art world; rather they sought inspiration from the artistic community of New York. The energy and creative atmosphere in the great metropolis stimulated and inspired the Western art world, making the city a focal point for artistic activities in the art market. American art had finally come home and did so in triumph.

OVERVIEW

The Period Program 17 concerns itself with the artistic developments from the end of World War II to the late 1950s.

American Life The end of World War II heralded a new era of growth and prosperity in the United States. The returning GIs took advantage of many educational and economic opportunities, facilitating a rapid and smooth transition to a peacetime economy. With the fascist threat gone, the communist threat became of national importance. Alger Hiss, a member of the State Department who was sympathetic toward the Communists, was convicted of lying to a Senate committee investigating the influence of communism in the federal government. Overriding President Truman's veto, Congress passed the McCarren Internal Security Act (1950), which severely restricted the rights of Communists in the United States. In 1953, despite widespread cries for clemency, Julius and Ethel Rosenberg were executed for passing government secrets to Russian agents. The Red scare reached its zenith during the McCarthy hearings (1950–1954), in which Senator Joseph McCarthy accused all branches of government and sections of private industry of being overrun by Communists. He eventually accused the Senate itself of being Communist-dominated, an act which led to his censure. The economy entered a recessionary period in 1956, but was revived when the government entered the space race with the successful launching of the United States' first man-made satellite, Explorer I, in January of 1958.

American Literature New horizons were being explored in literature as well as painting. Norman Mailer's *The Naked and the Dead* (1948) and Joseph Heller's *Catch 22* (1961) stripped away the romantic glitter of war and dealt with the cruel realities of battle. The trials and tribulations of coming of age were explored in J. D. Salinger's *Catcher in the Rye* (1950). Arthur Miller's play *Death of a Salesman* (1949) vividly dramatized failure in an affluent society, and Tennessee Williams portrayed the decay of society in *The Glass Menagerie* (1949). Jack Kerouac's novel *On the Road* (1957) and Allen Ginsberg's poem *Howl* (1956) announced the arrival of the beat generation.

International Events International events were dominated by the rising conflict between communist and capitalist countries. The United States and Russia became the major opponents in a war of nerves—the cold war—which eventually led to the famous Berlin airlift of 1948. In an attempt to bolster Europe's sagging economy and to stop the rising influence of communism, the United States initiated the European Recovery Act (the Marshall Plan), loaning over $12 billion to her allies between 1947 and 1950. The Communist invasion of South Korea precipitated a major armed confrontation between Communists and non-Communists; the ensuing Korean Police Action (1950–1952) widened the gap between the United States and Russia. The Russians launched the first successful man-made satellite in October of 1957, beginning the race for space supremacy. In 1958 President Eisenhower honored the request of the South Vietnam government for military aid by sending American military personnel to act as advisers.

CONTENTS OF THE PROGRAM *Abstract Expressionism* Program 17 traces the development of abstract expressionism from its inception during the 1940s to its most successful period, the early 1950s. The major artists and trends of the movement are discussed in depth.

VIEWER'S GUIDE

PRE-LOGO ILLUSTRATION *The Liver Is the Cocks Comb* (Gorky); *Mahoning* (Kline); *Woman I* (de Kooning); *Convergence* (Pollock).

ABSTRACT EXPRESSIONISM

Six Views of the Interior of the Museum of Modern Art.

The origins of abstract expressionism, often referred to as the New York School, can be traced to the decade of the thirties when a series of events and interactions helped to forge the future of the movement. The WPA's employment of artists to decorate public buildings helped bring young artists into contact with each other, fostering an atmosphere of open communication and laying the foundation for an artistic community. Many of these artists felt uncomfortable with the realistic approach favored by the regionalists and the social realists (see Programs 15 and 16), the two dominant styles involved with the WPA projects. They chose instead to explore a more personal kind of expression, relying more upon abstract imagery and personal statements, as opposed to the social or political messages that were so much a part of contemporary representationalism. This alternative style was aided by the arrival in New York City of some of Europe's leading artistic figures who were forced to flee the advancing fascist threat. Most of these artists were members of the surrealist movement that dominated the European art world during the 1930s. The young

native artists found in the Europeans the moral support as well as the direction they needed in their quest for a more personal mode of expression. This combination of European and domestic influences evolved into Abstract Expressionism.

Abstract expressionism developed into two distinctive styles: gestural abstraction and reductive abstraction. The gestural painters, such as Jackson Pollock and Willem de Kooning (see below), used loose brushwork, abstract and primordial images, and large canvases to create an active and free style. In their work, dubbed "action painting," the process of painting became an expression of subconscious, often accidental, creation. Although reductive painters such as Mark Rothko and Barnett Newman (see below) were also concerned with the involvement of the subconscious in the artistic process of painting, they tended to favor a minimal and less active approach, using the interrelations of color to create a dynamic tension in their work.

The abstract expressionists were concerned with a personal form of expression and used a highly symbolic pictorial language in their work, resulting in the most radical and nonobjective art ever to appear in America. Many art critics, patrons, and gallery directors saw in abstract expressionism the emergence of a new type of art based on a totally new set of values. For them the validity of the movement was unquestionable, but for the general public abstract expressionism remained a mystery. The popular press ballyhooed the new art form, labeling it a sham and a hoax, and equating it with the doodling of infants or monkeys. Society in general was unable to deal with the complex set of questions that abstract expressionism raised, and dismissed it as ugly and absurd. Nevertheless, abstract expressionism took its place among the most innovative artistic movements of the twentieth century. However, the public, with its inability to cope with nonobjective painting, has yet to accept abstract expressionism.

Tornado (1929) by John Steuart Curry (Program 15).

Tombstone (1942) by Jacob Lawrence (Program 15).

American Tragedy (1937) a detail of a painting by Philip Evergood (Program 15).

Drought-Stricken Area (1934) by Alexandre Hogue (Program 15).

Chief (1950) by Franz Kline (see below).

WPA/Federal Art Project (mid 1930s).

WPA/Federal Art Project (mid 1930s).

New York City Skyline (n.d.).

Artists in Exile (1942). (anonymous photograph.). This photograph was taken at the Matisse Gallery in New York during the opening of the first American exhibition of works by the surrealists who had immigrated to the United States.

Of all the European artists who immigrated to New York in the 1930s, none had more of an impact on the New York art community than Hans Hofmann (1880–1966), whose unique ability as a teacher helped give direction to the young artists who were to be instrumental in the development of abstract expressionism. Hofmann believed that the artist's act of creation was a personal

expression that must be guided by his own intuition and imagination, taking into account only natural law and the potential of the medium.

Effervescence (1944). Hofmann tended to practice his theories in his own work, as is evident in this painting, where he has exploited the tactile qualities of paint by applying it in thick layers. The buildup of paint on the surface of the canvas helps to give the work a textural appearance.

Mississippi (1935) by John Steuart Curry (Program 15).

Magenta and Blue (1950). By opening his painting process, Hofmann was able to incorporate various painting styles into unique compositions. Here, he combines brilliant colors with imagery treated in a manner reminiscent of cubism.

The Lark (1960). Hofmann explored the ability of paint to flow in this work. The quick broad overlapping brushstrokes and the use of color to create line is more characteristic of drawing than of painting.

Song of a Nightingale (1964). Hofmann spent his early years in Paris among some of the major figures in twentieth-century art, including Picasso and Matisse. Like Matisse, Hofmann treated color as a plastic reality. Color and the interaction of colors were worthy of becoming the subject matter of a painting, as in this late work. By overlapping strong vibrant colors and using the texture of the paint to build up flat areas of highly saturated colors, Hofmann demonstrates his concern for color as subject matter with all the plastic qualities and psychological impact of more conventional types of images.

Senicitas (1928) by Salvador Dali (b. 1904), a member of the surrealist movement. His approach to art best exemplifies the realist or representational technique that was favored by a large number of surrealists.

Surrealism, an artistic movement that began in Europe during the 1920s, was based on the premise that all thought and motivation for artistic creation was the result of the subconscious, without any form of control exerted by reason and outside of all conventional forms of aesthetics or morals. In order to avoid the interference of the conscious, the surrealists developed several approaches to their art, including dreams, as subject matter and a source of some of their images, and a system of painting called automatism, a method whereby the artistic process is totally controlled by the subconscious and the artist makes no conscious effort to dictate the direction of the tool he is using. The abstract expressionists adopted and refined many of the ideas of the surrealists, including automatism.

Onyx of Electra (1944) by Sebastian Antonio Matta Echaurren (b. 1912), called Matta, a member of the surrealist movement who paints in an abstract style. Matta was one of the first of the surrealists to use abstract images to express the surrealist ideal. His strange and exotic images had a lasting effect on the work of Arshile Gorky (see below).

Harlequin's Carnival (1924–1925) by Joan Miró (b. 1893), another one of the surrealists who used abstract imagery in his work. The full and rounded biomorphic forms that Miró uses in his work seem to have a life of their own, and though they are not recognizable, there is little doubt that they are animated living beings.

Red Sun (1948). Large oval forms and rounded areas of color combined in loose compositions are characteristic of Miró's "quick" period of the forties. Gorky was to experiment with these similar types of images when he began to break away from traditional surrealist values.

Arshile Gorky (1904–1948), considered by many to be the transitional link between surrealism and abstract expressionism, was heavily influenced by the surrealists when they first arrived in New York. Adopting their basic philosophy and some of their approaches to painting, he soon became a member of the group. Eventually, his work became more open than the surrealists' paintings, expressing his fantasies by using a pictorial vocabulary that was uniquely his own. He represents the bridge between the more sedate surrealists and the free and open style of Jackson Pollock.

Detail of the center section from *They Will Take My Isle* (1945). Unlike Miró, Gorky tended to separate color and drawing in his work, creating a loose and open effect.

Garden in Sochi II (1940–1942). In this, perhaps Gorky's most revolutionary work, we can see a direct influence from Miró, especially in the large foot-shaped image in the center of the composition that is very similar to several images the surrealist used. This particular painting is the second in a series of three; Gorky was one of the first artists to use series of paintings to work out a final visual solution rather than painting multiple versions on the same canvas.

The artist who is most often associated with the open and free style of painting characteristic of gestural abstraction is Jackson Pollock (1912–1956). Pollock was the first artist to take the process of automatism to its natural limits. Working with large unstretched canvases, he eventually abandoned all contact of the brush with the surface of the painting, relying upon random movement dictated from the subconscious to guide both his hand and the paint. The act of painting became the subject of the work and the process itself was the motivation.

Water Figure (1945). Before turning to his drip paintings, Pollock worked in a more figurative style. He was influenced by the ideas of Carl Jung (1875–1961), an Austrian psychologist who believed that mankind shared a common pool of symbols deeply embedded in an area of the mind that he referred to as the collective unconscious. These symbols, called archetypes, represented the most basic and primitive ideas of man. In his work, Pollock attempted to express visually these archaic symbols.

Detail of the top portion of *Water Figure* (1945).

Detail of the center portion of *Water Figure* (1945).

Detail of *Recurrent Apparition* (1946) by Adolph Gottlieb (see below).

Recurrent Apparition (1946). Gottlieb, like Pollock, often turned to images he interpreted as expressing the mythic or archaic.

Evil Omen (1946). As in *Recurrent Apparition*, Gottlieb uses a grid composition that resembles the pictograms of ancient civilizations, which seem to convey a feeling of age and mystery.

Hand Catches a Bird (1945). Miró often used random doodling to suggest an image.

Male and Female (1942). Pollock's painting moved through several stages, including this one where he bases his composition on forms that have a special meaning for himself.

One (1950). In an effort to explore the full plastic potential of paint, Pollock began to use a method of painting whereby the brush never touched the surface of the work. This process, known as drip painting, relied upon accident as a factor in creation. It should be noted, however, that although the brush, or in some cases the stick, never touches the canvas, the artist still exercises a certain amount of control over the tool he is using.

Interior of the Museum of Modern Art.

Two photographs of Jackson Pollock. (All the photographs of Pollock are by Hans Namuth.)

Photograph of Pollock at Work (early fifties).

One (1950) (detail of the center).

Thirteen photographs of the artist at work (early fifties). These photographs offer a vivid visual description of Pollock at work using his drip technique.

Detail of Autumn Rhythm (1950). In this work, the swirling effects of the patterns of dripped paint and the enormous size of the canvas ($8\frac{1}{2}$ feet high by $17\frac{1}{2}$ feet long) combine to create an encompassing environment. The painting overwhelms and draws the viewer into the surface so that audience and painting merge. This effect is partially the result of the equal partnership of line and color that is common to Pollock's drip paintings.

Convergence (1952). Another example of Pollock's large drip paintings.

Photograph of the artist at work (early fifties).

Another member of the gestural branch of abstract expressionism is Willem de Kooning (b. 1904). De Kooning, unlike Pollock, was never able to free himself completely from the use of figurative images, and relied upon the images of women to convey his feelings for the more primitive aspects of humanity.

Interior of the Museum of Modern Art with a view of a de Kooning painting.

Willem de Kooning at work (n.d.).

Queen of Hearts (1943–1946). De Kooning's works from the forties still reflect his early training in more traditional forms of painting. Using the flat space of the cubists, de Kooning created a setting that helped display his superior qualities as a draftsman.

A detail of the center of *Ashville* (1941). De Kooning experimented with combining drawing and color into open and erratic compositions during the 1940s. These works relied on a more symbolic imagery rather than the representational forms of his earlier work.

Woman IV (1953). Returning to a highly abstract figurative image, de Kooning began a series of paintings during the 1950s depicting his relationship to women.

Woman I. De Kooning broke up the surface of this image in a manner reminiscent of cubism and included a paper cutout of a mouth as part of the composition.

Woman and Bicycle (1954).

Two Women in the Country (1954).

Marilyn Monroe (1954). De Kooning uses his own imagery to interpret the essential qualities of one of the fifties' most popular movie stars.

Study for the Women Series (1950).

De Kooning in His Studio (n.d.) (anonymous photograph).

Franz Kline (1910–1962), like most of the abstract expressionists, was originally a figurative painter. His style relied heavily upon drawing, and quite often his work was monochromatic. Eventually, he transferred this concern for drawing and his limited palette to action painting.

Palladio (1961) (the illustration is sideways). Kline, along with other artists in the 1950s, often used commercial paints and brushes rather than artists' materials. The large and more coarse brushes and the cheaper paints lent themselves to the artists' style.

Figure 8 (1952) (the illustration is sideways). The broad sweeping brushstrokes of this work resemble the highly linear and rhythmic appearance of oriental characters.

Mahoning (1956). Kline's fondness for line is apparent in his action paintings of the fifties.

Adolph Gottlieb's (b. 1903) paintings of the 1940s were concerned with the symbolic and primordial nature of man as expressed in basic and universal images, but later he abandoned representational images in favor of abstract forms constructed from large areas of color.

Thrust (1959). Gottlieb positions areas of color, such as the unrestrained form at the bottom of the canvas, along with more sedate images on a neutral ground creating a setting for the emotional conflict caused by the interaction of different hues.

Unknown title.

Untitled (1957) (illustration is upside down). Clyfford Still (b. 1904) uses colors that range from dark earth tones to elegant cool shades to construct the jagged and solid figures that are characteristic of his work.

Number 3 (1948). This painting by Bradley Walker Tomlin (1899–1953) is characteristic of the open and rhythmic quality of his work from the forties. Eventually, Tomlin's work became more consolidated, forming gridlike patterns based on cubist space.

Number 20 (1939).

Elegy to the Spanish Republic No. 34 (1953–1954). Robert Motherwell's (b. 1915) series on the Spanish Republic uses large oval forms to establish an emotional relationship between the viewer and the work.

Elegy to the Spanish Republic No. 59 (1953–1954).

Detail of the right side of *Elegy to the Spanish Republic No. 59* (1953–1954).

Red Painting (1952) by Ad Reinhardt (see below).

Covenant (1949) by Barnett Newman (see below).

Interior of the Museum of Modern Art.

During the first part of the 1950s a different approach to abstract expressionism was developed by a group of artists who relied on simpler and more formal compositions. These artists, collectively referred to as "reductive" painters, used large areas of intense color to create emotional compositions. The best-known of these artists was Mark Rothko (1903–1970). Rothko favored large-size canvas on which he constructed areas of intense colors. His soft-edge

images seem to float above the surface of the canvas, moving back and forth on a field of color in a subtle rhythm.

White Center (1957). Rothko placed a rectangle of white on a field of red in this work, causing a reaction between the coolness of the white and the fiery character of the red.

Mark Rothko (n.d.).

Number 10 (1950). The white ground acts as a field on which Rothko places areas of blue and yellow. The artist leaves very little evidence of brushwork in this work, although he does expose the white ground near the top of the canvas so that the viewer will be able to decipher the role of the underpaint.

White and Green in Blue (1957). Rothko uses dark colors in this work to express a solemn mood.

Ochre and Red on Red (1954). Rothko's subject matter was color itself, arranged and presented in such a manner as to elicit an emotional response from the viewer. Since the paintings were about color, it would seem logical that the titles were also concerned with color.

Vir Heroicus Sublimis (1950–1951). This painting is by Barnett Newman (1905–1970), another reductive painter, whose works were to have a lasting effect on the art of the late fifties and early sixties. His big and austere paintings of large areas of color would often have different colored lines, called zips, intruding on the ground. This intruding zip would create an inner tension in the painting owing to the ambiguous relationship between the two colors.

Another view of *Vir Heroicus Sublimis* (1950–1951).

Who's Afraid of Red Yellow Blue (1960). The large area of red dominates the canvas, causing the viewer almost to miss the secondary tones, while the highly saturated colors intensify the emotional content of the painting.

Concord (1949). Newman's approach to painting was philosophically oriented. This intellectual approach eliminated the spontaneous quality that is so characteristic of the other abstract expressionists.

Who's Afraid of Red . . . II (1967). The act of creation was of paramount importance to Newman. He saw aesthetics as pure idea and his paintings as expressions of this pure state.

Abraham (1949).

Number 111 (1949). Ad Reinhardt (1913–1967), as can be seen in this work, was closely associated with the gestural painters. However, he eventually abandoned the personal expressiveness and accidental qualities of action painting for a simpler and more controlled style of painting.

Detail of the center of *Red Painting* (1952).

Red Painting (1952). Reinhardt seems to have eliminated all the images from this work, leaving only a field of red. But on closer examination the viewer realizes that there are tonal variations in the red creating different images. This gentle varying of the primary color causes the surface of the work to pulsate; geometric images float off the canvas. The large scale of the work helps this process by amplifying the unsteady character of the emerging rectangles.

Abstract Painting (1960). Reinhardt would often use more than one color in

his works, but even when the tonal changes are more obvious to the viewer, the effect of pulsating movement remains the same.

Autumn Rhythm (1950) by Jackson Pollock (see above).

The Irascible Eighteen (1951), a photograph by Nina Leen taken for *Life* magazine, during an exhibition of the New York School of Painting. All the major figures of abstract expressionism are in the picture.

Blast I (1957) by Adolph Gottlieb (see above).

Garden in Sochi II (1940–1942) by Arshile Gorky (see above).

Number 3 (1948) by Bradley Walker Tomlin (see above).

Woman I (1952) by Willem de Kooning (see above).

Conversion (1952) by Jackson Pollock (see above).

Who's Afraid of Red (1967) by Barnett Newman (see above).

New York Skyline (n.d.).

Palladio (1961) by Franz Kline (see above).

POST-PROGRAM ILLUSTRATIONS *Conversion* (Pollock); *Ochre and Red on Red* (Rothko); *Garden in Sochi II* (Gorky); *Untitled* (de Kooning); *Jackson Pollock* (Namuth); *Untitled* (Still); *Study for Woman* (de Kooning); *Woman IV* (de Kooning); *Mahoning* (Kline); *Magenta and Blue* (Hofmann); *Elegy to the Spanish Republic No. 59* (Motherwell); *Evil Omen* (Gottlieb); *Song of a Nightingale* (Hofmann); *Willem de Kooning; Abstract Painting* (Reinhardt); *Mark Rothko.*

QUESTIONS AND PROJECTS

I. Define or identify:

Carl Jung	biomorphic
pictograph	calligraphy
primordial	archetype
automatism	Surrealism
"action" painting	"drip" painting

II. Questions for development:

1 *Surrealism.* What role did surrealism play in the development of abstract expressionism? Which surrealists seemed to have the most influence and upon whom? What similarities are there between abstract expressionism and surrealism? What techniques did the abstract expressionists adopt from the surrealists?

2 *Hans Hofmann.* What effect did the teachings of Hans Hofmann have on the abstract expressionists? What were the major tenets of his approach to art? Who seemed to be most influenced by Hofman's theories? In what manner?

3 *Gestural Painting.* What was so innovative about "gestural" painting? What were the major characteristics of the style? In what ways is this approach to painting similar to surrealism? What role does scale play in "gestural" painting? Explain the artist's attitude or approach to his painting?

4 *Reductive Painting.* What are the most outstanding features of "reductive" painting? How does the artist express his ideas? Was surrealism more important to the "reduc-

tive" painters than the teachings of Hans Hofmann? Explain your answer. Who are some of the leading "reductive" painters and what characteristics do they share?

III. Opinion and judgment questions:

1 Abstract expressionism had two separate branches that in many ways were quite different from each other. Compare and contrast "gestural" painting with "reductive" painting. How are they similar or how do they differ? Is one more expressive than the other? Can you consider one more important or valid than the other? Why? How does each reflect the influence of the surrealists or Hans Hofmann?

2 Abstract expressionism was a radically new style, quite different from anything else produced in the United States. Does abstract expressionism fit into the mainstream of American art? Can the movement be reconciled with the tradition of realism in American art? What, if any, characteristics of American art does abstract expressionism have? If there is no connection between American art tradition and abstract expressionism, can we consider it to be an American art movement? Why or why not? Does the lack of American tradition have any effect on the validity or importance of the movement?

IV. Projects:

1 Gestural painting was very much the expression of the artist's inner feeling. Quite often people felt that the individual artist's technical abilities weren't very well developed; therefore the artists painted in this "sloppy" manner; anybody could paint this way. Using long sheets of butcher's paper and tempera paints, try making a "gestural" painting. See if you can allow your subconscious thoughts to dictate your use of paint. Try "drip" techniques with both a brush and a stick. Add other objects to the surface of the painting. Does this approach to painting seem more valid now that you have experienced the painting process? Is it easy to make a "gestural" painting? Can you better understand the concern for process that the "gestural" painters had?

2 Color relationships are quite complex and involved. Obtain some construction paper or colored paper and use it to create compositions of overlapping shapes. How does the color change as you add and subtract shapes? What does this tell you about the relationship of colors to each other? Does the concept of a "color theory" seem more realistic? Are there emotional differences between color combinations?

BIBLIOGRAPHY

Hess, Thomas B.: *Barnett Newman*, Museum of Modern Art, New York, 1971. A look at Newman, his work, and his ideas.

Los Angeles County Museum of Art: *New York School; First Generation*, Los Angeles County Museum of Art, Los Angeles, 1965. The catalogue of a large exhibition of painting from the forties and fifties. The book includes an extensive bibliography as well as statements by the artists on their work.

Robertson, Bryan: *Jackson Pollock*, Harry N. Abrams, New York, 1960. A detailed biography of Pollock including a complete catalogue of the artist's work.

Sandler, Irving: *The Triumph of American Painting*, Praeger Publishers, New York, 1970. A well-written account of the development of abstract expressionism, including sections on all the major figures in the movement.

PROGRAM 18
THE FIFTIES

Everything in nature has limitless possibilities. In my work, there is some attempt to distinguish the possibilities.

Jasper Johns

The fifties were rich in artistic experimentation and innovation. Abstract expressionism, despite radically changing both the goals and the content of painting, provoked a strong reaction among succeeding artists. Many painters sought new approaches to creativity and found more congenial approaches in color-field painting, hard-edge abstraction, and realism. Sculpture, which had long been the most conservative of the fine arts, began to move in new and dramatic directions.

Louise Nevelson, Black Wall, 1964. Courtesy of the Hirshhorn Museum and Sculpture Garden.

OVERVIEW

The Period Program 18 covers approximately the same period as that treated in Program 17, although the sculptors discussed here began work in the 1920s and the 1930s. As with Program 19, the period is as much a state of mind as a time sequence.

American Life, American Literature, International Events See Program 17.

CONTENTS OF THE PROGRAM *Sculpture* American sculpture, which had for the most part been satisfied to follow the lead of the Europeans, began to shape its own identity. The work of Alexander Calder, David Smith, Isamu Noguchi, and Louise Nevelson is given primary consideration here, with some additional comments on John Chamberlain and Richard Stankiewicz.

Painting In the wake of abstract expressionism, painters reevaluated their art and began to move in new directions. The Abstract Imagists, like Al Held and Ellsworth Kelly, explored the relationships of large color areas. The Washington Color School, of whom Morris Louis and Kenneth Noland were the most distinctive members, demonstrated somewhat similar concerns. A third group of artists, including Robert Rauschenberg, Jasper Johns and Larry Rivers, turned toward representationalism.

VIEWER'S GUIDE

PRE-LOGO ILLUSTRATIONS *Dutch Masters Cigars* (Rivers); *Sun Garden No. 1* (Nevelson); *While* (Louis); *Three Flags* (Johns).

SCULPTURE

It was not until after World War II that American sculpture began to develop an originality that was truly American. Sculptors like Alexander Calder and David Smith combined modern technology with artistic ability to create a contemporary American style of sculpture that relied upon industrial innovations for materials and eventually images as well. Machines and mechanics became an important factor in the development of American sculpture.

Other artists turned toward their environment for inspiration and materials. Louise Nevelson, John Chamberlain, and Richard Stankiewicz, to name a few, began to assemble works from discarded junk and found objects. Artists like Isamu Noguchi combined the heritage of his ancestors with contemporary concerns for form in a unique artistic style that effectively blended the old with the new.

Alexander Calder. The son and the grandson of well-known sculptors, Alexander Calder (1898–1976) was doing no more than following a family tradition when he became a sculptor. Yet his contribution to the art was more original

and far-reaching than that of the previous Calders. Born in Philadelphia, Calder studied mechanical engineering at Stevens Institute of Technology before entering the Art Students League of New York in 1923. He left for Paris in 1926, and it was in Europe that he received the training and inspiration for his later work. He is best known for his delicate and imaginative mobiles. In later years he also experimented with large-scale metal structures known as stabiles.

Alexander Calder (photograph).

Circus in New York (1929 photograph by Andre Kertesz). Calder's first work as a professional artist was as a free-lance artist for the *National Police Gazette* from 1924 to 1926. One of his assignments was a series of drawings on circus life in 1925. Calder spent almost every evening for 2 weeks sketching activities in the Ringling Brothers and Barnum and Bailey Circus. From this experience grew the artist's circus of wire and metal animals. In 1926 Calder published *Animal Sketching,* based on drawings from this assignment and began building his miniature circus. The following year he started staging performances of his circus in his Paris studio (Isamu Noguchi frequently was in charge of the music). Many artists, writers, and critics attended performances of the circus; by 1931 Calder was performing to audiences of as many as 100 people. By then the circus had grown to some fifty-five figures of animals and people, including a trapeze, lion's cage, tent, ring, and other equipment.

Acrobats. This is one of Calder's many drawings of his circus. It demonstrates the single-stroke technique of drawing which Calder learned in art school. This technique was evidently an important influence on his early wire sculpture.

Elephant. Calder used wire in his sculptures much the same way as he used line in his drawings. His circus figures are three-dimensional actualizations of his earlier sketches. By using wire, the artist suggests volume and defines the shape of each image while allowing the work to remain open.

Ringmaster.

Clown.

Lion Tamer. This is another of Calder's drawings, which were made around 1931–1932 and then misplaced for some 30 years.

Lion.

Tightrope Walker. Another of Calder's sketches of his circus.

Elephant.

Kangaroo (1927). Calder made a series of movable sculptures that were eventually manufactured as toys. The *Kangaroo* with its simple geometric body and abbreviated appendages and head was an ideal design for a toy.

Horse.

Clown.

Circus Ring.

White Frame (1934). In 1930 Calder visited the studio of the Dutch abstractionist Piet Mondrian, and became enthused with his art. He painted a few canvases in a style which generally follows Mondrian's lead, but he soon transferred his interest in abstraction to sculpture. The visit to Mondian was a turning point in his career. From this visit he took away two goals; to create a kind of move-

ment in his sculpture as Mondrian had done in his painting and to use color in his work. Having already experimented with movable objects in a fixed frame, he turned to movable sculpture, as in *White Frame*, one of his most ambitious motor-driven works. But even as he was perfecting motor-driven sculpture, he was already turning his attention to wind-driven pieces, the mobiles with which he has been so closely identified.

Effect of Red (1967) (mobile). Strongly influenced by the biomorphic images of the surrealists Jean Arp and Joan Miró, Calder's mobiles are three-dimensional interpretations of these two-dimensional images. Although the mobile explores space through its capacity to move, the shapes that make up the pieces are basically flat and the overall effect is very linear.

Stainless Steeler (1966) (mobile). The movable nature of the mobile introduces an element of chance into the relationship of the parts to the whole work, causing many new configurations or compositions as the work shifts and sways.

Two Discs (1965) (stabile). Calder's first stabiles were simply small stationary sculptures. They were called stabiles to distinguish them from the mobiles. In the late 1930s, however, modern alloys and new types of machinery enabled Calder to expand his stabiles to monumental proportions. *Two Discs* represents the stabile in its mature form. The oval shapes in much of Calder's sculpture are abstractions derived from selected animals that belong to his circus. Rather than use figures to develop mass in his work and to develop a feeling of depth, Calder positions flat shapes in such a manner as to create and define three-dimensional space.

Three Red Lines (1966) by George Rickey. Rickey combines the movement of the mobiles with the large shapes that are characteristic of the stabiles into a monumental sculpture that is in a constant state of flux.

David Smith. Like Calder, Smith (1906–1965) studied at the Art Student League in New York City and was deeply influenced by European art, Picasso, Mondrian, and Kandinsky in particular. His origins as a painter explain the two-dimensional quality of much of his work. His work stands as a bridge between the European-influenced art of Calder and the decidedly American art of the pop sculptors. He infused his sculpture with a quality of heroic achievement which makes it unique in American art.

Cubi XII (1963).

Cubi XVIII and Cubi XVII at Smith's Bolton Landing studio. The Cubi series, Smith's last work, is composed of twenty-eight monumental works of stainless steel created between 1961 and 1965. Like Calder's wire figures, these works are in many respects three-dimensional translations of drawings. The sharp angular shapes and the smooth bright surface of the steel helps to emphasize the dimension of depth, while the sheer physical size of the work tends to overwhelm the viewer.

Head (1935) by Julio Gonzalez (1877–1940). Smith's first sculpture was a wooden *Head* (1932). In the following years he produced a series of welded heads made from boiler plate, all in a manner reminiscent of Gonzalez's work. A member of the avant-garde group in Paris, Gonzalez was the first sculptor-

welder in Europe. Like Smith, Gonzalez was a trained metalworker and he had studied painting rather than sculpture.

David Smith (photograph).

Helmholtzian Landscape (1946). Prior to 1946 Smith created primarily isolated objects, but with *Helmholtzian Landscape* he began a series of landscape sculptures in which he attempted to create a sensation of spatial depth. The frame of the sculpture serves to orient the viewer as well as to contain the scene.

Deserted Garden Landscape (1946).

Big Rooster (1945).

Hudson River Landscape (1951). This sculpture grew out of drawings Smith made during trips by train from Albany to Poughkeepsie. Although it is abstract in appearance, the sculpture is intended to represent an actual scene along the Hudson River.

The Letter (1950). As with *Helmholtzian Landscape* the frame merges with the base and encloses the work. It is actually a letter, with a salutation (Dear Mother) at the top, followed by a message "O OHIO / O Y (why) I O Y (why) / O O O Y (why) / H O O O" and a signature: David Smith.

24 Greek Ys (1950).

View of Bolton Landing Studio Landscape (photograph).

Wagon (1962).

Wagon I (1964). Smith's sculpture is remarkably powerful and frightening, often reminiscent of imagery from a science fiction story.

Voltri VI (1962). One of three chariots Smith made in this series.

Voltri XIX (1962). In June of 1962 as a guest of an Italian metallurgical company, Smith created twenty-six monumental sculptures in a factory near Genoa. The quantity of his output is truly amazing, particularly when we consider that Smith's best yearly production had been only twenty. Smith made two sculptures of the workbench: *Voltri XIX* and *Voltri XVI*. Of the two, *Voltri XIX* is considerably more surrealistic: note the limp forging tongs hanging over the edge of the workbench.

Bec-Dida Day (1963). The title of the sculpture is taken from the names of Smith's two daughters Rebecca and Candida. In it he exploits colors as an aid to the creation of three-dimensionality. The three parts of the sculpture are each painted in two colors in such a way that the spectator necessarily must appreciate the depth of each one of the elements.

Circle II (1962). After his return from Italy, Smith completed a series of three multicolored circles, followed by a fourth the following year. He obviously considered them an ensemble, however, since he displayed them as such at his studio at Bolton Landing.

Cubi at Bolton Landing (photograph).

David Smith (photograph).

Isamu Noguchi. The son of a Japanese father and a Scottish-American mother, Noguchi (b. 1904) spent most of his early years in Japan. He began his study of art as an assistant to Gutzon Borglum in Connecticut, quit that to study medicine, and then returned to sculpture. Noguchi was awarded a Guggenheim Fel-

lowship in 1927 and left for Paris, where he began an apprenticeship with the sculptor Constantin Brancusi. He returned to the United States in 1929, where he supported himself with portrait busts. In 1931 he studied art in China and in Japan. He became extremely interested in social problems during the 1930s. During the 1940s and afterwards his sculpture will tend to express social outrage in abstract form.

Isamu Noguchi (photograph).

Mount Rushmore (1927–1941) by Gutzon Borglum.

Newborn (1920) by Constantin Brancusi. Brancusi, one of the most important of the European sculptors who worked directly with the materials of sculpture, played a determining influence in Noguchi's development.

Jomon (1962).

Kouros (1944). In 1944 Noguchi began to use marble slabs intended for surfacing buildings in his sculpture. In this sculpture he organizes the slabs in a way which calls attention not only to its abstract qualities, but at the same time suggests its position as an archaic remnant of Greek civilization. *Kouros* seems to span thousands of years of sculptural art.

Woman with Holes, II (1969).

Beinicke Rare Book Room & Sculpture Courtyard, Yale University (completed 1964). While in Hawaii during the 1930s Noguchi became interested in landscape environments, proposing models for a park to the city government of Honolulu. Noguchi placed his organic and geometric shapes on a marble surface etched with intersecting arches and grids in the sculpture garden at Yale University that is an integrated part of the overall design of the building. The artist translates into marble a combination of modern images and traditional Japanese garden designs.

Louise Nevelson. Born in Kiev, Russia, in 1900, Nevelson came to the United States in 1902. An extremely gifted person, she refused to adjust to the demands of life as a society wife and left her husband to study art in Europe in 1929. Like David Smith, she began with painting, working with Diego Rivera on several mural projects, but shifted to sculpture in the mid-1930s. Nevelson developed a style of assembling pieces of wood, often used in the form in which they were found, into rectangular cubbyholes that are combined to form a larger work of art. Quite often, each individual compartment is a separate work of art and can often stand by itself. When the work is fully assembled, Nevelson usually paints the entire surface a neutral color, helping the different parts blend into a unified whole.

Louise Nevelson arranging her boxes at the Whitney Museum of American Art (1967).

Sun Garden (1964).

An American Tribute to the British People (1960–1965). The high center and rough symmetrical composition suggest an altar, although Nevelson disclaims any attempt at spiritual effect. The gilt paint unifies the individual boxes in one shimmering effect.

Sky Cathedral—Moon Garden (1957).

The Fountain (1917) by Marcel Duchamp (see Program 13).

The Minotaur (collage, 1933) by Pablo Picasso (see Program 14).

Essex (1960) by John Chamberlain. Chamberlain (b. 1927) specializes in creating sculptures from junked or wrecked automobiles. Here, the interwoven metal scraps form a compact shape with a great deal of inner tension.

Secretary (1953) by Richard Stankiewicz. Stankiewicz (b. 1922) seeks his materials, like Chamberlain, in the junkyard, welding his materials into abstracted images that are often quite amusing.

PAINTING

The impact of abstract expressionism eventually led to the development of three distinct movements in painting during the late 1950s. Artists such as Al Held, Ellsworth Kelly, Robert Rauschenberg, Jasper Johns, Morris Louis, and Kenneth Noland abandoned the ambiguous use of space and the personalization of images that were so popular with the abstract expressionists, while maintaining some of the movement's characteristics that they felt were valid: large scale, directness of approach, and a concern for abstraction. The exploration of the relationship of large areas of color that was begun by Mark Rothko and Barnett Newman (see Program 17) was further explored by the hard-edge artists and the members of the Washington Color School. At the same time, a group of artists, including Rauschenberg, Johns, and Larry Rivers, were reviving interest in representational art. It was these artists and their reaction to abstract expressionism that were to set the mood for painting in the 1960s, one of the most productive artistic eras in the history of American art.

Jackson Pollock (n.d.) (Hans Namuth).

One (1950). This action painting by Jackson Pollock is discussed in Program 17.

Elegy to the Spanish Republic No. 34 (1953–1954) by Robert Motherwell (Program 17).

Interior of the Museum of Modern Art.

Woman I (1952). It was images like those in this de Kooning painting that caused the most reaction from the artists of the late fifties.

Willem de Kooning (n.d.).

Green Blue Red (1964). Ellsworth Kelly (b. 1923), an abstract imagist or hard-edge artist, painted large canvases that were dominated by austere forms of color. Unlike Rothko, Kelly's color areas are precisely defined by sharp edges, hence the term *hard-edge* painting. The highly saturated areas of well-defined color work with and against each other, setting up an active interplay of energy.

Coenties Slip (1959). Another member of the abstract imagists was Jack Youngerman (b. 1926). Youngerman relied upon shape as invention in his work, and although his images are more rounded and less linear than Kelly's, they still are defined by a sharp edge.

Ivan the Terrible (1961). Al Held (b. 1928) was closely associated with the abstract expressionists early in his career, but soon found the personal nature of their art to be too confining. Using large geometric figures, Held began to ex-

plore the relationship between size and image. By extending the images to the end of the canvas, as in this work, Held presents an open composition that allows the individual to place his own limitations on the work.

Noah's Figure III (1971). Later in his career Held reduced his images to simple geometric line drawings. These large-scale works opened the internal structure of the composition while reinforcing its relationship with its surroundings.

Mountains and Sea (1952). Helen Frankenthaler's (b. 1928) stained paintings had a strong emotional impact on several artists in the Washington, D.C., area, including Morris Louis.

Iris (1954). The preoccupation with color that began with the reductive painters of the early fifties led to the development of a style of painting often referred to as the Washington Color School. While the hard-edge painters relied upon image and size in their works, artists like Morris Louis (1912–1962) were exploring the sensory nature of color. Using a staining technique on unprimed canvas, Louis was able to blend together different color washes made of acrylic paints into compositions that exploited the pure sensation of color.

While (1960). By utilizing washes poured directly on the canvas to create stains, Louis was able to eliminate any trace of the artist's hand in the execution of the work, while at the same time he was able to retain a much greater control than the gestural painters.

Alpha Tau (1961). Louis's last works were becoming more concerned with the relationship of color and space. In this work he extends the paint in diagonals along the sides of the canvas while leaving the middle bare, resulting in an open composition that allows the paint to visually run off the canvas into the viewer's space.

Beginning (1958). Another color-field painter was Kenneth Noland (b. 1924). Noland was concerned with the relationship of colors to the shape of the canvas. By using concentric circles of color while leaving the outer edges of the canvas blank, Noland confines the image and the color to the surface of the work. Yet, at the same time, the uncertain character of the circumference of the outermost circle prevents us from seeing the image as being finished.

Via Token (1969). Although he was interested in the spatial relations, the major concern of Noland's work remained with color. His compositions at times are very close to the works of Barnett Newman with the exception of the bare areas of canvas at the top and bottom of this work, which effectively close off the composition by confining the physical range of the colors.

And Again (1964). Noland uses the shape of the canvas to accent the composition.

Double Portrait of Birdie (1955). Not all the reaction to abstract expressionism was positive. Some artists rejected the personal nature of the imagery in the paintings of the New York School by returning to a more representational style of painting. Larry Rivers (b. 1923) turned to common, often mundane, subject matter for his paintings, using them for their visual content rather than their literal meaning. In this painting, Rivers uses the figures of a man and woman strictly as images rather than subjects.

Dutch Masters and Cigars (1964). Although Rivers treats representational images as if they were only formal artistic elements, there is a certain sarcastic content to his restatement of a popular object or a well-known work of art. Here he takes a cigar-box image that is an interpretation of an old master's work and then interprets it again in his own style.

Washington Crossing the Delaware (1953). Art is no longer sacred to Rivers, and all pictorial compositions become fair game, like this rendering of Emanual Leutze's famous painting of Washington crossing the Delaware River.

Robert Rauschenberg (n.d.).

Factum I and Factum II (1957). The artist who had the most dramatic reaction against action painting was Robert Rauschenberg (b. 1925). In this series of two works, Rauschenberg manages to destroy the basic premise of abstract expressionism through his duplication of compositions. Not only does this negate the spontaneous accidental quality of gestural painting, it also eliminates the concept of uniqueness that is central to the idea of painting as a fine art.

The Bed (1955). Rauschenberg often included real objects in his paintings, such as the bedspread in this work.

Canyon (1959). By placing real objects in unreal or unnatural settings, Rauschenberg is using these forms strictly as images rather than symbols. The idea of a recognizable item in a nonreal environment, a device favored by the surrealists, helps the artist break down the barriers of sacredness that traditionally surround painting.

Detail of the upper left corner of *Reservoir* (1961).

Detail of the lower right corner of *Reservoir* (1961).

Detail of the center of *Pantomime* (1969).

Detail of the center of *The Magician* (1959).

Buffalo II (1964). Rauschenberg's art at times has a strong symbolic content as in this work inspired by the assassination of John Kennedy. The collage effect of this work uses silk-screened images juxtaposed on a canvas with paint and pieces of paper.

Double Feature (1959). Rauschenberg's irreverences toward painting were his way of attempting to bring art into contact with the real world. Like the Ashcan School artists (see Program 12), he felt that art and life were inseparable.

South Beach Bathers (1908) by John Sloan (Program 12).

Detail of the standing woman from the center of *South Beach Bathers* (1908).

Detail of the sitting women from the center of *South Beach Bathers* (1908).

Goin' Fishin' (1925) by Arthur Dove (Program 14).

The Fountain (1917) by Marcel Duchamp (Program 13).

Monogram (1955–1959). This work takes Rauschenberg's concern for the three-dimensionality of his work to the extreme. This piece is neither a painting nor a piece of sculpture, but in reality a combination of both. He has broken the boundaries between two different art forms, creating an ambiguity by using real objects in unreal settings.

Painted Bronze (1960). Unlike Rauschenberg, Jasper Johns (b. 1930) used a more direct approach toward his figurative images. Johns was concerned more with the process than the product of artistic activity. In this work, he uses a real

and commonplace image, ale cans, as a visual statement. It becomes important to him that the object, regardless of its outward appearance, is in reality a work of art.

Three Flags (1958). Johns takes symbols that we encounter every day and changes them into icons of the twentieth century through the use of an artistic process. Here, the American flag becomes the basis for an exercise in color relationship without losing its other and more symbolic meaning.

Map (1963).

Detail of the bottom of *0-9* (1963). In this lithograph Johns uses numbers as an artistic image as well as communicative symbol. What is important for the artist is the visual aspect of the forms and their intrinsic meaning.

Targets with Plaster Casts (1955). The target, because of its structure of concentric circles, lends itself well to paintings that explore the relationships of color. However, Johns added a row of plaster casts in small cubicles to the top of the canvas, creating an intrusion into the color field of the painted circles. These little wooden cubicles contain casts of different parts of the human anatomy placed in random sequence. The uncertain nature of the work is enhanced by the inclusion of hinged flaps that can be lowered to close any of the small niches, thus allowing for an endless number of configurations, or works of art.

False Start (1959). By labeling the colors in this work with the wrong names, Johns sets up a dichotomy that is very reminiscent of Marcel Duchamp's ready-mades. The viewer encounters the painting with the mislabeled colors and is forced to decide for himself the reality of the work. Johns is presenting us with a visual stimulus, and it is our responsibility to interpret the content.

Detail of bottom portion of *Painted Bronze* (1960). Johns did a series of bronze casts in the 1960s which he entitled *Painted Bronze*. In this particular work, Johns was inspired by an old coffee can he used to hold his brushes. However, unlike Duchamp, who would choose an object because of the reaction it would generate, Johns chose the object because of its visual presence. Moreover, because the resulting product must be a work of art, Johns reproduced the object by casting its shape in bronze and then painting the casting exactly like the original rather than just using the original.

Painted Bronze (1960).

Painted Bronze (1960).

Painted Bronze (1960).

Detail of *0-9* (1963). Another development of the late 1950s was the reemergence of print making as a primary vehicle for the artist. In this work Johns makes use of the lithographic process.

Detail of the center portion of *Buffalo II* (1964). Rauschenberg also used print techniques such as the silk screening incorporated in this work.

Campbell Soup Cans (1962). Andy Warhol (see Program 19) incorporates many aspects of Johns's works in this painting of soup cans, including the use of mundane everyday objects as the subject of the work.

Spiral Jetty (1970). An earthwork by Robert Smithson (see Program 19).

Myth Masks (1966). A happening by Ann Halprin.

Back Seat Dodge-38 (1964) by Edward Kienholz (Program 19).

POST-PROGRAM ILLUSTRATIONS *Hudson River Landscape* (Smith); *Noah's Focus III* (Held); *Cubi at Bolton Landing* (Smith); *Coenties Slip* (Youngerman); *Sky Cathedral—Moon Garden* (Nevelson); *Green Blue Red* (Kelly); *Beginning* (Noland); *Red Gong* (Calder); *While* (Louis); *Painted Bronze* (Johns); *Red White* (Kelly).

QUESTIONS AND PROJECTS

I. Define or identify:

stabiles	kinetic sculpture
mobiles	Julio Gonzalez
welding	acrylic paints
assemblage	'color field' painting
Piet Mondrian	combines

II. Questions for development:

1 *Sculpture.* What influence did the surrealists have on the sculpture of Calder and Smith? What is innovative about the materials and techniques that the artists used? How did this choice of materials influence their work? What is the relationship between abstract sculpture and abstract painting?

2 *Hard Edge and "Color Field" Painting.* What influence did the "reductive" painters have on the art works of the abstract imagists and the Washington Color School? How did their work differ? Explain. Which style of painting seems more valid or successful? Is there really much difference between the paintings of the "reductive" and the "color field" painters?

3 *Representational Painting.* How did the representational artists react to surrealism? What approach do these artists take towards the images that they incorporate into their works? Is their approach more comfortable to the viewer than the abstract expressionist? Why or why not?

III. Opinion and judgment questions:

1 The reaction to abstract expressionism varied greatly in the late 1950s. Compare and contrast the painting of this period to abstract expressionism. What did these artists adopt from abstract expressionism? What was rejected? Does the style of painting in the late 50s seem as important as abstract expressionism? Why? Is the painting of the late 50s closer to the traditions of American art?

2 Compare the sculpture of Alexander Calder and David Smith to the paintings of Jackson Pollock or Barnett Newman. What characteristics do they share? How does each group of artists use scale, contemporary materials and modern technology? Does the sculpture seem influenced by Abstract Expressionism, or could it be the other way around? Explain.

IV. Projects:

1 We have seen how Duchamp made art out of everyday objects that he called ready-mades, and how different sculptors used found objects, junk, and other already-produced objects in their work. Try to assemble discarded objects and junk in general that could be used in a work of art. Assemble some of the objects into a piece of sculpture. What difficulties do you encounter? Is creating junk sculpture as easy as

it seems? Did you get personal satisfaction out of this process? Can you better under-
stand this type of art after producing it?

BIBLIOGRAPHY

Ashton, Dore: *Modern American Sculpture*, Harry N. Abrams, New York, 1968. An in-
sightful and interesting survey of recent sculpture in America.
Geldzahler, Henry: *New York Painting and Sculpture: 1940–1970*, E. P. Dutton and Co.,
New York, 1969. An exhibition catalogue of American painting and sculpture from
the 40's to the 60's, including critical essays by some of the leading art critics of the
time.
Sculpture: An Evolution in Volume and Space, Wittenborn, New York, 1955. Biographical
and bibliographic material on seven American sculptors including Alexander
Calder and David Smith.
Tomkins, Calvin: *The Bride and the Bachelors*, Viking Press, New York, 1968. Tomkins, an
insightful journalist, has written essays on five individuals involved with the
avant-garde world of the 1950's including Robert Rauschenberg and Marcel Du-
champ.

THE SIXTIES

PROGRAM 19
THE SIXTIES

The Future lies ahead.
Mort Sahl

The tensions, torments, frustrated hopes, and new-found fears of the decade are repeated, magnified, and often clarified in the work of contemporary artists. The many different labels which critics manufactured to keep up with the varieties of creative output—pop art, minimal art, hard-edge abstraction, op art, ob art, earth art, conceptual art, photo-realism—suggest not only the dedication of the artist, but the intense search for new creative avenues as well. The art of the sixties is as varied as the personalities of the artists who made it, the critics who judged it, the patrons who bought it, and the public who viewed it. As a period it is relatively easy to study; we have only to look about us to recognize the subject material.

George Segal, Bus Riders, 1964. Courtesy of the Hirshhorn Museum and Sculpture Garden.

249

OVERVIEW

The Period Program 19 covers in general the period from 1960 to 1970, although the artists discussed in it did not do all their work during those 10 years. The sixties, in fact, were a state of mind as well as a time period.

American Life Violent solutions to political and social frustrations became so common as to seem almost routine. Medgar Evers, George Lincoln Rockwell, John Kennedy, Malcolm X, Martin Luther King, and Robert Kennedy were among the politicians murdered for their beliefs. Violence and confrontation reappeared in many other places and for many other reasons: in Berkeley, California, in the free-speech movement; in the ghetto riots in Watts, Detroit, and Newark; and in countless demonstrations against the war in Vietnam. All were not activists, however. The hippies simply dropped out of the system, preferring to live by expedience rather than join the race for the American Dream, various adherents of new religious movements likewise questioned the American emphasis on material possessions, and many frustrated urban dwellers formed themselves into communal groups which tried to become self-sufficient and independent.

The civil rights activities which preoccupied Americans, and particularly young Americans, in the early part of the sixties, gradually merged into the protest against the Vietnam war in the latter part of the decade. Women began to organize to fight a social bias which they felt had kept them in a state of unnecessary economic dependence on men. Blacks and other racial and ethnic minorities also began to organize. But with so many movements for civil, political, social, and legal rights, there was bound to be disagreement over priorities.

Phenomenal technological advances were a feature of the sixties. The Russians sent a man into space, and the Americans put a man on the moon. Jet passenger liners, having become standard in air fleets around the world, stepped up the pace of modern business.

American Literature In a period so close to the present, it is impossible to name all the important writers and all the significant books. Moreover change in literary and ideological style was as rapid in literature as in art. Betty Friedan's timely and influential report on women, *The Feminine Mystique* (1963), was soon surpassed by other feminist writers. John Barth (*The Sot-Weed Factor* and *End of the Road*), Saul Bellow (*Herzog*), Kurt Vonnegut (*Slaughterhouse-5*), Joyce Carol Oates, and Joan Didion were a few of the widely read writers of fiction. Norman Mailer, who began as a novelist, turned to reporting and produced three accounts of contemporary American events in *The Armies of the Night* (1968), *Miami and the Siege of Chicago* (1969), and *Of a Fire on the Moon* (1970). The movies contributed some of the decade's most typical images in films like *Bonnie and Clyde* (1967), *The Graduate* (1968), and *Easy Rider* (1969).

International Events Crises and violent solutions were typical of the international scene as well. The Berlin Wall, erected in 1961, became a focal point of East-West tensions. The Cuban missile crisis of October 1962 narrowly missed pushing Russia and the United States into war. France and China developed their own nuclear devices. Separatist movements in several countries of mixed linguistic populations, such as Canada and Belgium, gained prominence.

CONTENTS OF THE PROGRAM *Pop Art* Pop art is probably the best-known art movement of the sixties. Pop artists whose works are seen in this part of the program are Jasper Johns, Andy Warhol, Robert Indiana, James Rosenquist, Richard Lindner, Roy Lichtenstein, Ernest Trova, George Segal, Claes Oldenberg, and Edward Kienholz.

Photo-Realism Rendering subjects from popular culture with technical brilliance, the photo-realists continue the painterly manner typical of one current of the nineteenth and early twentieth centuries. Philip Pearlstein, Ralph Goings, Robert Cottingham, and Richard Estes are discussed here.

Postpainterly Abstraction (Note: This designation is not entirely satisfactory, since abstract expressionism still possesses many adherents, but it serves at least to distinguish, however imprecisely, the emergence of a new kind of abstract painting.) Works by Tim Scott, Frank Stella, Kenneth Noland, Larry Poons, Donald Judd, Ellsworth Kelly, and Jules Olitski are shown here.

Optical Art Op art is a very specialized strain of postpainterly abstraction. Op artists shown here are Bridget Riley, Richard Anuskiewicz, Benjamin Cunningham, and Josef Albers.

New Art Forms The sixties saw numerous variations on old themes as well as some entirely new forms. Dan Flavin, Chryssa, and Rockne Krebs worked with neon sculpture. Ann Halprin and Allan Kaprow staged happenings, as did Robert Rauschenberg. Beverly Pepper, Christo, Robert Smithson, and Dennis Oppenheim delved into a new kind of art, variously called conceptual art or earth art or impossible art. These new arts often depart radically from previous modes of expression.

Photography Both documentary and fine arts photography gained adherents and prestige. Works by Minor White, Aaron Siskin, Danny Lyon, Judy Dater, Emmet Gowin, Jerry Uelsmann, and John Gossage are shown.

Architecture Ludwig Mies van der Rohe, Eero Saarinen, R. Buckminster Fuller, Louis Kahn, and Robert Venturi represent some of the many directions taken by contemporary architecture.

VIEWER'S GUIDE

PRE-LOGO ILLUSTRATIONS *Art* (Cottingham); *Darabjerd #3* (Stella); *Americanoom* (Chryssa); *One Hundred Campbell Soup Cans* (Warhol).

POP ART

Abstract expressionism, the first art movement to develop in the United States and spread to the rest of the world, marked the emergence of American artists as independent creators. Yet although American artists gave abstract expressionism a unique American flavor, the impetus of the movement had come from Europe. Pop art, too, first appeared abroad. In the early 1950s a group of British artists, who had grown up during the period when the United States, as the

great and powerful ally, seemed to be the source of all good things, became fascinated with the various manifestations of American culture. But even though British pop artists preceded their American counterparts, they did not contribute significantly to the American pop movement. Indeed at about the same time American artists in widely scattered parts of the country also turned their attention to the many and varied artifacts of American popular culture.

Uniquely American in its content and style, pop art made a tremendous impact on the art world in the early 1960s, polarizing opinion among critics and spectators. The reaction was both varied and intense: it was not in the art tradition, it glorified the vulgar and the tasteless, it was a perfect mirror of American society, it was a joke, it was ironic, it was stupid, it was openly critical of American society, it was not critical enough of American society—these were a few of the comments about pop art and pop artists. The artists themselves often did little to help clarify the situation, deliberately misleading critics with apparently sincere statements of artistic intention. (The "put-on," in fact, emerged as a kind of minor art form in its own right.) Yet despite all the denials and protests of critics, pop art was truly the culmination of the American artist's search for an American subject matter, realized in a truly American style and exempt from European influences.

Numbers 0 to 9 (1961) by Jasper Johns (Program 18).

Marilyn Monroe's Lips (1964) by Andy Warhol (b. 1925). A master of the public relations game, Warhol has done an excellent job of publicizing himself as well as his art. His most controversial effects have been achieved by a silk-screening process which duplicates images endlessly. The mechanical means by which he produces his paintings, the subject choices, and his treatment of them (consider how unappetizing Marilyn Monroe's lips are in this rendition) ensure that critics either love him or hate him. His apparently cool attitude toward life, his unshakable detachment leave critics undecided how to approach his work, whether to take it seriously or as a joke. Warhol has also directed and produced a number of films which are as unconventional and controversial in the cinema world as his paintings are in the art world.

The Beware-Danger Dream #4 (1963) by Robert Indiana (b. 1928). Indiana became fascinated with signs early in life, and his major contribution to pop art has been the sign format evident in this example from the *American Dream* series. Indiana drew on Charles Demuth's *I Saw the Figure Five in Gold* (see Program 15) for his composition.

The Light That Won't Fail, I (1961) by James Rosenquist (b. 1933). Rosenquist worked at many jobs, but probably none was more important than his experience as a billboard painter. This work increased his feeling for color and his awareness of the standard advertising images which surround us every day. Rosenquist likes to jumble images together, without specific comment, and allow them to impress themselves upon the spectator's senses in whatever way they can.

Detail of girl in hair dryer from *F-111* (1965) by James Rosenquist. Made up on 81 separate panels, *F-111* is 10 feet high and 86 feet long, the approximate length and height of the fighter plane. Rosenquist mixes images of everyday American life with his bright, metallic representation of the airplane.

No! (1966) by Richard Lindner (b. 1901). Born and educated in Germany (he came to the United States in 1941), Lindner approaches his art in a manner that varies greatly from the other pop artists. Although *No!* is a statement about American teenagers of the 1960s, and includes such common items as a Hula Hoop, formed from the "O" of *No!*, his work lacks the humor and light-hearted attitude that is so much a part of the mainstream of pop art. The heavy blockish manner in which he renders his subjects is more in the style of the various abstract art movements of the 1930s and 1940s.

The Meeting (1953). Lindner's massive figures seem to have a sinister quality that creates a solemn mood in his works.

Marilyn Monroe's Lips (1964) by Andy Warhol and then pan to *Study: Falling Man (Carman)* (1965) by Ernest Trova (b. 1927). Trova is best known for the series of faceless, robotlike sculptures he created during the mid-1960s. Here his human figure is incorporated as the body of the car, with the hands and feet becoming spidery wire wheels. Trova's *Falling Man* series depersonalizes man, presenting him as a total abstraction in a mechanized universe.

Study: Falling Man (Carman). This second image of Trova's sculpture allows a better view of how he incorporates the human figure into the body of the car—and then pan to *Bus Riders* (1964) by George Segal (b. 1924). Segal, unlike most other pop artists, takes a real interest in his characters and adopts a very compassionate position toward their suffering. Made by assembling plaster casts of real people, Segal's sculptured individuals stand out as pale, ghostlike bodies in their real environments. The contrast between white plaster and dark environment reinforces the sensation of loneliness, which is often an important part of Segal's compositions.

One of the most interesting devices used by the pop artists is the assemblage, a composite work of actual physical elements of the environment (cars, furniture, bathroom fixtures, and so on) and some artistic addition—a painted image or, as here, a sculpture.

Bus Riders (1964).

Detail from *F-111* (1965) by James Rosenquist.

No! (1966) by Richard Lindner.

Bus Riders (1964) by George Segal.

Flatten, Sand Fleas! (1962) by Roy Lichtenstein (b. 1923). Lichtenstein may not have fully grasped the artistic possibilities of the comic-book image until late 1950s, when he painted a comic strip character for his sons, but he had been experimenting with the new subject matter for several years before that important moment. The Donald Duck, however, made clear to Lichtenstein his special affinity with the comic-book characters, and he began to explore comic-strip subject matter. He has since perfected his technique considerably. The apparent simplicity of his work belies the painstaking care with which Lichtenstein works up to the finished painting.

"Pop," *Newsweek* cover for April 25, 1966, by Roy Lichtenstein. By the spring of 1966 pop, which had appeared in force in 1963 with several major shows across the country, was at its peak.

Self-Portrait (undated) by Andy Warhol. Warhol's ability as a self-salesman has made him a kind of art world "super star."

Andy Warhol (photograph by Richard Avedon).

Andy Warhol showing the scars suffered in an assault on him by a former associate (photograph). Warhol's scars were almost as big a news item as President Johnson's.

Marilyn Monroe (1962) by Andy Warhol. Violent scenes, such as highway accidents of a particularly gruesome nature, were so frequent in Warhol's early work that he was often criticized for excessive morbidity. This portrait of Marilyn Monroe, one of Hollywoods most glamorous stars, would not be considered morbid in itself, but it appeared soon after the actress died of an overdose of sleeping pills.

Andy Warhol drinking coffee (photograph).

Andy Warhol signing Campbell's soup can (photograph).

One Hundred Campbell Soup Cans (1962) by Andy Warhol is a good example of the way he comments on American life through the national emphasis on sameness and profitable repetition.

Pastry Case (1962) by Claes (pronounced CLAWS) Oldenberg (b. 1929). Oldenberg seems compelled to absolutely control the world around him. Since he obviously cannot have full control over the external environment, he creates his own personal realm of existence, supplying it with objects that are part of reality, but in unreal forms. His childish fantasy world is actualized through the use of plaster casts of food, giant appliances, soft bathroom fixtures, etc.

Dual Hamburgers (1962). Oldenberg's works are quite humorous, often making comments on the real world as in this parody on cars and food.

7-Up (1961). Like many of the pop artists, Oldenberg often used objects that were recognizable by their names.

Soft Typewriter (1962). Oldenberg used vinyl stuffed with kapok to make this version of an office typewriter.

Soft Washstand (1965). One of Oldenberg's soft bathroom fixtures.

Ironing Board With Shirt and Iron (1964). The large size of these objects and the awkwardness of the materials used set them apart from the real things.

Sculpture in the Form of a Trowel Stuck in the Ground (1971) by Claes Oldenberg (shown on the ground by the base of the sculpture). Feeling that more common, everyday items would be more appropriate than neoclassical sculpture, Oldenberg proposed a series of monuments that consisted of giant reproductions of objects that were common to the site. The giant trowel was one of the projects that was actually carried out.

Good Humor Bar in Downtown Manhattan (1967) by Claes Oldenberg. One of Oldenberg's earliest project suggestions.

Clothespin (version II) (1967) by Claes Oldenberg.

Three-Way Plug (1971) by Claes Oldenberg (shown overseeing the correct emplacement of the sculpture.).

Back Seat, Dodge—38 (1964) by Edward Kienholz (b. 1927). Kienholz's specialty has been the assemblage, a blend of real object and artistic construction. His intention is often to shock and by shocking to impress more forcefully on us certain typical aspects of contemporary American life.

Back Seat, Dodge—38 confronts us with a possible reminder of our sexual

past (it was dismissed as pornographic by some early critics and spectators) not only through the image of the car and the embracing couple, but by the placement of several mirrors about the car.

The Wait (1964–1965) by Edward Kienholz. One of Kienholz's most frequent themes is the passage of time.

Detail of photographs on wall and birdcage from the right side of *The Wait* (1964–1965).

Custom Painting, No. 3 (1964–65) by Peter Phillips. The English pop movement began before its American counterpart, but there was in no sense a relation of cause and effect between them: the two groups developed independently.

PHOTO-REALISM

Male and Female Nudes with Red and Purple Drape (1968) by Philip Pearlstein (b. 1924). Pop painters for the most part reduced the human figure to its poster attitudes and dimensions—two-dimensional, large, and slick—but Pearlstein continues the tradition of the great figure painters of the nineteenth century. He creates nudes with volume and establishes them in a meticulously illusionistic "space." (Cutting off parts of the body with the frame helps draw attention to the space and thereby suggests the incompleteness of vision which is a limitation of artists as well as human beings.) Pearlstein very adroitly renders the color and texture of his models' skin, but he apparently takes a special delight in exaggerating physical deficiencies—flabby skin around the waist, bulky legs, sagging muscles.

Two Female Models (1971) by Philip Pearlstein.

Detail of reclining nude from *Two Female Models* (1971).

Olympia Truck (1972) by Ralph Goings (b. 1928). The photo-realists, with whom Goings is grouped, seek a photographic precision in their work. To achieve it, they often use photographs as compositional aids and carefully mark out the canvas before executing the work. Goings emphasizes the impersonal machinery of ordinary American life, never including people in his paintings.

Detail of upper right section of *Kentucky Fried Chicken* (1973) by Ralph Goings.

Kentucky Fried Chicken (1973) by Ralph Goings.

Art (1971) by Robert Cottingham.

Untitled (1970) by Ralph Goings.

Subway Stairway (1970) by Richard Estes.

POSTPAINTERLY ABSTRACTION

Abstract painting of the late 1950s and the 1960s differs from prewar abstract painting in its emphasis on the effects of color juxtaposition rather than on object and form interrelationships.

Quali #1 (1967) by Tim Scott. Scott's sculpture continues in the direction set out in the 1950s by David Smith.

Arundel Castle (1959) by Frank Stella (b. 1936). The rectangularity of *Arundel Castle* is typical of Stella's earlier work.

Pagosa Springs (1960) by Frank Stella.

Darabjerd #3 (1967) by Frank Stella. In the 1960s Stella began to experiment with unusually shaped canvases. He abandoned symmetry of design in attempting to effectively control depth of color, figure appreciation, and surface modulation through color juxtaposition and shaping of the canvas.

Unidentified sculpture by Tim Scott.

Bend Sinister (1964) by Ken Noland (Program 18). Noland's canvases are invariably larger than the spectator can take in at once and often seem therefore to engulf the viewer. Like Stella, Noland concentrates attention on the interaction of colors, composing his colors in stripes which often are transformed into chevrons by running two lines together. Noland uses Magna colors, which do not lose their intensity when diluted and therefore maintain their power better than oil paints.

Detail of color dots from *Via Regia* (1964) by Larry Poons (b. 1937). Poons, a serious student of music before turning permanently to painting, has engaged in a long experimentation with placing dots of color on a monochrome field. His compositions result from a carefully prepared grid of squares, diagonals and other geometric shapes. Like Noland, Poons employs large canvases, frequently over six feet by eight feet.

Untitled (1969) by Donald Judd. Sculptors in the 1960s began to pay particular attention to the cube and to box-shaped structures. Warhol's *Brillo* boxes are an example of this interest. Judd's sculpture consists of several rectangular boxes which are themselves exploded equal segments of a larger box.

OPTICAL ART

Optical art, or op art as it is often called, is one expression of postpainterly abstraction. It removes specific content from the painting, particularly with reference to the artist's emotional and social commitments, concentrating on the physical response of the eye to visual formations. Op art, like trompe l'oeil painting of the late nineteenth century (see Program 7), deals with illusions; not illusions of real objects in real space, but the illusion of movement and often of depth. The op painting acts on the eye much the way the trompe l'oeil paintings acted on the mind. Josef Albers (b. 1888) influenced much of the speculative force of the op artists with his investigations into the power of color squares placed on top of one another. Later op artists created paintings which seem more appropiate to psychology textbooks than to art galleries, but nevertheless op paintings are often as humorous and whimsical as pop paintings.

Red White (1966) by Ellsworth Kelly (see Program 18).

Bad Bugaloo (1968) by Jules Olitski (b. 1922). Olitski's huge canvases feature great luminous expanses of color with narrow stripes of hard-edge colors ac-

centing the edges of the painting. Olitski aims solely at stimulating the eye; his paintings are passionately nonobjective.

Current (1964) by Bridget Riley.

Entrance to Green (1970) by Richard Anuskiewicz (b. 1930). Anuskiewicz's paintings, in many ways typical of op art, group colors in such a fashion that they stimulate the eye, forcing it to move over the surface. Op paintings often stimulate the eye the way a vibrator stimulates the muscles.

Degree of Vividness (1964) by Richard Anuskiewicz.

Equivocation (1964) by Benjamin Cunningham.

Homage to the Square: Glow (1966) by Josef Albers (b. 1888). Albers, who came to the United States from Germany, showed a special fascination for the square. By reducing his geometric problems to the simple lines of the square, he was able to concentrate on the possibilities of color juxtaposition and to experiment with colors. Albers approached his painting like a scientist; he is always precise and his precision holds a special kind of fascination for the spectator.

NEW ART FORMS

Light sculpture, or neon sculpture, is a relatively new field for artistic experimentation. Until the development of neon tubes, it was necessary to use reflections to light a sculpture, but since the early 1960s artists have been creating neon sculptures with the light contained within.

Untitled (1969) by Dan Flavin. Flavin discovered the possibilities of the neon tube in the early 1960s and has remained consistent in his use of tubes as linear components, much like the lines of a drawing, in his sculptures.

Americanoom (1963) by Chryssa Javacheff (b. 1935). Originally from Greece, Chryssa was greatly influenced by the sight of the bright lights of New York City, in particular the lights of Times Square. Unlike Flavin, she has experimented with volume by layering the tubes.

Day Passage (1971) by Rockne Krebs.

Myth Masks (a happening) (1966) by Ann Halprin.

Ann Halprin's Summer Workshop (photograph, 1966).

Household: A Happening (1964), organized by Allan Kaprow. The happening, a child of the sixties, was discovered and developed by Kaprow, himself a painter. For him a happening was a unique experience, one which defied the art rules of space, time, and so on. At first Kaprow tried to maintain the happening as an elusive, unverifiable, and unreproducible event, but in time he bowed to convention and arranged to have a documentation—in this case, photographs—made of the event.

Household: People Meeting (1964).

Household: the Sacrificial Volkswagen (1964).

Household: the Jam-smeared Volkswagen (1964).

Household: The Ritual.

Household: Burning the Car (1964).

Jackson Pollock at work (Hans Namuth). The happening was an extension of Pollock's action paintings.

Monogram (1959) by Robert Rauschenberg (Program 18.).

Household: Burning the Volkswagen (1964).

The desire for new creative expression led artists in many surprising directions in the sixties. The happening and earth art (or impossible art) are examples of a totally different kind of art, one which could not be bought and kept by a collector, called conceptual art. A conceptual art piece in its pure state remained just what the term implies: a concept, a thought; there was no need to carry out the project (in fact, there was no need even to write it down). Some conceptual artists, however, saw no contradiction in actually executing the project. Christo's monumental packages of geography, even though they are carried out, are thus still conceptual art. (For some additional comments on conceptual art, see Chris Burden's remarks in Program 20.) The happening, of course, was intended to be an unreproducible event. But as with the happening, it became the practice to assemble photographic documentation of the work. Ephemeral conceptual art projects like Christo's packages soon remain only in the documentation. Others, like Robert Smithson's *Spiral Jetty*, are too distant to visit and so become accessible only through the documentation.

Dallas Land Canal, Dallas, Texas (1971), by Beverly Pepper.

Wrapped Coast (1969) by Christo.

Spiral Jetty (1970) by Robert Smithson.

Cancelled Crop (1969) by Dennis Oppenheim.

Nebraska Project (1968) by Dennis Oppenheim.

PHOTOGRAPHY

Photography in its early days was a tool for recording the appearance of the external world. The first important photographers were portraitists, like Southworth and Hawes (see Program 5) and reporters, like Mathew Brady (see Program 10). Because it was a mechanical process, however, photography was not considered an art on a par with painting. But as photographers explored their medium, they found that the camera offered many creative possibilities. The experiments in abstraction by painters and sculptors in the early twentieth century had their influence on photographers as well. Man Ray, an American painter living in Paris, and László Moholy-Nagy, a Hungarian painter working in Berlin, experimented during the 1920s with patterns of light and dark. Their work had relatively little influence at the time, but it was rediscovered after World War II when abstract photography underwent a resurgence. Aaron Siskind (b. 1903) and Minor White (b. 1908) are two of the best-known nonobjective photographers.

Other photographers, however, have continued to use the camera as a kind of research tool, exploring the world they live in. Often it is a highly individualized and personal world, despite the apparent objectivity of the photographic process. The best example of this kind of personal documentary work can be

found in the photographs of Diane Arbus, which have a definite personal flavor despite the photographer's careful restraint.

Cobblestone House, Avon, New York (1958) by Minor White. White likes to photograph real structures and natural phenomena in such a way that they suggest, by their shapes and their textures, something else.

Ritual Branch (1958) by Minor White.

Chicago (1949) by Aaron Siskind. Siskind is primarily interested in form and contrast, but he uses his objects in a personal way. As he put it in the 1950s, "The emphasis of meaning has shifted from what the world looks like to what we feel about the world and what we want the world to mean."

Cliff and Clouds (1966) by Minor White.

Moon and Wall Encrustations (1964) by Minor White.

Chicago 25 (1960) by Aaron Siskind.

Gloucester, Massachusetts (1944) by Aaron Siskind (glove).

Pacific (1948) by Minor White.

Untitled (1971) by Aaron Siskind (string).

Nude (1947) by Minor White.

Sparky and Cowboy, Gary Rogues, from *The Bike Riders* (1965) by Danny Lyon (b. 1941). Lyon grew up in Chicago and began to take photographs of the places and the people he knew there. He began a series on motorcyclists, called *The Bike Riders,* in 1963, and recently he has completed a photographic essay on prisons.

Jack, from *The Bike Riders* (1965) by Danny Lyon.

Illiana Speedway, Indiana, from *The Bike Riders* (1965) by Danny Lyon.

Wisconsin (1963) by Danny Lyon.

Twinka (1970) by Judy Dater (b. 1940).

Four photographs by Emmet Gowin (b. 1941), titles and dates unavailable.

Bride and halo.

Children on rumpled bed.

Baby boy on bedspread.

Santa.

Untitled (1969) by Jerry Uelsmann (b. 1934). Uelsmann is best known for his strange, dreamlike scenes, the product of careful composition and effective overprinting.

Common Grey Squirrel (1974) by John Gossage.

Landscape and windows. Emmet Gowin.

Uptown Chicago (1965) by Danny Lyon.

Nancy (1969) by Emmet Gowin.

ARCHITECTURE

American architecture of the twentieth century is a dynamic combination of the clean, unadorned lines of the Bauhaus School (also known as the International style) and the applied functionalism of Louis Sullivan and Frank Lloyd Wright.

Ludwig Mies van der Rohe summed up the principles of the Bauhaus School with his often-quoted aphorism: "Less is more."

View of New York City skyscrapers (photograph). Born in Chicago, the skyscraper grew to an early maturity in New York City, where the high cost of urban land and the presence of large, wealthy companies made it a practical necessity. Early skyscrapers had much exterior decoration, but in the 1930s, under the influence of the International style, the emphasis shifted to straight, unadorned lines. The clean, hard lines of the metal-frame, glass-covered skyscrapers of the 1940s and the 1950s eventually grew too sterile, prompting architects to incorporate murals, sculptures, and other decorations in their designs.

Lakeshore Drive Apartments, Chicago, Illinois (1957), by Ludwig Mies van der Rohe (1886–1969). Mies van der Rohe first practiced his art in Germany, where he was associated with the Bauhaus. Nazi opposition brought him to the United States in 1938 as director of architecture at the Illinois Institute of Technology in Chicago, where he spent the next 20 years designing a campus for the school. The clean lines and precise proportions of these apartment buildings are in keeping with the architect's belief in unadorned surfaces.

Dulles Airport (1962) by Eero Saarinen (1910–1961). Son of Eliel Saarinen (1873–1950), whose design for the Chicago Daily Tribune Building in 1922 had an enormous influence on the development of skyscraper design, Eero Saarinen showed in his design for the Dulles Airport the aesthetic possibilities of concrete as well as the great opportunities offered modern architects by technological advances.

Control Tower: Dulles Airport (1962).

Geodesic Dome by R. Buckminster Fuller (b. 1895). Fuller has been one of the most vocal advocates of increased emphasis on technology and technological advances. The geodesic dome, which he has applied to many varied uses, is his main contribution to modern architecture and contemporary life. Perhaps his best-publicized accomplishment, and one of his finest achievements, was the United States Pavilion at the Montreal World's Fair in 1967. His 250-foot-high bubble housed all the United States exhibits under a transparent sheath which allowed a clear view of the exterior while permitting complete climate control of the interior.

Interior of *Geodesic Dome*.

Salk Institute of Biological Studies (1959–1965) by Louis Kahn (b. 1901). The Russian-born Kahn has followed a more humanistic approach in his designs, and in so doing has drawn attention to the excesses of architects who turn out great, sterile monuments of steel, glass, and concrete. In designing the Salk Institute, Kahn did not merely follow the requests of the scientists who would be working there; he questioned them closely and when he found they were overlooking essential facets of human psychology, he redirected their thinking and produced a research facility that is both professionally effective and humanly rewarding.

Illinois Institute of Technology, interior by Ludwig Mies van der Rohe.

Lakeshore Drive Apartments, Chicago, Illinois (1957), by Ludwig Mies van der Rohe.

Reston, Virginia, Planned Community (aerial view). Developed by Robert E. Simon, Jr., Reston (the name is formed from Simon's initials plus the suffix for "town") is located some 45 minutes from Washington, D.C. Eventually expected to provide living space for some 75,000 people, Reston has also been successful in attracting new industry to provide work for community residents. Reston then is not just a bedroom community, but a true city, with recreation, entertainment, shopping facilities, and businesses.

Residents of Reston Planned Community (photograph).

Las Vegas Strip (photograph).

Nevada Highway near Las Vegas (photograph).

Guild House (1965) by Venturi and Rauch. Robert Venturi and his wife Denise Scott Brown have questioned the image of the architect-hero and sought instead to deal more directly with the environment as it exists. Venturi has studied the environment in *Learning from Las Vegas* and *Learning from Levittown*. The Guild house is done in a traditional, plain style, yet the building stands out as different because of Venturi's personal additions, like the wire sculpture in the form of a TV antenna on the roof.

Fire Station Co. 6 (1964) by Venturi and Rauch.

Detail of facade of *Guild House* (1965).

Las Vegas Strip (photograph).

POST-PROGRAM ILLUSTRATIONS *Untitled* (Goings); *Bus Riders* (Segal); *Degree of Vividness* (Anuskiewicz); *Via Regia* (Poons); *Homage to the Square: Glow* (Albers); *Two Female Models* (Pearlstein); *Liz Taylor* (Warhol); *Clothespin* (Oldenberg); *Spiral Jetty* (Smithson); *Soft Washstand* (Oldenberg); *Soft Typewriter* (Oldenberg); *Nude* (White); *Sparky and Cowboy* (Lyon); *Illiana Speedway, Indiana* (Lyon); *Nancy* (Gowin); *Dulles Airport* (Saarinen); *Geodesic Dome* (Fuller).

QUESTIONS AND PROJECTS

I. Identify or define:

pop art	happening
postpainterly abstraction	minimal art
Andy Warhol	assemblage
photo-realism	op art
earth art	conceptual art

II. Developmental questions:

1 *Pop art.* Who are the principal pop artists? What unifying element do you find in their work? What kinds of subjects do they choose?

2 *Abstraction.* What innovations did abstract painters and sculptors of the sixties contribute? Who are the principal abstractionists? What are the major goals of abstract artists of the sixties?

3 *Architecture.* What are the primary building materials of the sixties? What design changes do you find from previous generations of architects? Who are some of the most important contemporary architects?

III. Opinion and judgment questions:

1 Review the American Scene painters from Program 15. Choose one of these painters and compare his/her work with that of one of the pop artists. Do you find any similarities in attitude, technique, or subject matter?

2 In what ways do the postpainterly abstractionists differ from the abstract expressionists? Does the term *postpainterly abstractionist* have any validity as a critical designation?

IV. Projects:

1 Put yourself in the place of the pop artist and consider your life—particularly the places where you spend a lot of time—as material for your art. What places or what artifacts would you choose to transform into art? What reasons motivate your decision? What does this kind of investigation tell you about the aims and techniques of the pop artists?

2 Take a tour of your community and pick out examples of the art of the sixties. Wherever possible, verify the origin of your choices.

3 Examine the recent architecture of your community. What principles underlie the designs? What building materials are most in evidence?

BIBLIOGRAPHY

Berger, Bennett M.: *Looking for America*, Prentice-Hall, Inc., Englewood Cliffs, N.J., 1971. A collection of essays on youth, suburbia, and other American obsessions.

Calas, Nicholas, and Elena Calas: *Icons and Images of the Sixties*, E. P. Dutton & Co., Inc., New York, 1971. A series of short essays on the major artists of pop and of the sixties.

Hoffman, Nicholas von: *We Are the People Our Parents Warned Us Against*, Fawcett Crest book, Fawcett World Library, New York, 1967. An account of the hippie scene in the summer of 1967.

Kirby, Michael: *Happenings*, G. P. Dutton & Co., Inc., New York, 1965.

Rublowsky, John: *Pop Art*, Basic Books, Inc., New York, 1965. A series of short biographies, with many pictures, of the most important pop painters: Roy Lichtenstein, Claes Oldenberg, James Rosenquist, Andy Warhol, and Tom Wesselmann.

ART
AMERICA 200

PROGRAM 20

ART AMERICA 200

I must force myself to contradict myself in order to avoid conforming to my own tastes.
Marcel Duchamp (circa 1960)

OVERVIEW

Contemporary art is always more difficult to assess than the art of the past. Critics, public, and artists are so intensely involved in what they see and do that the personality of the artist often becomes confused with the artist's work. As a result critical judgments of contemporary art tend to be highly subjective. In addition, today's art is rich in new art and new artists. The contact among artists today, both nationally and internationally, is probably greater than in any previous period. The more artists, it seems, the more possibilities and the greater the difficulty in either judging today's work or predicting tomorrow's trends. Even if we cannot find definitive answers, however,

Claes Oldenburg, Inverted Q in Concrete, 1976. Courtesy of Leo Castelli, New York.

265

it is important and useful to ask the questions. In this closing segment of *Art America*, several members of the art community give their answers to the questions which have carried us through the series. In addition to identifying the illustrations, we have included one or more remarks from each speaker as a way of identifying the person and indicating the general tenor of the remarks.

The participants, in order of appearance, are as follows:

Sylvia Stone (b. 1928), a sculptor whose preferred medium is plexiglas, was born in Toronto, Canada. Now an American citizen, she lives in New York City.

Abram Lerner (b. 1913) is the Director of the Hirshhorn Museum and Sculpture Garden, Smithsonian Institution, in Washington, D.C. Initially an artist (he studied at various art schools in New York City and in Florence Italy), he has been Director of the Hirshhorn Museum since its completion.

Leo Castelli (b. 1907) is the Director of the Leo Castelli Gallery in New York City, specializing in American avant-garde painting and sculpture.

Douglas Davis, (b. 1933) is a video artist and art critic who now lives in New York City.

Al Held (b. 1928) is a painter and minimal artist who lives in New York City. He studied art in New York and in Paris.

Chris Burden (b. 1946) is a conceptual artist and sculptor. A native of California, he studied art at California schools, receiving an M. F. A. in 1971, and now lives in Venice, California.

Harry Lunn Jr. (b. 1933) Director of Lunn Gallery/Graphics International Ltd. is an art dealer in Washington D.C. He specializes in nineteenth and twentieth century prints and drawings, rare photographs and the estates of Milton Avery and George Grosz.

John R. Gossage (b. 1946) is a photographer who lives and works in Washington D.C.

Carl Andre (b. 1935) is a sculptor and minimal artist who lives and works in New York City. His voice is heard commenting on his work and on Conceptual art.

To focus on specific issues, the following interviews have been intercut. The quotation summarizes the person's contribution to the discussion.

VIEWER'S GUIDE

Film of Soho section of New York City.

Hagmatana I (c. 1969) by Frank Stella.

Breezing Up (1876) by Winslow Homer.

John Singer Sargent and *Madame X* in Sargent's Paris studio (1885).

"Bedlam in Art" from *The Chicago Sunday Tribune*.

Exhibition Hall of the Smithsonian Institution (National Collection of Fine Arts).

Narrator: "Is there a distinctly American art?"

Abram Lerner: "I think there is a distinctive American art. . . . (In the painters of the nineteenth century) there was this tremendous feeling for the land, for the geography of the country."

Niagara Falls (1857) by Frederic Edwin Church.

The Lackawanna Valley (1855) by George Inness.

Lerner: "There is a realism in American art which very often hovers on the romantic, but which is . . . attached to the mores of the country."

Detail of the poker game from *Arts of the West* (1932) by Thomas Hart Benton.

Mrs. Thomas Eakins (1899) by Thomas Eakins.

The Swimming Hole (1883) by Thomas Eakins.

Lerner: ". . . we have produced an art . . . that is . . . a celebration of everyday life, of everyday life in a very particular place in the world and of the countryside. . . ."

Snap the Whip (1872, Youngstown, Ohio, version) by Winslow Homer.

Cornhusking (1860) by Eastman Johnson.

The Wrestlers (1905) by George Luks.

Lerner: "Well, if one wanted to stretch a point, I suppose that even the most avant-garde American art, which is abstract expressionism, at least the best-known of American avant-garde art, is in itself a kind of realism in that it strives to express the true emotion of the artist. . . . It's the realism of the artist's feelings."

Chief (1950) by Franz Kline.

Woman I (1950–1952) by Willem de Kooning.

Leo Castelli (standing in front of Roy Lichtenstein's painting *Masterpiece* (1962): "Art does not occur apart from life. . . . The comic strip culture is a distinctly American phenomenon."

Details of *Masterpiece* (1962).

Chris Burden: ". . . I don't think most European artists get it (i.e., the meaning of American art), you know?"

Al Held: "(My painting) is distinctly American insofar as I'm an American."

Narrator: "(The) inseparable relationship of the artist to his environment has played another part in shaping American art: that of determining the artist's role in society."

Kindred Spirits (1849) by Asher B. Durand.

The Painter's Triumph (1838) by William Sidney Mount.

Detail of the two men from *The Painter's Triumph* (1838).

Painters at work (WPA photograph).

Details of *Connoisseurs of Prints* (etching, 1905) by John Sloan.

Four details from "Armory by Powers," cartoons of the Armory Show (1913).

Narrator: "Does this alienation and misunderstanding (of the public after the Armory Show) exist today? What is the relationship of American art to American life?"

Sylvia Stone: "Well, part of the American public would be alienated by

today's art. . . . It's interesting that no one questions music, no one questions listening to Beethoven."

Abram Lerner: "The attendance at the Hirshhorn has been phenomenal. . . . In one year's time we had 1,800,000 people. . . . I think it's safe to say that from the point of view of the number of visitors there must be a tremendous interest in art."

Douglas Davis: "No, no, I don't think the average American can relate to the painting and sculpture or art that's being made today and I don't think it's important that he does."

Voice of Carl Andre: "Children and small animals seem to understand my work."

Two of Carl Andre's pieces installed.

Narrator: "What is happening today in American art?"

Interior of 1973 Biennial Exhibition at the Whitney Museum of American Art.

Flatten, Sand Fleas! (1962) by Roy Lichtenstein.

Narrator: "The art of the seventies seems to be less radical than that of the sixties."

Montenegro I (1975) by Frank Stella.

Chairman Mao (c. 1963) by Andy Warhol.

Narrator: "Minimal and formalist art continues."

Progression with Tubes (*Gold & Green*) (1975) by Donald Judd.

X Delta (1970) by Mark di Suvero.

Narrator: "Many artists are pursuing more individual concerns."

Al's House (1973) by Duncan Tebow.

Narrator: "A renewed interest in subject matter seems especially apparent. One popular manifestation can be seen in the work of the photo-realists."

Kentucky Fried Chicken (1973) by Ralph Goings.

Olympia Truck (1974) by Ralph Goings.

Narrator: "And a preoccupation with fantasy."

Ablaze and Ajar (1972) by Roger Brown.

Narrator: "The macabre has also appeared."

J. G. (1972) by Nancy Grossman.

Narrator: "There's also a renewed interest in the figure, sometimes startlingly lifelike."

Reclining Figure (1970) by John De Andrea.

Tourists (1970) by Duane Hanson.

Narrator: "Or as the pretext for the analysis of a formal problem."

Room 318 (1972) by Sidney Goodman.

Videotape segment.

Three views of exhibits of 1973 Whitney Biennial, Whitney Museum of American Art, New York City.

Interior of the National Collection of Fine Arts, Washington, D.C.

Narrator: "What, if any, conclusive statements can be made about American art today? What factors are shaping the direction American art is now taking?"

Abram Lerner: "I think there's a great deal going on (in American art), much of which we never get to see."

Sylvia Stone: "You can never produce great work unless you're taken seriously."

Douglas Davis: "American art is now almost totally an international phenomenon. . . . We live here, but we work all over the world."

Neon sculpture by Dan Flavin.

Italian Family Seeking Lost Baggage (1905) by Lewis Hine.

Austrian tapes (Douglas Davis).

Narrator: "What is the state of video art?"

Douglas Davis: "(Television) is, in fact, a very private medium."

Sylvia Stone: "Video I consider an absolute bore."

Douglas Davis: ". . . . video art is a very lively and hot phenomenon."

Leo Castelli: ". . . video art . . . may replace collecting." (*Masterpiece* (1962) by Roy Lichtenstein is in the background.)

Harry Lunn: ". . . photography, combined with video, . . . quite possibly will become the dominant art form."

John R. Gossage: "Every photographer I know works in more than a single image. . . . (Photography) is one of the major mediums right at this point. . . . It is a medium of subject matter and in that way it will be the major medium of subject matter in the twentieth century."

Huntington Gardens (1975) by John R. Gossage.

Narrator: "In conceptual art . . . the idea and not the materials dominates."

Segment of videotape presentation in blue.

Chris Burden: "There is no such thing as pure conceptual art."

White Light/White Heat (February–March 1975) by Chris Burden. "That was pretty close to pure conceptual art."

Shoot (1971) by Chris Burden, with Carl Andre narrating.

Carl Andre, commenting on conceptual art: "Art which (is) purely idea would cease to be art entirely."

Al Held: "Too many people change media without letting go of them."

Chris Burden: "I don't think all painters are artists."

Al Held: "I think painting and sculpture are basic language forms."

Chris Burden: Art is a residue (of the creative act).

Abram Lerner: "Museums are not depositories of ideas. . . . Museums can only show objects."

Chris Burden: "A lot of my work just travels by word of mouth."

Shoot (1971) by Chris Burden.

The Swimming Hole (1883) by Thomas Eakins.

The Austrian Tapes (1974) by Douglas Davis.

Film of Douglas Davis.

Chris Burden from *Shoot* (1971).

Paul Revere (1768–1770) by John Singleton Copley.

POSTPROGRAM ILLUSTRATIONS *The Boating Party* (Cassatt); *Fur Traders Descending the Missouri* (Bingham); *South Beach Bathers* (Sloan); *American Gothic*

(Wood); *Nighthawks* (Hopper); *Tourists* (Hanson); *Painted Bronze* (Johns). *Snap the Whip* (1872, Youngstown version) by Winslow Homer.

BIBLIOGRAPHY

Contemporary art is constantly in a state of change. By its very nature it continues to grow at a rapid pace. Therefore, any single monograph that might be cited as a reference source would soon be outdated. Instead, below we have listed a series of art journals that deal with current trends in American art. We suggest that the student examine any of these publications, on an informal basis, to keep abreast of current happenings on the American art scene: *Art in America; Art International; Art News;* and *Artforum.*

GLOSSARY

Academic. Academic tradition. The academic tradition is the style of painting or sculpture taught in, and enforced by, the national art academies. Since academies usually tend to be conservative in their conception of the possibilities of art, "academic" is often used by critics to describe work they consider mediocre or repetitive. In France, where the academies have been very important, almost every innovation in nineteenth-century painting was forced to develop outside their walls.

Aquatint. A method of intaglio printing which produces prints of very subtle tonal gradations. The name comes from the resemblance to drawings made with watercolor washes.

Armory Show. (See Program 13.)

Balustrade. The balustrade is the combination of railing (bannister) and supports (small posts called *balusters*) often used to decorate the roofs of houses in the colonial Georgian style.

Beaux arts style. Beaux arts eclectic style. The Ecole des Beaux-Arts in Paris encouraged its students to a free and personal interpretation of classical and Renaissance architecture, with particular emphasis on interesting combinations

of forms and profuse ornamentation. Designs in the beaux arts style were usually logically precise, with a straight axis and bilateral symmetry.

Centennial Exposition of 1876. The Philadelphia Centennial Exposition sought to dramatize the current state of the arts and sciences. The principal attraction of the celebration, the 700-ton Corliss steam engine, provided the power for all the exhibits.

Chiaroscuro (literally "light-dark"). The use of a sharp contrast between light and dark to create form and depth in painting.

Chicago School of Architecture. A school of commercial architecture established in Chicago in the late nineteenth century which helped to develop the great American skyscrapers of the twentieth century. Louis Sullivan was the inspiration of the group, and Frank Lloyd Wright was its most famous practitioner. The Chicago architects were basically antagonistic to the European tradition, exemplified in the beaux arts style, of borrowing from past architectural practice. They considered each architectural problem in terms of the physical requirements of the structure and in terms of its intended use.

Chicago window. A window occupying the full width of a bay and divided into a large fixed sash flanked by a movable sash on either side.

Classical. This term may refer either to (1) the art of the ancient Greeks or (2) the period of highest achievement and purest form of a style or technique. (See Program 14.)

Collage. A pictorial composition in two dimensions or in low relief. It may be created by gluing fabrics, papers, toys, or other objects to a piece of wood or canvas.

Colonnade. In architecture, a row of columns carrying an entablature or arches and usually supporting one side of a roof.

Composition. The organization of objects within the picture space.

Conceptual art. (See Programs 19 and 20.)

Corinthian. See *Order.*

Drum. In architecture, one of the stone cylinders which are stacked together to form a column.

Ecole des Beaux-Arts. See *Beaux arts style.*

Entablature. The entablature is the part of the building supported by the columns in classical and neoclassical architecture. It consists of architrave (lower part), frieze (middle section), and cornice (top). The proportions and detailing vary according to the order.

Expressionism. (See Program 14.)

Farm Security Administration. (See Program 16.)

Fauvism. Fauvists. (See Program 14.)

Federal style. The prevalent style of architecture in the early years (1785–1810) of the American republic. Largely based on Roman models, the Federal style received its name because of its widespread use in government buildings.

Genre painting. Basically a "scene from everyday life," a genre painting usually displays very detailed realism on a minor scale. All genre painters are

realists, but not all realists are genre painters. In genre painting the scene is not idealized, although it may be allegorical.

Georgian style. The Georgian style of architecture, typical of the eighteenth century, appears primarily in the great city and country houses of the Eastern American colonies. Characterized by restraint and bilateral symmetry, the Georgian style in America (known as colonial Georgian) is smaller and less decorative than its English counterpart.

History painting. History, mythology, and religion provided subjects which allowed the painters of the eighteenth century both to display their talent and to catch the admiration of the public. Each crucial historical encounter selected for depiction was taken as representative of a total human experience.

Impasto. Paint applied in extremely heavy layers or strokes.

Ionic. See *Order.*

Iron-framework construction. Iron-framework construction was begun by James Bogardus (1800–1874) in the 1840s in New York City. He built a five-story building in which cast iron was the basic structural material. The pieces were bolted together and then faced with masonry. The strength of the metal reduced the size of the supporting columns, allowing larger windows and increased interior lighting.

Limner. Limner style. Strictly speaking a limner is a painter. The term was first used in the Middle Ages to designate a manuscript illuminator. When portraiture became widespread, the term was used to designate the portraitist, who worked in a style similar to that of the illuminated manuscripts. Finally limner became a synonym for painter. Portraiture in England during the Tudor period (1485–1603) was carried on by foreign artists of high reputation, such as Hans Holbein the Younger, and by English provincial artists. These provincial portraitists were "untrained professionals": although they were paid to perform certain artistic tasks, they did not have extensive art training. These untrained professionals are the source of the limner style since it was the provincial portraitists who brought painting to the English Colonies. In true limner portraits the sitter is shown full-face or in three-quarter profile, in front of a neutral background. There is very little shading to suggest volume, which makes the poses seem stiff to our modern eyes, and there is an emphasis on linearity in preference to volume and color. We use "limner style" in this manual to designate only the basic 1670 portrait style. There are modifications in later work, in *Ann Pollard,* for example, or in Thomas Smith's *Self-Portrait,* which make the designations "limner" and "limner style" unsatisfactory. The desire to render volume indicates a change in awareness on the part of the artist and his patron. This evolution in awareness is lost if we use "limner style" to group all the portraiture, anonymous or signed, of the seventeenth and eighteenth centuries, which have a marked degree of flat forms and linear development.

Lithography. The lithographic process was invented in 1798. The artist draws on the surface of a block of special limestone with a special grease pencil. After the stone is chemically treated to fix the greased portions, it is wetted and inked. The ink adheres to the greased portions but not to the wet sections. The

wet portions therefore print white and the others in shades of black (in black-and-white lithography). Color lithography requires a repetition of the process for each color used.

Local color. Local color is the actual color of an object, without regard to reflected light or neighboring colors.

Luminism. The luminists were a group of nineteenth-century painters who developed a special interest in landscape painting which depends heavily on atmospheric and light effects for a significant portion of its beauty and charm. Horizontality, precise spatial organization (i.e., the objects are always carefully and exactly placed), and muted colors are frequent characteristics of luminist paintings.

Mezzotint engraving. In the mezzotint engraving process, a plate is covered with innumerable tiny holes made by a special machine called a roulette. In this condition the inked plate will print as a full rich black. The engraver scrapes away the surface with a special instrument to produce the scene, with the depth of the holes determining the degree of blackness (i.e., the deeper the hole, the richer the black). The process permits a finely graded contrast of light and dark. The medium was so widely practiced in eighteenth-century England that the mezzotint became known as "the English manner."

Modernism. Modernists. (See Program 13.)

National Academy of Design. The National Academy of Design was the most important institution of American art throughout most of the nineteenth century. Founded in 1826 by artists (among them Samuel F. B. Morse and Asher B. Durand) who were displeased with the excessive business orientation of the American Academy of the Fine Arts, the National Academy helped establish New York City as the art center of the country. The annual Academy exhibition and its public reviews were important artistic and cultural events. In the latter half of the century a group of young artists educated in Paris and Munich attacked the Academy for its aesthetic narrow-mindedness and formed the Society of American Artists to oppose its policies. The new organization eventually merged with the National Academy, but the Academy remained a conservative force in American art. The two most important art movements of the early twentieth century—the Eight and the 291 Group—developed outside, and in opposition to, the National Academy of Design.

Neoclassicism. A development of the late eighteenth century, neoclassicism was most successful in France. Its simple elegance was modeled on the ancient Greek and Roman statues recently excavated in Italy.

Order. In classical architecture, a column with base (in most cases), shaft, capital, and entablature, decorated and proportioned according to one of the accepted modes: Doric, Tuscan, Ionic, Corinthian, Composite. Doric developed first, although the Tuscan style remained the simplest in decoration. Ionic originated in Asia Minor in the sixth century B.C. Corinthian was invented by the Athenians, although it reached its fullest development in Roman architecture. The Composite is a Roman combination of the Ionic and Corinthian orders.

Palladianism. Palladian Revival. Palladianism is a style of architecture based on Roman forms as described, and prescribed, by the Italian architect Andrea

Palladio (1508–1580). The Palladian Revival began in England in the early eighteenth century, spreading to the American Colonies in the latter half of the 1700s. The most important American Palladian was Thomas Jefferson.

Pastel. Pastels are dry, powdered colors formed into crayonlike sticks about the size of a piece of chalk. When the sticks are rubbed against a hard surface, the powder breaks off and adheres to it. Soft pastels almost duplicate the appearance of oil painting, but the medium is difficult to control since the powder can easily fall off the paper or smudge. Pastel drawings are normally displayed under glass to protect them.

Patronage. In the eighteenth and nineteenth centuries, patronage was the practice of supporting an artist with no view toward a return on investment.

Patroon painters. This name is applied to the artists, many of them unknown by name, who worked in New York and the Hudson River Valley during the period from approximately 1675 until 1750. These painters are considered to form the first recognizable school of artists in American art.

Pediment. In architecture, the pediment is a low-pitched gable above a portico, formed by running the top member of the entablature along the sides of the gable. It may also be a similar piece of triangular decoration above doors and windows, either inside or outside the house.

Pennsylvania Academy of the Fine Arts. The first art school in America.

Perspective. Perspective refers to the point of view in looking at a picture. Vanishing-point perspective, invented during the Renaissance, assumes that all parallel lines meet at infinity and constructs parallel lines which meet at a certain point (the vanishing point) at the back of the picture. Aerial perspective involves a progressive darkening of the blues of the sky to suggest a receding horizon.

Phidias. According to tradition the greatest of the Greek sculptors, Phidias achieved particular renown for his statue of Aphrodite. His work, however, is known largely through what appear to be inferior Roman copies.

Pointillism. Pointillism is a branch of postimpressionism, in which pure colors are applied in tiny dots rather than as solid expanses. Forms in such a painting are recognizable only at a certain minimum distance, at which point the dots merge and form a solid area of color.

Pointing up. Pointing machine. Pointing up is a technique for transferring a plaster model directly to marble. A pointing machine is used to measure the depth of given verticals, and then holes are drilled in the marble. When enough points have been taken, a stone mason chips away the marble and produces the sculpture. It was common practice among American sculptors of the nineteenth century to do only the plaster model and to consign the heavy work to skilled Italian craftsmen.

Portico. In architecture, a portico is a roofed space, open or partially enclosed, forming the entrance and centerpiece of the facade of a temple, home, or church, often with attached or detached columns and a pediment.

Postimpressionism. Postimpressionism is a general term to describe the trends in modern art in the last decades of the nineteenth and the first decade of the twentieth centuries.

Puritan heritage. The first settlers of New England, the Puritans and the Pilgrims, had strict views on work, pleasure, and art, which have had a lasting influence on the American attitude toward art.

Realism. Realism in this manual usually refers to one of two things: (1) the depiction of figures, objects, and scenes as they appear in nature, without distortion or stylization; (2) a movement in French art between 1850 and 1875, led by Gustave Courbet (see Program 5). Courbet sought a frank, even harsh picture of everyday life.

Romanticism. Romanticism is basically an approach to art which emphasizes the personal, the emotional, and the dramatic. It developed as an alternative to the more sterile and intellectual neoclassicism.

School. In the painting sense, school implies a group of artists who are in agreement concerning the methods and goals of their work. According to this definition, there have been very few schools in American art history.

Spandrel. In a multistory building, a spandrel is a wall panel filling the space between the top of the window of one story and the sill of the window of the story above.

Tour de force. Literally a "feat of strength or skill," a tour de force is an artistic accomplishment against heavy odds.

Trompe l'oeil painting. Trompe l'oeil (literally "fool the eye") designates a style of painting in which the artist renders objects in such minute detail that the spectator believes them to be real objects rather than representations of real objects.

Wood-block engraving. The popular press of the early nineteenth century was limited in its coverage of current events by its reliance on engraved metal plates for illustrations. Metal engraving was both slow and expensive. Lithography, although permitting faster work, was unsuited for large press runs. The problem was solved by the perfection of a method of engraving on wood. The artist would draw the illustration, often directly onto the wood block. The block was then passed to a craftsman who cut away the wood between the lines, leaving a relief design which could be inked and printed. For large press runs the wood-block design was transferred, by a simple mechanical process, to a metal plate. By making possible low-cost illustrations of the latest events, wood-block engraving caused illustrated news magazines and newspapers to appear in great quantities.